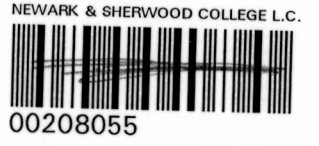

Sally Festing

BARBARA HEPWORTH

A LIFE OF FORMS

VIKING

VIKING

Published by the Penguin Group
Penguin Books Ltd, 27 Wrights Lane, London w8 5TZ, England
Penguin Books USA Inc., 375 Hudson Street, New York, New York, 10014, USA
Penguin Books Australia Ltd, Ringwood, Victoria, Australia
Penguin Books Canada Ltd, 10 Alcorn Avenue, Toronto, Ontario, Canada M4V 3B2
Penguin Books (NZ) Ltd, 182–190 Wairau Road, Auckland 10, New Zealand

Penguin Books Ltd, Registered Offices: Harmondsworth, Middlesex, England

First published 1995
1 3 5 7 9 10 8 6 4 2
First edition

Typeset by Datix International Limited, Bungay, Suffolk
Printed in England by Clays Ltd, St Ives plc
Filmset in 11.75/15 pt Monophoto Bembo

A CIP catalogue record for this book is available from the British Library

ISBN 0–670–84303–2

CENTRE	NEWARK
CHECKED	Jc
ZONE	Black
ZONE MARK / SUFFIX	730·92 FES
LOAN PERIOD	1 MONTH

TO MICHAEL

CENTRE	
CHECKED	
ZONE	
ZONE MARK / SUFFIX	
LOAN PERIOD	

'The close of the past century was full of a strange desire to get out of form. I now feel an impulse to create form.'

YEATS, 1903 (*the year of Hepworth's birth*)

'It is difficult to describe in words the meaning of forms because it is precisely this emotion which is conveyed by sculpture alone.'

BARBARA HEPWORTH

'Passion can create drama out of inert stone.'

LE CORBUSIER

'Look, with me it may happen at times that my hands grow aware of each other.'

RILKE

Contents

CONTENTS

Illustrations

Foreword

Often, people have asked me how I came to write about Barbara Hepworth. Indirectly, our paths crossed. My husband was at school with the Hepworth-Nicholson triplets in far-off Dartington days, I met Simon when he was at Cambridge, my brother worked briefly with Naum Gabo, and my father once belonged to a Cambridge Scientists' Anti-War group led by Desmond Bernal. None of which actively affects this book; for I never met her. Before I began, I knew precious little about her personal life; I hadn't even been to St Ives.

More pertinent was growing up in a home scattered with modern painting and modern sculpture. We, children, took this for granted; so perhaps our real initiation was in Llandaff Cathedral, where my parents took us to see Epstein's figure of Christ. Epstein was God until he was usurped by Gaudier-Brzeska when we lived in Cambridge, near Kettle's Yard.

Whenever or however we were first bewitched, my brother and sister became artists and sculptors, while I find myself writing about sculpture in the hope of conveying to others what it is that moves me. Years ago, I wrote occasionally for the arts pages of the *Times Higher Educational Supplement*; once, as it happened, about Hepworth's *Family of Man* jauntily skipping down a green slope in the Yorkshire Sculpture Park.

What I knew of her work and loved was pure, precise and severely beautiful; a world of forms somewhere between shells and musical instruments, totems, birds and weathered pebbles; wrought with a mesmerizing authority. It could be as delicate as a flower, as fierce as a Celtic cross. Were bare human hands

capable of creating such infinitely cherished surfaces? Did a classical cadence go hand-in-hand with a strong call to nature? How did Barbara Hepworth learn to make crystals dance? Paradoxes clamoured to be explored: the prospect seemed, from the moment of inception, tantalizing, challenging and full of promise.

For a number of years, at the crest of the Modern Movement, Hepworth was breaking entirely new ground. Extolled and berated, because she is strong and energizing, she remained difficult to ignore. Professional to her fingertips, nurturing her reputation as single-mindedly as she did everything else, she earned herself twenty-five years of international fame. Today, her sculpture inhabits countries throughout the world, rising in public places as familiar as the setting to the United Nations building in New York and Battersea Park. Since her death in 1975, her reputation has been not so much neglected as dormant. Few seem to doubt that she was a great sculptor; yet she has been allowed to slip from view. Although her bronzes were being priced at up to £20,000 the year she died, she wasn't shown in a group until 1992.

Some find the works in wood warmer and therefore more approachable, some think that she was first and last a carver – a superb craftsman whose vision was inured by the power and adaptability of bronze. Now that I know the work better, it seems, in the latter years, deeply uneven. On the whole, it does seem to be the small-scale and experimental works that retain their energy. But there are grand exceptions to the generalization. It bewilders me that an artist of Hepworth's force and potency should be represented by a public piece like the one on the side of John Lewis's Oxford Street store. *Winged Figure* 1962 isn't the sort of sculpture calculated to cure the doubts of those of uncertain faith. Yet what we choose to represent our artists says almost as much about us as it does about them. At best, Hepworth was both classical and spiritually radiant, not loud, but poetic, searching and exquisitely precise, one of her most remarkable qualities being an unselfconscious femininity. However stringent the forms

she used, there are gestures of sheltering or embracing, hollowed-out egg-shapes, with delicate shells and mysterious interiors, labyrinths of chambers into which filters milky light.

Part of the attraction about my subject was Hepworth's romance with the land. I wanted to set her life against the great creative forces of her surroundings in Yorkshire, Cornwall, Tuscany, Greece, and St Ives, where she lived among a jumble of cement-washed roofs for exactly half her seventy-two years. (There is something purposeful in such exactitude.) Most of her 500-odd sculptures were made in Cornwall.

On May Bank Holiday, 1989, travelling south-west for several hours, I began to recognize the names of places I was approaching from W.S. Graham's poems; the open moorland, pagan and flooded with light, deceased tin mines, even the winds off Zennor, had a sort of familiarity. Just as the sea, when I reached the port, *was* made by Alfred Wallis. From the window of a guest-house in an arc full of guest-houses, I could hear the clamour of gulls, see the tidy, pier-protected harbour, two lighthouses nodding to each other as I knew they would, across four miles of bay. From Woolf I knew the rhythms, from Wallis, the forms. Like Graham, I was travelling where I seemed to have walked before.

The proprietor of my guest-house was a histrionic Irishman retired from the merchant navy, where he had served as ship's relief on the P & O. In a graphic introduction, he informed me: 'Barbara Hepworth was a personality and an eccentric. You know what I mean? She'd wear a black wool cape with a hood in the winter and walk through the town like a bat. Whooosh . . .' His arms moved backwards and sideways like a sculpture by Kenneth Armitage. 'Then she was gone.

'She used to tipple up at the Castle. She'd see me there – I was younger then. "Home on leave," she'd say. "Home on leave again?" That was what happened in the end. Her end was like her life.' He didn't explain his final comment: perhaps that was where my assignment began. In her garden, full of bronzes and

gusts of petals from the cherry trees, bathed in brilliant sea-reflected light, her work feels totally at home. I could almost hear the carefully modulated voice say, 'Silly girl, you mustn't ask questions', and I should have been, had I confronted her, just a little frightened of the first woman to enter the mainstream history of art.

One of her bogies has always been the idolization of Henry Moore. Even though Hepworth had quite a reputation, she lived in his shade, creating a rivalry in which Moore was not altogether passive. I don't wish to exaggerate its significance – in some ways, Hepworth was the antithesis of Moore; where he is rugged, brutal and strongly allied to the primitive, her more contemplative sensibility is smooth, calm, essentially classical. Near the outset of her career, moreover, she gave up making obviously figurative sculpture, to produce a huge body of abstract work. Among critics, Norbert Lynton perfectly realized that 'In a way she has always been underrated – overshadowed by Moore and perhaps seen through that special inverted telescope we tend to reserve for creative women other than novelists.'

I had no idea, when I began my story, how important the feminist issue was; that in a life infused with radical, intellectual commitment, Barbara Hepworth was aware of herself every waking moment, as a woman paving the way in a man's world.

At least ten monographs sing Hepworth's praises. What is remarkable about this huge exposure is how she largely controls her image. Herbert Read took the initiative, punctuating a prestigious, illustrated volume with her statements about her development. Hodin and Hammacher faithfully expanded Read. Sir Alan Bowness, Hepworth's son-in-law, slightly readjusts the image, but only by drawing in more autobiographical material. In the *Pictorial Autobiography* this happened once again. The interpretations are perfectly tenable. By describing what was going on behind her sculptures, she helped to create a set of terms and a framework of ideas and values within which her work has been discussed ever since. It's just that they make rather an

elusive portrait. Margaret Gardiner's memoir staggers Hepworth's letters with a delightful, independent commentary. Obviously valuable, it is, nevertheless, as pertinent for what it omits as what it tells. Alan Wilkinson and Penelope Curtis have made illuminating investigations on the source of Hepworth's inspiration and the vicissitudes of her career. Their catalogue for the first retrospective since her death, at the Liverpool Tate Gallery, comes out as this book goes to press.

Before she died, Hepworth discussed her biography with Alan Bowness. His withholding the archives has deterred outsider views, though his book has not appeared. I have no doubt that it will be worthy, yet it is difficult to avoid the implication that it is Barbara Hepworth's final word.

Her life is important because every experience, cerebral, emotional, mystical and psychological, is somehow tipped into an artist's work. The brief I gave myself was to interweave the sculpture with its greatest influences, people and places, not forgetting to examine the legend; something surprisingly independent. Without access to the family archives my project has been arduous, although something held me to it when so many obstacles stood in the way. There was a book that needed to be written by a woman, and if I was to see my subject through the eyes of those who interacted with her, there wasn't time to lose. Along with Hepworth's contemporaries, material was disappearing, without which history would be permanently leaner. I would like to feel that the contribution from the many who have died since they spoke with me are a kind of memorial to them.

A handful of the family felt that their first allegiance was to the authorized biography, a few friends were loath to contribute to a larger picture over which they had no control, or worried that what they revealed might upset Barbara Hepworth's daughters. That they were so few is a measure of the debt I owe to more than seventy who have trusted me with their memories.

★

'Unlike other sculptors,' Hepworth's *New York Times* obituary pontificated, 'she did all her own polishing. An arduous task for a woman so slight.' Patently, this is nonsense; Barbara had sixteen assistants, up to three at a time. Denis Mitchell began working with her in 1949, and two were with her when she died. Tracking them down was my first, fruitful endeavour.

Roger and Pat Leigh not only shared their recollections but lent me the wide-walled granite cottage in Carbis Bay from which I made forays into St Ives. There and in London, I had extended conversations with Denis Mitchell, Breon O'Casey, the Leonards, Charmian and Keith and Tommy Rowe; Brian Wall, Angela Connor, and Michael and Lali Broido. Each gave me a slightly different perspective, some of them with considerable insight.

If I was going to understand my subject, I knew I must tease out the early years. I don't know what I would have done without the Hepworths' Nanny, Kath Ovenden, and Barbara's niece (Joan's daughter), Anne Ellis, who led me to Sir John and Elizabeth Summerson.

The West Riding was opened up by Jack Hepworth's research into the family, Margaret Hardcastle's entertaining booklet on Wakefield Girls' High School, and Wakefield's archivist, John Goodchild. Besides putting his considerable local knowledge at my disposal, Mr Goodchild checked the relevant chapters and put me in touch with three of Herbert Hepworth's fellow masons. Through Stephen Beaumont, Will Read and Reggie Fennell, I got to know a man (Barbara's father) who, although he now came only indistinctly into the focus of memory, had printed himself upon those he met with extraordinary clarity.

Contemporaries at the High School, Edith Blaire, Edna Hewlett, Mary Glover and Molly Parker, were impressed by Herbert Hepworth and his daughter. To lively accounts of long-remembered days, Margaret Knott, one-time headmistress, was able to add a later instalment, while Pat and Ralph Round, who live in the West Riding, helped to fill me in on Yorkshire ways.

Following Hepworth to Leeds and thence to the Royal College, my sole contacts were Raymond and Edna Coxon.

John Skeaping was Barbara's first husband. His son, Nick (by another marriage) and his pupil, Bob Carruthers, extended what Skeaping wrote about his four years with Barbara in his enjoyable, if self-devaluing, autobiography. But this period didn't fall into place until my sojourn in the British School at Rome. There, Hugh Petter sympathetically explained the ropes, while my brother and I traced the wonders the Skeapings had seen before.

From the time the Skeapings returned to England, the struggle began. This was the period when Sir Solly Zuckerman packed some of their work in a suitcase, in a vain bid to interest one or two of the American art world. Eleanor Chandler let me wander inside the famous Mall Studios, where Barbara's second husband, Ben Nicholson, filled Skeaping's place. To this fascinating period, Cyril Reddihough, friend, purchaser and frequent companion of Nicholson, helped me piece together the jigsaw, along with Margaret Read and her son, Ben Read, Leslie Martin, Myfanwy Piper, Edward McWilliam, Miriam Gabo and Nicolete Gray. With Margaret Gardiner I had one, for me intensely revealing, conversation.

Letters from Barbara to Ben's first wife, Winifred, were shown to me by Jake and Shirley Nicholson, whose steady support was enormously cheering. Jeremy Lewison's scholarly contributions on Nicholson accompanied me from the start; Andrew Nicholson and Angela Verren-Taunt each added a little where they could.

To some extent, the tale of Barbara Hepworth is also a tale about St Ives. From this era, I made a large number of contacts. Their puzzlingly varied views of Barbara Hepworth didn't necessarily make my task easier, but this was the nature of a woman who imprinted herself forcefully upon all she met. Some felt used, some stood up for themselves and were dismissed, some envious, some angry. One or two were sycophants. While a lot of people didn't like Barbara, others remained genuinely fond of

her to the end. A number of ridiculously inaccurate and catty articles about her in the recent press suggest that the former are still trying to control her image. If I have been successful, all who helped me will discover something of the person he or she perceived, together with views they may not have known about and certainly didn't feel.

It is probably to St Ives artists I owe the most. Tom Cross, whose book on the local art movement made admirable background reading. Margaret Mellis, who cooked me delicious lunches, and Janet Leach, who buoyed me up with whisky. Alexander MacKenzie guided me in unremitting drizzle to coastal haunts that Barbara knew. Wilhelmina Barns-Graham was cautious, Terry Frost wasn't, which said something, too, about their relationships with Barbara Hepworth. Architect Henry Gilbert made me aware how much she had done for the town.

Sebastian Halliday took pains to help me understand a complicated triumvirate Barbara made with his parents, Rene Brumwell let me loose in her fabulous art collections, and Silvie Nicholson, Christopher Cornforth and Peter Tunnard helped to explain Simon's side of a perplexing quarrel with his mother. A.M. Hammacher, Paul Hodin, Dudley Shaw Ashton, W.T. Oliver, Stanley Jones and Eric Gibbard helped me see my subject moving in and out of her studio.

Sir Anthony Lousada and Sir Norman and Lady Reid knew Dame Barbara in private and establishment roles, respected her work and loved her, if not uncritically. With the aid of taped conversations, I was able to ponder at leisure the vicissitudes of her success. Contributions arrived from Michael Canney by very long letter. Chris Stephens enlightened me through some of his own research. Others who, each in their own way, filled in the gaps were Elsie Capener, Tom Crowther, Lady Carol Holland, Linden Holman, Louis Stanley, Roger and Janet Slack, Jackie Watson, Monica Wynter, E.A. Ramsden and Margo Eates.

It is sometimes difficult to draw a line between personal and official assistance. At the Tate Gallery archives, my chief resource,

Jennifer Booth, Louise Ray and the supporting team have been helpful well beyond the call of duty. Hepworth's letters to Herbert Read were sent by Dietrich Bertz from the University of Victoria. Other correspondence was shown me by Kay and Peter Gimpel of the Gimpel Fils Gallery, Victorine Martineau at the British Council in Spring Gardens, Barley Roscoe at the Holborn Museum in Bath and Ben Dhaliwal at the Henry Moore Centre in Leeds. The Public Record Office at Kew holds British Council archives, the Royal Festival Hall those for the Arts Council. All correspondence was invaluable: my special thanks must go to Silvie Nicholson, Sir John Summerson and Sebastian Halliday, Father Donald Harris, Revd Canon Douglas Freeman, Roger Leigh and Alexander MacKenzie.

Others from the nooks and crannies of officialdom, without whom the book would be less comprehensive, include Penelope Curtis of the Henry Moore Centre, Peter Murray of the Yorkshire Sculpture Park, Brian Smith, Del Casdagli and Norman Pollard, who made me a welcome visitor at the Hepworth Museum in St Ives, Antonino Vella at Wakefield Art Gallery, Andrew Murray at the Mayor Gallery, Mike Tooby of the Tate in St Ives, Geoffrey Parton at MFA, BC, and Emma Ayling at the Whitechapel Art Gallery. The British Council in Portland Place, Leeds Art Gallery, the British School at Rome's London office and the London Library provided source material. The jolly crew at Colindale's press library rendered my tedious task there a mite less tedious.

I am grateful for Sir Alan Bowness's cooperation. He is Barbara Hepworth and John Summerson's executor. Without his permission I could not reproduce Barbara Hepworth's work or quote from her writings, published and unpublished.

David Brown, Judy Collins, Roger Leigh and Sir Norman Reid read the manuscript at breakneck speed: it was marvellous of them. Any errors remain, of course, mine.

A Sort of Magic

All day long gulls scream round Trewyn Studio, diving and bombing what might, from their swirling heights, look like a seaside fairground. Palms and deciduous trees harbour a medley of sculptures: ovals, curves, hollowed-out, womb-like, and protective feminine shapes miraculously controlled in stone and bronze. In a corner, a group of late geometries hold clandestine conversation; on a small lawn, filtered by the shadows of foliage, a giant walk-through asks to be circumnavigated, peered at and into. Not far away, a divided circle invites the light through its framing windows, its huge split swivelled lobes, as dramatic as a stork standing on one leg, becoming incandescent in sunlight without losing the force of their still contours and deliberate mass. Palpably it is a meditation upon man's relationship with the sun, moon, and planets.

In the cold months you notice knotted tree-trunks, and how the red of a stretching prunus plays against the soft blue patinas of the bronze. Wind blows through the holes, and water collects in recesses in little pools. Individually, the sculptures have an eerie calm; here, and together, they are light fantastical.

The garden is wound with paths that make you want to take them though they don't lead anywhere except round again, and secret places, hidden away, suddenly reveal poised outlines. 'In-placeness', as Seamus Heaney called it, helps to convey something of the depths Barbara Hepworth was after. One envisions the closed gardens of the world, where people can make their thoughts grow up because of the smallness and beauty. But reverence is scoffed by the gulls, Kyo-kyowing; circling the

enclave. Soaring higher, they rise above a finely curved bay of white sand against which the sea heaves itself endlessly back and forth, jumpy at the edges, fussing, flopping down rhythmically.

Finding Trewyn, Barbara acknowledged, was a sort of magic. For years she had passed without knowing what lay behind the twenty-foot granite block walls. Here was a studio, yard and garden alive to air and space. Perched on a hill directly above the parish church, it was roughly in the middle of the bay and in the heart of the seaside town of St Ives. The sky was huge, the light penetrating: a white light thrown off the sea on to the faces of houses, sharp enough to make stone come alive.

Tuesday, 20 May 1975 was set to be a normal working day. Barbara woke as she had for a quarter of a century, in her light-bombarded room, and gauged the weather. All her life, she said, as if she commanded some witchery, she had enjoyed the mysterious and exciting feeling of being compelled by the elements. The previous night, a neighbour had been out late for a drink. On the way home, close to midnight and worse for wear, he banged her front door and rang the bell. Crossly, she phoned Brian Smith, her social secretary, who, living opposite, had likewise been disturbed. Afterwards she was, as often, restless and unhappy. Otherwise nothing was untoward. Jaquie Watson, Barbara's domestic help, had put on her jacket and stepped from her home into the narrow salt-smelling alleys. Reaching Trewyn, she was pottering about downstairs. Nothing suggested that the following twenty-four hours would interrupt the pacings of the little seaside town, throwing it briefly into horrifying headlines. Yet there is a sense of drama about the Land's End coastline. Even on a cloudless day, it fails to give the impression of being quite at peace. Waves around the rocks, splashing the seagulls and cormorants, have an irritable flick to them. The northern coastline is just as beautiful as the southern one, but somehow more brooding. Much of what happens – wrecks, storms, gales and mine disasters – is on an epic scale.

Barbara was ill. Cancer reduced her appetite, so she bolstered

herself with alcohol; a fractured hip, from which she never fully recovered, caused her considerable pain. While her body was a battleground defended by drugs, she threw her bird-weight upon a stick, even now, with a sense of style. She would not give up. Early on, she had decided, it was best to 'think out a policy, stick to it and then devote oneself to work quite ruthlessly'. This reliance on systems, structure and habit had been pivotal to her success.

Work was all she did, people kept saying, fascinated by the fierceness of her commitment: it was where she had become accustomed to put the private force of her feeling. She redefined the very meaning of 'work'. Too frail to wield her tools, too frail even to descend the stairs alone, she spent increasing time on the business, smoking continually, powdering negligent ash over sheets of plastic thrown over mounds of personal belongings. Crammed in round the bed was a swivel armchair, a cabinet full of sculptures, a tray with bottles that comprised her drinks cabinet and a television. The bed, on which she worked, was littered with papers. To Father Donald Harris, Vicar of St Paul's in Knightsbridge, she had fretted about being in a state of grace. Once a month the Revd Douglas Freeman took communion to her room.

From this room, Barbara could have heard voices grunting in the workshop and in the yard. Soon the familiar heartbeat rhythm of mallet on chisel and chisel on stone would tap, tap, on and on and on, pausing, before it recommenced. Rituals had long since been prescribed: from the first chip into new material to the last laborious refinement, everything could be defined by its sounds. If the actual carving was being done by Norman Stocker and George Wilkinson, she supervised, wrote out specifications, or marked where the stone was to be carved, guiding their hands to the minutest fraction. Because the house sloped steeply, her bedroom was at ground level at the rear. To speak to her assistants, Barbara hobbled out into the yard, a diminutive figure, awesomely shrunk, dry-apple-faced, red-

scarfed, and crinkly-haired. With what seemed like words perfectly in place, emotions utterly contained, she'd move up close to the work, touch it with the palm of her left hand, and say 'Yes', scarcely raising her voice before the great sacred thing itself.

She had a way of speaking that made you listen. 'Oh my' might be all her expression when transformed with emotion, but the intensity of feeling was visible whenever anything visual was the subject. It was as though she clutched her seriousness to her, retreating behind a barrier she had cultivated with meticulous care. Sensitive to an extreme degree, she seemed to carry this barrier on tiptoe, holding it like a priceless piece of glass, thinking about the way she sat down, got up, spoke or crossed a room like an actress giving thought to a part she was learning. Sometimes her powerful hands would gesture a reaction almost more articulate than her words. All she did was self-conscious to a degree that seemed at times to be as perilous as a circus act.

'You must have a passion,' she said, 'an obsession to do something. My idea is to play it hard.' She had played hard and played to win. Like a well-decorated war veteran, she received her deserts. 'One of the most influential figures in the arts of our times', 'The first woman sculptor to achieve an international reputation', 'the greatest woman artist in the history of art' read her obituaries.

The last Hepworth was a composite sculpture set on a low turntable: two spheres, and half a sphere, two monoliths of unequal height, flat-topped to stop them rising, and an oval scooped into a crater. Theoretical, logical, playing largely on conscious and subconscious sympathy, it makes few concessions to the viewer although the tall forms might suggest male and female. Geometrical without being pure geometry, since all was accomplished by eye, the interrelationship between the masses provided 'a perfect relationship between the mind and the colour, light and weight which is the stone, made by the hand which feels'.

4

In one way, *Fallen Images* 1974–5 was a throwback to the thirties. The difference is that it lacks the defining characteristic of the early work. One looks for, and misses, tension. This wasn't a sign of tiredness, though inspired pieces came less frequently. *Fallen Images* is invested with the whole fling of Barbara's intelligence. The randomness is as purposeful as an early Alberto Giacometti;* surreal sculptures she had once used as models for severer forms. The turntable symbolizes the revolving earth and the erosion of time: 'We are so placed here, geographically, that both sun and moon rise over the water with a great radiance and this fact sets up a remarkable tension in my everyday life.' What she did was to take on the permanent forms of pristine nature: the heavenly bodies, the hills, waves, currents and bay, transmuting personal emotion into abstract beauty, as if the seething natural universe were a beast in chains.

Success, professionalism and the apparent assurance of her last years depressed and humbled the painter Keith Vaughan, who saw Barbara Hepworth's perfect armour complete with promotional trappings: everything always going forward, big projects in the morning, small ones in the afternoon. Describing her as a tightly wound spring of tension, he detected not a trace of self-doubt or self-questioning. This was the image fostered by Hepworth's stoicism: each year was more marvellous than the last, she told the *Times* diarist in 1972. She was an 'enormous optimist'. One had to be wary of taking all her statements at face value. 'I'm still fighting . . . I still feel as violent . . . as I was when I was thirty. I won't change.' You can't help admiring her courage. Barbara had gambled in life and in her work; that taking risks is precarious, she was far too intelligent to be unaware. Her end was like her life, my merchant seaman had mused. Maybe he meant 'dangerous'. The last time Breon O'Casey, artist, jeweller and one-time assistant, saw her, he was passing Trewyn on his way home from work. It was dusk and, shying from the effort of

* Particularly in *Model for a Square* 1931–2.

encounter, he watched from the seclusion of a nearby shop a taxi pull up outside her door. Barbara emerged on the arm of her taxi-man, climbed into the back of the taxi and the taxi drove very slowly up Fore Street, carrying her fragile silhouette upright in her seat. As the taxi retreated, the silhouette, visible inside the back window, gradually keeled over. It was a few days before she died; she was on her way to have supper with Frank and Nancie Halliday.

Her fear of fire was ironic. 'Always look for the fire extinguisher in your hotel room,'she had cautioned Brian Smith, as the Great Western steam train puffed and clattered up to London, way back in 1968. Often, she shared the last minutes of the day with the potter Janet Leach,★ telephoning from her bed between 11.00 and 11.30 p.m. During their conversation, Barbara would take a sleeping pill, which took about fifteen minutes to be effective. Then they lit, together, ceremoniously, a final cigarette. The cigarette lasted ten minutes. Before Barbara put down the receiver, they would stub them out. After that, Barbara would fall into a heavily induced sleep. At least once before the end, she had had an accident in her bedroom. Three days before her death, Smith's diary reads, 'BH phoned over during afternoon to say she had set papers on fire. I went over and used extinguisher. Mess everywhere.'†

After lunch, on the last day, she took her usual siesta. Jaquie came in shortly after three and woke her with tea. The afternoon was spent dictating letters and answering the telephone. At some time or other, the physiotherapist arrived to massage her arthritic limbs. But she was uncommonly tired, and tiredness brought on a feeling of decrepitude. When the night nurse was called into the bedroom, just before ten p.m., to make sure she was bolted in, Barbara had already surrendered to the day. It was her habit

★ Bernard Leach's third wife.
† The fire extinguisher had been given to Barbara by Gilbert Lloyd of the Marlborough Gallery.

A SORT OF MAGIC

to take a nightcap of whisky, turn on the television and smoke the initial bedtime cigarette.

Though localized, the fire was fast and furious.* Dense smoke and darkness foiled various attempted rescues. Someone heard a cry and an explosion. A schoolteacher who lived opposite, reaching Barbara's bedroom, heard music playing before he was beaten back. The licensee of the Castle Inn came up with a fire extinguisher, but it was hopeless, he said: the heat was terrific, the fumes and smoke had choked him. Two policemen from their station less than fifty yards away also reached the bedroom, crawling on hands and knees. All this came out at the inquest, where the story began to unravel. A knot of people gathered outside saw flames leaping through the glass, before the window shuddered and cracked.

John Milne, who lived next door, told friends how he had smelt the smoke and begun to feel the fumes. Barbara, he thought! She must be in bed. She's been smoking in bed. Milne was attempting to break in when the fire brigade arrived.

Midnight phone calls jarred chasms of silence. Brian Smith telephoned Barbara's lawyer, Anthony Lousada. 'The studio's on fire and she's inside.' 'I said, "Oh God how awful, but what can I *do*, I mean I'm in London."' The next day, he travelled down with Alan Bowness to what was absolute shambles. After the fire, scenting a story, the press mercilessly hunted down the family. Silvie Nicholson was besieged by telephone calls, none of which she would answer.

The extravagance of Barbara Hepworth's death, its manner and its abruptness, eclipsed the simple fact that an ill and profoundly Christian woman had died. It was shocking, particularly to those close to her. Two decades later it is one of the first things about her that people remember. Something provoked her to push her luck. Without consciously willing her end, she had a

* Pictures by Ben Nicholson hanging on the wall the far side of the studio were undamaged.

7

strong impulse towards it. But there never was any question of suicide and in someone who had invested seventy-two years with Sophoclean drama, the episode was perhaps less remarkable.

There *is* a mystery, though it concerns Barbara's life; touching upon the contradictions in a woman simultaneously sensitive and formidable, vulnerable and tough, withdrawn, and animated by friendship. She demanded a very special degree of consideration and respect, and invariably got it; that she endured loneliness goes almost without saying; one has only to look at photographs of her haunted old face. People felt sorry for her, they told me, 'at the end'.

Possessing a furious, calculated energy, wanting motherhood, husband and success commensurate with her skills, she was obliged to adapt to a life in which rewards are selectively bestowed. Her consuming passion to release her art trapped her into single-mindedness for which there was, surely, a price to pay.

Defiant against the human problems that battered her body and saddened her soul, she went on polishing and placing pellucid marbles, displacing space, defying balance, enticing light and shadow, charging with tension the one great meaningful area over which she had control. She could do this because her sculpture sprang from a part of her that she kept free, drawing strength and tension from her knowledge that her way of seeing was not the old way. Despite the fact that she was living alone and felt unloved, she sculpted the faith she felt in the future of man. The faith was genuine. Looking back, she could remember very clearly a girl who had stood out, she knew she had, wherever she was, among others, not only by virtue of her intelligence, but by her style and her manner. The girl was paying back the debt she owed for being born and loved and given chances not everyone had shared.

Earnest and passionate were the two things she never stopped being. The earnestness made her predicament curiously inevitable. It was upon these qualities, presumably, her line of fate was once revealed, literally in the palm of her hand. She was at a party,

and a fortune-teller had refused to tell her what her hand revealed. Puzzled, Barbara had insisted; still the woman declined. 'If she'd only told me,' Barbara said, 'then I could have laughed it off.' Like a line of fate. But oh, how dire.

When she was seven, Barbara had first been exposed to paints; an experience so dramatic that upon being dragged unwillingly away, she had 'screamed and screamed'. Generally she repressed the violence of her feelings: it wasn't obvious in her measured voice, the loaded statements she was inclined to make, as if her ideas were being distilled into phrases of epoch-making significance, or in her marble-cool conceptions, yet all her passions were intense. It was like fire riding calmly in the air. 'You don't look back along time but look through it, like water. Sometimes this comes to the surface, sometimes that, sometimes nothing. Nothing goes away.' The sands haven't changed in St Ives, nor have the façades of the boarding-houses. Seagulls go on pecking in the sand.

Grim and Wonderful Contrasts

The great industrial Yorkshire is where the story begins. To the south of Leeds and Bradford, two towns grew up on the busy River Calder: Wakefield, where Barbara Hepworth grew up, and Dewsbury, the family home. For hundreds of years, sheep had grazed in the Pennines, swift-flowing streams gushed lime-free water for washing and dyeing wool, and water-wheels were built along their banks. When the West Riding became, with adjoining parts of Lancashire, the chief centre of the British wool industry, blankets were Dewsbury's speciality.★

Hard work, steadiness and business acumen were the attributes that prospered a Dewsburyite. Faith in God, church or chapel, inured him to misfortune and broadened his social life, enterprise was an asset, a comely wife a bonus. On all these counts Benjamin Hepworth† scored. Marrying Frances Chadwick to provide him with sons, he founded a firm to try his fortune in the blanket trade.‡ A photograph taken when Frances was ninety-two shows a trim old lady with a classically sculpted profile, straight nose and chameleon-like eyelids, wearing a small feathered hat and a

★ Both sides of the American Civil War slept on Dewsbury's blankets.
† Hepworth was a fairly common name throughout the West Riding, and generations of Barbara's family came from Dewsbury.
‡ Yorkshire Woollen District Commercial List was issued to subscribers on the understanding it was destroyed at the end of the year. A precious copy in Wakefield Library for 1915–16 follows the fortunes of the Hepworth firm: Greenwood & Hepworth 1809, Benjamin Hepworth 1848, Benjamin Hepworth & Sons 1875, Hepworth & Hayley 1891, Hepworth & Hayley Ltd 1903, Issued Capital of 340,000 1915.

fashionable dress pleated into a high yoke, the sleeves puffed at the shoulders. With her is her daughter-in-law, Elizabeth Anne, her grandson, Herbert Raikes, his wife, Gerda, and their daughter, Barbara Hepworth. Frances had lived just long enough to take in her arms her great-granddaughter. The year must have been 1903.

Family and firm prospered. When mechanization arrived, coal was at hand. By the mid nineteenth century, Benjamin Hepworth had been joined by two sons, Samuel Chadwick and Benjamin George. A market and an Italianate town hall were signs of progress to Dewsbury's inhabitants. While the population grew rapidly, rows of tenements were erected round the mills, smoke hung over the town during weekdays, and the Calder became heavily polluted. Pavements black with soot turned, after rainfall, to an oily sludge.

Though rags turned cheap materials like mungo and shoddy* into profitable pickings, the woollen industry was far from secure. The price of raw materials was notoriously unstable and small firms proliferated, the result being aggressive competition. During the great Victorian depression, a large number went bankrupt. Without social security, this could be calamitous. Benjamin George, however, was by nature a survivor. After marrying, at the age of twenty-four, a wife as handsome as his mother (good figure and clothes-consciousness remained a trait among Hepworth women), work, church and Elizabeth Anne† became his full life. The work ethic was deeply instilled. If Benjamin Hepworth's initiative had set up the business, it was his son's shrewdness and hard work that made it thrive. At Dewsbury's New Wakefield Mills, with outlets in London and Manchester, the firm was producing 'carriage, travelling and fancy seal & other rugs of every description, mantle cloths, dyed & army

* Felted wool, used in making poor quality cloth.
† Daughter of William Haley whose 'mill joint' (Dews. Reg. Elec. 1898) was next door to that of Benjamin George at 21 Sharp Street.

blankets, woollens etc.' As often happened, Elizabeth's brothers joined the firm.

Eighteen eighty-one was a high point in the fortunes of Hepworth and Haley; eighty-odd men, eighteen boys and eighty-two women employed all day long, amid the clash and clang of machines, tested, carded, dried and dyed, finished, warped, wound and wove cloth. Benjamin George was renting a fine York stone house in St Mark's Terrace, Birkdale Road. Being on the Halifax side of town it afforded splendid northerly views of the valley rising to Caulm's Wood. Two servants, a nineteen-year-old from the town and – maybe a sign of progress for a twenty-eight-year-old householder – a nurse-cum-domestic from Hamburg, helped out with the children, Percy, Frank Arthur and Herbert Raikes, the last of whom was born that year.

Two girls, Cissy and Connie,* were not expected to move outside the home, consequently we hear little about them, but two of the boys, Arthur and Herbert, were, we know, remarkably bright. Education was a priority to which everything else took second place when the family moved to a modest detached house in Commonside, Hanging Heaton. 'Woodfield House' is still carved on two chipped stone gate-piers of what was Herbert's home until he married. One can't help wondering what the upheaval cost them in aesthetic appreciation. The long view of the railway from those gates could scarcely be more different from the one the family had left behind them. Barbara's tram and train journeys to visit the older generations made her aware of the scrubby grass, stunted houses and pit ponies, amid a wasteland of collieries, foundries, mills, work-yards, mines, slag-heaps, and warehouses, places where the very earth seemed to exhale black smoke. Like a dirty umbrella the smoke spread, blocking off the sky.

Allegiance to the lore of learning carried its own rewards. Arthur received from Wheelwright Grammar School a scholarship

* The man she married became Mayor of Dewsbury.

to read medicine at Cambridge. There he took a first before going on to St Bartholomew's Hospital. For high-minded, level-headed Herbert there might be even greater things in store. Never before had the family been able to afford a boarding school. To meet the sort of people who would help him to advance, Herbert became a boarder at Monkton Coomb.

Gertrude Allison Johnson wasn't, on the face of it, a suitable wife for a high flyer. Disappointment, if not disapproval, could have kept Herbert's parents from his wedding. But this is speculation. What we know is that the couple had been childhood sweethearts, and they were head over heels in love. The wedding took place on 2 April 1902 in a parish church long turned from buff-gold to charcoal. Arthur was his brother's witness; Lucy Johnson accompanied her younger sister.

To the markedly handsome couple, the occasion cannot have been free of care. Herbert's self-description, 'Surveyor and Engineer', suggests an optimistic licence; at twenty-one, he was no more than a fledgeling. True, he had hopes of a good career, and 'Gerda' was a beauty. In Barbara Hepworth's *Pictorial Autobiography* her mother looks reasonably pretty, but those who knew her reckon the portrait scarcely does her justice. As a young woman she was absolutely striking and so she seems to have remained, at least to men, in middle age. Her family was the problem; not only were they slightly lower in social scale, they were penniless.

Gerda's father, Charles William Johnson, had worked for his father before setting up with his brother as a woollen card maker.* The year Herbert Hepworth was born, Johnson's eldest son was ten, Lucy was seven and Gerda, three. Before Gerda was ten, her father and uncle were bankrupted. It is felicitous to reflect that the marriage of his favourite daughter and the birth of her first child could have been the sustaining pleasures of Charles William Johnson's final years. Gerda's father died two years after her wedding, not yet sixty, trying to earn a living as a salesman.

* A card is a comb used for pulling or carding fibres of wool.

Wakefield was cleaner than Dewsbury, and no doubt Herbert Hepworth was amenable to settling ten miles from what must have been a strong paternal influence, but his first reason for moving east was proximity to Wakefield's dome-towered County Hall. In the town's august civic centre he spent his entire working life, proving his early boast by progressing from Second Assistant Engineer to the Surveyor of the West Riding, to be Chief Surveyor himself. Home was 15 Duke of York Street, a neat Victorian terrace★ running off from Jacob's Well Tavern and the Albion Print Works.† Today it is overlooked by a vast gasometer and separated by heavy through-traffic from the centre of Wake-field, despite which the area maintains a charm. One of the first things that strikes you is the crocketed cathedral spire, rising above the roofline as you walk into town; a recurring image in Barbara's life.

Like a chessboard, the future lay before Herbert and Gerda Hepworth. Gerda was an expert seamstress. Thrift, like cleanliness, was next to godliness, and satisfaction arose from scrimping to make ends meet. One imagines her, making shopping expeditions to the market-place,‡ where electric trams soon increased the confusion of horse-drawn carts and cabs. Basket in arm, she might trip through the fine old buildings of Upper Westgate, visiting the Misses Ada and Edith Turner's confectionery, buying chops and ribs from a butcher's hung with carcasses. Dressing and visiting were high on her list of attractions; from the first weeks of marriage, moreover, she was pregnant.

On 10 January 1903, she bore a daughter with such penetrating eyes they seemed to glow like jet-stones below a broad, high forehead. From her parents, Barbara received the attention reserved for an eldest child. Being the first in her generation gave

★ Dwellings on the Hepworths' side were and are preferred for their longer gardens.
† After the Second World War the factory became Double Two Shirt Company.
‡ Later called the Bull Ring.

her a special position in the extended family. Like a princess, she remembered being presented to them.

Unlike their neighbours in Duke Street, where most of the employed inhabitants worked for a weekly wage, the Hepworths had prospects, and realizing these prospects required mobility. They were to move twice in the first four years of marriage, first to a slightly larger accommodation opposite the West Riding Asylum, 24 Eastmoor Road, and, shortly after, to a spacious Edwardian semi-detached house in Alverthorpe's Hawthorn Bank. As the family grew they moved again, but only to the house next door. The price they paid for middle-class aspirations was continuing financial strain.

Family concerns were inevitably picked up by the highly impressionable youngest member, from social conscience and politics — local and national news were followed with a good deal of interest — to judicious housekeeping. 'We were poor' was to become the prominent second sentence of Barbara Hepworth's *Pictorial Autobiography*. A little later, the words 'save' and 'scrape' appear, then 'necessary stern frugality'. Elsewhere she explained that homework, domestic mending and her father's books took a mutually competitive place in the living-room. Barbara's Alverthorpe homes were a great deal more roomy than those of many of her contemporaries, even Gerda's sewing-machine was a relatively expensive item. In many ways she would be called a privileged child, yet the ghost of need was instilled. The Hepworths *felt* poor. Like her mother, Barbara grew to enjoy money and in her final years she allowed herself to be generous, but privation preyed on her mind. Years after she was comfortably off, she found it difficult to spend, and always she was niggardly about small sums.

There was a lot in Barbara of her paternal grandfather: his intellect, toughness, and rigorously practical attitude to work, his sense of social awareness and deep-seated sense of family. Elizabeth, Barbara's younger sister, remembered her paternal grandmother as a lovely woman both in looks and in character, and

Benjamin George as a real hard Yorkshire mill-owner, straight out of a Victorian novel. His austere side wasn't mentioned in his long *Dewsbury Reporter* obituary, for he had been a prominent churchman, a generous donator to the local hospital and a life-long champion of Sunday Schools; but reading between the lines, a certain tightness is evident in the character of this high-principled, stern and pious, profoundly conservative, clever, capable man. Someone whose toughness, tenacity, strict moral ser-iousness and unswerving faith in his ways made him a good friend and a supportive, if taxing, father.

Under Benjamin George's command, Hepworth & Haley remained operative long after Barbara was born. His eldest son, Percy, managed the works, and the boss, being a man of habit and stalwart constitution, travelled down from his final home in Harrogate until shortly before his death. A Commercial List for 1915 finds the firm with £40,000 capital from manufacturing 'railway rugs'.★ When Benjamin George died, thirteen years later, it still had standing in the commercial world.

Barbara grew to love the sweep of Yorkshire's hills and the wind-rushed blast of space. Loving and leaving her birthplace – a circumstance familiar enough among artists and writers – she lost touch with the country and with Yorkshire's indigenous people; sometimes, rueing what felt almost like neglect. But eighteen impressionable years in the West Riding left her with the music of landscape so intrinsically experienced that it remained with her always. And Yorkshiremen were producer people; they made steel, mined coal and wove cloth. The Yorkshire impact was by no means wholly positive. Set against the loss were the bonds she made with fellow Yorkshiremen. Unless one has personal experi-ence, one doesn't realize how strong it is. Henry Moore, Herbert Read and Barbara Hepworth made, at a strategic point in their careers, a remarkable triumvirate. Frank Halliday, Gertrude Mc-Croben, Fred Mayor, Cyril Reddihough, John Crowther, and

★ Rugs for covering the knees when travelling by rail.

countless other Yorkshire people were special to her in a way that wasn't immediately apparent to outsiders.

In later years, Barbara dwelt increasingly on the bonhomie of mill workers from a land of 'grim and wonderful contrasts where men and women seemed to me, as a child, very tender and exceedingly strong in their belief in life':

> . . . inside the Mills mankind
> With bodies that came and went
> Stayed in position, fixed like the stones
> trembling in the song of the looms . . .

In a precocious, talented child, the powerful youthful images kindled a lifetime's polarization. Everything was beautiful or ugly, good or evil, loved or loathed. But was this duality acquired, or was it part of Barbara's personality? Round her centre she was to spin a complicated web to preserve – and extend – her creativity; at the centre she was creative, tenacious, obdurate, Yorkshire, tough.

Finding What One Wants to Say

(1907–17)

'Perhaps what one wants to say is formed in childhood,' some-thing told Barbara Hepworth, 'and the rest of one's life is spent in trying to say it.' Searching her mind for significant images, she lit, like a butterfly dipping for nectar, on experiences that had fed her imaginative life. A musical box had once seemed an incredible magic, sprinkling out like birdsong in the midst of ugliness; on the first day at school, she squished vermilion paint, smutless and brilliant, from a tube. A year or two later, an illustrated talk on Egyptian sculpture rooted her to her chair in wonder. Scattered through childhood, she had had these unaccountable, mysterious and exciting engagements. Passion was beginning to emerge.

We get only the highlights. What she didn't do, because she may have thought it too mundane, is sketch in everyday things. She doesn't mention her old nanny, who knitted her children sweaters and kept in touch with her for over seventy years, or Wakefield Prison – surely an object of curiosity for a child who passed its ramparts every day she went to school. Wakefield's famous nine-arched Chantry Bridge is bound to have made an impact. From its chapel, she might have seen barges making their way, barely a foot visible above the waterline, to and from Hull with corn or coal. Barbara thought that the fullness and complete-ness of her imaginative life was more real and more important than her ordinary mortal days. Only through her imagination would she find what she had to say.

The memory of her walking, upright and seemingly contained, to Wakefield Cathedral's Sunday service, was etched in the mind of one of her old neighbours. In the cathedral Barbara Hepworth

was baptized and confirmed. In the sanctuary she took communion, in its pews she prayed. Today you can hardly step back among shops and banks in the centre of Wakefield to get a proper view of the tallest, knottiest spire in Yorkshire, but travelling in from Leeds, Pontefract or Huddersfield, the slim, serrated outline is immediately recognizable, a visual and a spiritual landmark rasping the sky over miles of countryside. Ironically, its façade is mirrored into weird Gothic contortions by the upper storeys of British Home Stores, bringing God and Mammon literally face to face.

Like Dewsbury, Wakefield was a good business town. To commerce it owes its Georgian houses and prosperous green squares. Before the nineteenth century it determined the quality* and finish of cloth brought in from surrounding villages; thereafter, a few cloth mills appeared along the Calder tributaries. But the market-place was as integral as the factories. The capital of the West Riding never became a major industrial centre. The gentility of a neighbourhood – 'where the clack of the shuttle never breaks upon the ears of the stately citizen' – was reflected in Pevsner's 1950s impression that open country lay immediately behind the backyards of the main streets.

We get glimpses of Barbara in Eastmoor Road, her second home, opposite the asylum. Playing on the pavements, watching, as children do, obsessively shuffling patients. Then the focus swings to Alverthorpe with its few-hundred-odd houses, its double-line railway station† and the occasional mill. The Hepworths lived on the edge of the village, abutting the Wakefield–Batley road. The track past Hawthorn Bank remained unmade, a huge field lay opposite the front door, and hills on the south dipped into the Calder valley where ox-eye daisies grew. Socially, the middle classes turned to Wakefield; it follows that the Glovers, who played a major part in Alverthorpe's community

* Called 'stapling'.
† Closed in 1964.

activities, thought Mrs Hepworth was 'a bit apart'. Neighbours with more in common were the Sogars, who introduced Gerda Hepworth to Christian Science. She became totally committed; even Herbert subscribed. Barbara alone maintained her loyalty to the cathedral, with its beautiful music and words.

Local gentry played no part in the ordinary social life. They met friends in their large houses and attended church in their villages, where they generally read the lesson. Next came the professional upper-middle classes into which fell affluent mill-owners and the Headmaster and Mistress of the High School. They too attended church and chapel, where they might be wardens. The Hepworths would have belonged to Wakefield's swollen middle-middle strata, along with the senior managers of the mills and officials in the town and county hall who were not town clerks or county clerks. Domestic events, however, were the ones that most affected young Barbara. The third move had made room for two additions to the family, a competent, energetic and hard-working seventeen-year-old domestic help, followed, when Barbara was three, by a baby sister. From the moment of her arrival, strong-minded, strong-bodied Kathleen Ovenden was to make herself an integral part of Hawthorn Bank.

Kath's grandfather was presented by Queen Victoria with medals for serving in the Crimea, establishing a tradition of public service. Her father started off in the army, then entered the prison service, first as a warder, then an educationist at Wakefield Prison. Kath had always adored babies, so a household with a young family was a natural situation for her.

Aged 101, Mrs Ovenden, a large-boned woman with a long face, clear eyes and a decisive manner, recalled a wonderful picture of a loving, caring, busily interacting Edwardian family, with its routine, its upward-striving and clearly defined roles. In a framed portrait beside her bed stood the young Hepworths, ranged in years roughly from three to eleven; Barbara, Joan, Tony, and Elizabeth. Barbara has an alert triangular face offset

by a spread of long straight hair. Joan has a wide mouth, broad lips, and fair curls. Tony, reputedly 'quiet as a mouse', was a delicate child. Elizabeth, eight years younger than Barbara, has a cherubic ballet-dancer face with darting eyes, wide cheeks and a small chin. Unlike any of her siblings, Elizabeth had a temper.

Love and discipline were the keynotes of child-rearing at Hawthorn Bank. Kath was very strict. Each child had weekend duties: Tony would dust, Joan cleaned the stairs, and Barbara, the nursery. Two neighbouring houses had nannies, with two children apiece. Kath had, eventually, four, whom she managed with far less trouble: a fact she ascribed, with pride, to being a natural nanny. The children worshipped her; they were her greatest reward. 'We never sort of showed them off. If they quarrelled, well, we stopped it. If ever they went to a party or at school they used to say how they were the best children.' Kath developed a tigerish loyalty to her charges. She was with the Hepworths for five years before taking a day's leave, and this from choice.

Every day Kath walked young Barbara, in a pram, down country lanes. That was happiness, in the child's wonder at it all. Outside, or in the nursery, with the girl's tinkling laughter, was where she felt most at home. Later on, when Elizabeth was the babe, Saturday mornings meant Wakefield Market, where Kath took the children to meet her sister and buy bananas. Around them were the colourful stalls with their vendors, women conversing, the clatter of life. With quiet Joan, in many ways the homely one, Barbara got on well; she didn't know Elizabeth properly until they were adults. The Hepworth girls remained throughout life fond of one another; Tony was the odd man out. And despite their model behaviour, all clashed from time to time with their mother.

Generally Gerda spent the morning meeting her friends while Kath took charge of the children. Not only did she sew exquisite clothes, she made drawn-thread handkerchiefs and painted wine glasses to give away as presents. Like the dolls she dressed for Marshall & Snelgrove, her creative pastimes were regarded as a

contribution to the economy. She might dust though she seldom helped in the kitchen, and Kath eventually took on the cooking as well as washing and ironing. Up at the crack of dawn, she lit the fires and the copper for the washing, woke the children, washed and dressed and breakfasted them before seeing them off to school, then she'd tidy the dining-room and lay it for the older generation. In fact Gerda's sociability rather suited her. The picture one at first forms of ineffective femininity soon has to be readjusted. The first thing Gerda did each day when she walked into the dining-room was run her finger along the sideboard to make sure it had been dusted. Her insistence upon standards was demanding.

Barbara's arguments with her mother disturbed the even tenor of the household because Barbara plainly got upset. Kath always took her side, since she too, from time to time, quarrelled with Gerda. When this happened, Kath gave in her notice, the children rushed to her side, weeping at the thought of losing her, and Herbert Hepworth was called in to mediate.

No one had rows with Herbert Hepworth; by force of personality he compelled immediate respect and Barbara grew to idealize her frequently absent father, whose expressive eyes quelled any semblance of misbehaviour. Never did she hear him speak roughly; often she sought his advice. John Skeaping, Barbara's first husband, whose impish non-conformity gave him less than obvious rapport, found Mr Hepworth pompous (and his wife stupid), but novelist Leo Walmsley detected, more discerningly, 'a dour hard-headed Yorkshireman' with 'very great force of character, ability' and laconic charm. Herbert Hepworth would win at tennis without making him feel beaten, and convey his pleasure, during fishing expeditions, without speaking at all. Walmsley saw how his poise and self-control brought a sense of proportion to his children's lives. Since Barbara modelled herself upon her father, it is worth noting that respect was the general reaction to 'H.R.', as he was known among friends.

To the young Hepworths there was no one quite like their

father. In one way or another his whole purpose and direction was seen to feed back into the family. Hardly ever talking and never laughing, yet infinitely kind and patient, he had a compelling charm. Within the family his self-control gave him almost a god-like aura and like his Papa, he was inclined to be self-righteous. But you didn't trifle with Herbert Hepworth nor contradict him lightly. If his approval was the clearest encouragement, his disapproval was the severest censure. Long after she left home, for ever perhaps, Barbara particularly would struggle to meet his exacting idealism.

West Riding County Council is proudly remembered for its sovereign role, and annual reports from the County Surveyor's office★ reveal the careful, organized intelligence of the chief surveyor. After seven years in office,† through sheer hard work Herbert Hepworth was able to report, with a note of congratulation, that the highways compared favourably with those of any other northern county. Only roads are mentioned in these reports, and it looks as if his chief occupation in later years was that of management. But Barbara remembered how her father's technical designs for bridges and roads familiarized her with the language of engineers, making accessible, later, the aesthetic theories of Russian constructivists like Gabo and Pevsner.

H.R. was a Mason, in the words of fellow Mason Will Read, 'from the tips of his fingers'; a prominent senior Freemason and Grand Officer of the Grand Lodge of England, in the much venerated Unanimity 154. Founded in 1766, which makes it the third oldest in the West Riding, 'Unanimity' was a small, very mixed lodge of collier owners, lawyers, and worsted spinners of whom it was said that it was harder to join than Heaven, and even someone as basically reserved as Hepworth was known to fellow Masons. 'Very quiet', 'tall', 'conservative', 'serious', 'inscrutable', and 'a bit pedantic' were words Mr Read used to describe

★ H.R. became County Surveyor in 1921, when he was forty.
† 1,030 miles of main road came under his surveillance at the time.

him. If H.R. had to say anything, it was always to the point and always well said but rarely humorous. Read guessed that H.R. was less austere than he appeared, a man who, as the Masons say, 'lived respected and died regretted'. Stephen Beaumont, Master of Unanimity 154, saw H.R. as equally gentlemanly if marginally less mild. Generally unsmiling, he could appear formidable, didn't suffer fools gladly and rarely laughed.

Barbara was a man's woman, lots of people have observed; and the preference wasn't just sexual. Intellectually and emotionally, she was more at ease with men. It could scarcely have been otherwise. From youth she had watched her father, full of striving and moral seriousness, stooped over his books after long working days, while her mother indulged a tireless social round. Herbert Hepworth had, to his credit, what Barbara was to call 'an unusual sense of liberalism, wherein a boy and a girl were equal'. He didn't discriminate: but she did. Throughout her life Barbara Hepworth set out to prove that practically and intellectually she could match a man, yet her greatest respect and admiration was reserved for the other sex.

Respect for the male, moral seriousness, social awareness, a tendency to self-analysis and a certain frailty in coping with anger were characteristics evident in the willowy youngster growing up at Hawthorn Bank. Another distinguishing quality was Barbara's creative and intellectual searchings to extend the boundaries of place and time. The family lived very carefully, though school extras were invariably indulged, and now and then they enjoyed tastes of luxury through wealthier friends. Such was the summer house in Robin Hood Bay on the east Yorkshire coast, lent by friends in Scarborough. Scarcely a rest for Kath Ovenden, whose chief memories were of running up and down steps, carrying food, the month's holiday was, nevertheless, hugely enjoyable. For the children, it was an essential feature of childhood; for Barbara, few experiences remained more entirely etched in her mind.

The bay itself is a huge, scalloped arc edged with cliffs of

boulder clay and a line of emerald hills. **Looking** down from the approach, there was, and is, a clear view of the Hepworths' white-balconied house with two dormer windows,* situated just above the slipway. In 1963 a sea wall was built below this vulnerable corner; before then it was even more open to tides. All day and night the sound of sea could be heard in the house; at high tide, waves thumped virtually below it, sending spray all over the balconies.

The shore's upper reaches are strewn with boulders and pebbles; ochre, pink, grey, brown and plum-pudding composites, some delicately traced with fossils, others glittery. Further down, tiny crabs scuttle in and out of weedy pools of sea anemones, limpets, winkles and sea-urchins. Fulmars soar on wind-currents, black-headed gulls make a general nuisance of themselves and herring-gulls perch on the chimney-pots, laughing, screaming, mewing. In Barbara's youth, this was one of the best crab grounds on the north-east coast. For hundreds of years powerfully bowed, flat-bottomed cobles had sailed out with square brown sails, to return piled high with crab pots, unshipping their masts before landing and being manoeuvred on to heavy wooden wheels to haul up the slope.

In Barbara's attic room, the crashing sea was a sort of miracle that made her feel at the centre of extraordinary creative forces. Always occupied, retiring into a realm of her own, she would lay out her paints, invent and illuminate scenes in a model theatre, and arrange seaweed pictures. At dawn, she crept out 'to collect stones, seaweeds and paint, and draw by myself before somebody organized me'. Her words speak of a half-explored, half-suppressed mutiny, of the need to avoid domination, to remove the clutter from her life and concentrate on what really mattered. Bay Town was where the long-legged, ten-year-old schoolgirl first met Leo Walmsley, when a friend of his identified her seaweeds at the marine biology laboratory. Like St Ives, Bay Town

* Added in 1897 and used by local historians to date old pictures.

attracted artists: there was born, Barbara told Professor Ham-
macher, a yearning to join a world evoked for her by the smell
of turpentine.

To someone following the life of Barbara Hepworth, there are
pertinent similarities in St Ives to what might be considered its
northern counterpart: Bay Town, with its pantiled roofs and
irregular intersecting chimneys, its alley-like streets with short
flights of steps and cobbled slopes, linking a congestion of narrow
stone terraces. At Robin Hood Bay, ritual had given way to
feelings of excitement and release, bringing together place and
purpose in an extraordinarily meaningful way. The long sound
of the sea spreading itself over the shore was to be an insistent
echo.

When she was a young woman, Barbara was to meet someone
who attached supreme importance to childhood's hidden intensi-
ties. Herbert Read, critic, writer and one of her chief promoters,
had a hunch that all creative energy in the arts springs from a
desire to recall these fleeting moments of suspended thrall. The
artist's vision was childhood's vision. Both children and artists see
things innocently, as if for the first time. Collaborating, he and
Barbara Hepworth produced a monograph which has under-
pinned her reputation for more than forty years.

A Special Kind of Compulsion

(1909–19)

Shortly before Barbara began her formal education, the sixth form of Wakefield Girls' High School burnt a Suffragette effigy; not challenging the principles of the women's movement, but opposing their violence. Social awareness and restraint were demonstrated, both of which suggest the newcomer would suit her environment. In fact the Hepworth girls caught the High School during a spell of remarkable achievement, and Tony was equally well provided for at Queen Elizabeth Grammar or QEGS. Coming from the sort of family in which getting on was regarded very seriously made schooling extremely important. Barbara started when she was five, in an imposing brick building in the smartest part of town.

Parents had been invited to share their daughter's lessons – an amazingly enterprising suggestion when it first took place in 1897. Since then, a few pupils had been to university, societies flourished, and a new library was rapidly acquiring books. To open their doors to the mature world was the school's resolute ambition; 'old girls' were lured back to share their experiences with the institution that had nurtured them, and current pupils were encouraged to venture into the community.

Behind the new ethos was an exceptional woman. Miss Gertrude McCroben, at the age of forty-five, and at the peak of her career, was vigorous, cultured and intelligent, with a handsome, pear-shaped face, alert eyes, perhaps a little too close, a good nose and definite mouth. Although she read mathematics at Newnham, she spoke Italian fluently, lectured on Renaissance art, lingered

over the romantic poets and flourished Indian clubs until a qualified mistress was obtained to take Swedish Drill.

One of Barbara's contemporaries who became a school governor, Mrs Edith Blaire (née Martin), fully appreciated the debt they owed to their old headmistress. She had been, Mrs Blaire admitted, a little awed in the presence of so august a woman. But awe and admiration were the general reaction towards Miss McCroben; even admiration was a small word for the love and gratitude bestowed upon her by parents, pupils and staff. Love and 'worship' were the unreserved terms preferred by another ex-pupil.* No less revered in educational circles, Miss McCroben drew to her school streams of progressive and influential people such as Professor Michael Sadler, Vice-Chancellor of Leeds University, and Dr Williamson, the father of five of her girls. Williamson had begun donating reproductions of Italian masters, a beneficence he continued to the count of 190. Throughout the building, in Barbara's day, the pictures were on display.

However progressive, girls' education was full of dos and don'ts. Miss McCroben was an autocrat, it was part of her success, and a parent who dared to complain was roundly ridiculed in the local press. School days were a preparation for life, she insisted at Barbara's first speech day: 'Habits formed during these more impressionable years are very difficult to change afterwards. It is of the utmost importance that a girl should develop some of the fighting spirit which made it possible for her to choose the right path, no matter whether it was hard or easy.' These were rousing sentiments to someone reared on frugality and strong discipline, early rising, long hours of work and early bed.

Barbara's mind seemed able to grapple with any field of learning and speedily assimilate it. Every six months, it seemed, she moved to a higher class. Sometimes her father worried about the strain; the school, however, insisted that she was able. Since Hawthorn Bank contained few books, she borrowed endless

* Edna Hewlett, née Way.

novels, read parts of *Encyclopaedia Britannica* at her Uncle Arthur's, and thanks to Miss McCroben was besotted by poetry by the age of fourteen. Three years later she was devouring the soul-searching Russians, Tolstoy, Turgenev and Chekhov. Besides being exceptionally clever, Barbara was reliable, responsive, artistic and a regular concert show-piece on the piano.

To Miss McCroben, all work was sacred, and this included art. On one of the rare occasions Edith Blaire visited the Royal Academy, she met her former Head and Deputy walking up the steps. Barbara's facility with a pencil was soon noticed. Though the games fields had been sown to grass, she, detesting sports, was allowed to spend her afternoons in the new art room, sharing the edifying company of Greek statues. Royal Drawing Society certificates being duly obtained, she was called upon to provide posters for school functions, and, as she worked her way up the school, her work was often on show.

Little survives in public collections beyond a few imitative water-colour sketches she presented as gifts or autographs. There is a more interesting portrait of a gym teacher from her last year at the High School, in which one sees her pencil run and pause with the strong, delicate line that was to become so personal a part of her mature language. Barbara was, the other girls noted with interest as much as envy, a favourite with their beloved Head. For someone already beginning to think of herself in some way as set apart, Miss McCroben's sympathy was an enormous boost.

Being closeted in the art room while the rest of the school dispersed to the playing fields didn't necessarily endear Barbara Hepworth to her contemporaries. Like a roe-deer strayed into a kitchen garden, she didn't seem quite to belong where she was. In fact she was a bit of a stranger to ordinary life: she was always trying to run away. 'Very dignified', was a comment from Edna Hewlett, who was in the same form for eight years and lived less than 100 metres from the Hepworths' front door. Her approval was tacit because the two never spoke to one another.

If Barbara had a reputation for being difficult to know, both Edna Hewlett and Edith Blaire were struck by her physical presence. On one occasion, passing her in the corridor, Edith registered an image of her looking absolutely immaculate in her velvet yoked uniform, worn with black stockings, and, outside, a straw hat. Unacknowledging, she had seemed to claim airs to which the outgoing Edith objected. She didn't like her, Edith decided. It is difficult, entirely, to discount in Wakefield a touch of envy for the local girl who won success, but Mrs Blaire's views are perfectly legitimate. Barbara was always to polarize reactions. Like Miss McCroben, she was aloof, and some felt, instinctively, the faint odour of superiority to which children are so alert; as if she was a species to which the generality did not belong.

Outside school, Barbara's solitariness was often mentioned by people from Alverthorpe. John Wolfenden,* who lived just round the corner, wrote how he, too, had stood on the sidelines, dangling a black and yellow tassel from his cap because he was a prefect at the grammar school, missing out on the rich play-life around. There were Scouts and Girl Guides, acorn forays, by permission of the Misses Clarkson at Alverthorpe Hall, and cricket on the big green field outside the Hepworths' home. A little group caught trams into the bustling city of Leeds, and, as they matured, took off on their bikes at weekends, penetrating wonderful countryside.

It is easy to forget that Barbara had sisters at the High School. Betty was Titania in the school production of *A Midsummer Night's Dream*; Joan, who was everyone's friend, felt a little outshone by her sisters: but both won medals for gym, and Barbara, who adored dancing, was in her element when Professor Jacques Dalcroze's eurhythmics enjoyed a spell on the curriculum. With their smooth complexions and lithe figures, decidedly they

* Author of the Wolfenden Report which recommended the decriminalization of homosexuality.

were a good-looking trio. Shimmering in her black tunic, Barbara looked to young Edna Hewlett, 'absolutely gorgeous, like a Grecian goddess'. Inside Barbara, heartbeat rhythms pounded away. Turning in upon herself, she seemed to feel the floor quicken beneath her feet.

A studio photograph taken around her seventeenth birthday shows her wearing her first evening dress. Her forehead is wide and deep, the complexion translucent, eyes well set; shining hair, centrally parted, is coiled over each ear. Already she had adopted the shy downward gaze. The romanticism of the upper face, however, is not answered in the lower half, where a smallish, turned down mouth, short upper lip, and long, rather prominent chin make definiteness the overriding characteristic. Stephen Beaumont, meeting the elder Hepworth sisters at a dance in the High School assembly hall, found them standing slightly aloof, 'Not being at all like wilting wallflowers'.

Current affairs were part of the High School's rounded course of instruction. When the First World War was declared, Miss McCroben appealed: if they were to be victors, they must master themselves as well as overcoming the enemy. Only thus could they pave the way for a greater England. Gallantly, they supported the war effort. Girls planted potatoes, hoed mangels, knitted socks and wrapped parcels for prisoners in Germany. Just when the governors were deciding there was too much emphasis on war work, the real shock was received. The school building was to become a military hospital. Promptly, pupils scrubbed cupboards and distributed furniture to scattered locations in the town, whilst boys from QEGS, borrowed to carry desks, staggered by on the opposite side of the road. Fearing that her school would lose its identity, Miss McCroben read prayers alternately in its various premises.

Barbara was sixteen when the First World War ended; in her own mature reflection, obsessive, secretive, stubborn and difficult to live with. Asked to wave her hat in the air like everybody else, she remembered being reprimanded for disobeying. Events had

taken place that she, with her idealism, could not accept. She couldn't rejoice for the thought of all those dead. Being a star pupil didn't redeem life's shortcomings. She looked at the school art department and found it amateurish, friends requested 'pretty' Christmas cards, and no one cared for Bach which she loved to play. She was sensitive but she wasn't always subtle; sometimes she was a prig. There was more than a hint of rebellion: the conflict between her aesthetic instincts and the life she was pursuing had become, she told Professor Hodin, unbearable. At her bedroom window, Barbara felt a melancholy which could have echoed her unbelongingness.

Ostensibly, her schooldays shone with progress. So remarkable was her skill at the piano that at first it was considered she might become a professional musician. Later on, it was assumed she would go to university. At the same time, there were strong messages coming back to her about her creativeness. At home, she modelled heads of her sisters in clay and plaster; at Robin Hood Bay, painting and drawing out of doors, she was rewarded with the certainty of things being satisfyingly in place. Watching professional artists, she felt an obsession that matched her own. Barbara's first commission, small thing though it was, was won through her father's sense of pride. Herbert Hepworth was showing his daughter's art file to a friend, when the friend suggested Barbara draw his daughter. The portrait of Mary Fennell is sensitive, if not wildly unusual. Looking hard, Barbara caught, Mary's brother agreed, a characteristic expression of the demure twelve-year-old in her blue-grey dress and crimped collar.

Sometimes Barbara accompanied her father on business trips throughout the West Riding, in the car that went with his job. These journeys reaffirmed in her a powerful sense of the land and its occupation. Mostly silent and therefore undisturbing, Herbert Hepworth drove, while his daughter perched in front of one of the early types of car. Hardly any private vehicles were on the roads. Travelling carefully so as not to frighten the horse traffic,

they seemed like birds, soaring over the landscape; high enough to see over the hedges, through monumental ice-carved, water- and wind-worn hills and dales. Here and there, smoke-stacks rose in the valleys, and all night long, slag-heaps from the coal-mines burned in their deep hot hearts. Very quietly, terse and consider- ing, her father would point out features of interest, leaving spaces in which the landscape continued to float in his daughter's mind. He didn't intrude upon her privacy; this was part of the bond.

How often Barbara made these journeys doesn't seem to matter: it is enough that they rank among the events that moulded and directed her life. As an adult, she recalled with a pious sense of wonder, passing from the hot colours of the industrial cities into the unspoiled countryside, its texture, pattern and form. 'The hills were sculptures; the roads defined the form. Above all, there was the sensation of moving physically over the contours, of fullnesses and concavities, through hollows and over peaks – feeling, touching, seeing, through mind and hand and eye.' 'Every hill and valley became a sculpture in my eyes, and each landscape was intrinsic in the astonishing "architecture" of the industrial Pennines which spread west, north and south of us.' The sensation did not leave her. She *was* the form, the hollow, thrust and contour. It was as if all she had known in the early days had been inside her ever since.

Without its people, the land was incomplete. Out of Yorkshire sprang plain-speaking men and women, dignified, kindly and reliable. Sometimes figure and landscape seemed to be in har- mony, but the Yorkshireman showered the limpid air with his black industrial waste. Barbara was appalled that the dirt and smell of the towns was so unbelonging to the countryside. On one hand she saw the great upturned face of the land, leaping hills, massive contours; on the other, the black shadow of an industrial area. Here was a worrying state for which her mill- working stock bore stern responsibilities. Some kinds of work created havoc and ugliness she couldn't condone. The blackness was a challenge she felt called upon to counter. The way to do it

was by working to the rhythms of the countryside. Only through 'magic', one of her favourite words, could she break through the line which divided beauty and squalor.

Barbara often spoke of stark feelings of contrast made by alternating land and city scapes. Black and white, good and bad, beauty and ugliness. What marked her was the violence of her reactions: withdrawal, shyness, tension, determination. Work was a passion and an obstinacy; she wanted her sparkling engagement with the landscape to move mountains. Tugging away at her was what she called a special kind of compulsion. She writes as if her mission were almost evangelical: you could say her faith was a sort of obstinacy; that it didn't allow much give and take. Perhaps the extremes she saw in the landscape made it a metaphor for those inside herself. Two people had impressed upon her a sense of what she might one day do in the world, her father and her unusual headmistress.

Most of the people Barbara met and admired in her formative years were men; simply by being a woman, Miss McCroben readjusted the balance. She, moreover, must take credit for a vital episode. In greatest confidence, while pursuing her university course, Barbara was allowed to sit for a scholarship to Leeds School of Art. She won, of course, a Junior County Award. Never, Barbara vowed, would she forget her school, where her talents were spotted and encouraged. Years later, she was invited to a gathering of past pupils by Miss McCroben, then writing a book on Dante, and her former deputy, in their house at Kew. Barbara sat at the feet of her old headmistress, who stroked her hair.

At the High School, Barbara received almost every possible prize, scholastic, musical or artistic, including a water-colour sketch by Miss McCroben for 'the High School Girl who showed great promise in art'. Edna Hewlett remembered, with radiant identification, end-of-term assemblies when honours were an-nounced from the platform. Barbara's name was always there, and both came from Alverthorpe. On the other side of success

lay Barbara's expectations for herself. Why did she need to explain the prizes she didn't receive from the Royal Drawing Society, by suggesting that the pet mice, newts and frogs she had chosen as subjects had little appeal to the examiners? Barbara went as far as to write, on one occasion, that the only prize she received at school had been for a collection of seaweeds, gathered from holiday rock pools. The patent untruth is pretty revealing. Tacitly, it was understood that Herbert and Gerda made a sacrifice to educate their children, and this put upon the latter a responsibility. Acutely sensitive to emotional pressure, Barbara felt subconsciously that there was a debt she was obliged to compensate by being conventionally good and doing everything exceptionally well. Carrying the worries and tensions of needing to excel, she still felt undervalued. Whatever she achieved was not enough.

No Aim Beyond Getting On

(September 1920–September 1924)

'Life is marvellously free,' Barbara wrote, starry-eyed, from the Royal College of Art. 'The so-called Bohemianism, which is so condemned, arises from the doings of the inartistic who try to be artistic by being unconventional and very foolish. Whereas the real artists are so obsessed with their work that they have no time for scandal or a superficial way of living. There are no people more broad-minded and kind at heart.' The naïveté of her contribution to her old High School magazine doesn't disguise its self-righteousness. Five years after leaving school, she was a strange mixture of dedicated woman and sanctimonious child.

In a sense, Leeds and London were progressive escapes, not only from the strictures of a fairly narrow background but in a queer way from herself. The butterfly was bursting out of its chrysalis, entering a chosen world, and it was an immense enlargement of life. The 1920s had arrived, with high waists, high hems and flat busts. Barbara had a perfect twenties figure, although art students were no slaves to fashion, least of all Barbara Hepworth. In a gesture that expressed her independence as much as anything, she chopped her hair to the nape of her neck.

Meeting her after a gap of ten years, Leo Walmsley was intrigued. Later on he was to describe, in an autobiographical sketch, her beauty and sense of style. Barbara did not approve of his portrayal of her in *So Many Loves* and one can see that it lacks the reverence with which she tended to invest herself. Being described like the subject of a romantic novel smacked of sensationalism; 'real' artists were far too busy for superficiality. At twenty-one, she was already convinced, an artist was, by virtue

of his calling, set apart. In a life edgy with wonder and beauty, there was 'never any rest from work'. The student's time might be his own but he had 'no aim other than to get on'. Bound by duty to exploit opportunity, she worked desperately hard, even when the task seemed uninspiring, first at Leeds Art School, then at the Royal College. Her explanation, that she needed to win scholarships, was a convenient pretext for a deep-seated impulse to climb to the top of whatever ladder she encountered. Already the 'freedom' she had claimed seems a little relative. Did she, one wonders, grasp the complexities of another paradox?

During her first year of college, Barbara took a train through flat, fertile country into the smutty centre of Leeds. While trams stamped and spat blue sparks, she dodged between cars and carriages, past civic buildings grimed with soot, to the purpose-built art school, airy and clean-lined, that is now called the Jacob Cramer Gallery. Climbing the steps, she entered its pillared hall.

British art establishments were notoriously reactionary and Leeds was no exception. Provincial art education had scarcely changed since Henry Cole and his Superintendent, Richard Redgrave, at the Department of Science and Art laid out their formidable curriculum sixty years before. A weighty syllabus comprised architectural drawing, drawing from memory, life, the antique, perspective and anatomy. The days were long and tightly structured, the accent on doggedly imbibing methods and rules. Condensing a two-year course into one, Barbara drew religiously, never so much as picking up a paintbrush, let alone venturing into certain delightful fusty basement rooms reserved for wood, marble, stone carving and plasterwork. As a fellow student complained, portraying the shadow cast by a gravestone with a cross on top, while the sun shone at an angle of forty-five degrees, encouraged technical proficiency rather than creativity, stretching neither intelligence nor imagination.

One of the perks of art school was the opportunity it provided for meeting other students. At Leeds, where the discipline was

unusually large,★ Barbara was drawn to a slightly younger, high-spirited slip of a girl on the same course, Edna Ginesi, generally known as 'Gin'. It wasn't long before Barbara and Gin befriended two ex-servicemen in their second year, Raymond Coxon and his friend, a sculpture student, Harry, or Henry, Moore. All had a depth and purposefulness that marked them among fellow students.

The purpose of Leeds was avowedly practical. With the Principal,† students had little contact. They were there to equip themselves for the Board of Education Examinations to the Royal College, a task at which W.B. Pearson, the kindly Quaker drawing master, was eminently successful. The only attempt to extend their education was made by Professor, now Sir Michael, Sadler. Indeed it was said to be thanks largely to Sadler that Leeds *had* any cultural life. Art critic Roger Fry thought the University Vice-Chancellor had civilized the city single-handed. Sadler invited the brightest art students to a house full of exceptional Post-Impressionist painting; this was probably Barbara's first experience of originals by Gauguin, Van Gogh and Matisse. Though their host had, as yet, nothing modern, it wasn't long before he would include both Hepworth and Moore in his collections.

Sadler's authority on African art made him a profound influence on Moore. That Barbara benefited less from this contact deserves perusal. Professor Hammacher's suggestion that the Vice-Chancellor was apathetic about girls studying sculpture can't really be accepted. Such a convinced feminist was Sadler that he had moved and carried, in his first year as an Oxford undergraduate, a Union motion in favour of higher education for their sex. Friendship with Miss McCroben would also have predisposed him to Barbara's interests. A more likely explanation is that Sadler's obvious rapport with the genial, confident and easy-going Henry Moore made Barbara diffident. Moore's drive was stimulated by interaction, hers by withdrawal; that was one

★ 892 students in 1923, according to Penelope Curtis.
† Hayward Ryder.

disadvantage. Added to which, she was shy, introspective *and* female. Moore was just as competitive, but it was less acceptable in a woman. Barbara was convinced that Henry owed the comparative ease with which he established his reputation to being a man. If this wasn't the whole truth, there was something in it. She had to protect the source of her inspiration, and prove herself as a woman. Not having to prove himself so hard, he could be more casual.

Two years in the forces had given Moore a semblance of worldliness. With indomitable appetite, he was delving into the rewarding realms of sculpture and architecture. Barbara was four and a half years younger, and predisposed to find male figures to whom she could pay obeisance. After a short flirtation, the slim, attractive girl, her forehead 'bulging with brains', adopted the role of a younger sister. It is possible to see their very association as something from which she gained. She held Moore's talent in tremendous respect, and he more than anyone else alerted her, during the student years, to contemporary sculpture. But Barbara had an original creative insight, a fact that Moore of all people recognized. In the 1930s they would encounter each other on equal terms, a situation, Moore's biographer* pointed out, he didn't entirely relish. From the beginning, the value of his salesmanship is unlikely to have escaped her. A complicated, dynamic and mutually enriching if somewhat wary tension developed between the two exceptional and exceptionally ambitious artists. Barbara had discovered a new ladder and it soon began to look as if only one person lay ahead.

Unlike Henry Moore, who left posterity with details of his development at every stage, Barbara gives us no idea what sort of art she was looking at or reading about. This is important, because from Leeds onwards the two careers are automatically connected and compared. Moore's life is so much better documented that it is difficult not to project hers in terms of his. In

* Roger Berthoud.

the public image, her subordination is automatically impressed because art history and art criticism are unanimous in assuming that a woman artist who has contact with a male artist must either be his pupil or deeply under his influence.

A certain rivalry existed among all four friends. Mrs Coxon, as Gin was to become, remembered how their drawings were displayed every week in order of merit, and 'the boys', being a little older, usually came first. Not to be outdone by each other, all attended evening classes in life drawing. They didn't end until 9.00 p.m., after which Barbara caught trains via Wakefield to Alverthorpe, Moore went to Castleford, Gin to Horsford, and Coxon, who lived in Staffordshire, returned to his digs. Unsurprisingly, they were among seven or eight students from Leeds who received major scholarships. By autumn 1921, the Leeds quartet were ready to dazzle the Royal College.

In Europe, during the previous fifty years, the whole conception of art had changed. No longer were classical principles adopted during the Renaissance felt to be the only or the most appropriate guides; the arts were drawing from far-flung cultural and geographical spheres, expressing, in the wake of Jung and Freud, a new and infinitely wider spectrum of experience. The world had been producing sculpture for at least 30,000 years. Folk art, medieval art, oriental woodcuts, tribal heritage from Africa, America and the South Seas, Indian painting and prehistoric cave design were all there to be engaged and assimilated. The power of this strange, remote and almost timeless art was opening up a rich creative vein. In Roger Fry's legendary Post-Impressionist Exhibitions of 1910 and 1912, London was exposed to Picasso, Matisse, Van Gogh, Gauguin, and perhaps the most radical of all the Modernist pioneers, 'the primitive of a new sensibility' as Cézanne referred to himself. The first of these exhibitions at the Grafton Galleries has remained, ever since, the fashionable point from which to explore twentieth-century art.

In sculpture the situation was very similar; the Continent was where things were happening. Amid a clamour of statements, the

1. *(Above)* Barbara Hepworth, 1903–75
2. *(Below left)* Barbara's mother, Gertrude Allison Hepworth, known as Gerda, 1878–1972
3. *(Below right)* Barbara's father, Herbert Raikes Hepworth, 1881–1958

4. *(Above)* Kathleen Ovenden, the Hepworths' nanny, with Elizabeth and Tony

5. *(Below)* Tony, aged four, Barbara, eleven, Joan, seven, and Elizabeth, three

6. Wakefield, the year trams began operating. Barbara was one year old

WAKEFIELD HIGH SCHOOL REVIEW

1913

7. *(Left)* Miss McCroben, Headmistress of Wakefield Girls' High School

8. *(Right)* The cover of the High School magazine

9. *(Above)* Barbara wearing her first long dress

10. *(Below)* Miss Murphet: Barbara's pencil drawing of her gym mistress, February 1920

11. *(Opposite)* Work at the Royal College: Prix de Rome submission, 1924

12. *(Above)* John Skeaping, about the time he met Barbara, 1924

13. *(Below)* Barbara with a bird-cage, probably in Rome, *c.*1925

14. *(Left)* Drawing of John Skeaping by Barbara Hepworth, 1925

15. *(Right)* Sculpture of Barbara by John Skeaping, at the British School in Rome, 1925

16. Barbara Hepworth carving, *c.*1929–30

17. *Infant* 1929, Barbara's carving in Burmese wood of her two-month-old son, Paul Skeaping

Italian Boccioni called, in 1912, for 'complete renewal of this mummified art'. Picasso had already made sculptures from discovered objects; a year later, Marcel Duchamp exhibited a bicycle wheel. In 1914, Gaudier-Brzeska published a manifesto in Wyndham Lewis's magazine, *Blast*, that was to have enormous significance for the young generation. Only he, Epstein and Brancusi, Gaudier insisted, fully realized the potential of wood, metal and stone. Brancusi had reduced the human head to a series of highly polished eggs, and the year Barbara went to Leeds, Archipenko made a standing figure from a sequence of triangles and arcs. Mainstream and Modernist were light years apart. Sculpture, however, had reached a watershed.

In the Middle Ages, sculptors chipped away at stone with a hammer and chisel, a rather obvious method of carving, sometimes referred to as 'direct' to distinguish it from what became the fashionable alternative. This was modelling works in clay and casting them in plaster before they were copied by assistants, with the aid of a cross-shaped 'pointing machine', in marble and stone. A clay model doesn't necessarily retain its essential qualities in stone reproductions, and to the purist there is something artificial about the transference from one material to the other. The results could look, it was observed, like sucked sugar almonds. The new method, however, gained in popularity and stone cutting was all but abandoned. To the uninitiated, it seemed more of a craft than an art, though Michelangelo had recognized it as the more skilled of the two. It wasn't until William Morris set up a cry for truth to materials that the situation was reappraised. Direct carving has a certain drama because once something is chipped away, the action is final. Independently, a number of truly innovative artists picked up their tools and began attacking stone: Modigliani, Derain, Gaudier, Brancusi and Lipchitz on the Continent, Epstein and Gill in England.

The work of these men had a revolutionary flavour: it looked as if the dawn of a new age in sculpture had arrived, when the

First World War intervened. At the end of the war, British establishment sculpture had scarcely altered for twenty years; demands for war memorials only exacerbated prevailing insularity. In Britain, at least, the new impetus had to some extent been forgotten. Gaudier was dead, Gill's subjects tended to look backwards, and Epstein, working on smooth, geometric, human and birdlike forms, had reverted largely to modelling. Besides, his sculptures had strong primitive associations. Considered outrageous insults, they dismissed their creator as a noisy Jewish German expatriate. Even his champions dubbed his work 'outsider' art. From the moment Epstein carved the statues on the new British Medical Association building in the Strand in 1908, he was at the centre of controversy. The tomb for Oscar Wilde's grave in Paris and the half-mechanistic *Rock Drill* 1913–14 were more harangued than praised. Smear campaigns were rife and there wasn't much of his work around. At the Leicester Gallery in 1920, he had a show coinciding with the release of Dieren's Epstein monograph. In 1924, he was again at the Leicester Gallery. Barbara might have been familiar with his work before she left Leeds, but it is just as likely that she hadn't heard of, let alone seen, Epstein, Brancusi or Gaudier when she stepped out at Paddington from the Great Northern Line express.

The girls' London début contrasts significantly with Coxon and Moore's ecstatic entry to the metropolis. No doubt combining woollen business with familial responsibility, Benjamin George Hepworth escorted Barbara and Gin, staying with them for a night on the top floor of the Russell Hotel. From there, the fledgeling students moved into rooms near the Thames. Mrs Coxon had vivid memories of the first, insect-infested quarters. After luring vermin with a candle and stabbing them with grease in the middle of the night, they had turned, in emergency, to Miss McCroben. For two nights they lodged with Barbara's old headmistress, before settling in Holland Park.

While the Slade, under Henry Tonks and Wilson Steer, was producing Gwen and Augustus John, Wyndham Lewis and

Matthew Smith, the Royal College had dropped into second place. Drained by the war, training art teachers to teach more teachers, it had the look and smell, it was said,* of an inferior elementary school complete with clerks. Hardly anyone in the art world so much as knew where it was. Small wonder the college hadn't been attracting the best type of student. All was on the brink of change. The previous year, after much deliberation and much protest from the National Society of Art Masters, William Rothenstein, small, bumptious and bespectacled, had been called in as new Director. At twenty-one, Rothenstein had been referred to as 'Paris in Oxford'. During the winter of 1917, he had ridden across Morocco to paint official war records, wearing the tin hat and goatskin in which he contrived a famous self-portrait. Seeing himself first as a painter, he stressed aesthetics, and being a social climber, he fancied enticing the famous. The Permanent Secretary had felt it extremely desirable that 'new blood and new ideas should at once be infused into the staff', and he was not disappointed.

The conservative element was not easily quelled: a spirit of unrest pervaded Rothenstein's early years. Artists or designers, however, were immediately brought in to supplement existing staff: within a year academic pedagogy had been eclipsed. The new principal was not without his shortcomings. Surprisingly conservative in his taste, and impervious to Cézanne, he was, nevertheless, adept at scenting talent. A few exceptional students, he reckoned, would raise the standard of his entire school. There wasn't long to wait: Rothenstein's second intake of 120,† two-thirds of whom were women, included four determined students from Leeds. With their example and the Director's excellent

* By John Rothenstein; see Christopher Frayling, *The Royal College of Art*.
† The Royal College was much smaller than Leeds. Rothenstein's obituary in the *Yorkshire Observer*, 19 July 1935, says there were 120 students in 1920; Moore gives the much lower figure of sixty-six in a notoriously unreliable interview, the *Sunday Times*, 25 May 1975.

promotion, it wasn't long before his establishment was said to rival or even improve upon the Slade.

If the sculpture department, in which Barbara Hepworth spent three years, largely escaped progressive influence, it wasn't Rothenstein's fault. Eric Gill and Epstein both refused offers of appointment, and Derwent Wood, the current professor, was the most stodgy of academics. Overwhelmed with commissions for war memorials, he left most of the teaching to his assistants, Will Coxon (no relation to Raymond) and stonemason Barry Hart. Only one half-day a week was spent in a workshop, but lack of encouragement, far from deterring students, gave them something to bite against. It wasn't long before Barbara Hepworth was tracing Moore's steps to the British Museum. Epstein and others had cleared the way. Modelling had come to represent everything they most disliked, the stale realism of much British nineteenth-century work, the monumentalism of Rodin and the lacklustre, academic tradition endorsed by the establishment. Twice, Barbara mentions her unsuccessful attempts to carve a block of stone.*

The biggest debt the vigorously self-propelled Leeds quartet owed the Royal College was to its Director, for his invitations to his home in Airlie Gardens. They were much as Sadler had made at Leeds, only students did more than see pictures, they met famous politicians, academics, poets and novelists, many of whom had sat for their portraits in the Principal's studio.† 'All the time whether he knew it or not, he was raising our standards of cultural things,' explained Coxon, noting that once again, the confident Moore was singled out as a favourite. The other member of staff who made his mark was Rothenstein's drawing teacher, Leon Underwood. Forceful, original, nail-biting Under-wood was something of a subversive element, and said to evoke in weaker students a shiver of fear. To the more confident, he

* Brancusi called carving the 'truest' path to sculpture, but also, for learners, the most treacherous.
† Between 1920 and 1922, Rothenstein produced 167 portraits.

was a natural teacher. What is more, he had discovered primitive art. In his own back yard, he was chipping away at blocks of stone. His approach to drawing was no less iconoclastic; poses were shorter, there might be more than one model, and he discouraged the traditional, meticulous, shading according to light and shadow. Interpreting form was all-important; volume should be conveyed with the greatest possible economy. Like Gaudier, Underwood drew to please the senses, and his new students never missed a class.

Edward Bawden, Eric Ravilious and Edward Burra joined the Royal College during Barbara's term. Painters and designers shared the communal hall that acted as common-room and dining-room. There they might have noticed a stunning girl, shy and involved, leafing through copies of *Cahiers d'Art*. Initially, Barbara joined the boisterous 'Leeds table' at lunch. After the first half-year, she escaped, quietly, into the throng. Gin was perplexed by someone who needed friends but seemed so self-contained. Having tea with Barbara's family, she, who had grown up with four boisterous brothers, couldn't understand a home in which emotions were repressed. Like her father, Barbara seldom wept, laughed or betrayed her ardent feelings. Her veneer was polished, her clean face inscrutable. Sometimes Barbara wanted to help, and sometimes she did. She had her way of being a friend, her intentions were genuine, but when she introduced a clergyman with buttons down his front to talk Gin into being confirmed, Gin felt patronized. Unlike Moore and Coxon who marched in step to tutorials and shared, for a while, a double bed, after a couple of terms together the girls took tiny separate rooms. The move was precipitated by the monthly composition. While Gin sat up late at night, finishing her essay, Barbara organized her time more carefully. Late nights worried her. Lacking Gin's flexibility, she wanted to sleep.

At the end of the Christmas term, it was traditional for freshers to stage an informal show. Gin was part of a play, and Barbara, wearing a Spanish costume, performed a castanet dance. She

really was very pretty. Though she looked untouchable, she was never short of suitors. Half-envying, half-disapproving of her guarded ways, her companions missed in her a sense of humour. Barbara's concentration was coiled about her, her speech was slow and unclarified, as if she was unconsciously imitating her father's voice; her smile, quick and definite, but disengaged. Even with intimate friends she stood a little outside their lives, wanting only a small part for herself. What made them want to criticize was the hint of superiority that made her adult self seldom miss an opportunity to emphasize her intellect or her achievement. The painting schools were full of girls, but she, the dramatic exception, was a student of sculpture. It was her life and her goal; in pursuit of which there could be no diversions. The clear-headedness of her twenty-year-old drive was something they found a little awesome. Nothing that might govern her future was left to chance. Often, she gave the impression of being more self-assured than she was. This is not to say there weren't times when she was sure, and things she was vehement about: it is just that she remained more dependent upon approval than a lot of her contemporaries. Feeling her way beside Moore's extra-ordinary vitality, simultaneously challenged and inspired, she was no less obsessional but less sure where her talent lay.

Leo Walmsley wasn't a challenge because he was a writer, and that made Barbara more relaxed. She often visited him and his artist wife, Claire. But sometimes Harry Moore came with her. Walmsley tells of them endlessly discussing modern sculpture. Even if they talked politics, it was natural for her to turn to Moore with his common background of factory hooters, clanking trams and grime. Nearly all the students were impecunious, some painfully so, and Walmsley noted how much Barbara complained about money. She took him and Claire to see her studio, close to the Fulham Road: a small space, ascetic as a prison cell, with blinds drawn over the top lighting, a divan bed and a recess for washing and cooking. The walls were covered with powerful nudes, mostly in chalk line, and an uncompleted clay model

stood on a central stand. Walmsley knew that her work was good.

Roger Fry taught his contemporaries not only how to look, but what to look at. Through his writings, he influenced a second generation – Barbara's.★ Early in 1921, Henry pounced on his vibrant collection of essays called *Vision and Design*. That it was shared with Barbara goes without saying. Broadly, Fry's message was clear enough; great art provides a particular kind of aesthetic enjoyment, dependent upon what Clive Bell called significant form. What made form 'significant' was an artist's ability to communicate. Italian Primitives, Negro sculpture, Sung and T'ang pottery, Giotto, Masaccio and Cézanne shared inherent qualities of vision, design, and formal integrity, providing, thereby, an antidote to the literary values of nineteenth-century sculpture. 'What a right little, tight little, round little world it was when Greece was the only source of culture . . .' argued Fry in an essay on Negro sculpture, as fresh and apposite now as the day on which it was written. African artists managed to suggest forms that possessed a life of their own. 'Without ever attaining anything like representational accuracy, they have complete freedom.' For the modernists, this was crucial.

Gaudier-Brzeska and Epstein had both made thorough studies of primitive art. To Barbara, Epstein was more of a creative stimulus than a model, but Gaudier, whose death at twenty-four deprived Europe of a prodigious talent, was more than this. *Dancing Figure* 1923–4 – a model from Barbara's college days of which a good illustration survives – echoes the rhythmic quality of Gaudier's long-limbed *Dancing Girl* 1913.

Aesthetically and emotionally, her horizons were being extended, a process in which two foreign ventures doubtless played a part. During Barbara's second year at the RCA she went to Paris in the summer vacation, and a few months later she was in

★ By the time he died, in 1934, Fry had established himself as the country's leading art authority.

Florence to celebrate receiving her Diploma. Autobiographical writings imply that she visited Paris more than once during her student days, and eclipse altogether her first experience of Italy. Both distortions, slight enough in themselves, convey an impression of slightly more sophistication than she possessed.

Barbara had visited Paris as a schoolgirl. Moore, however, had been there, alone, the previous year. With the benefit of his experience, travelling at night because it was cheaper, the four of them patronized the hotel he had discovered off boulevard Montparnasse. It must have been June, because Mrs Coxon remembered eating strawberries and cream. Moore, on his first visit, had spent the morning in private and public galleries before moving on to studio art schools,★ where he sketched quick poses. In the evenings he treated himself to a drink. A pattern had been set, though it might be improved upon, and each morning the four set out to see what the day would bring. This didn't work for Barbara, who had definite ideas about what she wanted to do and was uneasy about wasting time. So she loped off by herself. The others didn't mind. Barbara inhibited what felt natural, vital and spontaneous. But one evening they were all eating lobster in a fish restaurant, poking out the flesh with sticks, when she reprimanded them for holding the claws in their hands. The episode was laughed about and remembered.

In Florence, Barbara stayed with family friends, Captain Richards and his wife, making excursions in their company, and modelling, throughout her sojourn, the plaster bust Walmsley had seen in her room. The holiday was the prelude to a long, concentrated stint of work. Returning to college, she was set to try and win the prestigious £250 p.a. scholarship administered by the British School at Rome to study abroad for three years. Only the élite applied; after Henry she was considered the best pupil at the Royal College, and Henry was standing aside. It must almost have seemed as if fate was abetting her.

★ Colorossi's and La Grande Chaumière.

In January 1924, portfolios were duly presented. Life drawing, studies, photographs of modelling, records of original work and, in Barbara's case, an expressive bas-relief of naked dancing women were judged by the Sculpture Faculty at the British School. From seven entries, four were short-listed, two men and two women including Barbara, to proceed with the final part. This time, a decorative plaque for the main entrance of a hospital had to be modelled in clay and cast in plaster of Paris. The very idea suggested conservatism to Barbara. The selectors, moreover, were nearly all elderly and old-fashioned. To please five die-hard Academicians,★ she reckoned she would do best choosing an obvious biblical reference, draping all the figures to make the whole thing as conventional as possible.

Perhaps the final, eight-week suspense was the worst part of all. Henry reckoned Barbara's relief was technically of high quality and a brilliant satire upon the Royal Academy, but he had also seen and was impressed by the entry from Jack Skeaping, the Slade School favourite. As the time for the decision drew near, rumours were confirmed. There was little doubt about the superiority of Barbara's work among the Royal College students; the judges, however, were deeply impressed by Skeaping's drawing of animals and a torso he had carved in wood. Waiting for the result, Barbara seemed deceptively calm. Jack Skeaping had made less concession to academic art, and his originality was being acclaimed. Perhaps she had underestimated the selectors. (Was this another excuse?) Tidings of a more personal nature suddenly intervened. Jack Skeaping had an inflamed appendicitis: he was very ill. Quite quickly there followed the news that Barbara was runner-up. He had won. Everyone was sympathetic, and Rothenstein thought she might get a travelling scholarship instead. All the same, she didn't like to be beaten. She had, Walmsley perceived, a good measure of her father's tenacity and determination.

★ Sir George Frampton, Goscombe John, Reid Dick, Jagger Ledward and F.W. Pomeroy.

While the Prix de Rome was monopolizing the scene, Barbara was making her début in the London art world. A modelled head, cast in bronze, was shown in the Redfern Gallery with work by a number of Royal College students, including Raymond Coxon, Edward Burra, Helen Binyon and Eric Ravilious. Barbara Hepworth and Henry Moore were the only sculptors. None of Barbara's art school work survives except the bust of Mrs Richards, and this isn't sufficient evidence upon which to judge her standard. Although she had expressed interest and awareness in modern sculpture, she doesn't seem to have made any. A note should be added that Hepworth and Moore exaggerated their role in the rebirth of direct carving. Kineton Parkes's *Sculpture of To-day*, published in 1921, mentions several now unknown artists such as Ernest Cole and Arthur Walker, who were busily cutting stone. There was even a woman, Phoebe Stabler, who 'worked in miscellaneous materials'.

However pedestrian the exercise, the skills Barbara acquired at Leeds gave her a sound basis for the future, but the faculties she had developed above all, by the time she left art school, were certainty of direction and purity of vision.

The Fulfilment of a Dream

(September 1924–October 1926)

It was night-time when Barbara arrived in Florence; an exhilarating, climactic moment. The West Riding travelling scholarship was, she said, the fulfilment of a dream. Twenty-one and alone, with nine pounds in her pocket, she made her way to an international hostel.

A suggestion of casualness would be misleading. Naïve she might have been, but not irresponsible. Though she spoke little Italian, and that was a handicap, she had been in the city before. The Richardsons, with whom she had stayed, may even have been in residence. Perhaps the first instalment of her grant was waiting for her at an Italian bank. Notwithstanding, the next two years could hardly have been less predictable. Florence was a strange destination for someone more interested in the primitives than in Botticelli, Michelangelo and Leonardo. Stranger still, Barbara produced hardly any sculpture. During the first year she did none at all. Some chord was pulsing away inside her, since the lull presaged a highly prolific period. Was she gently gestating, or was she being influenced by another major event to be taken into consideration – that after two months, she fell passionately in love? The classical tradition, with its preparatory research and patient constructing, definitely had something to offer. It is tempting to see her personal metamorphosis, at the very least, rousing her receptiveness.

What Italy itself opened up was 'the wonderful realm of light', transforming, revealing, intensifying the subtleties of form, contour and colour. Luminescence drops into Italian cities at dawn, invading their quiet streets, slipping beneath arches, spreading,

clearing, opening courtyards and piazzas, pouring on to the hats of their pantiled roofs. Dancing into the countryside, light pencils the cypress, dallies outside the doors of small candled churches, swaggers through flowering grasses, fills out the olive and parades the hills. Sometimes it rains; in midsummer it can be blazing hot, especially in the enclosed Florentine valley. The sun had never shone enough upon Barbara's childhood, a dearth which followed her from Yorkshire to smoggy old London. Shadows were never sharp, surfaces never brilliant, the atmosphere seldom cleared. The radiance of Italy was a revelation: even its stones answered the touch, not hard or cold, but voluptuous and alive.

Barbara spent her first months in a little village half-way between Florence and the ancient town of Fiesole: an ideal place to be installed in. From shuttered windows, she could watch the days begin and end, listening to the frenetic chirping of small caged birds. Life at this level has a society of its own. Wandering round, she encountered bright-eyed children, black-clad crones sitting by brooks and fountains, churches full of prayer.

In a landscape held by Roman ruins, Etruscan ramparts, a Franciscan priory and a barbaric Romanesque cathedral, architecture seemed to her now profoundly implicated in the arts of each period. From her half-way house she could see, over pearly fields, Florence's mists pierced by Brunelleschi's magnificent cathedral dome, slim as a rugger ball, its delicately ridged sections transforming it to rare sculptural beauty: windows, doors, archways, arcs, angles, curves and hollows, all poignantly delineated. One imagines her, dressed like a cross between a Pre-Raphaelite painter and an archetypal shepherdess, inhabiting museums and open spaces, quiet and studious, pencil in hand. To find what she needed, in the midst of such visual riches, and concentrate on it, was a steadying thing to do. By degrees, she could dip into the incredible visual honey-pot that Florentines, since the Middle Ages, have felt inspired to lavish upon their home.

A diet of culture was fine for a while. After two months, she wrote to Henry Moore, she was longing for company. It was he

who arranged that she should meet her Prix de Rome competitor. Just about recovered from his operation, Skeaping was travelling out to take up his scholarship. Barbara stood at the foot of Florence and the right way seemed to be Rome.

Meeting her at Rome station, Jack Skeaping was astonished. Snaps of Barbara tend to be either self-consciously posed, or to catch her looking away from the camera, as if spontaneity were out of order. Like an overhanging rock, her forehead projected further at the hairline than at its base. She didn't like, in photographs, her inverted dish-shaped face and this might account for her diffidence. What needed, anyway, to be seen live, to appreciate, was the perfection of her grooming; her hair parted precisely between her ears, her brown eyes orientally lidless, her skin silken. In a long coat with astrakhan collar and cuffs, and a pillbox hat with a Mussolini tassel, she was spectacular. Skeaping was proud to be seen with her, for she attracted a great deal of attention from Rome's young men.

In the two years he attended the Royal Academy Schools Jack had won every prize that was open to sculpture students, including the RA Gold Medal and travelling scholarship. No one, said Henry Moore, was born with more natural artistic facility. Barbara needed a man's approval, a man, moreover, whose talent, drive and personality she respected; one who shared her dedication and sensitivity to the arts. But little could she have dreamed that two months after leaving Moore's taxing if genial influence she would attach herself to the next most dynamic man she could find. Time has largely obscured the debt she owed her first husband. Some of those who glitter briefly in the limelight are destined to step sideways, out of the public eye, however auspicious their lot seems at the time. Barbara, who would move on to fame and fortune, was, like others round her, too careful of her own reputation to credit the influence of other artists; an allowance could so easily be misrepresented. Not that this was something Skeaping complained about.

Her debt, personal as well as professional, is to some extent

evident from her letters to Leo Walmsley. For a long time, she didn't write: then her silence tumbled into words. Never before had she been so happy. She had met 'Jack' Skeaping. They liked each other's work. They had in common, moreover, a passion for dancing, fondness for animals, and tastes in music and food. In fact, Barbara felt, ingenuously, they had the same philosophy of life and art.

The critical issue was Jack's creativity. After that, every sameness has to be qualified, because he was, above all, versatile. A whole range of instruments, from a banjo to an accordion, he could play by ear; he was good at ballet as well as ballroom dancing, indeed, his physical prowess extended to riding, skating, skiing and swimming. Always the scope of his activities exceeded Barbara's, and, temperamentally, their differences were still more obvious. Jack Skeaping's father was an artist, four children had been brought up without formal education in anarchic paradise, and all excelled in the arts. Talent was taken for granted; Jack had, in his own capacity, boundless faith and boundless enthusiasm. Art, he believed, was instinctive. Direct and unconventional, even in adulthood, he retained the totally unselfconscious curiosity of a small child. Against his nervy Pan-like zest, Barbara worked away law-abidingly, chastely, her perfect mastery governed closely by her intellect. Almost 'stolid', by comparison, was Walmsley's immediate verdict. Like the yellow lathes of a sunflower Jack was outwardly directed, generous; Barbara was the absorbing central face.

To start with, by virtue of his experience, Jack was the leader. His RA travelling scholarship had already taken him to Italy;* everywhere, all at once, or so it seemed. In Rome, on his own reckoning,† he had spent six months apprenticed to a stonemason and tramped the city from end to end, assiduously recording churches, monuments and museums. In Carrara, he had made

* In 1920.
† The chronology in Skeaping's antobiography is totally unreliable.

54

statues for English cemeteries. Visiting Naples and Florence, sampling Tuscany's proverbial hill towns, he had fallen steadily more in love with the country. He had even taken the trouble to teach himself Italian. The sentiment was mutual: Italy had warmed to his impetuous personality, hardly could he have been less like the stereotype Englishman. With his huge capacity for enjoying life, Jack not only charmed Italians; at the British School, where he was based throughout his stay, he left a trail of goodwill.

Since 1913, scholars in architecture, painting and sculpture had enlivened a tribe of gentlemanly British archaeologists at the British School in Rome; an odd if potentially enriching mixture of disciplines augmented by a stream of visiting academics. Occasionally the art students got out of hand; William Rothenstein naturally felt they would be better served by supervision from someone directly involved in the arts. Notwithstanding, Skeaping's meeting Bernard Ashmole, an expert on Classical art, and the cross-fertilization that ensued, was a perfect example of what Rome scholars were intended to achieve. High and white, like a nesting swan, Lutyens's dignified building in the Valle Giulia commanded a superb position, next door to the Modern Art Museum and close to the National Museum of Archaeology. Through the once fashionable walks of the Borghese Gardens, the whole spread of Rome was accessible.

'It was inevitable that we should fall in love,' Skeaping wrote, as if topography placed upon himself and Barbara an ineluctable spell. An institution, however, was not the easiest place to conduct a rapidly developing courtship. Always happy when he was on the move, Jack decided to introduce Barbara to some of his old haunts, Siena, Volterra, and San Giminiano. The heavy accented penultimate syllable evokes from the very names of these Tuscan hill towns a Mediterranean exoticism. There was a touch of swagger in the plan. Barbara could not but have been impressed by his Italian authority.

By train, they sped along river valleys rising to small patterned

hills of vineyards and olives. Here and there, towns and villages interrupted trim, sweet, tended country, their skylines stuck with castellated towers, the roofs spread, like waffles, beneath the sun. It was impossible to remain unmoved by the nuance of light, the dance of rhythm, colour, mass and inclined planes. To Jack Skeaping, Michelangelo and Donatello were the height of sculptural achievement and Siena the most idyllic town. The only traffic consisted of wagons drawn by hefty oxen, their street-wide horns almost spanning the medieval thoroughfares. A natural guide, he probably showed Barbara the incredible weathered Pisanos in the cathedral museum and two giants of the Renaissance, Ghiberti and Donatello, brought together in a single magnificent font in the cathedral. Work hard and play hard was his maxim, his single rather innocent vanity being for his swashbuckling good looks. At midday, with his sunburn and his large Borsalino hat, prattling like a native, he would sit in a café on the gently dipping arena of the huge semi-circular Campo.

To me, following Barbara's footsteps, she and Jack were everywhere. San Giminiano has a silhouette like a template for New York, with thirteen ancient towers floating above long views of grasses and spring-tasselled robinias. There they undoubtedly visited the church full of frescoes. Late in the afternoon, nearly seventy years on, children were jumping around on the steps of a fountain in the main piazza and someone, at an open window, was playing a flute.

How different Volterra was! Thither they went. No wine flows from the denuded hills of the high plateau; just floods of wild flowers among quarries of alabaster, salum and salt. Through a gateway in the old wall, with its three smashed faces, the town divulges a fine Etruscan museum and busy alabaster workshops. In and out, in heat and sun, they must be imagined, to noisy bells, furiously nodding and clanging, one inviting the other, and then another, to the *Angelus*. Volterra has the prosaic sternness of more southerly cities. Street corners set with shrines, piazzas rich

with cathedrals, ridiculous tiled campaniles, and palaces with overhanging eves.

Back at the British School, Barbara and Jack were in luck. Ashmole became director shortly after they arrived, and he took a liberal attitude towards his Rome scholars' partners. But New Year arrived, and Barbara knew she must return to base. Being in love transformed everything. In a state of exhilaration from which she now and then descended, she rented a little apartment on Costa San Giorgio. From there it was but a short way through an area of cheap trattorias and leather workshops to the church of S. Maria del Carmine, where Masaccio began the now famous frescoes when he was twenty-three.

Prostrated before them, sensible to all that Italy had brought her, Barbara tells of a still moment of deep aesthetic joy. Her shrine was the erotic painting of Adam and Eve's expulsion from the Garden of Eden. Masaccio had set great store by his nudes. Adam's huge, clumsy shoulders rock with sorrow, and Eve's body takes on the sufferings of the world. It was as if Barbara saw in the picture her own reflection transformed, and having seen her inner self, glowing, loved it and idealized it, as an image by which she could tune her life. All she had to find was a way through.

It is a measure of her single-mindedness that she was able to extricate herself, if only physically, from her romance. Jack, hopelessly unsettled, was evidently doing little work. Two months' delay in reporting his progress to the British School headquarters in London, was due, he claimed, to being unwell. This may have been true. For the rest of his life, his response to emotional strain was manifest in acute digestive troubles, a predicament he accepted with remarkably little fuss. As for the present, travel would be his elixir. 'If one has no ideas or any compositions on the go it is a difficult matter to concentrate . . . During my trip I intend to make many drawings and studies of everything of interest and value.' The trip would take him back through Tuscan villages to Florence.

Psychologically at least, the demands of life were threatening the demands of art. By spelling out the spirit of reform, he intended appeasing the British School and, simultaneously, to be with Barbara. By mid-February, he had asked her to marry him; an offer she accepted by return post.

Jack was constantly pushing against official boundaries. On 10 March a telegram caught up with him in Siena. Fourteen days was considered the absolute limit for a first-year student to absent himself. Under no circumstances, moreover, would the faculty contemplate his doing plastic work away from Rome. They much regretted his absconding before consulting their advice. Though he could scarcely ignore the censure, he wouldn't abandon his plan, and a compromise was agreed upon. The second week in April, he was let loose. The moment he and Barbara were together, they immersed themselves in an intensive study programme. In less than two months he had added between sixty and seventy drawings to his file, mostly from the Uffizi Gallery, and some 250 chalk studies of sculpture and architecture. At the same time he was making complicated arrangements for the wedding. No less industrious, Barbara was drawn increasingly to Cimabue and to Giotto – the great Florentine innovator who changed the face of painting with his statuesque figures and new feeling for space.

On 13 May 1925, Barbara Hepworth and John Skeaping made their way across the Ponte Vecchio with its razzmatazz of trinket-selling stalls. The wide, olive-coloured Arno slipped away beneath them. Hardly could they have chosen a more memorable setting for their marriage than the fantastic old Palazzo Vecchio, its painted embrasures and escutcheons thrown in high relief against the sky. Eric Whelpton, a journalist friend of Skeaping's, stood in as his father; Tom and Jane Monnington, fellow students at the British School, made up the party. Maybe Whelpton took the wedding photograph. Barbara's haunted look needs considera-tion. Her parents hadn't seen her prospective husband. To what extent was she incurring their disapproval? To her Wakefield

upbringing, it could have seemed like rebellion. Perhaps the rate at which things were happening had made it all a bit of an ordeal. Part of her was anxious to do the right things to be good and please adults. She didn't like disapproval; didn't like upsets. Yet being an artist implied choosing her own standard of values and accepting the obligation to try to live up to them. Not only moral values but a clarity of behaviour. There were ordinary people, and artists, and Barbara's overriding responsibility to her artist self was to stimulate and control her imaginative life.

Bound, now, to go home and make their peace, the Skeapings discovered an England full of tensions. Family reactions to the union were ones of incomprehension, verging, at least from the elder Skeapings, on dismay. Barbara could be very definite; they were hostile towards what they saw as her high-handedness. Maybe they saw her as the stronger of the two, and maybe she was. Jack, in turn, was aghast at the Hepworths' bourgeois milieu. Confronting parents was bad enough; Barbara had to own to the Board of the West Riding Scholarship that she hadn't done any carving. Her marriage aggravated their disapproval, or so she said. It was a habit of hers to emphasize opposition, throwing thereby her righteousness into relief. At least the trip consolidated the marriage. Between her and Jack, there was no pretence; both were relieved to return in September, to Rome and to work.

When he was a child Jack had wanted to be a jockey, then a ballet dancer, infatuations replaced only by a developing passion for art. What didn't change was his obsession for animals, the almost exclusive subjects of his drawing and painting. The Borghese Gardens provided, in a huge naturalistic zoo, deer roaming in the shade of rhododendrons, flamingos stepping deliberately among palm trees, withdrawing into their stalked pink cockades, and bears haunting enormous simulated rock constructions. As if this weren't sufficient, Jack built, at the British School, an aviary for pigeons and tropical birds. Then he and Barbara bought Pipi, a monkey.

With or without monkeys, the British School was not an easy place to run. One of the reasons was that Lutyens's British Pavilion had been built as an exhibit for the International Exhibition in 1911. Never intended as a permanent structure, it was ill-equipped with basic conveniences such as heating and plumbing. Though a certain style was expected and maintained, there were never enough funds to go round. Inefficiency made matters worse. The School needed careful management, Ashmole saw immediately, to which integration was a key. Even today, he is remembered as the man who brought sensitivity and diplomacy to his leadership.

Ashmole not only liked, but had a high opinion of Jack Skeaping, a sometimes wayward student he went out of his way to accommodate. Correspondence in the archive of the British School explains that he and Barbara were no more than chance subjects in a lengthy debate. At the same time, Ashmole's attitude made a great deal of difference to them. The issue concerned the school's lack of provision for the wives of its male students. Though officially banned, wives commonly lodged there. All Ashmole asked was that recognition be official. Marriage didn't interfere with a student's work, and community life, he argued, was at stake. Both French and Spanish Academies had relaxed their ruling; only the British branch stuck fast. Letters between Ashmole and Evelyn Shaw, the General Secretary, crossed and recrossed. Shaw worried that students, upon receipt of their £250, would immediately marry, and Ashmole had to promise he would draw the line at babies. What Shaw didn't in the least suspect was that throughout the correspondence, a particular couple were already, with Ashmole's approval, sharing one of the studios: a not inappropriate first home.

The Skeapings seemed to attract a wave of young married artists; the Monningtons, the Emil Jacots, the Robert Lyons and the David Evans, several of whom Barbara portrayed in strong crayon studies. Wherever he went Jack's easy camaraderie, his naturalness and warm human sympathy, won him friends, a huge

rag-bag, among them some who were eminent and others not in the least. Streams of visitors to their studio included the versatile modeller, the ageing Alfred Gilbert. To eminent visitors, Ashmole made a point of promoting his students' work. Two at least bought Skeaping's drawings: Edward Marsh, private secretary to Churchill, and George Hill, Keeper of the Department of Coins and Medals at the British Museum, of whom the latter was to become a future patron of Barbara's.

Back in the old routine, the Skeapings scoured museums and art galleries. In Rome's Modern Art Museum, there were war paintings by Balla, and some striking Italian Futurist sculpture produced around the First World War by Boccioni, Archipenko, Roberto Melli and the more traditional Serbian sculptor Meštrović. At some point Barbara and Jack saw Piero della Francesca's beautiful blemished frescoes in the church of San Francesco in Arezzo; at some point they stopped off at Lucca. For two months they stayed in Siena. Another time they travelled north, through a lush landscape of river reeds, silver-skinned birch and lizard-running walls, to the foot of the Apuanian Alps. At the quarry face beyond Carrara, in a lunar landscape of glistening white, marble was being cut by hand. Jack had taken courses in stone masonry at the Central School of Art, he had worked in the quarries on his first trip to Italy, and subsequently cut marble with Giovanni Ardini, a professional employed among others by Ivan Meštrović. Every aspect of materials intrigued him, and Barbara was fascinated by the mechanics of moving weights. Picturesque foundries and sculpture yards at nearby Pietrasanta must have been a revelation to her. Hundreds of skilled craftsmen were at work, supplying traditional wares for transit all over the world. Everything had taken on extra relevance because both had begun to carve.

The annals of art history contain nothing about Ardini, whose contribution to the story of Barbara Hepworth rests on the stimulation his workshop provided and a chance remark that Jack interpreted. Looking upon Jack almost as a son, Ardini had gone

to a great deal of trouble to help him make arrangements for the wedding. Afterwards, Jack was anxious for Barbara to meet him. Ardini wasn't prepared for the silent, forceful girl who sat to one side, watching. It made him uneasy. A quarter-century later,★ one of Skeaping's pupils at the Royal College, Bob Carruthers, met this huge man with marvellous regal gestures, still in his workshop in Rome, with his son and half a dozen employees. 'Trouble, first, middle and last', was Carruthers's version of the way in which Ardini presented Barbara, remembering, after all those years, with evident vehemence. A fundamental assumption on the part of a sculptor is that his stone and wood are not dead materials, but that they are, in themselves, vital. Watching him cut twenty-ton blocks of marble, listening, enthralled, to the sound of metal on stone, Barbara was doubtless totally unaware of the intimidating effect she was making. What Ardini said was that stone takes on a different colour under the hand of different sculptors. Everything, she realized, depends upon an artist's personal touch.

Jack had carved wood while teaching at Armstrong College, a skill he passed on to Barbara, approving the fact that he was luring her from Moore's influence and asserting his own. By nature he was an adventurer, and Barbara's introduction to primitive art led to a deep admiration for Gill. Other things affecting his impulse to carve were his knowledge of different marbles, and his study of French animaliers at Blackheath School of Art. Italy and marriage must also have played a part in the spontaneous liberation that took place. Barbara had attempted stone-cutting when she was at the Royal College. Trying again, observing from life, she carved two stone pigeons, and the first work with which her opus has become associated: a marble dove, gossamer tender, emerging effortlessly from a piece of alabaster. Nothing is tentative. The feel of the bird, buried eye level in feathers, is strong inside the fold of the wings in this deft, sure

★ In 1952.

little piece.★ It was one of those occasions when knowledge, skills, ability and an underlying passion for art tumble into rare achievement. On a wave of triumph Jack carved, between September 1925 and the following June, a head of Barbara in Carrara marble (since lost) which he thought the best work he had ever done. Paris was the centre of contemporary arts, Berlin had some credentials: it was paradoxical that Rome, with its conservative classical tradition, should be the place where two young sculptors started work which brought them to the threshold of the Modern Movement.

A fountain was to be built in travertine, Ashmole wrote to Shaw in February 1926, for the British School at Rome. The design was rather severe but, he thought, none the worse for that. Mr Skeaping proposed to carve the slabs *in situ*. During the summer, a series of fuzzy photographs reveal, a three-ton block of stone and two top slabs were carried by horse and cart to the pond in the cortile. Two men, using only planks, levers and a jack, positioned the plinth in a torrent of rain, before raising the top slabs on a makeshift scaffolding and slipping them sideways on to the plinth. Giovanni Ardini is the thick-set man wearing a singlet, baggy trousers hitched into a wide leather belt, and a traditional newspaper hat. 'We tried the water & it looked & sounded topping,' Skeaping wrote with cheerful zest on the back of the final photograph. 'The joints have still to be cemented.' The fountain that was his valediction to Italy is still in the courtyard of the British School. And here, the Italian intermezzo ought to end.

An unsatisfactory epilogue is that Jack had spent two hot summers in Rome; he was 'rather stale' and the climate was stressful, circumstances in which he began to develop a stomach ulcer. A short spell in an Italian hospital convinced him that he needed medical attention in England. He rued losing Pipi; Barbara, more practically, bewailed leaving behind prize blocks of

★*Dove 1925.*

marble. With a few carvings and some favourite birds, they travelled home. In Walmsley's opinion, Jack Skeaping's future was secure; in reality, it was Barbara's that lay, like a neat coil, inside her. Jack could have been as much of a catalyst as was Italy, for what she called 'my most formative year by far'. All she needed, to realize her source of energy, was England's hardness.

Two Brilliant Young Sculptors

(October 1926–November 1930)

The Skeapings arrived in England, after prolonged absence, with very little money and few possessions. Jack had a duodenal ulcer. How did they, during this crucial period, support themselves, let alone start building their reputations? Throughout the 1920s there were high levels of unemployment. The first Labour government was out of office within ten months. While the economy went from bad to worse, prospects for sculptors were especially bleak. It was 'not a lucrative profession', the first book on contemporary sculpture demurred: '. . . those who pursue it tend to be artists who . . . have force of character sufficient to prevent them from being deterred by poverty from the use of so unpromising a medium.'

At studios in Fitzroy Road, Regent's Park, Barbara was working on two portrait models for some of her father's rich friends. He was making a small regular contribution towards their keep, without which, she acknowledged later, they couldn't have survived. Despite his assistance, it was hard enough. Jack was spending on doctor's fees what money they had saved, when they urgently needed cash for materials. It was incumbent upon them to keep themselves solvent, and a sense of loss hovered over them. The British School had not forgotten their impoverished protégés. 'Be kind to him,' urged the splendidly instrumental Ashmole to Evelyn Shaw; Skeaping was 'a very hard worker' and 'an excellent member of the school'. Friends were the other blessing. Leo Walmsley's offer to let the Skeapings the basement flat of his Queen Anne house in St John's Wood tipped the balance during a bad fit of blues.

Jack promptly built a new aviary where he installed budgeri-
gars, weavers, waxbills, and Nyasaland lovebirds. Barbara, who
loved birds as much as he, stood watching the newcomers dance
along metal perches, cocking their heads on one side, chomp
chomp chomping – small, precise movements with curved bills.
When she spoke to them, the birds grabbed the chicken-wire,
rattling the cage, clambering sideways and up and down. Bird
seed spilled on the floor, attracting swarms of mice which became
quite tame. Almost, it seemed as if the careless rapture of Rome
could be restored. The only drawback to the accommodation
was the basement passage's being too narrow to take big blocks
of stone.

Jack was up and down like a yo-yo; when he was 'up' he was
raring to go. Life was delightful, he wrote pragmatically, all
they lacked was money. When they were broke, he took on
commercial commissions: one for Aveling and Porter, manufactur-
ers of steam-rollers, another for Wedgwood – a series of animals
for reproduction in glazed china. He wasn't indifferent to money,
being short was very stultifying, but he was too unbusinesslike to
secure royalties, though his animals were mass-produced. Nor
was he a purist. His autobiography is full of ingenious devices for
survival and the comic predicaments they presented. During an
especially lean period he was joined by his brother, who played
the fiddle with an eminent chamber quartet. With Jack on a
piano accordion, they made the rounds of theatre queues, bringing
in, in three evenings, more than ten pounds, which was what he
made on a Wedgwood animal. Uncertainty had its excitements:
art was what really mattered. But Barbara wasn't prepared to
side-step what felt like the true direction; it would be betraying
herself. The first year in England, she modelled two sculptures
and carved five, the following year she carved nine or ten in
exotic Italian marbles. Alive to their different resistances, she was
experimenting with a huge range of hardnesses, from alabaster at
one end, to onyx at the other. Alone in his attic, trying to write,
Walmsley envied her the resounding thump, thump, thump of

the mallet as the stone hit back. A lifetime's pattern was being set: the days themselves took on a rhythm, long hammering days broken only by the occasional arrival of illustrious visitors. Thanks to the British School word was passing round, collectors were beginning to call.

Few asserted themselves more diligently on the Skeapings' behalf than George Hill,* on his reluctant way to becoming the first archaeologist Director of the British Museum. Hill was a Trustee of the British School at Rome and a dear friend of the Ashmoles; therein, no doubt, lay the root of his ministrations. His parents-in-law had left a modest collection of paintings and a few good Chinese enamels. Over the next few years he added a number of drawings and sculptures by Barbara and Jack. Equally important, Hill brought in his friends: Laurence Binyon of the British Museum Prints and Drawing Department, Binyon's precocious daughter, Nicolete, and Richard Bedford, Head of the Sculpture Department at the V & A. A little influence went a long way. Bedford, in turn, introduced the doyen of wealthy collectors, the Greek millionaire George Eumorfopoulos. What all had in common was a taste for non-Western, particularly Oriental, art.

Whether this affected Barbara is an interesting speculation. Obviously she was aware of a current so evidently being picked up in Jack's work. An article Bedford wrote about Chinese animal sculpture is illustrated by a very early little Mongolian pony carved in yellow-green marble† that was clearly a source of inspiration to Skeaping.‡ Her fully acknowledged influence on Jack's sculpture during these vital formative years was no less marked than his upon her. Both had been looking at Gaudier's strange blunted forms, noting his extraordinary power of evoking the essence of animals. Animals lent themselves to simplification

* Knighted in 1933.
† During the T'ang period or even earlier.
‡ Alabaster *Pony* 1930.

or abstraction, and hand-size sculptures were popular because they could be accommodated in domestic settings. Besides her better-known *Doves* 1927, Barbara carved a toad, goose, dying bird, dog, fish, and marten. Like Jack, she was carving classically still torsos, shallowly incised, almost Gill-like.* In scale, material, even in spirit, their work was close. Both were deriving ideas from Epstein, Gaudier and the British Museum. So much was, as it were, in the air. What was peculiarly hers and Jack's was their incredible receptivity to the mutability of different stones.

Laurence Binyon, poet, author, connoisseur of Asiatic art and, by this time, a prominent figure in cultural life, was, like Hill, a brilliant classical scholar. Bedford was fifteen years younger than either of them and no doubt reared on Binyon's influential *Flight of the Dragon*.† 'Art enters into our life at every turn,' Binyon reflected, but what was art? It was a question he had been pondering for at least twenty years. One of his conclusions was that rhythm underpinned the magic of an Indian dance or a Chinese vase. Sculpture and painting might not be capable of actual physical movement, but every statue was a series of ordered relations, controlled, as is the dancing body, by the will to express a single idea. Abstract design was a series of ordered, rhythmic relationships.‡ There were limitations to Hill's and Binyon's appreciation of the Modern Movement, but both accepted the Skeapings as promising beginners and helped them. Barbara was so grateful for Hill's faith in them that she gave him a mask in pentelicon marble and the exquisite carving of a baby she was to make in Burmese wood.

One of the first commissions Jack received in England was for what became an outstandingly accomplished bust of Binyon's beautiful sixteen-year-old daughter, then being educated at her

* See Skeaping's *Torso of a Boy* 1927–8 in Sicilian marble and Hepworth's *Torso* 1927 in Irish fossil marble.
† Written in 1911 and reprinted continually until 1935.
‡ Like Binyon, Read located the source of abstraction in ancient Chinese art (see *The Meaning of Art*).

father's old school, St Paul's. So 'taken' was Nicolete by the art of the emerging Moderns, that she bought with her dress allowance an Eric Gill, a Paul Nash, a Stanley Spencer and a Barbara Hepworth. To the impeccable young talent-spotter, Barbara seemed a little austere and very beautiful. In Nicolete, Barbara had, despite the age gap, a kindred spirit and permanent friend.

Month after month the Skeapings worked away, living from hand to mouth, hardly seeing anyone else. At the end of the first full year in England they held an exhibition, for want of anywhere else, in their studio. Would anyone come? When all was polished and arranged, they waited nervously, moving from room to room, unable to work. Right into adult life, the episode stayed in Barbara's mind. No one *did* come until the fourteenth day, when George Eumorfopoulos, the Greek collector, arrived with Richard Bedford. Critic, academic and carver, Bedford had known Gaudier and admired Modigliani, whose strikingly stylized woman's *Head* 1913 was exhibited at the Victoria and Albert Museum (V & A) when Barbara was still at art school. Now head of his department, Bedford was determined to exercise his powers on behalf of fellow-carvers.

Walmsley recalled the thrill of having a Rolls-Royce parked outside the house. Eumorfopoulos's speciality was Chinese porcelain, but for ten years he had been collecting modern art; already he had acquired work from Gaudier, Dobson, Bedford and Underwood. For a long time, it seemed, the collector was on the premises. When he left, Barbara and Jack danced with excitement. He had bought sculptures from both of them, commissioning from Barbara the svelte seated figure of a woman in pavonsetta marble (*Seated Figure* 1927). To have works in Eumorfopoulos's collection was the height of achievement. Looking her most glamorous, Barbara went to one of her patron's Sunday gatherings on the Chelsea Embankment. Through him, she sold to Charles Seligman, the banker, a little toad in green onyx (1927) that Nicolete Binyon thought a masterpiece. From

this point, moreover, the exhibition picked up. Binyon took along Nicolete, and Hill bought a torso from Jack.

A year after the studio exhibition, two London galleries, the Beaux Arts* and the Lefevre,† were showing Barbara Hepworth and Jack Skeaping in what became the climax to the Italian experience. William Morgan, Prix de Rome scholar for engraving,‡ was a co-exhibitor. Classical purity and firmness united the artists as well as circumstance, the *Times* art critic deduced in an exceptionally favourable review. Charles Marriott may have been impressed by the fact that Eumorfopoulos owned Hepworths and Skeapings, but he was prompted, too, by what his senses told him. Jack Skeaping was 'more curious' about materials; Barbara Hepworth, more conscious of form. Her carvings seemed as if they had been 'found' in stone. This last, seemingly simple comment raises an issue brought up time and again throughout Hepworth's career, in fact, more or less every time she was invited to explain her working methods, an issue that involves the vital relationship between image and gesture. Barbara conceived her sculptures in their entirety before she began working, each image being connected with a particular material. She also speaks of yielding to an image 'in tiny details of execution' while 'imposing' her will on the material, and notes that in stone-cutting, the material plays an 'active' part in shaping an idea. To claims that sound conflicting, the answer is that an infinitely subtle relationship existed between her first image and the demands of her material, each affecting the other to some degree. What she didn't do was doodle with a block without having a pretty clear idea of the end product.

By ill luck, the Beaux Arts exhibition coincided with Ascot, as a result of which it began as badly as its predecessor.§ When

* June 1928.
† September 1928.
‡ In 1924.
§ In his article in *The Medal* (No. 12), Hill muddles the Beaux Arts exhibition with the previous one in the Skeapings' studio.

George Hill looked in, everyone was on the racecourse; only one stone was sold and that was Eumorfopolous's commissioned piece. Promptly, Hill mustered anyone he could find. Goscombe John and Derwent Wood declined to visit, though they had been on the selecting panel for Skeaping's Prix de Rome. Since then, they reckoned, Barbara and Jack had lost their way. Faithfully, however, Bedford went along with Binyon and Nicolete, and this time Eumorfopoulos 'bought the shop'. Jack could scarcely contain his delight. With drawings in the British Museum and the V & A, they were making their mark upon the establishment.

The moment the Skeapings had money in hand, they knew they must find more adaptable quarters. Barbara had seen Mall Studios in Belsize Park, which, central as far as amenities were concerned, had a feeling of quiet privacy. Approaching through a wooden gate, a narrow alley led to a line of gaily painted front doors in a row of brick working accommodations. But so shaded by trees was the unmade path, it was barely possible to get an overall view of the red-tile roofs with skylights and chimneypots. No one would have guessed the block was tucked neatly away behind Parkhill Road. It seemed a perfect place, and so it proved. Numbers 1 to 7 were consecutive, number 8 stood at right angles to the end of the row, leaving an extra clearing in front of number 7, the Skeapings' home. It wasn't long before the caged birds were installed in a deceptively spacious studio looking on to a garden where Jack made a goldfish pond.

The studios made an obvious community. Next door was another Leeds Art School graduate, Cecil Stephenson, whose model railway ran into his back yard. Haverstock Hill, sloping gently from Hampstead village, was full of tiny stores and the Caledonian Market was close by. In winter evenings muffin-men and lamp-lighters made their rounds; in summer, Stanley Spencer trundled pramfuls of disreputable gatherings over Hampstead Heath.

All day, Barbara worked. There was so far to go, so much to discover, for 'Every piece of wood and every piece of stone has

its own particular live quality of growth or crystal structure, and one becomes utterly absorbed and blended rhythmically within the cutting of this. I think of all the activities it is the most rhythmical; the left hand, as it were, does all the thinking, holding the chisel, and the right is merely a motor . . . one gets a very easy rhythm which allows one's thought completely free rein as one tries to make the forms and contours which will express oneself. And this really goes on right to the end where the very final work – the finest rubbing and hand polishing – will reveal the state of mind of the artist and what he is trying to express.'

Success only reinforced her determination to move forward, the build-up to exhibitions creating the impetus for yet another working session. Jack was scarcely less single-minded; it was just that he didn't see why sculpture should be an exclusive activity. Success brought also, to his low boredom threshold, a restless need to stop what he was doing, however briefly, and do something else. People and pleasure were as necessary as the air he breathed; with them he could relax. Occasionally Barbara put on a beautiful dress and they went to parties. Everyone watched when they danced: a fearfully attractive couple, a little heady with wine, so that the floor seemed to sway to the slide of their feet, the turn of their shoulders and their heads in line. On and on they danced; conscious of themselves, and the music's beat, like the rhythm of a mallet hammering. If they were dancing, people thought, then they must be happy. But Barbara's refusal to allow herself time off created tension between them. Generous with his own time, Jack was cross that her work should always take precedence.

His first home was established in his mind as an ideal. Like the one he created round him later in life, it was a place of warmth and hospitality, with a kennel of poodles, oil lamps and small scampering children. From his flamboyant, contradictory behaviour, it was difficult to realize that part of his nature craved someone prepared to look after him in a sheltering sort of way. Barbara, being capable and methodical, did everything well.

Their clothes were meticulously pressed, the studio was light and bright, the house spick and span. It could have seemed like home if she had just stopped working so hard. Some were disconcerted by her habit of politely but firmly closing her front door to callers during working hours. She wasn't fit to live with, she confessed, unless she could do some work every day. Once in a good working rhythm, nothing on earth would stop her.

To offset the long hours she prescribed, Jack decided to broaden his activities by riding with the King's Battery of the Royal Horse Artillery in St John's Wood. Inevitably, he was attracted by a woman who seemed to him everything Barbara wasn't.★ Eileen Friedlander was worldly, an accomplished rider, and an eager lover, the first of a very long line to make herself an easy conquest. Jack Skeaping didn't, in his early days, pursue women so much as be pursued. Perhaps for Barbara, sex was sublimated. Left to itself, her libido would expend itself inexhaustibly in sculpting. Yet he was to accuse her of going to bed with someone else, which rather counters his charge of coolness. Was Henry Moore Barbara's lover? Jack seems to have been under the impression he was, and 'Henry admitted he'd had "a bit of an affair"'. When he left the Royal College, Henry had fallen deeply in love with Gin. Gin belonged to Raymond Coxon, and although Moore understood this, there had been a turbulence in him. Since the Skeapings' return to Britain, they had all been in touch. Jack was seldom at home, and Barbara had a sense of grievance, circumstances in which she certainly sought comfort from Moore. Both were in a sense alone. It is a bit of a conundrum, because Barbara's letters stress the sanctity of marriage.

Sometimes Barbara and Henry dropped in at the Walmsleys', talking all the time about art, though Walmsley felt they might occasionally have deferred to his interest in writing. Both appeared to him, in their contempt for the Academy and all it

★ Barbara never did ride a horse.

stood for, dogmatic to the point of obsession. They discussed each other's work, touched on cave and bush (South African) drawings, Chinese, Tibetan, Egyptian, Assyrian, Aztec and primitive Negro art, a few British painters – Constable, Augustus John and Frances Hodgkins – and above all, Epstein. That Barbara considered Moore a finer sculptor than Epstein must have been flattering to him.

Bids for recognition were jostling one with another in the ranks of the Moderns. Epstein put himself first and Moore second. Having taken the brunt of public criticism, he never managed to court favour in the way Moore did later on. But he gave full support to the admiring young man with an uncanny knack of doing everything right. By the time Moore was thirty, he was well on the way towards world recognition. His first one-man show attracted praise, vituperation and controversy in just the required proportions. Augustus John and Henry Lamb bought his work. 'Signs of genius' were recorded in the national press. Within months, he received his first big public commission. Epstein was responsible for two main groups of figures on the headquarters of London's underground railway.★ Among four young sculptors, he chose Henry to carve one of the *Winds*.

Keeping abreast of the artist network was vital to young sculptors. In isolation they wouldn't sell anything at all. Barbara and Jack exhibited in a mixed exhibition of Modern and African sculptures† in which Epstein was one of the contributors, and they joined the London Group to broaden the base of their communications. This was a band of English artists founded in 1913‡ in reaction to Roger Fry's exuberant Post-Impressionist exhibition. The strength of the society, however, was somewhat

★ *Night and Morning.*
† Sydney Burney Gallery, November 1928.
‡ Composed of earlier groups such as the Camden Town Group and the Vorticists.

dissipated. Jack worked faster than Barbara: he needed to sell, and as far as he was concerned, the more venues he had the better. Barbara was far more selective about the people with whom she associated. Everything that affected her image had to be vetted and pass approval. Who stood together and who stood apart could make all the difference. Her caution, Jack's compulsiveness, were sure signs of incompatibility.

Socially as well as professionally, their needs could scarcely have been more different. Everyone Jack admired he aspired to befriend, relying on whatever he happened to share, disingenuously trusting the rest to fate. In constant demand to play the accordion, night after night he partied with the wilder fringes of Bloomsbury at the Fitzroy Tavern★ or the notorious Café Royal in Regent Street. With artists like Cedric Morris, Arthur Lett Haines, and Augustus John he was most at ease. Eddie Marsh was a dapper civil servant, a monocle under his twisted eyebrow, who began to meet writers and painters when he became Churchill's secretary. More of a maverick than the museum men, though scarcely less erudite, and just as helpful, he was a sharp judge of literature, and a wonderful host. Marsh's apartment at the Inner Temple was covered from floor to ceiling with work by contemporary artists like Stanley Spencer and Gaudier-Brzeska. There, despite the establishment 'Sir', he mingled aesthetic friends and famous 'queens' from the theatre among his guests. Jack, who was a born actor, felt immediately at home.

Cedric Morris introduced Jack to Ottoline Morrell: at her parties he met Edith and Osbert Sitwell, both of whom became patrons in a small way. He was flattered by their attentions, but the fringes of Bloomsbury were no more Barbara's style than Marsh's bohemian parties. Years later, when Professor Hammacher showed her the manuscript of his Barbara Hepworth biography, the one sentence she asked him to delete was a passing and slightly negative reference to Bloomsbury art. To be

★ In Charlotte Street.

uncomplimentary was not enough; she did not want Bloomsbury so much as mentioned in 'her' book.*

There were difficulties in reconciling the demands of art with those made by ordinary life. Barbara was a clever girl, she led from the mind, while Jack was governed by his emotions. Her patient, self-absorbed pursuit of art seemed to him a contradiction in terms. Sometimes, he felt, she became rather pompous, almost absurd in her self-righteous attitude. It didn't mean that art didn't matter to him, just that he wanted it to be instinctive, and once something was finished, he took little further interest in it, a policy he would learn the hard way to reverse. Jack was to accuse Barbara of fraternizing only with people likely to assist her career, something difficult altogether to refute, though it was open to interpretation. Barbara craved recognition, and, feeling that her femaleness thwarted her endeavours to be taken seriously, she was drawn to the type of person who appreciated what she was trying to do. Often these people were able to help. With Binyon's romantic intellectualizing, she was immediately in tune. She could and did make other friends; though the sort of relationship she continually sought, spiritual, intellectual and emotional, was hard to live up to, let alone maintain. Something was wrong in the balance of their relationship that niggled Jack. A child might bring them together, he persuaded Barbara. To have a pregnant wife might change things.

Both liked Moore, even if Jack was jealous of the reverence in which Barbara held his work, and now their relationship was unsettled, Moore became a common bond. Just before the birth of her first child, Barbara located for him and his newly married Russian wife another Mall Studio. Sometimes Henry joined the Skeapings for evening drawing sessions, and sometimes, when work was done, a bottle of wine was opened for a game of shove-halfpenny. Like Jack, Henry had a schoolboy's sense of fun. Together, they baited goldfish with worms in the

* Hammacher didn't omit the offending passage.

little garden pond. Being a gang gave them a front. Appreciation of their sort of sculpture was very much an acquired taste; they were living hand to mouth, driven by a sense of mission, desperate to sell, gathering round them the few who believed in them and offered support. Life showed signs of improvement. For a time Barbara and Jack seemed to pull together.

Professionally, Hepworth, Skeaping and Moore were open to the same influences, they had mutual friends, and now they were living close. Small wonder their sculpture overlapped, as even a cursory glance reveals. Massiveness and simplification of forms were the rule, one critic complained. Instead of gesticulating river-gods, they produced 'torsos hewn out in sharp places', instead of elegant birds, 'leaden abstractions that make no concessions at all to the nature-lover'.

Barbara and Henry were both making animals, masks and heavy-limbed women. Her *Mother and Child* 1927 was very like work he had made three years earlier on the same theme. Her 'Egyptian' pieces, like *Musician* 1929, are similar to his in as much as they are bulky and brooding. In the 1930s, moreover, she began to experiment with asymmetry, as he was doing at the time. Skeaping and Moore were also interacting. Wary of Italian Renaissance art, Moore had nevertheless drawn the theme of the reclining figure from Michelangelo's *Dawn*. Skeaping's *Reclining Figure* 1930 in Hopton Wood stone looks extraordinarily like Moore's prostrate giantesses, though between 1930 and 1932 Moore's reclining figures began to take on Skeaping's more curvilinear style. Even in her early works, Barbara was expressing the interplay between the inner and outer surfaces of her figures by making orbits with cradling arms and folded hands.★ The sculpture she was producing was modern but not too modern, revealing suggestions of Moore, Gaudier, Epstein, Gill, Dobson and Picasso as well as Egyptian, Sumerian, African and Chinese sculpture. The women were lumpy, the animals

★ E.g. *Musician, Flute-player* and *Woman with Clasped Hands*.

embryonic but not too distorted or controversial to offend.

In a climate notoriously unsympathetic towards the Moderns, every favourable notice, every mention by name, was a small victory. Marriott took a prominent interest in the Skeapings to readers of *The Times*, and Roy Wilenski, writing in the *Studio*, complained about their omission in the Royal Academy Summer Exhibition, along with Epstein, Gill, Dobson, Moore, Alan Durst and Betty Muntz. Time and again, Barbara, still in her twenties, was being bracketed with the acknowledged leaders of the Modern Movement. Another boost came from a young architect by the name of Geoffrey Jellicoe. Jellicoe reckoned that Gaudier was still the greatest force in English sculpture, but he reserved two of six illustrations for Barbara Hepworth and John Skeaping. When they exhibited in Selfridge's Roof Garden, Barbara was picked out by several papers besides *The Times*. To compensate, Jack won second and third prizes in Wedgwood's Bi-centenary Vase competition to Barbara's 'highly commended'. In 1930, for the first time, her name appeared in a book. Stanley Casson's *Twentieth-century Sculptors* identified Hepworth's 'powerful control'.

One of Jack's positive pleasures, on his return to England, had been the weekly visit to the London Zoo on a pass from the British School. There, he modelled clay forms, very quickly, while standing in front of the cages, with a tray strapped to his waist. Meeting at the zoo a dashing young South African research anatomist, newly elected to a position on the staff, Jack, being Jack, befriended him and asked him home. Solly Zuckerman had a bright mind and the confidence of someone who was going far.* At Mall Studios, talking, watching the Skeapings work, meeting Moore, and absorbing the sense of what they were doing, he had his taste in art transformed.

It was a time of life at which one liaison quickly led to

* Within two years, he achieved his first recognition for a book on the sexual life of primates.

another. Zuckerman took Barbara to meet someone in whom she found life-long friendship and support. Shyness sometimes held her apart, but not with Margaret Gardiner, whose natural tendency to take talent under her wing can be judged by her friendships with the poets W.H. Auden, Louis MacNeice, and the brilliant, charismatic scientist J.D. Bernal. In twenty-seven-year-old Barbara, short of money and vulnerable from her breach with Jack, Margaret saw neatness, slimness, beauty and a handshake which suggested a deeper play of strength. In Margaret, Barbara found an ease and tolerance that made a direct appeal. They shared left-wing intellectualism and, for Barbara, an unusual degree of intimacy. It wasn't long before Margaret began to appreciate her work. Today, on the biggest Orkney Island, in windy Stromness, there is a collection that pays testimony to their friendship.

When the Coxons first visited number 7 Mall Studios, the setting seemed to them to be idyllic. The birds went 'tw-tw-tw' in the studio and there was just enough garden to make a natural extension. Barbara was pregnant. Gin thought how beautiful she was, how gentle. But any hopes Jack might have entertained of altering her behaviour must have been dwindling. She worked as hard as ever, standing for hours at a time with her heavy and swollen belly.

Paul was born on 3 August 1929, a beautiful, responsive child. She laid him in a cot or on a rug at her feet while she carved a glossy black baby in Burmese wood. The form is primitive: the block from which it was hewn has been taken as the key to the rhythms of the flattened head, long back and foreshortened limbs. Tiny arms are squarely raised, plump legs roundly bent: a subtle sympathy with which she has infused the infant immediately communicates the impotent, almost animal gestures of a very small child. In reality, a child took up a lot of emotional energy and Barbara had to go on sculpting. With a touch of reproach, Jack wrote that she immediately found a nurse. He wasn't making a home either; he simply escaped and the situation became further entrenched.

Barbara didn't want Jack to leave her. Loving his sensibility, his vigour, warmth, humour, the potency he habitually gave her, she didn't want to let him go. In an effort to sort out their problems, they rented a farmhouse on the Norfolk coast, took the one-year-old baby, and invited the Moores with Jack's old friend, Douglas Jenkins, and his wife. The house was a low, thatched building with receding views of the village church, and Happisburgh took Barbara in her memory back to Robin Hood Bay. Holidays not so much from, as with work. The three sculptors picked up from the beach ironstone pebbles that shone like bronze when they were carved and polished. The similarity between Barbara and Henry's work can be seen in her ironstone *Carving* and his *Mother and Child*, both 1930, which mirror each other in the silhouette of the faces and the formal lines of arms and shoulders. On one occasion Jack went fishing, while Henry sat at one end of the boat, filing away at an ironstone with a rasp, occasionally hauling in his line to inspect a catch.

Four years after the Skeapings' return to England, an exhibition of their work excited rapturous reviews. To be called brilliant young sculptors by the art critic of the *Sunday Times*, to be the 'talk of London' for weeks on end, must have been worth a lot. The show at Tooth's Galleries was literally dazzling; at first glance the catalogue looked more like notes for a geological exhibition: flint, lapis, ironstone, Ancaster, Hopton, Corsehill, Hornton, alabaster, Terveau, Portland, ivorywood, mahogany, teak and pine. Forty-seven pieces wrought over the past eighteen months were in twenty-five materials, some semi-precious, some thoroughly recalcitrant.

No longer was art expected to be representational: the search for essence, and new respect for form, were the touchstones of modern sculpture. Through Maillol, Archipenko, Brancusi, Dobson and Epstein, a gradual stripping of excrescences had given rise to the essential solidness of the Skeapings' work. Nor was being carvers remarkable; the post-war impetus led by Moore was making direct carving almost symbolic of the Modern

Movement. But the Skeapings' technical proficiency was superb. Had they been a little too clever in searching out new materials?★ Did concentration upon surface finish detract from their intrinsic truth? There was little cause for condescension towards artists whose talent, sincerity and drive were indisputable. The Skeapings' 'necessary' compromise between formal conception and respect for materials came closer to perfection, in the eyes of their ally on *The Times*, than any other modern artist he could remember. To counter hints of disapproval, John Grierson, writing in *Apollo*, declared that the variety of stones only braced up the craft of carving, adding 'gusto' to the mastery of form. In his mind, there was no reason why felicity of form should prevent an artist from being imaginative. The materials worked because the forms showed signs of a quickened consciousness, a deeper quest.

Jack was responsible for two-thirds of the exhibits, mostly animals, and he used the more exotic stones. Grierson, who had taught Skeaping to carve wood during a short spell at Armstrong College, called him the 'chief adventurer of the younger school, with a touch of Marco Polo in his record'. Among Barbara's sculptures, he singled out her own favourite, the two-month-old *Infant* 1929 in Burmese wood.

To two youthful and exceptionally good-looking people, the reception was determinedly generous. Husband and wife, 'they are really', appeared in the press variously posed: carving, or, like variety artists, with a banjo and an accordion, Barbara's rigidness more than compensated by Jack's ease. The variance affecting the Skeapings' private life was not obvious in their art, where, it was held, their individualities were so merged that without the aid of a catalogue it was almost impossible to distinguish between the two. Both, for instance, showed half-length figures of women, whose square shoulders and cubic clenched hands remarkably resembled a Sumerian sculpture in the British Museum. Moore

★ In 1930 Barbara began using English marbles.

had interpreted the same figure, the previous year:* the Moderns were chasing each others' tails.

Part of Jack had hoped, unrealistically, that a child might hold their marriage together. Barbara did for Paul what she considered proper, she gave him, and all her children, love. Later, she wished that she had done things differently. But was it possible to be both a good mother and a successful sculptor? Artists are always blamed, more or less, for the same thing: that what drives and possesses them is ruthless. One senses a deep and intense involvement with something more changeless than human relationships, something that suggests inherent concern with matters of the spirit and the imagination. Perceiving immortal beauty, she could do no other than strive to give it expression.

She and Jack had been so poor that he was reduced to playing to theatre queues; between them, there was a sensation not to be shaken off, of something coming to an end. But the birth of Paul had spun her into a prolific sculpting year.† After that, her output began to wane. Withdrawal into concentration always preceded a burst into a new direction.

* *Figure with Clasped Hands* 1929.
† In 1929 she carved ten or more pieces, in 1930, five.

Work Shapes Up More and More Strongly

(1931–2)

By the end of 1930, Barbara had made a breakthrough. The sculpture in question was a woman's head. Every line is definite and defining, the gentle brows, simple earlobes, the sweep of hair extending the back of the head with a heavy coil that follows into a chunky curve at the neck. An observer might feel that *Head* 1930 suggests very strongly the shape and size of the Cumberland alabaster block from which it was hewn. Barbara, nevertheless, felt she had freed herself from her material. She had been looking at ancient Mesopotamian sculpture, and, taking the sort of liberty made by Picasso (in paint), Archipenko or Lipchitz – reducing the features to the nearest geometrical equivalent – had achieved an expressionless look of serene immutability; as surprising, as apparently inevitable, as can be found in the British Museum. *Head* 1930 was an epiphany; afterwards, she could do anything she liked.

Later, Barbara wondered whether Ben Nicholson's fantastic dance of shapes hadn't also contributed. She had seen his work at the Lefevre Gallery and knew that she was in the presence of something brilliant. 'It often happens that one can obtain special revelations through a similar idea in a different medium. The experience helped to release all my energies for an exploration of free sculptural form.' But who was this painter whose landscapes might be represented by the merest touch of realism, whose jugs and cups,* quintessentially distilled, vibrated an amazing new life force?

* Ben was to inherit his father's collection.

For serious young artists no connection was more prestigious than the Seven and Five Society, known later as the '7 and 5 Society', then simply the '7 & 5'.* Less by chance than pattern, Ben Nicholson and John Skeaping were showing at their annual exhibition in 1931. Skeaping was a new recruit. Ben Nicholson had been brought in by Ivon Hitchens roughly half-way through the group's extended decade of active life, and immediately set about reforming it. First he brought in his wife, Winifred, then, one after the other, the cream of modern artists: Kit Wood, David Jones, the potter Staite Murray, and Frances Hodgkins. By 1926 Nicholson was President. Cézanne, Matisse and early Cubism were the basis of Seven and Five ideology. Ben, Winifred and Kit Wood showed still lifes and Cornish landscapes; other members were showing free naturalistic compositions. But it was the end of an era. 'Apples have had their day,' wrote Paul Nash, who was painting compositions made up of interlocking sculptured planes, like his *Kinetic Feature* in the Tate Gallery collection. Nash had columns in the *Listener* and the *Week-end Review* to air his views.

Since the dawn of the First World War, abstract art had fascinated some of the avant-garde. Nicholson had an abstract spell in the mid twenties, drawing pictures based on art and geometry, a style known as synthetic Cubism. Then, in one of those episodes quoted so often that it has become almost legendary, he and Kit Wood stumbled upon Alfred Wallis, a primitive painter in St Ives. In Wallis's paintings, Nicholson had seen possibilities outside the conventional square frame. A picture was no longer a window from which one saw an attractive little bit of nature, nor was it a means of demonstrating the personal sentiments of the artist, it was an event. Meanwhile, he was

* The eponymous name of the group alluded to its members, seven painters and five sculptors, although eighteen artists had shown in the first exhibition, an elasticity that remained characteristic. Barbara Hepworth and Henry Moore were to commit themselves later in 1931.

becoming progressively involved with the poetry of shape and space.

In April, Nicholson was sharing the Bloomsbury Gallery with his friend Staite Murray. Barbara had one sculpture in the exhibition and there she met the second man to sweep her off her feet. Ben's sardonic sense of humour was one of the first things about him she mentioned; something else she cannot have failed to have registered was his seriousness about art. To celebrate shared sympathies, she and Jack spent an evening with Ben and Winifred.

Even as a child, Ben Nicholson's visual receptiveness had been unusual. Not that this was surprising. Everybody around him, parents, brother, sister, and various other relations, was artistic, his father being a well-known portraitist and a gifted painter of still life and landscape. William Nicholson had loathed schools, discussion groups, movements and exhibitions, and he ran away to marry another artist, the sister of his partner, Mabel Pryde. In his day, he had been an iconoclast. As time progressed, however, Ben's father became an established figure in art society, while his mother settled down to raise a family.

Hugh Casson confessed to being a little frightened by young Ben; 'so much conviction and concentration packed tight into that frail-looking frame'. Only his mother, the boy felt, was sympathetic, though his relationship with his father was the great formative element in his character, and his early paintings owe a lot to paternal influence. William enjoyed his children, yet he found his fragile and difficult elder son a handful. They were too alike to avoid competition, too different for William to understand that, rebuffed by his teasing, Ben badly needed his support. Ben's understandable reaction was to exaggerate the differences. In order to map out his personal vision, it was imperative to distance himself from his family, Christian Science, vegetarianism, and the painting world. Rebellion took him to Paris to learn French, Milan to learn Italian, and Spain for his health – he fretted a lot about his health. Then, medically

unfit to fight for his country, he whiled away most of the First World War in California. Three terms at the Slade didn't convince him that painting was the right career, but in 1920 he married, naturally, an artist, and a considerable one. Winifred Dacre deployed in paint, with colour, warmth, innocence and freshness, portraits, landscapes and flower-poems. It was to her Ben owed his decision to concentrate seriously on art. From this time, there was to be no pause, no slackened pace; his whole life was spent cultivating his wonderful talent – everything else fell to second place.

The man Barbara met was a typical Nicholson, small and neat, with brown skin, quick eyes and feet, a small round head, and, strangely enough, something of Barbara's father in the proportions of his face. Against Barbara's nubile figure, Ben, who was nine years older, did indeed look a paternal figure, but his style, elegance and charm, the way he moved and wore his clothes, were what people noticed. Frank Halliday, a retired schoolmaster and writer, found in Ben the 'almost fanatical appearance of a medieval saint'. Blue shirts buttoned at the neck, a fringe of hair and deep-set eyes that seemed strangely at odds with a mischievous mouth. This older character was already present in essence; everywhere there was a teasing refusal to be predictable.

Naturally, Ben was flattered by a beautiful woman who cherished his work. To extend communications, he offered to lend the Skeapings some of his paintings. It had been marvellous to meet him and Winifred and the children, Barbara wrote. It was as if something momentous had happened. She had a feeling of power. One wonders whether Ben, in the first stages of fascination, felt that 'power' was an odd word for her to choose.

At the farmhouse in Happisburgh, more or less the same group gathered as the previous year for more or less the same things. They worked, walked, bathed naked, played the gramophone, danced, and hunted for pebbles on the beach. Moore stationed himself outside the door and wouldn't stop working; two-year-

old Paul pottered round, beginning to talk. The chief difference being that this time, Ben was there. Such a sweet gay party, he wrote, ecstatically, to Winifred on his first day. The next year, she must come. Barbara, whom he hadn't seen for five months, had a 'lovely' sculptor's vision and a sage understanding of Christian Science. Sculpture was a new world in the same language as painting: a magical transposition of ideas. Ben was never a member of the Church; at the same time the teachings he had been brought up with were thoroughly ingrained. Throughout his life, he consulted Christian Scientist practitioners about his and his family's physical and mental health. Having stubbornly rejected her parents' interest in the faith, Barbara saw it through Ben with a new receptiveness. Christian Science attitudes are evident in her writings from time to time.

In a group snap taken by Douglas Jenkins, Barbara stands, half-turned from the hips, arms behind her head, fiddling with her hair, a jaunty, dance-like attitude, slightly sullied by the cigarette hanging raffishly from her lips. Ivon Hitchens, capped and jacketed, raincoat to the ready, stands quaintly guarded beside the remaining, bare-breasted males. Maybe he felt as he looks, in his shiny shoes, a bit of a misfit. But the real outsider was not Hitchens so much as Jack Skeaping, who tore down on his motorbike later in the week, to find Barbara had set her heart on Ben.

Jack had fallen in love with Morwenna Ward. She was different from the women in several short-lived affairs: she was good for his work. No longer living with Barbara, he hadn't completely severed his ties, and lecturing to students at the Polytechnic School of Art, comparing the sculptor with the composer – both harnessing rhythm, balance, and perfect adjustment of the parts – he used, among his slides, photographs of her work. The press had lately referred to Skeaping as 'one of the greatest of the younger English group of sculptors', but living with Barbara sapped his impulse. In order to work he had to be keyed up and absolutely alive. She couldn't give him what he, in his restlessness,

wanted, a life wrapped round his creative needs. Jack had asked her for a divorce, inevitably, relations were stressful, and Barbara was worried about the effect his absence was having on Paul. She needed a man as much as Jack needed a woman; it wasn't his infidelity in the eyes of the law that concerned her, but Jack's constant abuse of what they together once held precious. Barbara had been feeling insecure for about half her six married years. We know all this because, in an odd triangular relationship, she confided in Ben and Winifred. Their marriage, just as unsettled, had deteriorated since Jake's birth. This doesn't mean that Ben didn't love and value Winifred: clearly he did. But he no longer wanted to live with her permanently and felt no obligation to do so. Several kinds of force were beginning to move all at once; everything trembling on the brink of what must or might happen.

Another photograph shows Ben astride a country gate, with Barbara sitting sideways on the crossbar. One by one the guests departed. Ben didn't tell Winifred that by the end of the second week he and Barbara were left alone. Marital problems had proved an intimate subject for his sympathy. The day he got home, Ben wrote to Barbara. By return post, she admitted she had fallen in love. All day she had been thinking about him. She loved him so dearly, it could only enhance the things they had shared. Ben, in turn, was aroused, physically and emotionally, by this intense girl who wanted to make the world swing upon the pivot of her art. Each had the potential to extend the other's work.

Throughout her career, Barbara attributed changes in her sculpture to personal events. To some extent, the concession was at odds with her professional stand. Professionalism suggests subordinating the emotions to the dominance of will-power. Maybe human and sexual encounters simply ratified what was happening anyway. Each time she fell in love, the reaction was a period of deep quest and suspended animation. With Jack Skeaping, she had, for a year, made no sculpture at all; with Ben

Nicholson, she made just three pieces. These three were, as it happened, a study in liberation.

The first was a half-length figure of a woman in darkish mottled alabaster, *Figure (Woman with Folded Hands)* 1931, less than a foot high, with enormous hands clenched beneath her breast. Pulling sideways, the hands rock the piece backwards and forwards, concentrating latent force into this orbital movement with such thrust and swing as to give the effect of perpetual motion. Robust, flat-headed, matriarchal, and slightly Moore-like,* the piece retained some of the primitive associations of her earlier works. Unseeing eyes and the abstracted anatomy make it as hypnotically compelling as an African figure.

Figure in Sycamore 1931 bears little superficial resemblance beyond the fact that the arms are folded. By tapering the three-quarter-length form towards the base, Barbara has lost all traces of monumentality, gaining instead a soaring, almost spiritual quality of plastic, waxing and waning. Spry, birdlike features, and the fingers being merely incised with lines, add an air of seductive suppleness. This is a moon creature, reflecting the gloss of light at every turn. Slightly reminiscent of Moore's *Seated Figure* 1930 in alabaster,† it is, through a refined femininity, in the end, her own.

Often there is an element of accident about a work of art. Precisely what supplied the seminal impulse for Barbara's *Pierced Form* 1931 (originally called *Abstraction*) was unconscious, but afterwards, she knew she had made a quantum leap. Shortly before its conception, in one of those strange coincidences that can subtly influence events, Grierson had written about Skeaping's 'new method of boring holes through the block', and his propensity to 'get compositions into the air'. The work Grierson was referring to was fairly prosaic, not even fully punctured, but it is possible

* See Moore's *Composition* 1931 in Cumberland alabaster.
† The very characteristic curves about the shoulders and hands could owe something to one of his two *Half-Figures* 1929 in cast concrete.

that Barbara, reading the review, was moved without realizing it to reinterpret the remarks. Both she and Jack had broken into the shapes of figures at the angle of knee or elbow, and various other sculptors had created holes in a figurative way. But when Barbara pierced her little organic shape,★ it felt to her entirely new. Something wonderfully invigorating had been released.

In Italy, she had recognized what light can do; how space was not an abstraction but real and tangible, a form that stands in its own right. Charged with this secret, looking for some sort of ratification of an idea which had germinated during the last two years, she 'began to burrow into the mass of sculptured form, to pierce it and make it hollow so as to let light and the air into forms and figures'. Air passing through the hole, becoming an intrinsic part of the sculpture, transforming the work, enhancing its three-dimensional aspect, totally changed the balance between the volume and its surrounding space. By allowing light to penetrate, she gave the spectator a stereoscopic impression of the interior surfaces. Changing shadows could now open the stone to a myriad possibilities. *Pierced Form* was by far her most experimental sculpture; the basis, she confessed twenty years later, of her work ever since.† Moore was profoundly interested: the hole had come to stay at Mall Studios.

As fast as Barbara was gaining ground, Britain's economy was closing the market for works of art. Two years earlier, when the speculative bubble burst in the US, American money had ceased to flow. In the summer of 1931, there was a run on the pound and almost overnight the remaining markets for British export industries disappeared. An emergency government was voted in to cope with the problem, but it was too late: people had even

★ Only ten inches high.
† She exhibited it in the Seven and Five Exhibition of 1933, and two views of it were used to accompany her statement in the Abstraction-Création *cahier* the same year.

less money to spend. While Barbara Hepworth, Henry Moore and John Skeaping were cavorting on the Happisburgh sands, England left the gold standard, intensifying the great Depression. All three were desperately short of money. Despite their predicament, morale was reasonably high. Before the end of the year, each was singled out by reviewers; Barbara, notably, for her woman's head. She, alone, was rewarded with a column in the *News Chronicle*. 'Pale triangular face, brown hair and dark eyes. Hands made strong and stiff as a man's by using hammers and wielding tools, so that she has had to give up piano playing and has turned to the concertina.' She worked on her own, except for a few twittering birds, and found it easier to start than to stop. The solitariness conveyed by the article was largely diplomatic. Since Happisburgh, Ben had taken a flat at Parkhill Road, and Barbara had seen him regularly. From March 1932, Ben moved in and out of Mall Studios.

John Skeaping was one of the three most promising young sculptors in the country, poised on the threshold of what looked set to be an illustrious career. This wasn't the case for very much longer, because some time later in the year, in a histrionic gesture he referred to in hindsight as a rebellion, he resigned from the Seven and Five as well as from the London Group. Having finally lost Barbara to Ben, Skeaping felt, despite himself, rebuffed. The Seven and Five, run by Ben, it must be said, with some autocracy, could have begun to feel alien. If Jack wasn't one of them, he smarted, he would throw in his lot with Eddie Marsh and Bloomsbury. While associating with Moore and Hepworth, he had shared their critical attention, the limelight was good for sales and he did care a little about fame. What he lacked was Barbara's intense discipline, her ability to sustain uncertainty, so that pressures made him want to fly off at a tangent. His advancement, however, was compromised. There hadn't been a single cause so much as accumulating tensions, though he gave his first reason for breaking away as Herbert Read.

Read enters the story as a man of considerable literary and

artistic sensibilities, and a will, surprising in someone often re-
ferred to as 'gentle', to make his mark on the twentieth century.
Poet, essayist, author, assistant keeper of the Ceramics Depart-
ment at the V & A, and man-about-town, he had begun, at
forty, the writings that would make his name synonymous with
the Modern Movement. Perhaps his greatest contribution was to
extend the boundaries of art appreciation so that it reflected the
psychological climate of his time. Read probably met Barbara
when he visited Moore's studio, in the spring of 1930. Silent and
inscrutable, he seemed to her a father-figure, to be loved and
respected, an image augmented by Read's reputation for half an
hour's silence before commenting upon a work of art. Bow-tied
and blue-bereted – the unorthodox mixture pervaded Read's
nature at every level – he was a Yorkshireman with a passionate
response to art and nature, an obvious advocate of Barbara's pure
and increasingly abstract work. Her sculpture appealed to the
intuitive, feminine side of his nature. Pretty soon, he decided to
promote her as a major artist. Naturally she was delighted to
have so receptive an advocate: hardly could there have been a
more auspicious basis for friendship.

Read shared Paul Nash's column in the *Listener*, a journal
where exposure of the visual arts, particularly abstract art, was well
above average. It was thanks partly to the *Listener*'s extensive
coverage that modern art became a popular controversial issue.
Timing was crucial. Much modern work shocked viewers because
it appeared unfinished or distorted. It was difficult to understand,
let alone like. But at least it remained recognizable. Abstraction
was a great deal more perplexing. Yet why, Read asked, should
modern art be easy? Had any great art, at the time it was
wrought, been accessible to its public? The nature of form is
essentially symbolic, he emphasized. Modernism has an authori-
tative intellectual pedigree based in philosophy and psychology.
Even abstract art has a perfectly tenable background* because all

* In geometrical, as distinct from organic art.

art *is* primarily abstract. 'For what is aesthetic experience, deprived of its incidental trappings and associations, but a response of the body and mind of man to invented or isolated harmonies.' Great art was a combination of the Romantic (intuition) and the Classical (intellect), or what he saw as the twin faces of Modernism, abstraction and Surrealism. So esteemed were Read's articles that a year's worth became, at the end of 1931, a volume with the name of his first essay, *The Meaning of Art*, and a review on Moore was soon turned into a book.

While allowing him a certain discretion for recognizing talent, Skeaping had no time for Read's psychology and resented being 'explained', especially in what he considered inappropriate terms. Read couldn't stand small-talk; that too suggested conflicting temperaments. Jack found his remoteness chilly and despised 'back-scratching' among the leaders of the Modern Movement, but what nagged him above all was the feeling that Read was subtly dictating. Eccentricity by definition leads to divergence: he couldn't accept dictatorship because of his stubborn belief that only unsophisticated freedom produced real art. The impulse to take a stand, if necessary to defy authority, was bred in him, surely, by his family. Unlike Barbara and Henry, prize pupils who had discovered, early, support in authority, Jack didn't like being told what to do.

Barbara was no longer directly affected. Being in love was throwing up a spectrum of ideas and emotions she wanted to share with Ben, whose past was proving a lot more intractable. Ben, of course, was married to Winifred; he had had affairs before, but Winifred was upset by this new turn of events. Ben compensated with informative, reassuring letters. Eventually, he would return, he and Barbara jointly consoled, and at first it seemed plausible. Winifred's domestic position hadn't been easy. During the months of uncertainty, she and the children were moving around among her friends. Marriage gave her a sort of authority; she felt that the family held her to Ben, and quite simply didn't want to let him go. Besides, she didn't like Barbara,

which upset Ben. Winifred could express her feelings by refusing to see him and denying him access to his children. In the summer, however, Ben looked after Andrew, Kate and Jake for a while so that Winifred could go to Paris. Precarious finances exacerbated general tensions. In 1931 his total net earnings were ninety pounds. He and Barbara had been making lino-cut fabrics to try and bring in extra money, and when he moved in with her, he took on her cousin, Jack,★ as a pupil. Winifred had inherited some capital; Ben could have lived comfortably with her, but he chose to live with Barbara, so he was hard up.

Inevitably, the two learned from each other. To Ben, since the early twenties, Paris had been the key to art, a fact that was immediately evident in the Surrealist influence in Barbara's work. 'Deep similitude' was perceived by Nash, reviewing a joint exhibition at Tooth's Gallery in the final months of 1932, in works which wooed 'the spectator to the core of their origins'. Ben's inclusion of Barbara and her sculpture† in a number of his drawings and paintings, like *Girl in a Mirror* 1932, conveys his fervent interest. At a more obvious level, both were fastidious about surface finish, and both used descriptive Miró-like lines and biographical silhouettes, independent of the carved shape of a stone or area of paint. Barbara was taking photograms of their profiles in a mirror, providing images which she incorporated in her work.‡ The heads of her carvings remained small, their faces impersonal, with memorable spritish looks – questioning, listening, watching: totally alert. By throwing the glance of a figure in the opposite direction from the form, she could vastly increase the rhythmic quality of a sculpture.

★ The son of Herbert's brother, Arthur.
† Nicholson's *Head with a Guitar* of 1932 incorporates a bust which resembles Hepworth's 1930 *Head*.
‡ Particularly, on *Profile in Green Marble* 1932. Le Corbusier, whom Barbara had undoubtedly read (see Chapter 9), said 'Contour and profile are a pure creation of the mind; they call for the plastic arts.'

Between trying to placate Winifred and enjoy Ben, her work was shaping up 'more and more strongly'. She had carved, in a surge of confidence, some extraordinarily diverse works. At one extreme there was a nubile slip of a torso in African blackwood, shallowly cut, entrancing for its suggested immaturity. At the other, a disturbingly intense Africanate female or perhaps asexual figure in rosewood, kneeling on one leg, head turned, eyes gazing steadily outwards, mouth slightly askance. As in Barbara's twenties pieces, its rigidly squared arms and shoulders and elaborately lengthened fingers seemed to hug in composure, bringing the whole compact frame into dynamic melody. She made an Arp-like reclining figure, its prominences, hollows and contours akin to landscape, and for the first time, in 1932, two heads in dialogue.

Herbert Read's first public declaration of interest in Hepworth was the introduction to her work in Tooth's catalogue, by which time, he opined, she occupied a leading position in the Modern Movement. Her work displayed far more than honesty to her medium; there were subtle archetypal qualities to 'delight' the imagination. Read, Nash and Jim Ede of the Tate Gallery were unreserved in their enthusiasm; more conservative colleagues were split. One or two of those who had backed her in the twenties remained supportive; others were bewildered by signs of increasing abstraction. Kineton Parkes, for instance, referred to *Pierced Form* as little more than a 'hole in the wall'. More than one was annoyed by Read's effusions. Even Marriott bridled at his elaborate claims. The Yorkshire papers, however, were triumphant. After puffing up Read as 'one of the few art critics with experience of contemporary Continental art', they took every opportunity to refer to their prodigies. A modern exhibition that omitted work by either Hepworth or Moore was sanctimoniously censured. For the first time, in the reviews of Tooth's, Barbara was being ranked with Moore. Though the *Yorkshire Post*'s blunt verdict, that Miss Hepworth was 'much influenced' by Mr Moore, was hardly a compliment. For a woman who felt keenly

her disadvantage, the imputation was frustrating because influence was certainly two-way. The year after Moore saw *Pierced Form*, he began tunnelling holes.

Nothing was casual about the pecking order in the higher echelons of the art world; no one was more aware than Barbara Hepworth, Ben Nicholson and Henry Moore how allegiances were being made and broken, reputations lost and won in the grand lottery. Read is sometimes assumed, single-handedly, to have put Hepworth on the map. This wasn't the case; metaphorically as well as literally, she had carved a name for herself before the end of the twenties. Charles Marriott of *The Times* always treated her as exceptional; he must take some credit for her entering the mainstream of art history rather than being marginalized, as women artists generally were.

At the Beaux Arts Gallery exhibition of 1928, Barbara's maiden name, 'Hepworth', had preceded those of William Morgan and John Skeaping in the catalogue, and she was referred to as 'Hepworth' throughout her *Times* review. If the *Scotsman* liked to dub her 'Mr Skeaping's young wife', such patronizing was unusual; *Studio* linked her emphatically with Ben Nicholson; 'two artists of the younger Modern British School'. By the end of 1930 Barbara Hepworth was Barbara Hepworth about half the time, against Barbara Skeaping, Mrs Skeaping, 'Mrs Skeaping – better known as Miss Barbara Hepworth', Mrs John Skeaping or Mrs Barbara Hepworth Skeaping. Wilenski had been another early supporter. Barbara wasn't mentioned in the text of his new book,★ but one of her works was illustrated, which was just as important.

The way in which the press referred to Barbara was further confused by the change of partners that was taking place. Ben and Winifred were being coupled by provincial newspapers, and she was apt, suddenly, to reappear as Mrs Skeaping. From time to time she and Jack saw one another, and after the first acrimonies they remained, until Barbara died, on friendly if distant terms.

★ With Zadkine, Underwood Moore and Bedford.

Winifred had set herself up with three young children in a second-floor flat in Paris, with a balcony overlooking the Seine. Two days before the exhibition (Tooth's) opened, Ben was anticipating a 'decent long stay' at Quai d'Auteuil the moment it was over. He was only sorry she couldn't see the show. He sent love and invited news. Towards the end of the show, he wrote again, jubilant that he and Barbara had sold over £300-worth. 'I can't tell you what it means to get a little appreciation at last.' Occasionally he stayed in Paris near Winifred and the children. Between times, it was Barbara's turn.

Art was the pivot: it was one of the happiest periods of Barbara's life, and her energies amazed her friends. To them, it seemed, by judicious planning, she squeezed more from her days than they could humanly accommodate. An August trip to Dieppe with Ben was just a prelude to what was coming. Taking charge, he was to expose Barbara to a wave of experiences that profoundly influenced her sculpture. With nimble-minded, quick-footed Ben, the future was full of hope. She was exchanging ideas with one of the leading figures in British art.

Imminent Discovery

(1933)

For five and a half years, at home, in England, Barbara's inspiration had been fertile. Ben enjoyed helping people whose work he admired. It was time for her exposure to new sources and new contacts.

Much as Barbara's father had first presented to her the landscape of Yorkshire, and John Skeaping revealed the sparkling beauty of Tuscany, Ben drew on the clear, light-filled landscape of Provence. Leaving England two weeks before Easter, the couple went, on a round trip, from Dieppe to Paris, to Avignon, St-Rémy, and back, visiting *en route* the studios of Arp, Brancusi and Picasso. A few months later, they returned to Dieppe. Footloose and with Ben, the sudden distance between Barbara and her usual environment, the breaking of the daily habits by which she was conditioned, released her from the creature that did the conditioning. The days seemed, she wrote, 'alive with a sense of imminent new discovery'. She was penetrating beneath the surface of things in a meditation upon the mystery of their nature, and on their location in time and space.

Surrealism was now a prominent part of the French scene. In Paris they saw work by, among others, Miró, and the sculptor Arp. Arp's poetic licence set Barbara thinking. Travelling to Avignon, she stood in the corridor of a train in a state of suppressed excitement, finding in fleeting views of the Rhône Valley a metaphor for the way in which Arp had fused landscape and human form, freeing himself from the demands of his material. 'I began to imagine the earth rising and becoming human. I speculated as to how I was to find my own identifica-

tion, as a human being and a sculptor, with the landscape around me.'*

In St-Rémy on Easter Sunday traffic lights in the main street made a surprising contemporary image (squares and circles, green and red) against a stone arch that had stood two thousand years on its flat green space of earth. People around the archway, sitting, walking, reclining and embracing, took on a special significance. They were, Barbara thought, a series of bubbles, each group entire in itself, being sucked into the great convection, the whole gaudy, glittering mass, going down the hill, into the gay café, hidden by trees, and out again. Each bubble separate from the others, and yet part of the vessel in which they streamed and swelled. Drawn a little apart, Barbara saw groups of people in silhouette and they became, at once, memorable. In the background, light and silence were punctuated by bursts of tinny music from a foreign radio station. The throb and swing of the music fitted into the country. Rhythm in all these things, and Ben's impregnable air, made Barbara feel alive. Possessed by harmony in the little Provençal town, she drew hard bare mountains and quiet olive trees. These were her last drawings of landscape. Thereafter, it was not in pencil or words but in sculpture that she would be impelled to retain the mystery of relationships. No sooner had she sat down to depict a scene, than ideas and forms for sculptures would appear.

Later, Barbara recalled in greatest reverence their visits to various studios. Arp wasn't at home but in his atelier at Meudon, in the suburbs of Paris, she and Ben were received by the sculptor's wife, another artist, Sophie Tauber-Arp. It was more than a year since Arp had moved from his largely experimental painted wood and string reliefs, and card collages, to free-standing sculptures. In the transitional phase he was assembling multiple forms, often in threes, clinging together like primeval squirms, to

* A *Pictorial Autobiography*, mistakenly, puts the visit to Arp's studio before the trip to Avignon.

which he gave the general term 'concretions'. Plaster was not a material Barbara was drawn to; nevertheless, she was intrigued by Arp's curvaceous rhythmic configurations. His wooden sculptures were more disparate: several forms, generally, again, three, placed on circular stands. It was the way in which they possessed the surrounding space that made an impact. Arp's work, she said, freed her from 'many inhibitions'. Immediately after the trip she began carving multi-part sculptures.

Something must have made Barbara want to show Brancusi her photograph of *Pierced Form*. From him she learned, at this fairly late stage of development, perhaps more than she learned from any other artist. You can't carve without loving your material, he had said, walking round, pulling the dust-sheets off one sculpture after another. Never particularly eloquent about his work, he let the quiet earthbound shapes speak for themselves. There were basic, humanistic forms that captured the life forms of nature: human heads, elliptical fish, soaring birds and the great eternal column that makes a metaphor for transcendence. In Brancusi's sculptures, the unity of rhythm and form is unique. To Barbara, his rhythms seemed to apprehend contemporary needs, making parallels with Stravinsky's music, sophisticated, and simultaneously archetypal and timeless.

After paying their respects to Brancusi, Ben and Barbara met the French painters Auguste Herbin and Jean Hélion, of whom the latter invited them to join Abstraction-Création, the Paris-based society. The group had been founded two years earlier expressly for abstract artists. To take her place alongside more than forty internationals was, for Barbara, a major accomplishment. In Paris that December, she contributed to a standing exhibition, and the next two publications of the society included illustrations of her work.

On the way home, Ben and Barbara visited Picasso in his studio at Gisors. From Château Boisgeloup, Barbara retained a vision of afternoon light streaming through the window and rebounding from a blaze of energy, as their host rolled towards

them, with an infectious flourish, some brightly coloured pencils.

Ben had always celebrated his family in an anecdotal, biographical way. Since meeting Barbara he had sketched them endlessly. In *St-Rémy, Provence* they are drawn together by their response to one another and to everything around them. Wide-eyed, brow to brow, austere personalized silhouettes are fused by a mirror. Ben's hand on Barbara's shoulder and the rich black paint convey the warmth of his desire, the shining sun and the sultriness of Provence.

Ben and Barbara had been together for more than a year, and Barbara knew that the clue to defining her direction lay in art from the Continent. At one point they considered moving to Paris so that Ben could move more easily between his two women, but Winifred turned down the suggestion of a *ménage à trois* and nothing came of the plan. Barbara and Ben, who were married in all but official terms, had swung a complete circle. 'Freedom' was what they wanted, and this meant Ben's divorce from Winifred. They had been to Paris to see her, to try to thrash things out. Divorce, Barbara argued, was facing reality: she and Ben were made for each other. Obstinately, Winifred dug in her toes: like Ben's mother, she was 'someone to be reckoned with'. Barbara was going to have to wait another five years before she could marry Ben.

A second, September trip took Barbara to Dieppe and Ben's admired model, Braque. But for all her wanderings, the greatest find was Ben himself: someone else set apart by an uncompromising, unconditional and unambiguous surrender to a particular role, a dedication more total than others were able to make. Professionalism entails not only an artist's imagination and his facility with his materials, the discovery of ways of circumventing abnormal stresses, the demarcation of the essential patterns of daily function: it involves a definition of his stance towards life, everything focused on the creative effort of mind and body to exclude what is peripheral, to bring experience within the jurisdiction of form. Professionalism was being able to throw, into the

great forward thrust of her work, dramatic happenings taking place in her personal life.

Wherever Ben was, he managed to convey the slightly subversive tension of thinking big, knowing people, knowing the *right* people, interesting the right people, doing the right things, not just art, but things that put art on the map. Planning was not only the national slogan for the decade, it was his forte. Something had to be done in the face of hostility towards abstract art and declining markets. Instead of fighting independent, mutually destructive battles, those at the forefront should band together, cross national boundaries and open up bigger horizons. For the first time in centuries, England must participate in something global. At first the Seven and Five seemed the best prospect, but despite a few cosmopolitan members, naturalistic styles and Post-Impressionist Frenchness remained predominant. At the annual exhibition in 1932, it had been clear that the Hampstead contingent were in the lead. When Paul Nash, artist, writer and agitator, advanced plans for a more progressive venture, they were ready to jump ahead.

Nash threw his net wide.* In the *Listener*, he wrote about contemporary art, industry, the community, modern textiles and the home; while *Room and Book* harnessed various other aspects of decorative and industrial art. Compared with Ben, his painting was literary and English; otherwise, his strength was his Catholicism, a quality reflected in his idea for a practical and sympathetic alliance between architect, painter and sculptor. The first move was suggesting to Moore that they should get together with the architect Wells Coates, and the painter Edward Wadsworth. Other possible recruits were one or two artists defined only by their general abandonment of 'truth to Nature': John Armstrong, Edward Burra, John Bigge, Ben Nicholson and, possibly, Barbara Hepworth. Barbara's connection with Ben was in her favour. Nash

* In 1919 he had been accused of succumbing to artistic internationalism.

'felt' her talent, but didn't entirely trust his judgement where sculpture was concerned. He would write guardedly to Ben until her eligibility was confirmed. Everything was coming to a head when Nash's historic letter to *The Times* announced what seemed, to the committed, a prodigiously radical stunt. 'Unit One' was to be the collective name for two sculptors, seven painters and two architects who stood for 'the expression of a truly contemporary spirit, for that thing which is recognized as peculiarly of *to-day* in painting, sculpture, and architecture'.

There was something about Nash's message that captured the public imagination. Two weeks after his letter appeared in *The Times*, the news made two columns of the *Observer*. Provincial newspapers relayed the story: 'Extraordinary Interest' was being generated in London, in the foundation and fortunes of a group whose select numbers involved a number of Yorkshiremen.* Fred Mayor and his assistant, Douglas Cooper, were positively disposed towards the avant-garde. For several years the Mayor Gallery became the group's headquarters. Read was the obvious choice to be editor of the *Unit One* publication. Bristling with idealism, the youthful movement was set to serve the world through contemporary art.

The inclusion of architects was a particularly happy proposal. Le Corbusier's challenging statement, *Vers une architecture*, had been translated into English in 1927 to a fascinated, if bewildered reception. Behind the curiously related images of cars, ships, planes, medieval cathedrals and Greek temples lay the message that architecture had everything to learn from the engineer. Inspired by laws of economics and governed by mathematical calculation, the engineer put man in accord with universal laws, thereby achieving harmony. If new steel and concrete buildings had, at first, received the same abuse as their sister arts, men like Leslie Martin, Wells Coates, Colin Lucas and Maxwell Fry were

* Barbara Hepworth, Edward Wadsworth, Henry Moore, Herbert Read and Fred Mayor.

beginning to give the profession a highly respected profile. Quicker than painters to realize Continental trends, British architects had turned, in particular, to West Germany's Bauhaus. Then gifted German architects Walter Gropius, Erich Mendelsohn and Marcel Breuer reinforced European contacts by fleeing to England as a result of Nazi persecution.★

Thirties buildings were severe, functional and humanistic. Did their plainness suggest lack of communication between sculpture and architecture? It was a topical subject to which Barbara Hepworth, questioned for the *Studio*, replied that good modern architecture needed no sculpture, it stood for itself. And bad architecture couldn't be rescued by ornament. Where sculptor and architect did liaise, it was essential for their aims to be in harmony. But far from being divorced, the disciplines could learn directly from each other. Abstract form was the common denominator. In Wells Coates's streamlined block of flats on Hampstead's Lawn Road there was a dynamic sample of modern architecture on the doorstep of Mall Studios, where Gropius collaborated with Maxwell Fry. The reputation of West Hampstead and Belsize Park for innovation was growing.

Disenchanted with marriage and an art history professorship he had been holding at Edinburgh for eighteen months, Read suddenly decided to bolt from both. In London, penniless, he appealed to Moore, who offered to lend his studio while he was on holiday. In Parkhill Road, Read and a vivacious violinist called Margaret Ludvic, or 'Ludo', shared Moore's quarters with a figure in Horton stone and a boxwood sculpture Read called the 'buttergirl'. Six weeks or so later, Ben and Barbara engineered a home for them at number 3 Mall Studios. The job of editing the *Burlington Magazine* was vacant at the appropriate moment. It wasn't full-time or very lucrative, but as a platform it promised to be invaluable, and Read accepted. Life in Mall Studios was an

★ Mendelsohn in 1933, Gropius in 1934.

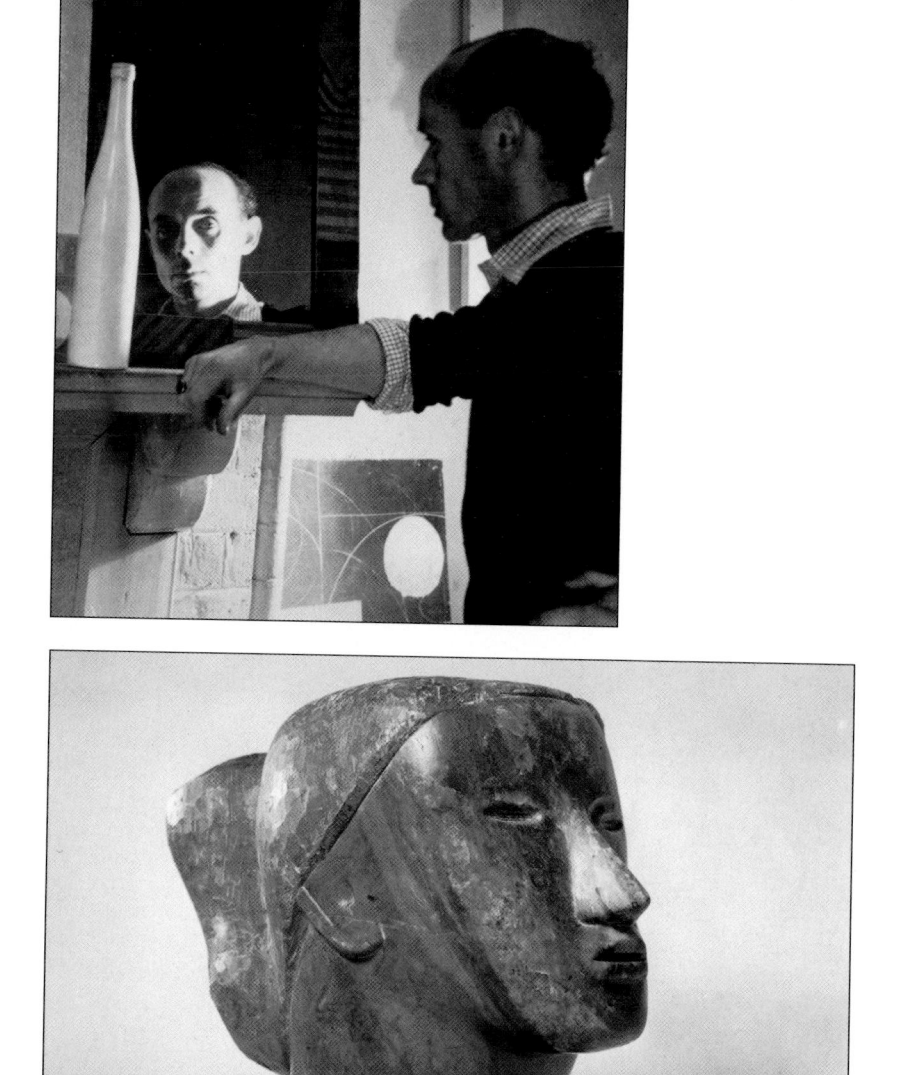

18. *(Above)* Ben Nicholson, by Humphrey Spender, *c.*1935
19. *(Below) Head* 1930. Afterwards, Barbara felt she could do anything

20. Barbara *(left)* with Mary Jenkins and Henry Moore at Happisburgh in Norfolk, September 1931

21. *(Left)* Hepworth's *Two Forms* 1934, in ironstones collected at Happisburgh
22. *(Right)* Moore's *Two Forms* 1934, wood cast in bronze

23. *(Above)* Barbara Hepworth
*c.*1932, holding a hand sculpture

24. *(Below) Pierced Form* 1931,
in alabaster

25. *(Above)* Mall Studio in Belsize Park

26. *(Below)* Barbara wearing a beret, from Herbert Read's *Unit One* publication

27. *(Above left)* Adrian Stokes

28. *(Above right)* Herbert Read
and his son Thomas, photographed
by Barbara Hepworth

29. *(Below)* Ben wearing the beret

30. The triplets in a cot

31. *Two Forms with Sphere* 1934, the first sculpture after the triplets' birth
The original is destroyed and this print is reproduced from an old photograph.

32. Ben with the triplets

33. Rachel, Simon and Sarah at the Welgarth Nurses' Training College in Golders Green

34. (Above) Sculpture with
Colour Deep Blue and Red
1940

35. Barbara's sister,
Elizabeth Summerson,
in Ben's studio, with a
Nicholson, a Calder and
a Hepworth

agreeable mixture of work, visits, conversation, disagreement and shared purpose. Almost daily, Herbert Read, principal apologist for modern art, was in and out of number 7 watching whatever work was in progress. The Read studio resonated with parties, so that after the rain, the leafy little path to the building grew muddy from footsteps.

Whether or not people liked Barbara's increasing abstraction, they reacted strongly to it, and Frank Rutter, art critic of the *Sunday Times*, for one, made a complete turn. Three years before, Barbara had seemed to him one of the most important young sculptors of her time. Now she produced 'monstrosities'. . . . 'It is just barely possible that the future may find beauty where I only see hideousness.' The only compensation was that alienation from one set brought her in line with another. People were gathering round who would escort her to the climax of her career.

Margaret Gardiner had introduced her to a new and important protagonist. Adrian Stokes was the same age as Barbara, a formidable iconoclast with a fair crest of hair, large hands and a mobile mouth. After PPE at Magdalene he had followed a mystic trail to India and the Far East, then fallen in love with Italy, Giotto, Masaccio and Piero, leading him to a passion for stonework. The books he wrote in the thrall of this affair, *Quattrocento* (1932), *Stones of Rimini* (1934) and *Colour and Form* (1937), brought him his greatest acclaim. Ludo didn't entirely approve of his bohemianism, but others found him fearfully attractive. Stokes played tennis with Ben at a club in Belsize Park, where other tennis fans, equally 'freakish' about playing games, were Marcus and Rene Brumwell. A decade later, Brumwell's games-playing had extended to buying two and a half businesses and a building, engaging three men at four-figure salaries and borrowing £30,000 to pay for it within weeks. It was an ability he was also to employ in the interests of modern artists and modern art.

Nearly everyone who knew Ben talks about his games. Assertive

and inimitably deft, he played well almost any he chose – golf, tennis, table-tennis and diabolo – a singular characteristic being his insistence on inventing or changing the rules. Games are a classic way of bringing life to order by giving it an attainable objective; even the loser can still control. Ben's object was to make games as difficult, and therefore as skilled as possible. One or two, generally uncompetitive, people like his friend Reddihough thought his entire motive was centred in the playing; that competition was unimportant. Others found that where Ben discovered stern opposition, he changed the rules in his favour; he *had* to win. Punning was a different sort of game. Ben punned endlessly, in letters and in conversation. Mostly his jokes were agile word-play, quick diabolic clevernesses achieved by hyphenating and random separation of syllables. Later on, his jokes niggled Barbara, and that too was a game. Despite superficial skittishness, he wasn't an easy man and playing the fool disguised how seriously he took himself. Painting and nature were, he said, religious experiences.

Two people who knew Barbara reasonably well, Cyril Reddihough and Margaret Gardiner, saw her in such different lights that their reactions are worth comparing. Both, let it be said, were fond of her. 'Red' was a Bradford solicitor, one of the first half-dozen people to appreciate and acquire Ben's work, and, because he was so entirely accommodating, a frequent travel companion. With Ben he was completely at ease. With Barbara, though the Yorkshireness was an asset, he felt bound to maintain his best behaviour. This was what most people felt. Barbara was so earnest, Red's wife, Oona, remarked. People noticed her sphinx-like silences and felt reproved. Margaret Gardiner, to judge from her *Memoir*, seems to have been the exception. She brought to their intimacy good company, nonchalance, audacity and a sense of fun. She liked Ben and wouldn't compete with Barbara, since competition didn't especially interest her. As a result, Barbara was more relaxed with her than with anyone else. To stretch the vitality of the moment was what seemed

important. Together, they made escapades at night, on Hampstead Heath, visited the market at Covent Garden, and, indulging the essential social habit of the age, they watched avant-garde European films at Hampstead's Everyman.

England was convalescing from the worst of the Depression. The thirties provided a better standard of living than the twenties, yet a sense of security was slightly false. The government was pinning its hopes on old industries rather than developing new ones, and mass unemployment still affected the old industrial areas. The wool industry, for instance, lost a quarter of its labour force between the wars. A great divide separated those who had work from those who didn't. One threat, moreover, was replaced by another. On 30 January 1933, Adolf Hitler became German chancellor with the avowed aim of making Germany, once more, a major power. Hitler might have been expected to bring the English together; in fact he pushed them apart. The Socialists disliked his dictatorship; the Tories disliked the menace he posed to security, a situation complicated by the Tories' fear of Communism and the Socialists' obstinate faith in disarmament. In theory, everyone wanted peace. The very existence of the League of Nations might have been expected to resolve disputes. But how should it be done? By 14 October 1933 Germany had withdrawn from the disarmament conference, a week later it backed out of the League of Nations. English arms estimates remained lower than they had been ten years before. It was difficult to know what was right. Barbara was committed to the League of Nations and to disarmament, but she wasn't, in the circumstances, an out-and-out pacifist.

To the adamantly left-wing artists of Belsize Park, socialist ideals were a binding concern. Cyril Reddihough was not impressed by her grip on politics, perhaps because the emotion with which she believed in any conviction she might be expressing made her sound naïve. The Nazis were as black as the Soviet Union was white. Roused by war and injustice beyond the point where her feelings got the better of her intellect, her letters thrust

and flay through vehemence to vengeance. Since human lives were at stake, who can say that she was being intemperate? Hardly less committed than Margaret Gardiner's friend and lover, crystallographer Desmond Bernal, who had already made two trips to the Soviet Union, Barbara and Henry Moore were both on the Committee of FIL (For Intellectual Liberty), a pacifist organization of which Aldous Huxley was President and Margaret Gardiner Secretary.

Two women friends who took a consistent interest in Barbara's work were Nicolete Binyon and Helen Sutherland. All three had a slightly formidable presence and an incisive mind. Helen was the daughter of one of the great self-made Victorian businessmen, Chairman of the P. & O. During the critical late twenties and thirties, she had devoted herself to patronage of the arts. Her judgement was acutely discerning. Like Red, she had been a very early purchaser of Ben's work, but she also bought from Hepworth, David Jones and Naum Gabo long before they were famous. Kathleen Raine, the poet, wrote of her, 'Friend, consoler, perfectionist, she called out in all whom she admitted into her circle of friends in whose work she believed . . . by a combination of entire imaginative sympathy and exacting attention to detail, their best work.' Helen and Nicolete knew one another through the art network. After taking up a Rome Scholarship, in the summer of 1933, Nicolete married, at the youthful age of twenty-one, the capable Basil Gray, of the British Museum.

Between European guided tours, throughout 1933 and much of the following year, Barbara was experimenting with organic forms, one or two of which seem to have borrowed directly from Arp's identification with the landscape.* Basically, her espousal of her material, and the still, inborn intensity of her carvings weren't like Arp at all, and this stemmed from their

* The abstracted torso in pink alabaster (*Carving* 1933, Hodin 49) (since destroyed) bears resemblances to an exuberant, extroverted torso Arp had carved two years earlier (*Torso* 1931).

working methods. Arp experimented until a particular bulge or dip pleased him, whereupon he accentuated that part. The part grew until the original forms had become secondary and were, at length, suppressed. New sculptures, which might take months or even years to find themselves, gave the impression of being arbitrary and fluid, like a dream floating through light and space. Compare this with Barbara's structural conceptions, the formalities upon which they are based never compromised, born into their material with a mallet, a claw for pulling together, a puncher for shifting large pieces, and a chisel for cutting surfaces before rasps, files and emery paper were industriously applied to acquire the perfect finish. Unlike Moore, Barbara didn't work from small-scale models. Like Brancusi, putting the spirit back into his simple egg-shapes with directness and simplicity, she explored her sculptures through and through, and round and round. The tone, consequently, is exact.

All the time, her work was developing, a gradual and continuing metamorphosis from the Egyptian solidness of the early years to amazing equipoise. Tapering columns towards the bottom, pinching right in at the base, defying gravity, was part of the freeing process. A good example is a very simplified human form in grey alabaster, somewhat cruciform, pierced beneath the breast. Though only seven and a half inches high, its delicacy and poise give a bird-like quality of arrested flight. It is worth recalling Barbara's fascination with the expressive potential of movement. The moment Cyril Reddihough saw the sculpture in her studio, before it was ever exhibited, he knew that he had to buy *Figure 1933*. Asked what feature had made such an impact, he replied that it was the balance that held him. Jim Ede, the art collector, once said if he could find another word for God, it would be 'balance'.

The physical precariousness of Barbara's sculpture had a less than welcome counterpart in her finances. 'If I send you £8.10 for the Mall rent is that right,' Ben wrote; 'have you any at all to pay your share? Please tell me? I have to find £25 as well for 53

Parkhill Road.' By nature as much as from necessity, Barbara was a businesswoman. Fred Murray of the Mayor Gallery, brother of the potter William Staite, and another sympathetic Yorkshireman,★ had seen her torso in African blackwood at Tooth's and expressed interest. Hoping to clinch a sale, Barbara suggested he took it and paid for it whenever he liked. Running simultaneously was an exhibition at the Sydney Burney Gallery of sculpture from all periods and countries. Here, Sir Michael Sadler, seeing her work, was inspired to buy.

★ His father was a Yorkshire artist.

Absolute and Permanent Values

(October 1933–October 1935)

Barbara relished Ben's encouragement; she was influenced by what influenced him, and even pooled what was, to some extent, her domain. Infatuation was mutual. Dropping in on Arp, Ben had shown him photographs of Epstein's work, some of Barbara's (Arp preferred the former) and simply because he was proud of her, some snaps of Barbara, naked, on the beach. But long before he met her, Ben had been interested in materials and techniques, stressing the process of formation by emphasizing the surface of his background and the texture of paint. The pair had been making lino-cuts together for a couple of years when he took a further step in the direction of sculpture and began to 'carve' his celebrated white reliefs.

The right sort of communications were imperative to him. Prompted only partly by having Winifred and the family on the Continent, he was back and forth like a tennis ball. In Barbara, small bouts of stimulation went a long way. From time to time she opened the door just a chink, to replenish herself, before rushing back to the studio where she was secure, working out her creative imagination to familiar rhythms. She had a shrewd idea what was in her best interests, and didn't want incidentals to confuse her muse. Besides, Ben was a perfect filter. Return visits to London were made by Braque, Calder, Hélion, Gabo, Erni and Léger, all of whom visited Mall Studios.

At Alex Reid and Lefevre, towards the end of 1933, the couple were causing excitement. It was gallery policy to encourage new talent. Duncan MacDonald, one of the directors and a particular friend, spent four or five months a year in New York,

where he had many contacts. He liked their work and did all he could to promote it. If they weren't selling much, they were at least being picked up by the critics. No English sculptor came near to Moore, in Geoffrey Grigson's estimation, except Barbara Hepworth. Stokes was also doing his best for her. Not only what he said, but how he said it, set his criticisms apart. Conditioned by his study of Kleinian psychoanalysis, he produced prose spun out to a baroque and sometimes abstruse voluptuousness. In a world entirely animate, even stones, possessing life, formed part of the huge breathing, ungovernable, inchoate flux of which he felt himself to be a disorganized part. So absorbed was he with the sensual world, so original, provocative, and oddly questing, that he almost conveyed in verbal images the visual and tactile impact of the sculpture he was describing. A column in the *Spectator* commended the femininity of a mother and child sculpture Barbara had lately made, in which the mother is represented by a truncated sitting figure, the child by a simple rounded form. So poignantly, he thought, had she conveyed the relationship, that the matrix *was* mother, the pebble *was* child. Five sculptures of the mother and child theme she began carving in 1934 were prompted by the fact that, once again, she was pregnant. Soon she had twitchings so lively it was hard to forget.

Beguiled by Stokes's caressing style, Barbara used in her contributions to *Apollo* and *Unit One* phrases very similar to those in his *Stones of Rimini*, a paean of praise for whiteness, stoniness and light, which had been published the same year with a cover by Ben. Borrowed Stokesese didn't altogether work. Rutter thought the statements in *Unit One* were vague and almost as difficult to understand as the paintings and sculptures. The group had been building up pressure for nearly a year when a combined exhibition and publication erupted with a full promotional clatter, in the springtime. Questionnaires sent by Read to help the eleven artist contributors spell out their aims were used in varying degree. Basically each participant felt bound to defend his own position.

To Barbara, abstract art reflected an attitude to life charac-

terized by a universal, impersonal 'right idea'. 'I feel that the conception itself, the quality of thought that is embodied must be abstract.' She was taking a metaphysical stand from Abstraction-Création, where her statement read, 'In all the arts let us become pure spirits, not only liberators but necessarily and before all: liberated.'

The visual images she recalled are patently those evoked by St-Rémy that evangelical Easter day: the long white road between trees, the ancient stone arch seen against the craggy crests of Les Alpilles. Then, like shaking a kaleidoscope, watching the circles and flakes fall, she introduced symbols of contemporaneity: an electric train plunging before its steam clouds, blue aeroplanes, like seagulls, rising on thermals of air, pylons making dynamic patterns on buoyant and assuaging turf. Since the First World War, the customs and values of the new world had been eclipsing those of the old world. From these things, jumbled, neatly she picked and folded her future, turning what Wordsworth called 'the bundle of accident and incoherence of that moment' into 'something intended'. She could have been paraphrasing Eliot's reflections on time. Tradition mattered. Like 'the growth of some great tree' the past seemed drawn into the great creative process. Listening to echoes and invitations, she tried to explain how the present remained, despite increasing poverty and a lot of rejection, so expectant. Discovery trembled, as it were, from fragile leaf-tips.

Each artist in *Unit One* was represented by seven photographs, a portrait, his or her hands, his studio and four illustrations of his work. Barbara was thirty-one, the only woman among eleven, conspicuous by her sex, and, perhaps in deference to it, prominently placed. Beneath finely stencilled eyebrows in a pale triangular face, the 'Haverstock Venus', as she was known, stared out coolly, beautiful in a Garboesque way; strong, but guarded, like an animal defending its territory. Definiteness is concentrated not only in the lower face, but in the force of her judgemental eyes. The mouth is, as ever, firmly set, a beret stuck in assiduous

casualness on one side of her head. Flat-chested, sturdy about the hips, she folds her arms like one of her sculptures. Whatever uncertainties she may have felt, the pose implies resolution. It was a face of self-possession: there are no loose ends; Barbara Hepworth is forward-bound, complete. The image was truthful without being the whole truth.

The first aim of Unit One was avowedly strategic. In the realm of pure art, Read saw, the gap between the artist and his public had never been greater; the breach, moreover, was widening. The young Moderns must be their own propagandists. If Unit One was to have impact, it needed friends among critics, art dealers and a supporting network. Every ally was a vital cog, every exposure counted. In fact, the gap between various critics was almost as noteworthy as that between artist and public. In the *Daily Express*, Hepworth was coupled with Moore, both Yorkshire, both vigorously attacked by conservative critics, both preferring unusual materials. She, however, shared a studio with Nicholson. Mutual back-slapping was perfectly in order. Ben's text cites Hepworth in a list of significant artists, the only British name among eight Europeans: Arp, Miró, Calder, Giacometti, Cézanne, Picasso, Braque and Brancusi. Amid an avalanche of conflicting reviews, *The Times* recommended tersely, 'there are some good carvings by Miss Barbara Hepworth'.

With the Bauhaus leading the way, stressing the centrality of the designer-craftsman in modern life, coupling art and industry had become a popular thirties theme. All the artists in Unit One were interested in design. Including photographs of their studios was intended to encourage people to buy works for their homes. Referring to himself as 'Britain's Commercial Traveller', the Prince of Wales addressed the Royal Society of Arts* to promote the cause. Commissions were increasingly being awarded to artists by manufacturers. In 1933 Barbara showed textiles in the Seven and Five exhibition, and at Lefevre, she had, besides

* November 1933.

sculpture, four collages and eight hand-printed fabrics.★ The following year, she designed a stunning coffee service for Thomas Ackland Fennemore, a director of E. Brain & Co., which traded under the name of Foley China. The pattern was of brown circles and lines on pale grey. A few years later, she accepted another commission for a contribution to a 'Constructivist' fabric range from Edinburgh Weavers.† She and Ben were fascinated by interior decoration, and spreading their talent was in their financial interest. In theory, there was no reason why they shouldn't stretch her art to simple, utilitarian household objects. In practice, Barbara only did so because they were hard up.

Few were more sympathetic to the plight of the impoverished modernist than unerring-eyed Jim Ede, future creator of Cambridge's Kettle's Yard. In his beautiful rambling old Hampstead house‡ artists might meet stars from the Russian ballet or authors like Arnold Bennett. Ede used his job at the Tate to make constant arbitrations on behalf of the impecunious and unacclaimed, a campaign that included doing everything in his power to establish Gaudier's reputation. In the second month of 1934 he was encouraging Staite Murray to buy from Ben. Had Murray seen the latest work? As far as he (Ede) could make out, Ben and Barbara were extremely pressed financially. It looks as if Ede's vicarious appeal was answered, because, shortly after the Unit One exhibition, Ben was writing to Murray from a hotel in Paris asking for a cheque to go straight into his bank. He had no money at all. Barbara was sending Murray photographs of her work. Living very much from hand to mouth, she was trying desperately to keep them solvent. Without Margaret Gardiner's support, she didn't know what they would have done.

To Margaret Gardiner's benefactions and Herbert Hepworth's

★ Ben showed rugs and collages.
† 1937.
‡ 1 Elm Row.

small regular contributions, Ben's father added, from the begin-
ning of 1934 until the end of the decade, ten pounds a month.
When finances were especially low, friends like Duncan Mac-
Donald lent money. Ben planned to set up a school of con-
temporary art with Nash and Moore, but it didn't come off.
One pressure had fallen upon another. On 2 October, after
watching a film, Barbara played rummy with Ben and Margaret
Gardiner. Then, feeling tired, she went up to bed. Before dawn,
the triplets were born. In wonder and surprise, Ben telephoned
Margaret with the news. Hours before the delivery he had
completed a white relief. When he had painted another to
concentrate his mind, he sent some cards. To Fred Murray, he
wrote that there were three babies, Simon, Rachel and Sarah, all
healthy. What would Murray's Scotties say? Ben was superb,
Barbara wrote; he was a tower of strength.

When people say, 'Barbara never got over the triplets,' they
have been referring to the shock of delivery, all at once, from the
same womb, of three little spines, six little hip-bones and three
tiny skulls. 'A basement flat, no washing allowed in the garden, a
kitchen doubling as bathroom and £20 in the bank.' Add three
scrumpled faces, looking, to Barbara, fairly belligerent, and the
practicalities seemed a bit grim. The girl babies, moreover, being
tiny, needed special care. For weeks, as was customary, Barbara
was confined to bed. Weakness made her feel desperate. Fright-
ened and exhausted, she wept inconsolably. Post-natal depression,
not uncommon in motherhood, was little understood at the time.
Twins had been a possibility, but £5 for an X-ray fee was
expendable; and in her mind, Barbara settled for one. A nearby
basement flat, rented for the confinement, was equipped with
one cot, one pram, one set of woolly garments, and being
Barbara, she worked until the day before she gave birth. Later,
she told her daughter-in-law how unequal she had felt to a
situation that looked like demanding more than was humanly
possible, from she who needed to control.

Family and friends rallied round. Elizabeth Hepworth, who

had trained for the ballet, moved in with her sister, and she was wonderfully helpful, virtually taking over during the day while the midwife managed the nights. In their own way, the babies were a delight. Barbara's response to motherhood was as strong as her response to everything else. It was just that three at once made insatiable demands, demands that were incompatible with a commitment to regularity, responsibility and the world of art. Rilke, Barbara's favourite poet, understood that we have a perfective power and it cries out to be used. Some structure was necessary for her babies that was stronger and more adaptable than she and Ben could provide. Logic prescribed that they place the babies in Wellgarth Nurses' Training College for a year at £250, get insured, work hard and save, which was what they did, leaving the triplets in patient hands. Barbara wanted to do what was right, though sometimes she was torn to know what it was. At Golders Green she could visit frequently, take out her three tiny babies and go back to work with the memory of their whimpers and smiles. What she had done worried her later, from time to time, when she felt estranged from her children. But having two exceptionally gifted parents added, anyway, to the stress in the family.

Until the final months of 1934, most of Barbara's work bore some human or animal reference, though it was increasingly elusive. A piece called simply *Two Forms* 1933 was an extenuated, slightly curved, triangular wedge, snugly fitting the U-shaped cup of a more stable, earth-bound component. It could represent a bird held by a hand, the latter suggested by a fluctuation of fingers along the edge of the protective, receiving form. It could, alternatively, be erotic. If Barbara occasionally seemed puritanical to those around her, repressed sexuality isn't suggested by her sculptures, several of which bear explicit reference to the reproductive anatomy and the sexual act.* That her main directive was

* *Two Segments and Sphere* 1935–6; *Ball, Plane and Hole* 1936 and *Two Figures* 1943.

towards abstraction had been clear since January 1933, when she delved back several years to find three abstract pieces for the Seven and Five exhibition.* While she was pregnant, she carved three curvaceous, semi-abstract mother and childs,† but she was approaching a turning point. After her confinement, in November, when she began to carve again, all traces of naturalism had disappeared.

The first work was stunningly stark. *Two Forms with Sphere* 1934 consists of two sharp-edged white alabaster monoliths leaning towards each other from opposite ends of a base, with a seemingly casually rolled globe in between. Everything accentuates the contrast between the two types of beautifully patinaed form, the monoliths, straight-sided, unstable, aggressive, light-resisting; the globes, accepting, light-caressed. The monoliths give the impression of being about to rise up, making a triangle over the sphere. The sphere makes a reflective shadow, within which it appears to float upon its alabaster base. Essentially theoretical, logical and hieratic, the work seemed inhabited with feeling, distanced as in a game of pig-in-the-middle. From the interaction of the forms, one upon another, and their interaction with space and light, a tremendous drama is produced.

Contemporary art derived its authority from Plato's approval of the beauty of lines and curves; not beautiful relatively, but 'always and naturally and absolutely', Read explained in *Art Now*, his latest, most evangelical defence of the Moderns. Artists were returning to abstraction because modern machines expressed functional perfection in their lines. The rise of Fascism was forcing them to establish an alternative world of 'absolute and permanent values'. Among a large number of black and white illustrations, *Art Now* contained a fair guide to its author's allegiances; four Moores, two Nicholsons and one Hepworth. At

* The following year she hadn't exhibited anything, and this could have been because she wasn't entirely sure what image to project.
† Of six.

their own cost did people fail to appreciate the book, Geoffrey Grigson, another dogmatist, argued.

Within months of the triplets' birth, Barbara and Ben held a studio exhibition to raise funds. Just before the new year, with work settling into a strong direction, Barbara allowed herself a few days in Paris. Since he had first met Mondrian,★ Ben had become more and more interested in the painter, who was trying to express on canvas his understanding of Theosophy. From the dynamic interaction of two basic coordinates, the horizontal and the vertical, it was possible to produce an essence that would catapult into the spiritual dimension. Mathematics, Mondrian saw, in an extension of the Platonic vision, is the underlying form for creation, a perfection beyond the reach of nature. Art was a universal truth, an escape from the material world of man. At a moment when Europe was in turmoil, imposing a vision of order with rectangles of colour and black lines was an elixir. Ben had enlightened Winifred; now he wanted Barbara to meet Mondrian in his studio in the rue du Départ.

Barbara must have seen Mondrian's pictures at Abstraction–Création. The comment that this was 'the end of painting' alerted her to the strength of the artist she was to offer rapt obeisance. Mondrian's personal impact was such that Winifred Nicholson and Myfanwy Piper both felt impelled to record meeting him. Some thirty years later Barbara recalled the boundless flights of steps leading to a high-windowed room almost resonant with silence. (No life, no water, no heating.) A silence matched by the perfect clarity of vast canvases. Three women in turn were mesmerized by the white table, almost an altar, upon which they received a mug of tea. The austerity wasn't broken until the dapperly dressed artist put on a jazz record, wound up the gramophone and began frenziedly to dance. Lost in wonder at the impact, Barbara and Ben sat outside a café deliberating.

★ They met initially in December 1933, when Ben was more interested in Arp and Calder.

Mondrian's painting wasn't the end of anything, but a beginning.

'It seemed to me that the integrity and strength of passion in Mondrian's work was an example which should give everyone courage to go forward, following the thread of his own particular direction right to the end until what he has an urge to find has been discovered ... No artists in our time have had such a powerful and *silent* influence as Mondrian and Brancusi.'

For more than a decade, Barbara Hepworth banished overtly figurative forms. Her first emphasis was on the impersonal purity of line and volume. From still materials sprang sculptures trembling with energy: an energy fixed by the interplay between volume and space, and by the rarity of space that forms almost an embodiment of the whole. Dialogue was increasingly apparent, since her sculptures were often multi-figure, two or three forms moved to an exact placement, with an extraordinary tension in their relationships. Of three works she exhibited at the Seven and Five exhibition of 1935, one was wood, one white marble and the other blue Ancaster stone. These three made a perfect ideogram of her work in the last half of the thirties.

The wooden sculptures are, from the natural rhythm of the material, softer, more sensuous than the stone. From Hepworth's extreme sensibility and by counteracting severity, they rank among her most beautiful. *Discs in Echelon* 1935 comprises two glossy orbs polished to the reflectiveness of a new conker. Like plates in a rack, except that they were tear-shaped in cross-section. Patently solid, they could almost be drops of water. Holding stillness, yet charged with energy, they offer, distinct and memorable, an image of utter calm.

However it is carved, a stone is foremost a stone, separated from the parent rock, retaining its force and immobility: a material to which the sculptor bequeaths what Ede called 'mutability of flesh and eternity of spirit'. *Three Forms* 1935 could be described as longish, flattish pebbles, sea-worn, marble, whiter than white, disposed on a rectangular base. But it was their spatial dispositions that inclined Henri Frankfort, an art historian

friend from the Warburg Institute, to find in the work an ageless 'essence'. And not from archaeology, but from music, did Frankfort borrow his analogies. The forms and spaces were like sounds and silences, each as important as the other and totally interdependent. If the sculpture was a bar of music, its flat, basal slab defined the parameters like bar-lines. Walking round such a sculpture, the eye of the spectator activates the forms, so that the spaces expand and contract. The spaces are silences: the rhythm of the composition, utterly distilled.

Two Forms 1935 was much more difficult to appreciate. Three and a half feet, tall and angular; one form is roughly cuboid, the other roughly conoid. Sharp-sided, they are less tactile than the other works, which makes the mass more neutral. Nevertheless they engage their space in a powerful way, so that the structural forces and tensions give a jumpy, nervous quality that is not so much Brancusi as Mondrian or Giacometti. Stripped bare to line and silhouette, precision, shape and structure, *Two Forms* 1935 is very dense, very scientific, conveying its message through rhetorical balance. The sculpture was first called *Two Figures*, and palpably, they are male and female. Whether or not they are representative, the forms are symbolic of figuration and the sculpture is *about* relationship. As Ben was incorporating sculpture in his painting, Barbara was aiming for the cool mathematical perfection she had found in Mondrian.

Societies were springing up, producing manifestos and, just as quickly, folding. It is clear from Read's introduction to Unit One that there had been problems in knitting together eleven patently individual aesthetic creeds. That the exhibition toured six large cities is a measure of his success. He had given a nucleus of artists a sense of themselves, allowing them to form creative friendships within the group, and encouraging the public to realize them as a group. From the start, however, there was tension between the Literary/Surrealist and the basically Cubist factions. Although Read and Moore had a foot in each camp, Barbara and Ben, increasingly purist, were finding the Surrealists

incompatible. Once the mission had been accomplished, soon after the exhibition, a group Grigson referred to as a 'paradox of disunion' split apart. In another 'bust-up', Ben and Barbara had resigned from Abstraction–Création. Hélion and Arp had already made an exit in reaction to what they saw as Auguste Herbin's dictatorship.★

The first of eight quarterly issues of *Axis* was launched in January 1935 and Ben was alerting his circle to the new enterprise. 'BH' and 'BN' would be among the first contributors, together with Grigson, Hélion, Giacometti, Sir Michael Sadler and Adrian Stokes. The editor would be Myfanwy Evans; the cost 2s. 6d., or 10s. a year. Profound sympathies for modern art, a lyrical pen and guts were what brought Myfanwy Evans to the strident fizz and babble of art politics. After Oxford she lectured in English at Morley College, but she had been looking at modern pictures since her schooldays and had come to know many of their creators. A trip to Paris completed her infatuation. Visiting Mondrian, Arp, Giacometti and Brancusi, just as Barbara had done two years earlier, she was intoxicated by their small, hyperactive worlds. It was Hélion's suggestion that she should start, in England, a magazine of abstract art comparable to *Abstraction–Création*, and, a little diffidently, Myfanwy agreed. Her husband, John Piper, a visionary landscape painter,† was co-editor.

A relative latecomer to the Seven and Five, Piper had immediately, at Ben's encouragement, become Secretary. In this position, he must have had an inkling of the risks he was taking, but something that never occurred to John Piper or Myfanwy Evans was that the latter's delighted trail round the studios of Paris might be considered trespassing on Ben and Barbara's hallowed ground. When the magazine appeared with Hélion's signature, they might feel almost as if he had been unfaithful. The inclusion,

★ In the middle of 1934.
† Then making picturesque collages and colourful abstract works.

in the first issue, of a patronizing piece by Paul Nash ruffled, further, the tender sensibilities of the die-hard abstractionists.

Besides, how abstract was abstract? Definitions were hard to come upon. It was one of those absurd questions to which there was no serious answer, though it cropped up insistently: like asking someone to define the word sky. The problem was acknowledged in the first edition of *Axis*, where 'abstract' was used as a general term for contemporary painting and sculpture that wasn't naturalistic, surrealist or purely decorative. Inadequacy, however, was acknowledged over semantics, and the opening definition was almost immediately qualified in an article by Herbert Read. Barbara had a high profile throughout. Every edition contained photographs, comments or reviews of her work; the third, a sculpture issue, featured her in the illustrious company of Brancusi, Calder and Moore. The circulation was only 200, but the magazine was influential among the initiated. For a couple of years she and Ben saw quite a lot of its editors, treating them to a meal in Barbara's spotless studio, in return for lunch at the Pipers' Fawley Bottom. This didn't prevent Barbara criticizing their magazine. The layout, she wrote, was 'not so good', the colour in Ben's work was 'bloody awful', though Read's article on him was 'splendid'. There was nothing like a magazine to invite controversy.

From Ben or Barbara's point of view, it was clear that if abstract art was to make a contribution to the contemporary aesthetic, deflections could not be allowed. The year Ben made his first white relief, he contrived a ruling in the Seven and Five that only non-representational works would be eligible for future shows. The fact that eight members elected to remain in the society suggests that a policy which seems at first to be one of significant self-interest had some common backing. Several, however, resigned and some of those who stayed on had misgivings about the purge. Either way, loyalties were at stake and the climax to the group's endeavours, the first abstract exhibition in England, was also to be their last. Once again, an object had been

accomplished. Henceforth the avant-garde were in a position to join international stakes. Like Unit One, the Seven and Five was impaired from within. It wasn't formally disbanded but the fizz had gone. Salvador Dali was shown twice at the Zwemmer Gallery in 1934, and a bigger, more influential adversary was taking a stand. A day or two before the opening of the Seven and Five's last show, Kenneth Clark, the influential and outspoken young Director of the National Gallery, made a concerted attack on contemporary art in the *Listener*. Read gallantly defended his side, choosing one of Ben's whiter than white reliefs to argue his case. Clark retaliated. The more geometric a work, the less vital it was. As the argument deteriorated, readers wrote in in his support. A revival of 'nice clean healthy nature' was what Read most feared. Another counter-reactionary force was the Marxist art historian and critic Anthony Blunt, who disliked abstraction-ists as much as Surrealists. A 'bedful of dreamers' was his comment on the final Seven and Five exhibition, where he singled out Miss Hepworth for snoring, 'à la Brancusi'.

Barbara and Ben were marching forward, refusing to be unnerved by the political uncertainty of the thirties. The Seven and Five, Unit One and Abstraction–Création were each more exclusive. The *Scotsman* detected in Unit One a 'Soviet-like flavour, savouring of mass production', and 'the collective man'. The *New Statesman* considered there was nothing more dooming than a 'partiality for Absolutes'. But for them, the future lay in absolutes. Even if these groups had turned out to be ephemeral, Barbara's inclusion in them had brought her significant promo-tion, giving strength to her relationship with Ben, developments in her sculpture, difficulties in selling it, acute shortage of money, and the untidy birth of triplets. In symbolic token of what she and Ben shared, both wear a beret, probably the same one (a sort of game), in their portraits in *Unit One*.

CHAPTER TEN

A Not So Gentle Nest

(January 1936–August 1939)

Confidence was what Cyril Reddihough felt on the occasional, for him celebratory days he escaped his Bradford office to drop in or stay at Mall Studios. There he made quarters on a tiny half-floor, accessible by ladder, where Barbara usually slept. Sometimes the triplets were in evidence. After three years at the Welgarth Nurses' Home, they had been set up with a nanny and Olive, a maid, at neighbouring number 4. People were in and out, particularly Herbert Read, emanating energy, generosity, and belief in the community. Barbara wanted meaningful people around her and Read's shared devotion to silence made him, in Reddihough's view, her closest friend.

There was politely polemic, witty and slightly Olympian Paul Nash, and respectful Elizabeth Hepworth, with whom Reddihough talked ballet. Far from being 'entertainment', dance was a sacred art; and dance talk fitted the rarefied atmosphere Barbara encouraged. Le Corbusier's acrobatic buildings were rising whitely into the sky. White was the colour of spirituality. In Barbara's white studio, with grey shadows, white paint, and white stone, the radio was tuned to Stravinsky and early music.

Drawn largely by Ben and Barbara, cultural refugees, threatened by Nazi persecution, were gravitating to north-west London. For a few frenetic years, with artists like Gabo, Moholy-Nagy and Mondrian on the doorstep, art and politics drew very close. Behind the art lay the Platonic belief that formal relationships reflected a metaphysical ideal, that underlying unity and clarity represented some larger vision of social organization. Art was a moral activity; work, the magic upon which everything

spun. A sculptor solved human problems through his own thought and medium by counterbalancing the wanton destructiveness of war. 'Suddenly England seemed alive and rich – the centre of an international movement in architecture and art. We all seemed to be carried on the crest of this robust and inspiring wave . . .' Like those around her, Barbara was convinced that artists could create a new art form, just as Communism would create a new man.

The trouble with purist ethics, high ideals and fervent strivings was that they polarized. Through art, you could be genuinely trying to save society without having the time or inclination for tolerance. You gathered your men and made a confrontational stand. Bullying was not unknown, ostracism a key ploy. Serious international upheavals, the Spanish Civil War followed by the Munich Crisis, became the background to some less than idealistic infighting in the arts. Myfanwy Evans brilliantly rebuked current tensions and contradictions.

'Left, right, black, red . . . Hampstead, Bloomsbury, surrealist, abstract, social realist, Spain, Germany, Heaven, Hell, Paradise, chaos, light, dark, round, square. Let me alone – you must be a member – have you got a ticket – have you given a picture – have you seen *The Worker* – do you realize – can you imagine – don't you see you're bound to be implicated – it's a matter of principle. Have you signed the petition – haven't you a picture more in keeping with our aims – *intellectual* freedom, Freedom, FREEDOM.'

What exactly was the Parisian intrusion known as Surrealism, of which Barbara and Ben, at first drawn by the work of Arp and Miró, would increasingly disapprove? Apollinaire coined the name, fellow-poets Rimbaud and Lautréamont nourished his inspiration, André Breton provided the intellect, and Ronald Penrose, wealthy collector and painter, arriving fresh from Paris* to West Hampstead, brought with him the full impact of a movement already prominent in Belgium, Yugoslavia, Spain and Japan. Surrealism was the belief in certain forms of association,

* In 1934.

the play of thought, and, above all, the Freudian interpretation of dreams. Anti-fascist and anti-philistine, it was not only a theory, Breton insisted, but an approach to life, incorporating its own morals and politics. Amid gloom, poverty, rising Fascism, moral confusion and social disorder, Surrealism offered the irresistible glitter of distraction. There was no reason why artists shouldn't draw subject matter from the unconscious mind, though the implications of actually cultivating the unconscious remained a little dubious. Some Communists failed to see how their revolution was going to benefit, and Surrealist shock tactics were anathema to Barbara. Read saw things differently, the sole criterion for his support being the excellence of an artist's work. What mattered was that the avant-garde, Surrealist or Cubist, should disrupt the decorums of the traditionalists. Every committee begged his counsel, every manifesto bore his signature, his solicitousness was proverbial. His five years at Mall Studios were the happiest of his life, yet there were jarring moments between him and the irascible Geoffrey Grigson. Moore had reservations about his partiality for Gabo's work, and Barbara felt, on occasion, betrayed by his Surrealist sympathies. Between them all, he had sometimes felt trapped by lines of fire. In the circumstances, the spirit in which he coined the famous phrase for the artists, architects, designers, critics and sympathizers living round him, 'gentle nest', seems to have been one of genial hindsight.

Winifred's birthday present to Ben in 1936 was a skiing holiday *en famille*. Three months later, when relations between them had plummeted, Ben didn't have enough money to go out and make amends. Few were more aware of the struggles of modern artists than Nicolete Gray (née Binyon), now a wife and mother. It is consistent with the strength and singleness of her concern that she should have organized, in cooperation with Axis, the first international exhibition of abstract art. Sponsors included a number of people who already possessed Hepworths, Sir Michael Sadler, George Eumorfopoulos, industrialist Marcus Brumwell, Mrs Laurence Binyon (Nicolete's mother), and

Nicolete's sister, Helen Binyon, as well as Ben's staunch supporter, Helen Sutherland. No longer is it significant that the critic for *Apollo* found Miró's work in Abstract and Concrete as unpleasant as Henry Moore's, and failed to mention Barbara Hepworth at all. The amount of space given to insulting work that is accepted fifty years later by the reasonably conservative is one of those riddles with which history is bursting. Since no London gallery was prepared to take on the exhibition, Abstract and Concrete opened in a room rented by the Arts Club in Nicolete's home town (Oxford) and ran on a shoestring. Among serious reviews, the *New English Weekly* opined, 'the new abstractionist movement has by now almost achieved the other kind of respectability . . . It is becoming "accepted" by the world of (intellectual) fashion.' Despite its good press, neither the Tate Gallery nor the Contemporary Art Society made purchases. Only five works sold, two of them to Helen Sutherland. Artists down to their last pennies couldn't live on the glow of intellectual esteem. Not even expenses were covered. After devoting enormous time and energy to the project, Nicolete Gray was out of pocket. Her contribution, however, was for all time. Touring Liverpool, Newcastle and Cambridge, Abstract and Concrete reached the Lefevre Gallery in May. For the first time in Britain, native and European artists were exhibiting on equal terms.

First-hand evidence from refugees had sharpened leading artists and writers to the realities of Fascism, and Spain's civil war brought sensibilities to boiling point. The 'gentle nest' were all different shades of socialist. In common with those around her, Barbara supported the Republican Government. When Hitler and Mussolini joined Franco, her choice was confirmed. Artists International (AI) was an obvious venue for one of strong Soviet sympathies.* The Leninist–Stalinist loyalties of AI† were a good

* Their first aim was to mobilize forces to protect the Soviet Union.
† Which added another 'A' to its name, hoping by becoming an Association to broaden its base.

deal more relaxed than had been the social idealism of Unit One. Read might despair of the group's amateurishness, but it managed to unite artists of very varying private sympathies. Since 1934, Barbara had supported their exhibitions on social themes, along with artists like Moore, Gill, Piper, Léger, and Zadkine. Mussolini was busy invading Abyssinia when Artists Against War opened, and over 6,000 visitors parted with threepence in solidarity. The spirit of hardship was a great unifier. Another AI exhibition to which Barbara contributed attracted 40,000.

Spain's Civil War* coincided with the International Surrealist exhibition, where 'the Surrealist phantom', actress Sheila Legge, walked through the assembly in intense heat, covered in roses and black silk, a dummy leg in one hand and a pork chop in the other. Barbara's reserved share in the outlandish side-effects seems to have been no more than a session of nude sunbathing. The direction in which she was moving could scarcely have been more different.

Several years had passed since she and Ben had met Gabo in Paris, recognizing immediately his idiosyncratic creativeness. Being expelled from primary school for writing a rude poem about his headmaster was an appropriate start. When he arrived in England he was forty-five, a trenchant radical, with a turbulent history behind him. Born in Russia, Gabo had lived through the Revolution and the Civil War, becoming immersed in avant-garde activity. When conditions threatened to cramp him, he got out. Two years later, he and his sculptor brother, Antoine Pevsner, published a manifesto† announcing the basic principles of their creed. Volume and mass were obsolete; space and time, expressed in sculpture through kinetic and dynamic elements, were the basis of their ingenious and poetic explorations. Barbara was to say of his work, 'his forms are the true forms of dreams'.

After Abstract and Concrete, in which Gabo, too, participated,

* In the summer of 1936.
† Known as the *Realist Manifesto*.

friendship with Ben and Barbara was confirmed. It wasn't long before Barbara was witnessing Gabo's marriage to a painter, Miriam Israels, and finding the couple a niche in Mall Studios. Ben and Barbara had discovered someone as impassioned about art and its social role as they were, the moving spirit behind their next venture. Gabo was to become the hugely influential catalyst to British Constructivism. If 1936 was the year of the Surrealists, the next twelve months belonged to the Constructivists.

Like Surrealism, Constructivism stressed the philosophy of art as enrichment of life, but its strait-laced puritanism, polemics and intellectual rigour had little popular appeal. Barbara and Leslie Martin's architect wife, Sadie Spaeight, were responsible for the production and layout of the heavyweight compendium intended as a first issue, *Circle: An International Survey of Constructivist Art*. Gabo, Martin and Ben Nicholson were joint editors. A year's frenetic activity preceded publication. Internationalism and the common ground between art and science were emphasized.★ Drawing in other fields, as the Bauhaus movement had done in Germany, strengthened the abstract position. Artists from all over the world were contacted. Lewis Mumford wrote about concepts of the city, Desmond Bernal on the culture split between science and art, and Leonide Massine on choreography. Read was allowed to contribute, but that was all, on account of his Surrealist sympathies. In size, number and the scope of its contributors, the Constructivist mouthpiece was intended to squash for all time the whimsical manifestations of Surrealism.

Barbara's contribution turned out to be one of the most comprehensive expressions of her aims she ever wrote. At thirty-four, she had arrived at a faith she would simply continue to affirm. 'Absolute' belief in man, landscape and ideas, and the integration of 'scale', which, being 'connected with our whole life – perhaps . . .

★ Gabo had abandoned medicine for civil engineering and philosophy before he became an artist.

is even our whole intuitive capacity to feel life'. Convincingly, she relates her spiritual inquiry to the pure, free line of simplification. In the increasingly political London cultural world, she wanted to be seen to stand for ideals that transcended the moment and its needs.

Producing *Circle* on top of a solid day's work had involved its editors in prodigious labour. A short interlude at Varengeville at the invitation of Alexander Calder and his family had been well earned by Barbara and Ben. Not that they took holidays in the general sense. On the south coast of France, Braque was working away in a nearby studio and Miró was staying with architect Paul Nelson. Surrounded by other artists, causes could still be advanced, influence spread, social solidarity maintained. Miró, Barbara noticed, collected pebbles and arranged them with the swift gestures of his painting. Calder had invented a type of mobile sculpture based on his craze for the cinema. By means of an electric switch, he contrived to set his shapes in motion. Were they toys, asked his bewildered public? Ben adored toys, while Calder's degree in mechanical engineering gave him common ground with Barbara. Like her, he had been roused by Mondrian's studio to the potency of abstract art. From time to time Barbara unbent. Years later, she told Terry Frost how they'd been playing jazz records when her feet fidgeted, and slowly took on a rhythm. So she and Calder got up and danced in the dark, their shapes flying and entangling, jigging and thumping and whirling until Calder got caught up in her belt. He was a big man; momentarily, she was like a rag doll to his mobile.

The high-powered machinations of the international art set seem a long way from the Wakefield suburbs Barbara had left fifteen years before. Gerda Hepworth was constantly updating, for the benefit of her neighbours, news of her three beautiful daughters. Joan provided the conventional romance. At fourteen she had rheumatic fever, which was said to have left her with a heart murmur. As it transpired, her weakness had nothing to do with her heart: she had cancer. Either way, she was supposed to

be cautious about what she could and couldn't do. Poor health and a less adventurous nature made her the one who was expected to stay home and care for her ageing parents. But Joan met a young teacher from Downside Preparatory School, fell in love, and married when she was twenty-two. In Jack Ellis, Wakefield gossiped, the delicate one had chosen well.

Tony, who was as good-looking as his father, was next to marry.* After gaining a degree in engineering, he worked for an oil refinery, married Nora Woodcock, whom he met through family friends, and lived in Manchester, where Nora produced two daughters. Tony wasn't on Gerda Hepworth's list of engrossing topics because he had lost the ability to realize his parents' expectations. Failing to become a grand master Freemason was the first big blow for Herbert Hepworth. Then his marriage failed. Nora and her two little girls moved back to her family in the Scilly Isles after the war, and completely lost touch with him. Thrice married,† unable to sustain relationships, Tony kept clear of his sisters and parents.

By 1934, only Elizabeth remained unmarried. Too tall for ballet and never a dedicated careerist, Barbara's younger sister was more than ready to abandon the scramble to earn a living when she met, at a drinks party hosted by Geoffrey Grigson, an extraordinarily elegant, witty and eligible man. John Newenham Summerson was a gifted organ player, whose writings on John Nash suggested an illustrious career ahead of him as an architectural historian. He had flirted with, among others, the American writer May Sarton, who remembered his playing the harmonium day and night. With Elizabeth Hepworth, Summerson had a different sort of relationship. Elizabeth wanted someone to mother and admire. If necessary, she would nurture his talent and tolerate his obsessions. Without flaring passion, the two drifted

* In 1933.
† The second marriage produced John, b. 1941; the third, to Audrey Windeatt, produced another Tony, b. 1955.

into loving companionship, which must, Summerson realized, end in marriage. On the last day of March 1938, with Ben Nicholson as a witness, twenty-five-year-old Elizabeth became the wife of someone Barbara liked exceedingly. Nothing but the best, she vowed, would do for her sister, and she had got it. To celebrate, Barbara held a party at Mall Studios.

Her own conjugality, or lack of it, occupied Barbara persistently. After the triplets' birth she made renewed efforts to win round Winifred, arguing that she and Ben were spiritual allies, which made his legal marriage a sort of polygamy. She tried to be rational, writing very long letters, positing the pros and cons of free love, the indissolubility of marriage, the continuity of parenthood. Using the language of Christian Science because it was Winifred's language and she was picking it up from Ben, Barbara identified God's laws and the 'perfect idea'. In desperation, she proffered Euclid, endeavouring, in a way that was cerebral, measured and controlled, to represent the complications of their three-way relationship with a formula of intersecting lines. Her letters to Winifred were, for the most part, humourless, self-justifying, tedious and not in the least what Winifred, who was profoundly anguished, wanted to hear. Intuition told Winifred, hardly illogically, that Barbara was taking Ben away from herself and the children. Ben wanted a divorce: whether or not he married Barbara, he wanted to be free. He could move marriage, like moving house, he said. He enjoyed making a new house, and didn't take his old furniture with him.

In September 1936, Winifred gave Ben his divorce. Less than two months later, on 17 November, at Hampstead Registry Office, Barbara and Ben married in the presence of their fathers. John Summerson was able to fulfil his debt by acting as witness, alongside Cecil Stephenson.* Now Barbara could devote herself to work, body, mind and spirit.

*Under Ben's influence he joined forces with the Moderns and began to be noticed, as did Barbara's cousin, Jack Hepworth.

One of the pieces she showed in Abstract and Concrete could be crudely described as a wedge of melon with a glacé cherry dangerously balanced on one end, standing on a semi-circular dais. Moholy and Hans Erni told Ben *Two Segments and Sphere* 1935–6 was 'the first plastic expression of her abstract idea'. The calculated balance of this white marble carving makes it Gaboesque. In fact the source is more likely to have been a surreal and overtly sexual piece by Giacometti, *Suspended Ball* of 1930.

Next, Barbara made a sculpture that was suddenly much larger than any she had carved before. *Monumental Stela* 1936 was six feet high, with the muscularity of an Epstein and the angularity of a rather similar vertical conception Ben carved in board the same year.* There is something totemic about the massive slab with deep projections, something about the circular hole near the top that makes it essentially figurative. *Monumental Stela* is not a comfortable piece; like *Monument to the Spanish War* 1938–9, it was inspired by revolutionary and reformist thought.

Each year until 1939 she carved ten or more pieces, tapering single columns, sprung with rhythm, soaring upwards as weightlessly as Brancusi; hollowed eggs, tender nesting stones, simple pebble-forms ingeniously juxtaposed, and some highly architectural, punctured forms. Size, texture, weight and the tension between the forms were all part of the exploration. 'Conoids' and 'helicoids' and 'spheres', their names purposefully devoid of association, *feel* more contrived. Like painters and architects, Barbara was using, with urgency and exactness, cube, cone and sphere. Logic was being employed in an uncompromisingly austere world of pure form, and the hard edge between the planes had come to stay. None of her work can be described entirely by geometry. Into the humanism she had first discovered in Brancusi's studio, she was infusing the obscure power of Mondrian. There are hints of Gabo and Giacometti, but very little, now, of Arp.

* *White Relief* 1936.

The relationship between artist and public was at the mercy of the social and political climate. If the years before the war were fruitful in production, they were lean ones for sales. Barbara took part in one or two group exhibitions in London and on the Continent,* but far and away her most important one was at the Lefevre in October 1937. This was when Desmond Bernal, writing the foreword to the catalogue, noted how the stark geometry of her basic shapes, sphere, ellipsoid, hollow cylinder and hollow hemispheres, gave the sculpture immediate relationship with modern architecture, likening it, in a curiously prophetic analogy, to neolithic menhirs.

'Fragile, slender' and 'pretty' was the *Daily Press* reaction to the artist discovered on her hands and knees, the day before the exhibition opened, painting pedestals to harmonize with their sculptures. It was 'abstraction, pure but by no means simple', the *Yorkshire Post* decided; a grumble repeated in various guises. Unlike Moore, 'Miss Hepworth never meets us half-way.' 'A high degree of formal sensibility,' *The Times* pondered, but all 'just a little too solemn'. Respect was by no means general from a press that tended to look *at* Barbara Hepworth rather than through her, to the dauntingly austere monoliths, stone rings, stone balls, and stone circles standing round like something out of science fiction. There was drama, because the more constraints one imposes, the greater the tensions. She wasn't representing things as they were seen, but as they were felt. Like trying to write a sonnet, Hepworth's impulse to create involved incredible self-restraint, burying deep down conflicts and torments, overcoming all that was restless and confused.

Some people find her work a little chilly, though Patrick Heron accepted cosmic coldness as part of the whole grand challenge: 'Nothing could be more remote from human kind than these superbly cold, calm, faceless works.' Rather a different

* One in Amsterdam, 1938; Living Art, The London Gallery, January 1939.

line, taken by academic Charles Harrison, is unease that what vitiates most of her work after the triplets' birth is the sentiment, or, by suggestion, sentimentality, of human relationship. To this, one could argue that sentimentality is the last quality most people associate with Hepworth, where strong personal themes are offset by idealism. From the almost allegorical presentations of early years, she had moved to a more symbolic, at times almost imagistic, idiom. Tired of the heavy suggestiveness, and under the influence of Gabo's space-trapping artefacts, she was opening up closed forms to reveal the space within, adding tenseness, contrast and vitality. The best way to advance, she had decided, was the risky way of leaving the predictable path. Gabo's use of strings, Ben's paintings and Stokes's *Colour and Form* had set her thinking. Both colour and strings were incorporated into a maquette she made before war brought the era to a close: a plaster sculpture, hollowed out, like all significant art, to an outer and an inner reality. From a blue-painted interior, working always by eye, not by mechanical measure, she drew a receding cone of strings. Blue has a particularly poignant relation to white, Stokes had written, against which, 'reddened strings' were 'a haven of comparative warmth'. Still ruthlessly deliberate, Barbara was adventuring beyond certainty, to a series of new beginnings.

Moore, working away just round the corner, had been using strings for a couple of years. After the war he stopped. He could have done hundreds, he said, with a jibe: 'They were fun, but . . . Ingenuity' rather than 'fundamental human experience'. Read's first monograph had given Moore a tremendous, enviable boost. Barbara thought his contribution was prodigious, though inevitably there were professional tensions. Friends remarked how, on seeing one another's work, he and Barbara would follow a long silence by remarking bizarrely, 'It's a nice piece of stone.'

Shared purpose, dearth of money, defiance and an aura of dangerous living gave to this period before the war a heightened sense of moment. Barbara and Ben had stood at the centre of an expanding group of non-figurative abstract artists, to which the

foreign influx added immediate strength. The breath of Bauhaus air was astringent, intelligent and cleansing. As the newcomers who had converged in England* began to make their way to America, the last bastion of Modernism had still to arrive. In September 1938, Mondrian was conducted across France by Winifred Nicholson, contemplating, delightedly, from the windows of the train, the grid made by telegraph poles. He had contributed to *Circle*; had kept in touch. Now everyone scurried round administering. In no time, Mondrian transformed a studio above Ben's, 53 Parkhill Road, into a replica of his Paris haunt. On cranky diets, in the neat suit of an exile, he set to work, pondering endlessly before moving charcoal lines a millimetre in either direction. Mondrian's intolerance of Fascists and reactionaries stretched, rather more ambiguously, to Surrealists, people who painted in green, purple or orange. All were impure. As war approached, it became harder and harder to sell work or to get jobs of a supplementary kind. Someone with the taste and money to buy a Mondrian was a rarity, though Leslie and Sadie Martin did. So did Helen Sutherland, Nicolete Gray, and Mondrian's most persistent advocate, Winifred.

The years of community were, increasingly, times of division and intrigue. Unless artists were aligned to one clique or another, they risked total obscurity. To some, the Constructivist stronghold looked like a mafia that had the power to put jam on the bread of one and take the bread itself away from another. Feeling rejected, outsiders complained that Ben and Barbara's talent for manipulation allowed them to impose exclusive views. 'The war between nations was not so bitter as the war between the constructivists and the surrealists,' wrote Winifred Nicholson in *Studio International*. Myfanwy Evans thought the history of the thirties curiously distorted because the shrillest voices identified with Mondrian at the expense of Picasso or Braque. Twenty thousand queued to see Picasso's *Guernica* when it was exhibited

* Moholy-Nagy, Walter Gropius and Marcel Breuer.

in London in 1939. Even if they called it names, they recognized its passion. Yet Herbert Read reckoned the Constructivists were laying the foundations for art that was to develop in England during the next twenty-five years. It is difficult to sort out conflicting views. Up to a point, polemic encourages creativeness in the arts.

Maybe it was a sense of an era coming to an end that encouraged Barbara to write a sheaf of 'adolescent' poems in the spring of 1939. Ben read them and said he didn't like poetry at all, which made her feel shy. With war impending, the triplets had been living for a year in Oxford with Ben's sister, Nancy Nicholson. When summer arrived, Stokes wrote inviting the whole family to stay with him in St Ives.

A Good Place to Live In

(1939–42)

How could the wind on the coast road be so strong? How could the rain fall so implacably? Out on the right where the sea lay, salt water was receiving fresh water with a salty smack of its lips. Boats gathered in for protection were bobbing like toys in a bathtub beneath the hailing shot of the spray. And in the midst of it all, on 25 August 1939, a ridiculously overloaded car, windscreen wipers slapping to and fro, was edging its way to Carbis Bay. Shut in by misty breath were five-year-old triplets, a weary nanny, the nursemaid Olive, Ben, and Barbara, her 'spirits reduced to zero'.

As far as Barbara was concerned they were driving into oblivion. On either side there was nothing, and beyond the driving shaft of light, everything was black. She could hear the darkness drip from the other world where people might be, for all she knew, asleep. It was difficult not to see the storm as a portent. War was imminent. But for someone who tended to view her life in cosmic proportions, it is appropriate that the second half should have been baptized in so elemental a way.

For Ben it was different. He already knew St Ives and was enchanted by what he remembered from his first encounter with Winifred and Christopher Wood. This was when they discovered the fisherman painter, Alfred Wallis, who had taken up art at the age of seventy, upon the death of his wife. In all his years of contact with the sea, day and night, light and dark, the crusty old seafarer had absorbed its ways. Out of his stored experience, he expressed without conscious thought the ships and dwellings*

* The same ones over and over.

with which he identified. After seeing Wallis's childlike images on scraps of cardboard, Ben had spent three weeks painting on Porthmeor Beach, a series of remarkably free and inventive landscapes.

Late that stormy afternoon, Ben located the tree-lined driveway to Little Parc Owles. Looking back at their arrival, Barbara thought it had been at midnight. Margaret Mellis, who met the car-load, insists it was late afternoon.

Adrian Stokes had met Margaret at the Euston Road School of painting. They had married the previous year, and moved to this beautiful rambling grey stone house with a long Cornish slate roof. Margaret remembered with nostalgia how the house nestled into its gardens on the edge of the coast. The strange bushes, the palms and the peach trees; everything ripe and humming and sunny in their first months together. Through a spinney of pine trees they caught wonderful views of the bay stretching from the black and white tower of Godrevy lighthouse all the way to the headland at St Ives. Rather like Robin Hood Bay, St Ives Bay was scalloped, with a river somewhere in the middle making a blue vein across the sand, where gulls sat on stakes marking the channel. The basin was always changing colour, now grey and white, now glaucous green or Prussian blue. Across the basin there was a great coming and going of little tramp steamers. Every morning deep-sea luggers left with their nets, and in the evening, the local herring fleet set out in their tarred sail boats, lights dancing. Rounding the headland, on their return journey, they would suddenly drop their sails.

Glittering under his blond thatch, Stokes drove his guests, the first evening, to the south side of the peninsula. Clusters of brown rabbits might have popped up as they passed through a patchwork of rain-rinsed farms and moors. Here and there, as dusk descended, great sculptured tors rose high from the bracken. Barbara didn't say very much, but Margaret knew that she was impressed. To someone who has known landscape once, the power of returning is given. During times of stress and dislocation

beset by lack of time, space and materials, Barbara found a 'sense sublime' in the remarkable pagan landscape with its mine heads like temples high on the horizon. Between St Ives, Penzance and Land's End, everything was bathed in a brilliant, any-angled light.

The magic was almost immediate. Within days of their arrival, Ben was telling a friend that if Leslie Martin ever built them a house it would have to be there, in West Penwith. Barbara, who reckoned she and Ben thought pretty well the same on all things, wrote, 'It's truly grand country . . . Very fertile. Unconquerable & strange, & my God how sculptural. Lanyons Quoit, The Men-an-Tol, The Nine Maidens − not far away − incredible stones everywhere so persistent & such an early civilization. It is a good place to live in & I can think of no better place in which to die. It is strange that Bernal's foreword to my show should have mentioned all these early sculptures which I knew nothing about.' War, it transpired, was two weeks off. Sculptures were farmed out to friends, galleries who had works abroad were asked to keep them, and Barbara stayed, the course of her life set by the Stokeses' choice of place.

One hundred and thirty years before, with a pack on his back, taking such lodgings as were available, but sometimes sleeping rough, Turner exuberantly trudged the south Cornwall coast path; sketching as he went, stopping off, on his return, at the little town of St Ives. He knew its fish lofts, alleyways and the cobbled streets of the old town, 'Downalong', where granite cottages crowd confused, and gardens sprout gigantic echiums behind whitewashed walls.

In 1876 a railway was built from Paddington to Penzance; within two years, St Ives was connected by a branch line and the Great Western Railway hotel, the Tregenna Castle, was opened above the town. Breaching the River Tamar remained a bit like entering a foreign country, yet travellers increased, among them Leslie and Julia Stephen with their daughters. During thirteen blissful childhood summers, the young Virginia Woolf became

familiar with a town that she held was, in the last decades of the nineteenth century, much as it had been 300 years before. A steep little scramble of granite houses in a hollow beneath the 'Island'.*
St Ives was built to shelter fishermen when Cornwall was utterly remote from England. Though tourists were soon to arrive in droves, it still felt largely unvisited.

The town wasn't cosy. There were no professional houses, carved doors or lintels, moss, thatch, or mellowness. The market place was just a cobbled windy square. Windows were tiny, walls were enormous blocks of granite, front doors were approached by a single iron rail leading up a flight of steps. At the dawn of the twentieth century it was already beginning to be spoiled by commercialism, Woolf regretted. Yet her 'windy, noisy, fishy, vociferous, narrow-streeted town' was in many ways the one Barbara discovered half a century later. Always there was the play between light and land and sea.

Artists as well as tourists puffed down from London on the steam trains, congregating, at different times, in Penzance, Newlyn and Lamorna on the south coast, St Ives and Zennor on the north. At almost any time of year, they could be spotted with stools and easels, in the streets or overlooking the sea. What they sought were picturesque subjects, the labyrinthine coastline and active fishing communities.

Newlyn was an important port for pilchard and mackerel fishing. It had an unspoilt village and held fish sales on the beach when the fleets unloaded the catch. Most of those who grouped round Stanhope Forbes and Norman Garstin in the 1880s had been on the Continent. These were the peripatetic rustics who turned Newlyn into silvery nostalgia, mostly figurative, authentic and anecdotal, that was highly acceptable to the traditionalists. In the annals of art history, the Newlyn school might be regarded as peripheral; in West Cornwall, the first artist colony provided the germ of what time has been adding to ever since.

* The northern headland is almost an island, hence its popular name.

Several Newlyn artists, including Forbes, made forays to St Ives, where James Whistler was depicting seascapes that earned from his young assistant, Walter Sickert, amazement that painted waves should hang for seconds while the foam 'curled and creamed under his brush'. Julius Olsson's moonlit seascapes were more typical of the several hundred pictures that travelled each summer by special train to the Royal Academy exhibitions. Converting cottages and sail-lofts into studios by fitting skylights into the roofs, a surprisingly cosmopolitan bunch of artists made St Ives the chief Cornish centre before the First World War.

Poor, hardworking, proverbially suspicious Cornishmen weren't, by nature, hospitable to outsiders. Not content with trying to lynch Charles Wesley when he went there to preach, local schoolchildren, papers report, stoned a Japanese visitor for painting on a Sunday. What each generation of artists did for its successor was to provide a social precedent. In 1890, the informal Artists' Club became the marginally more official St Ives Arts Club, with quarters on Westcotts Quay. Women were admitted soon after its initiation and the club expanded to include literary figures such as Leslie Stephen, Compton McKenzie and Hugh Walpole. Liberalization, alternating with restriction and consolidation, was a pattern set to stay. A dozen years before Barbara Hepworth's arrival, Julius Olsson opened the first exhibition of the St Ives Society of Artists. Most of the well-known local artists belonged: Stanhope Forbes, Lamorna Birch, two pupils of Olsson's with strong landscape aptitudes – John Park and Borlase Smart – and competent portrait artists such as Leonard Fuller. Each summer, in a flurry of fancy dress, members made merry at an Arts ball and artists opened their studios to the public.

More inventive painters like Frances Hodgkins and Matthew Smith paid their respects to St Ives between the wars. In 1920 Bernard Leach built an innovative pottery on the outskirts of the town, and a few years later, Wallis began to paint pictures with an impact so indelible that, once seen, they are impossible to forget. Discovering the Cornish landscape had inspired Adrian

Stokes to paint. In his friendly house with its seaside garden, he envisaged an anchor for his own restless creativity and an entice-ment for roving artists.

The Hepworth-Nicholsons' (Barbara and Ben had changed their names by deed-poll after the triplets' birth) arrival entailed major upheavals. Little Parc Owles contained four bedrooms, one so small you could hardly get into it, and everyone needed a workplace. In the event, Ben and Barbara had the guest bedroom. They weren't used to sleeping together because Barbara smoked and Ben didn't, so that took some acclimatizing. Triplets and nurse slept in Margaret's studio, and Barbara drew, after the day's chores, in her hosts' bedroom. Evenings carried the fervent and melancholy strain of hymn-singing from the chapel on the coast road, and night drew from open windows, far out, faintly, the continual breaking of waves. The garden bloomed, and wildings hung in the hedges, setting her alert and watchful. The landscape, she recognized, was a sort of compensation for the war and not having materials to carve.

The war was brutally present, not just in her private depriva-tions but out on the battlefields with Britain's youth. From isolated, wartime St Ives, standing a little outside life, like an adversary to field sports, haranguing its madness, her letters spill constantly into anger and frustration. 'We have ample chances at the moment for developing social changes that would strengthen us . . . an immediate change in the educational facilities. But we don't do it. Instead we shall regiment every idea, every individual to the lowest common denominator so that we can beat the Blacks & the Reds. Only the young can build a decent life & we shall kill them all off.'

At the outbreak of war, Naum Gabo had meant to move on to America but he changed his mind, and at the last moment he and Miriam were persuaded by Ben and Barbara to join them. For Gabo, St Ives was an unsettling venture. Despite his insistence that his forms arose from nature, Myfanwy Piper had noted his discomfiture at Fawley Bottom, finding himself among grass and

trees. After three incredibly productive years in London, the little fishing town felt like an impasse. For the Hepworth-Nicholsons, 300 miles from friends and supporters in an art colony hostile to what they were trying to do, Gabo was the staunchest ally. Their seriousness mustn't be underestimated – their dreams of a constructive revolution, a new society and a new art. Art, Read said, was always socially relevant, or it wasn't art.

Earning money was an immediate concern for the Stokeses' fluctuating band of refugees. Ben and Barbara in particular were virtually dependent upon their hosts' hospitality. William Coldstream and his wife were also at Little Parc Owles. It was while they were there that Barbara conjured a plan to camouflage the chimney-stacks of Hayle power station by painting them green. Another possible money-spinner was tutoring in drawing and painting. It wasn't long before Ben adopted, on Stokes's recommendation, the talented young Peter Lanyon as a student.

Lanyon was born in St Ives, and felt, as Wallis did, that the granite was embedded in his bones. Leaving school, he had become a pupil of Borlase Smart (again, advised by Stokes) and had then enrolled at Euston Road School. Neither art college nor a summer in Provence had entirely focused his aptitude, but meeting Nicholson and Gabo, seeing their work, he was immediately affected. During a few months of intense experiment, he became something of a phenomenon. To Barbara and Ben, his opening out was a joy, a circumstance not to be forgotten in what was to become a strange, disturbed relationship.

To be truthful, there was little peace at Little Parc Owles. It should have worked: Barbara and Ben were surrounded by sympathetic people, for whom manual labour in the Stokeses' market garden provided healthy outdoor recreation, but unless they could create, they all felt restless and irritable. Everyone had strong opinions, all completely different. Stokes was, for instance, an atheist, Gabo essentially a believer, and all preferred different types of music. Little things were an indication of the extraordinarily high state of tension within the household. In the morning,

so that Barbara could inject some regularity into her life, she would set her alarm clock. Ben didn't like the noise. If it went off again, he warned, he would throw it out of the window. So he did, the next time it rang, and after leaping out to recover the carcass, Barbara wept on Margaret's shoulder. Numbers alone created a lot of hard work. Stokes's intellect told him that Margaret was a natural professional artist, but his emotions said he had married someone to organize his social life and encourage his muse. (Was it chauvinism that prompted him to write in *Stones of Rimini* (1934) that carving was a male process, modelling a female one?) To Margaret, therefore, fell the tricky task of catering. It didn't help that Adrian insisted on an evening meal though the children preferred midday lunch, and everyone had his or her gastronomic idiosyncrasy. Butter for Ben was kept in an inviolable dish that nobody else could touch.

Ben actually came off best because almost nothing stopped him working. When the atmosphere downstairs became too strained, he retired to bed and Barbara took up meals on a tray. If he wasn't working he was bicycling round the countryside, ferreting out St Ives's potential for supporting the abstract movement, arranging, assessing, manoeuvring and stimulating others to approved action. Peter Lanyon was receiving his encouragement, so was Margaret Mellis, creating webs of communication between the two couples more complex than the strings on Barbara's sculptures. Adrian thought Barbara was a very good-looking girl to have about, and admired her art. Ben fancied and complimented Margaret. Adrian had always appreciated Ben's painting; Ben admired Adrian's writings but wasn't so sure about his art. Inevitably, Adrian was affronted, and the two fell out. Introduced to people who sapped their attention, Ben and Barbara would withdraw into impenetrable, discordant silence. Amid general coolness, they communicated with the rest of the household through little notes. To the Stokeses, in the first ebullient year of their marriage, the whole experience was remarkably dampening.

The forcefulness needed to make and sustain an artist of Barbara's calibre was bound to produce strong reactions in people around her. She did everything with a purpose, her effort so exactly directed there was scarcely any waste. Few were at ease with her because her manner remained too uncompromising. She was given to long, enigmatic silences which, together with the serenity of her features, exercised a powerfully unsettling influence. Through her remoteness she could make people feel graceless and ill at ease; as a result, while she attracted men, who hurried to be of service to her, to cause a flicker of interest or amusement to cross her grave eyes and immobile face, women often failed to find in her the sympathy and comfort they sought from others of their sex. Complaints were made that she seldom bent to humour and wouldn't bestow praise; that her silence was like frosted glass. Even when she spoke, she used an affected, toneless voice which became in practice rather exhausting. There was a 'nice' side to her, they admitted, unable to explain quite why her abstracted seriousness made them feel uncertain about themselves.

Although preparations for the journey had been minimal, Barbara had with her a hammer, a few tools for carving and the maquette of the first sculpture she stringed and coloured. They were what her mind clung to. Without work, she saw a threat to her existence, of which that house, that town, and these people were at once the tools and the reality. Her need was entire and it was everything. She hadn't heard of the relativity of work; and perhaps what animated her wasn't relative. Her future proved it to have been her one directed longing. That certain inevitable disparity between the working and the social self, public and private, outer and inner, was seldom more pronounced than during those four increasingly traumatic months. The threat was like a mist moving in that would engulf her careful, private life. Brought by the incomprehensible enmeshment of events to the brink, once more, of change, she felt she must give battle or become submerged; felt, already, submerged by her own forebod-

ings. With her smooth impassive face, her low inexpressive tone, she stood, intent on managing, balancing the burden with false calm. Without being able to carve she was impotent, because art was to her the most immediate and effective means of communication. Work was to her what George Eliot called the 'roar which lies on the other side of silence'. Of none of this she spoke in company. There was a struggle against the habitual silencing of feelings she had experienced in her father, as a child. She couldn't be scattered and sociable because she had to be very concentrated in order to work. Searching for things to refresh and nourish her mind, she poured her frustration into letters. Within days of her arrival, she was admitting, 'I must do some work.'

Everyone was concerned with order, balance, carefully arranged relationships, clear-cut architecture and environment. Barbara's fascination with crystals went back to the beginning of the thirties when she had learned about them from Desmond Bernal. A few years later, intrigued by their marvellous inner structure, she accompanied a mineralogist to the National Geology Museum. In 1936 she had carved a crystal-like structure,★ in 1938 she had begun to draw crystals with complicated networks of strings. They were a wonderful way of concentrating her mind and one senses it behind them, at once concrete and fastidious. The other potent influence was Gabo, whose precision and harmony were earning him inordinate praise from Herbert Read. To those she idolized, Barbara paid the unconscious compliment of drawing on their sensibilities. Plainly, there was a link between her crystal drawings and works such as Gabo's *Construction in Space: Spiral Theme* of 1941. Thrown back on her resources by the exigencies of war, using pencil and thinly washed gouache, she made over the next three years a large number of geometries.

The Euclidian aspect of spatial relationship had always appealed to her dependence on reason. Drawing was a means of exploring the common ground between the two arts, and of developing

★ *Form* 1936.

her command of sculptural form and technique. Sometimes a breakthrough came first in one form, sometimes in the other. Drawing or carving, she told Read, her aim was very similar. She was exploring the relationship of colour and line to inner form. Wanting to know what lay at the heart of all, she applied Pythagoras to probe deeper and deeper, knowing, with her analytic intelligence, that at every level of reality there was form. From the absolute abstraction of crystals, she progressed to ovals and spheres. By breaking out of confined shapes, rather as the little quay at St Ives let the sea sail in, she incorporated outer space in the severe discipline of her exercises. Without being exact copies, these drawings, with their impeccable balance, tonally shaded segments, strings of tension, and sweeping interlocking arcs, both reinterpreted in two dimensions some of the sculptures she had recently finished, and projected ideas for new ones.

With Christmas come and gone, the Hepworth-Nicholsons found a very small house they could move to quite near Little Parc Owles. Dunluce stands sideways on to Wheel Turn Road, the rooms are poky and ill-proportioned, it isn't a nice place to be in. But they were on their own. Elizabeth Hepworth performed the unenviable task of getting the furniture from Mall Studios, and Stokes paid the rent. After a hectic week of being plumber, carpenter and electrician, Barbara woke to the sun rising over the hills feeling peculiarly alive. Behind the house ran lanes reeking of wild garlic, small fields of cow-pats and buttercups banked with stitchwort, red campion, feathery grasses, cow parsley, bluebells, tiny uncurling ferns. Inland from the bay, with its flowering tide edges, there were stretches of flowers in deep valleys against bare silent rock-like structures. To the west, the cliff path wiggled its way through St Ives, round the conical almost-island bearing the square stone chapel of St Nicholas, and all the way to Land's End. High above a cellophane sea, thrift spread beneath granite boulders. Here and there, the bones of the landscape pricked the skin of the soil with rocky outcrops. On £250 a year, she pondered hopefully to her brother-in-law, with

the weekly cheque from her father, rent from number 3 Mall Studios, and garden vegetables, they could keep afloat. So she painted Dunluce white – as she would every house in which she lived – and because it was wartime and food was scarce, she put her mind to vegetable culture.

If a job was to be done at all, it would be well done. With habitual thoroughness, she researched the complexities of manures, fertilizers and efficient double-cropping. She even read Kropotkin's *Fields, Factories and Workshops* as background to her digging, hoeing, raking and planting. Kropotkin, the best known of the early Russian revolutionaries, suggested that advanced agricultural techniques could be used to rationalize and humanize the economies of industrial countries. On top of everything else, Barbara had set herself, with books begged and borrowed, an extensive reading programme in social politics. Meanwhile, Dunluce won a locally awarded first prize for husbandry.

The experience of cooking, caring for her children, and growing vegetables was nourishing, Barbara insisted, provided only that each day she managed to do some work, albeit a single half-hour, 'so that the images grow in one's mind'. Her letters seldom dwelt on domesticity in a way that suggests it was rewarding, but this may be because letter-writing fulfilled more neglected aspects of her life. During January, with Alistair Morton, an artist and textile-maker from Cumbria, bursting the house, somehow she found space and time to make a four-inch plaster model similar to the one she had brought from Hampstead. In Ben's as well as Barbara's work, colour began to play a more significant role. *Sculpture with Colour Deep Blue and Red* 1940 was the first of six stringed and coloured maquettes.

At first, conditions in Dunluce seemed so appalling that Ben and Barbara considered sending the triplets to North America for the duration of the war. The idea, however, being abandoned, Olive stayed with the family at least until the end of June, 1941; 'Nanny' Grey stayed longer, and Barbara gave, for a while, classes in drawing and painting for four neighbouring children as

well as her own. Encouraging her pupils to express themselves freely in paint and plastic mediums, using the results as a guide to health and happiness, she mused that no three could be more different in character than the triplets. Simon was as precocious and bold as Rachel was timid. Read, busy writing his major book on art education, made a receptive correspondent. Paul Skeaping usually spent alternate vacations with the Hepworth-Nicholsons, with whom he got on well. Unhappy and rebellious at Summerhill, at about this time he spent a term with Barbara at a school in Carbis Bay.

In a wider sense, the children's education was compounded by the flow of intelligent people in and around their home. SRS, as Barbara referred to the triplets, acquired a vivid vision of the colourful characters who knocked against them, many of whom were achieving eminence in their fields. Mondrian was stringy and equivocal, Jim Ede bore a crystal from California that Simon carried for weeks in his pocket, Gabo taught him some Russian. Margaret Gardiner was unfailingly sympathetic. Some of these friends and visitors offered lasting support.

Making and keeping contacts was something over which Barbara and Ben expended a great deal of time and energy. In the resident painters of St Ives they were not especially interested, but with gentle philosopher potter Bernard Leach, they had much in common. Besides, the Modernist group was growing: there were Gabo, Stokes, Lanyon, and John Wells, who had first met Ben in 1928, when Wells was a part-time student at St Martin's School of Art. Qualifying as a physician took Wells, as hospital registrar, to the Scilly Isles. From there he made frequent visits to St Ives. Sven Berlin, mature art student and budding sculptor, was, as a conscientious objector, serving in the Stokeses' market garden, and Willi Barns-Graham, a highly promising painter friend of Margaret Mellis, had lately alighted in the town. The younger generation were all involved in the war effort. Ben and Gabo were out every evening with the Air Raid Protection (ARP). Petrol was rationed, so everyone went everywhere on bikes.

If art was to overcome the destructive forces of war, cultural values had at all costs to be kept alive. At one point Barbara, Ben and Gabo planned to publish privately a quarterly wartime chronicle of new prose, verse, painting, sculpture and architecture. Artists in the armed forces were to contribute; Read would be literary editor. On to a new challenge, Barbara was like a firebrand. Meetings were held, discussions made, letters sent hither and thither to the increasingly dispersed avant-garde. But wartime exigencies beat an enormous expenditure in time and effort. A fund-raising project that relied on local communications was, in contrast, highly successful. Barbara, Ben, Gabo and the Stokeses devised the scheme to buy a mobile X-ray unit for the USSR. One way or another, it caught on in the town and within twelve weeks the targeted £1,500 had been reached. Not without some agitation in the ranks. Put in charge of publicity, which meant distributing posters, Barbara chose the prime locations for Hepworth-Nicholson contributions. Under public pressure, she swapped hers for those of other artists but refused to change Ben's. It was a typical St Ives skirmish.

Ben (the optimist) gave the war another year; Barbara (the pessimist) feared it would last much longer. While all were subjected to destruction and negation, the only victors, in her opinion, would be those who could work constructively. Often complaining how difficult it was to express herself in words, managing better than she realized, she was snatching moments from duties to correspond with an extended art circle. Militant and polemical, she spoke of what they might do for salvation. Being what she was, it was difficult for her not to put things in capital letters. She could argue logically, but she wasn't objective, she was letting off steam and fully aware of it. Like Ben, Barbara believed that the liberation in abstract – and particularly, Constructivist – art ran parallel with the liberationist war aim.★

★ Ben made this explicit in *Horizon*, October 1941.

Shortly before Alfred Wallis died,* Barbara had taken Read to meet the fierce, lonely, Bible-quoting little man who followed his own vision. In a house full of fleas, he had intoned, ceaselessly, a sort of epic poem about his life. Ben had taken Barbara there several times. She noticed Wallis's incredibly small, very serious eyes and how his face lit up at Ben's arrival. Every corner of the cottage was stacked with cardboard paintings, and in a tiny room, with nowhere to sit, a huge table was spread with Wallis's boards and best ship's paints. On his left hand was an enormous open Bible, further along, a teapot, perhaps a bread crust, a turnip and some sugar. Wallis had had a chip on his shoulder because locals thought he was an old dafty and their children threw stones at him. 'He maybe sensed, he certainly didn't know,' said Willi Barns-Graham, 'how much we all learned from him by his magical sense of reality, colour and tone.' The Stokeses paid for the funeral, Ben and Barbara made a contribution, and Bernard Leach decorated the tiles which cover the grave. Wallis was buried in the cemetery overlooking Porthmeor Beach.

In the spring of 1942 an exhibition called New Movements in Art was chosen for the London Museum at Lancaster House by art historians E.A. Ramsden and Margot Eates. Along with Surrealists, there was work by Hepworth, Gabo, Mondrian, and several new recruits in whose careers Ben had played or was playing a significant role: Lanyon, Wells, J.C. Stephenson and Mellis. The first opportunity the avant-garde had had to show a united front since the war, it was invaluable in spanning what Barbara referred to as the 'emotional' gap between modern art and its public. Her drawings enchanted Paul Nash, who was in no doubt that the Constructivists stole the show. Read reviewed the exhibition warmly in *Horizon*. What irked Barbara was a single derogatory implication he made in the *Listener*. In two long abrasive letters, she rebuked him for several failings of clarity, but her

* August 1942.

grievance was finally emotional. 'It is now the time for action – the artists are ready – society not yet – What do you suggest we should do? How must we live/eat?' This must have been clear to Read. He had let the side down.

Gabo was proving a far less placable unit in the Constructivists' united front. Wandering round in faded jeans and a white floppy hat, with a big white dog with a black tongue, he managed to provoke, with his strong Russian accent, profound suspicion in wartime St Ives. Billed as a foreigner and a Jew, he felt like a puppet shot against the volcanic conflagrations of history. Eighteen months after his arrival, he was again trying to emigrate. Ben and Barbara prevailed upon him to stay. Gabo stayed, but, as it were, under protest. Even Read agreed he was a 'B' to deal with. Trouble first arose over a magazine article. Marcus Brumwell was an editor of a series of articles for *World Review* entitled 'This Changing World' (later collected into a book of the same title). Articles by leading scientists, philosophers and art critics on aspects of contemporary activity were seen as central to the activities of the circles in which Ben and Barbara moved. Ben contributed, and E.A. Ramsden wrote a piece on contemporary painting and sculpture. To someone already feeling persecuted, the omission of his name was unforgivable. Ben was believed to have been involved; he too was shunned. The situation was not improved by Gabo and Ramsden's communications over the exhibition at Lancaster House.

In the ensuing cold war, Barbara, who loved Gabo dearly, endeavoured to patch up their relationships. Gabo suspected a campaign of silence against him. This was nonsense, she wrote, listing the charges. He had put his prices so high that nobody dare so much as ask what they were, and had studiously given the impression he wasn't interested in selling work. He avoided friends, even them, scorned *World Review*, and derided 'E.A.' instead of cultivating her friendship. What he should do was resolve the conflicts within himself. All in all, he was becoming like the Grand Lama of Tibet.

The rain shook through the trees, the wind hurtled along the road that curved in to St Ives. Asthmatic, faddish and hypochondriac, Ben loathed the streaming winters. All Barbara ever really *wanted* to do was work. To E.A. Ramsden, he aired a grievance that the conditions under which they were living were forcing them further apart. Barbara wouldn't spare the energy to make love with him. 'E.A.' sympathized: Barbara was just terribly overworked. Lack of money meant loss of independence, never a quiet moment, problems of keeping alive while trying to discover what might sell without reducing standards. Lack of money and lack of space were getting them down. One was a by-product of the other. Another problem was work-space. Barbara was selling her drawings but Ben wasn't too satisfied with the direction his art was taking: maybe 'space' was an analogue for work itself, and the quarrel was about competition.

A personal sense of crisis began to enter Barbara's letters. She wasn't sleeping at night and sometimes it felt like hell. Insufferably cramped, work-bound, fighting to exercise her right and need to work, feeling keenly the loneliness of long quiet evenings on her own. All these things and the anxiety of them had been building up. So that sometimes it was unbearable. She was boiling with the pressured energy of explosive forces confined in a small space. Dunluce was too small. On top of wartime privations, the triplets were going through the whole gamut of childhood infections. Always, inevitably, there were three, each demanding what the other two possessed, each wanting the attention a single child reckons his inalienable right. To Barbara it seemed as if her adult strictures made a perpetual 'No!' It was a situation to which there could be no solution and no winners, only two who would lose. In a more pliant mood, she was able to put three years of formidable domestic pressure behind her. The decentralization from Hampstead had been, after all, a good move. The years in Cornwall were the 'most intense & vital' she had ever experienced.

In September the family moved to a shabby, bigger house high on the sea cliff, called Chy-an-Kerris. From this time on, as

if the rhythm of the waves were echoing through her work, her sculpture was based on the persistent presence of the Cornish coast. It was as if the present place had opened its arms to her. Life was shaping itself as a voyage in.

I Was the Figure in the Landscape

(October 1942–November 1946)

There was nothing between the new home and the pounding waters; reminding one, with clarity, of the house where Barbara had once stayed in Robin Hood Bay. When she gazed from the window of her studio, the sea was a flat diminishing plane, holding within itself a medley of blues, greys, greens, and even pinks. The form of St Ives Bay, with the lighthouse and its strange rocky island, took on human proportions, so that the island became an arm with a hand and a face. The horizon of the Atlantic seemed enfolded by arms of land on either side.

Although the visual thrust was out to sea, the rock formation of the great crescent with its cliffs tumbling in a cascade of brown rocks had a withinness of form which led her imagination back to the land. Behind, she was intensely aware, lay the rich country of West Penwith, plumbed by old mine shafts, an ancient geology and prehistory that had once formed quartz, amethyst and topaz, spreading them, with feldspars and sparkling bits of mica, in the sand. Mostly the sand was pale granite, over which the tides made a strange calligraphy, bringing seascape to landscape until they fused.

Once upon a time, from the seat of a car, Barbara had sensed the mass and leverage of rolling Yorkshire country. Years later, in St-Rémy, a tension in the hills had given her an outrageous urge to dance. Now again, in West Penwith, impelled by the barbaric landscape, the formal pose of her body elevated her to become part of the world around her. The weights and tensions of her moving, dancing self were what she recreated in sculptural terms. Strings, holes, hollows and painted underbellies symbolized

aspects of landscape, human figures and human sensations. The sculptures aren't an immediate response to the visual world. Before her scooped out, penetrated forms took shape as art, her reactions had undergone a period of distillation, much had been discarded, and what remained had been subjected to tireless energy. Reflecting rather than recording, absorbing the numerous hidden bonds that link people to people, landscape and architecture, she touched and reached the world through ideas and feelings.

Lying on the shore with the sea rearing almost above her, she was quite a different shape and being from the Barbara Hepworth who stood tussling against the wind on sheer high cliffs, with seabirds circling below. There was the self who sheltered at the foot of great rocks, finding reassurance in their solidness, and the self who lay in the sun, allowing its warmth to penetrate her bones. When all was still, she was no longer looking at her surroundings, but *was* them. A distinct, indescribable, but in no way vague, still less emotional, shift of consciousness had taken place, so that she and St Ives Bay were one and indistinguishable. The transmutation of essential unity was a marvellous exploration. The bay was a part of her own consciousness.

Each passing day confirmed her sense of air, of lift and light. Light dancing off the shallows shifting in eddies on silvery sands. Light changing on the lighthouses that stood like barometers of mood, now blue and hazy, now close and green. There was light over St Ives, above the tower of the parish church, light frothing among banks of flowers in tiny fields, and the lift of the air was resonant, with the vigorous scream of gulls as they flap, flap, flapped and soared, holding their wings like sails when they landed on the water, floating backwards against the tide. For a few years, Barbara became the object. The thing formed – and this, according to Read, is the key to the whole of the modern development in art. One can be subjective as well as objective – can be the emergent sensibility of the artist himself. 'I was the figure in the landscape,' Barbara wrote, 'and every sculpture

contained to a greater or lesser degree the ever changing forms and contours embodying my own response to a given position in that landscape.'

Subtly, her work was to open into the curves and cavities that reflected the remarkable forms around her. Colour in the concavities plunged her, in her mind, into the depth of water, caves or shadows; strings were the tension she felt between herself and the sea, the wind or the hills. The stylization she had from necessity adopted with increasing abstraction allowed her to control precisely the fall of light on the form, harnessing light and shadow to the form's rhythm in a most emphatic way.

Over the next few years she made, on her own account, some of her best work. Despite the war, she held important retrospective exhibitions in the provinces and her work was bought by New York's Museum of Modern Art. Nineteen forty-six saw one of her sculptures on the cover of *Studio*, giving an enormous fillip to her exhibition at the Lefevre Gallery. The first monograph on her work appeared, and a one-man London show was visited by the Queen. By the end of the war, in a flurry of commissions and exhibitions, she emerged a leading British sculptor.

Normally, Barbara 'worked' most of the day. Even when it wasn't obvious, she was working mentally. Looking out of her studio window, sauntering along the edge of the sea, turning with her toes its rich tidal jetsam, or watching a seagull rising on air thermals, it was impossible not to absorb a variety of fleeting images. Although she enjoyed intensely, for their own sake, the sights and sounds of her surroundings, she didn't need to immerse herself in the landscape for long periods. It was not that she ceased to see or feel them – on the contrary, she saw them with extraordinary intensity. But her power of assimilation kept the visual impact with her in her imagination. She may even have dreamed about work when she was asleep, because sculpting demanded total concentration. All the time, just below the surface of her mind, there was a simmering of thoughts, feelings

and connected images that transformed visual reality into sculp-
ture upon which she was engaged. This layer, never entirely
quiescent, meant that every other activity registered as to some
extent the raw material of her art, motherhood, Ben, not only a
companion but a critic, and all her serious friends.

'I've finished two new carvings & feel slightly more human,'
she told Paul Nash. She wrote letters fast, in a large, increasingly
confident hand, defraying tension as well as confirming her
present life. Two days after her birthday, on 12 January 1943, she
was telling Herbert Read triumphantly that she hadn't realized it
was possible to feel, at forty, such elation. Lots of nice things lay
before her, many unpleasant ones had been shed. Violets were
out, the weather was balmy, the light from the sea and the sky
'magnificent'. Paul had returned to Summerhill and every day
the triplets played on the beach. In vibrant energy, she was
reading Rilke.

Stephen Spender and J.B. Leishman's translations inspired a
craze for Rilke in the thirties. Among the highbrows of Hamp-
stead and Belsize Park, his works were indispensable. Barbara had
special reasons for her rapport with his bewilderingly complex
metaphorical language. A friend of Rodin's and married to a
sculptor, Rilke actually wrote poems about sculpture. Many of
his formative literary influences, moreover, came from Russia,
where he felt more at home than in his native Prague. Of all
Barbara's sustaining muses – Beethoven,* Rilke, Donne, York-
shire and parts of *The Story of an African Farm* – Rilke, tragic,
romantic, abstruse and determinedly symbolic, affected her,
probably, the most. In his *Duino Elegies*, Rilke invokes the
transcendence of human beings into a visionary state.† This was
unobtainable, because, as Rilke was aware, an artist is bound to
the physical world. Therein lay life's underlying tragedy. A
drawing Barbara sent to Read was based on her understanding of

*Especially the fifth symphony.
† As angels.

1. Ben Nicholson, *St-Rémy, Provence* 1933

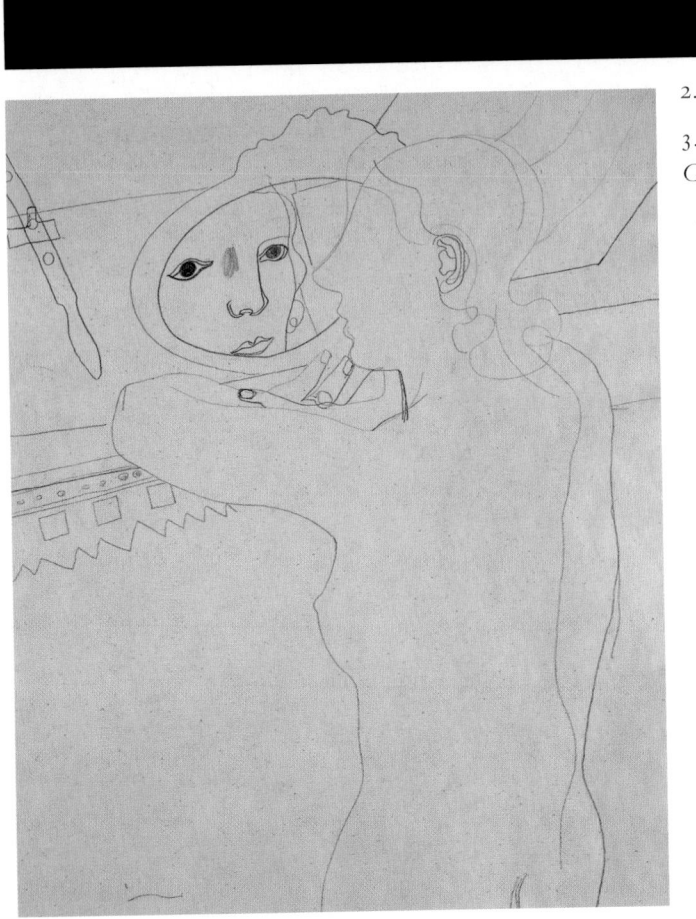

2. *Mother and Child* 1934

3. Ben Nicholson,
Girl in a Mirror 1932

4. *Two Segments and Sphere* 1935–6, marble

5. Lanyon Quoit, the stones of an ancient grave in West Penwith

6. The Men-an-Tol, remnants from a megalithic burial chamber near Land's End

7. *(Opposite)* The stone-carving workshop at Trewyn Studio, St Ives, 1969

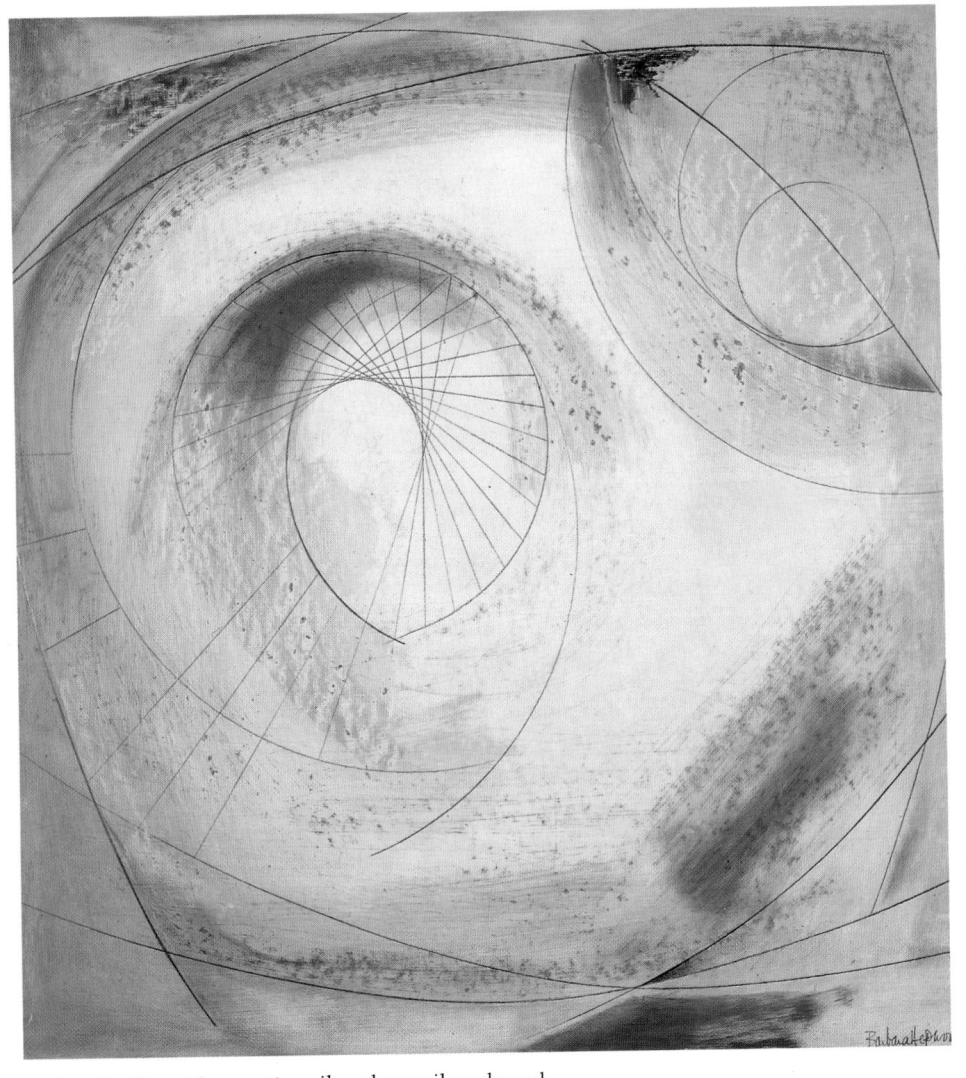

8. *Stone Form* 1961, oil and pencil on board

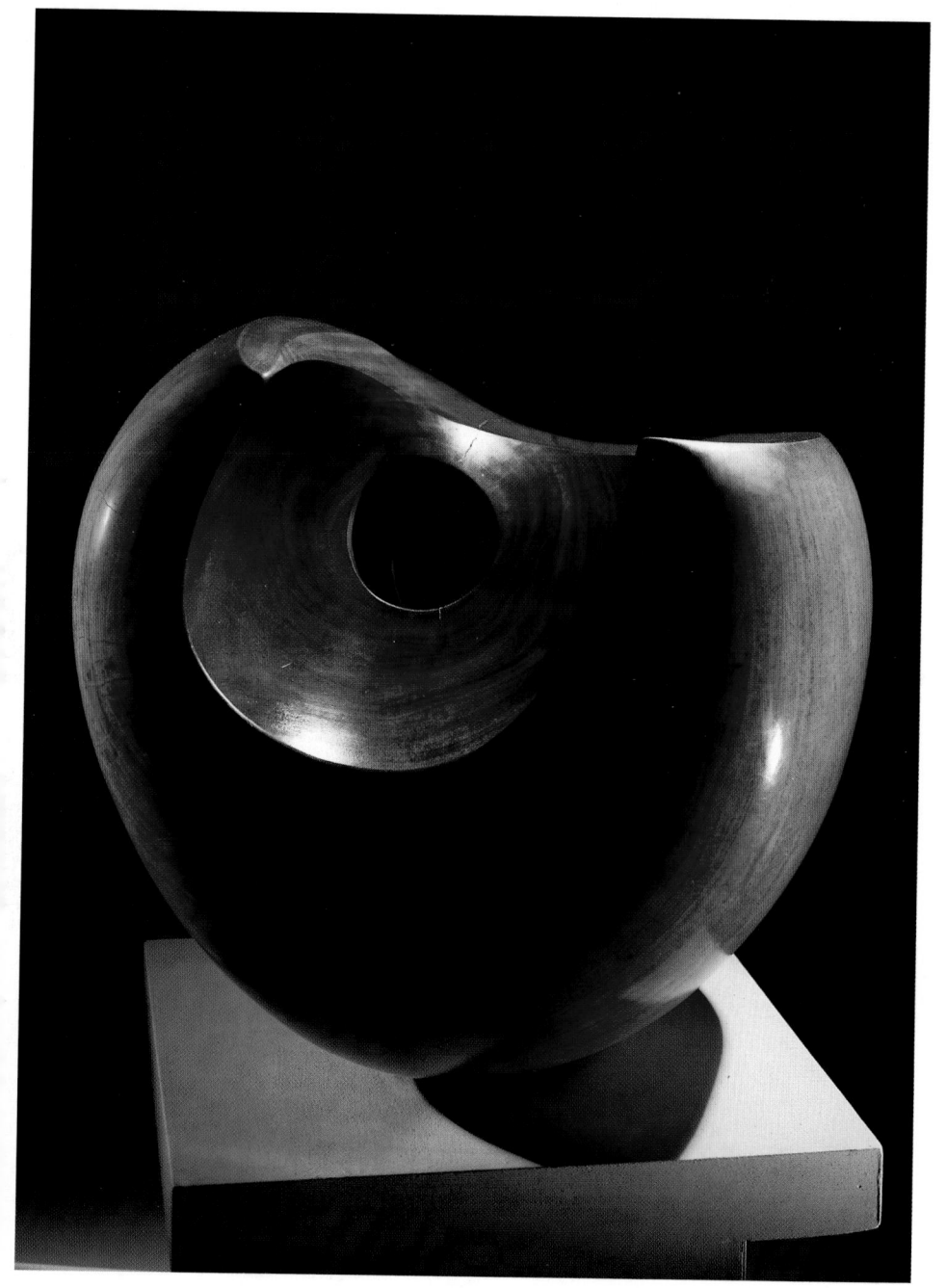

9. *Configuration (Phira)* 1955, scented guarea wood

10. *Single Form* 1937, holly wood

the first Duino elegy. Several new drawings were being used to illustrate a book of poems by another visionary writer, Kathleen Raine. Barbara enjoyed the project although, strangely, she never knew the poet.★

Poetry certainly gave an extra dimension to her strangely intimate relationship with Herbert Read. To him she gave the full confidence of her seriousness: he was an artist in words, she in wood and stone, and his portrayal of her was a lot more important than anyone else's. As spokesman, publicist and morale-booster, Read continued to play the loyal advocate: dropping Hepworth's name when it was politic, singing her praises, explaining and re-explaining her work as a natural progression of all that was best in art. Appearances don't necessarily convey reality, he postulated in a masterly introduction to her retrospective in Halifax. A permanent structure essential to understanding life and the universe underlies what our senses record. 'We might say that the aim of an artist like Barbara Hepworth is to give us some understanding of this essential structure. That of course is the aim of modern science, but science works by reason, analysis, dissection, classification . . . The artist . . . works by intuition, synthesis, insight and sympathy, and is thus able to give us some account of the wholeness which underlies the shifting appearances of nature.' He was suggesting that people could miss, as indeed they did, through inappropriate conditioning, a significant dimension in her work.

After the war, in a wave of intense nationalism, the countryside and its preservation provided the perfect boost to the establishment-backed Neo-Romantics. This contributed considerably to the poor reception for abstract art. Ben had been omitted from the Penguin artist monographs, whose manoeuvring editor was none other than Kenneth Clark. Equally galling to Barbara was her exclusion from British Council exhibitions. Various

★ Raine was Winifred's friend.

reasons, she could see, might be responsible – her being a woman, abstract, young, a wife, a mother, etc. etc. – but a recent catalogue had reinforced how scandalous it was. A largish retrospective under discussion wasn't sufficient compensation. She knew her strength, and wanted justice. Resentment needed periodically to be released.

In the newly decorated Temple Newsam at Leeds,* Philip Hendy showed what turned out to be a remarkably good combination, Hepworth with Paul Nash. Although Nash's work was Surrealist, even Barbara allowed that his earthy colour was natural with sculpture, while his 'isolation of the object' met her work 'half way'. William Gibson approved prominently in the *Listener*, and both Leeds and Wakefield bought Hepworths for their permanent collections. After Leeds, the exhibition went to Halifax and thence to Wakefield. Barbara didn't get to any of them. It could have been that she just wanted to work, but the reasons she gave were always domestic.

By means of remarkable management, two artists at the peak of their powers had kept the momentum going throughout the childhood of their sudden family. Delegation, the key to survival, had been maintained with the considerable assistance of paid labour, family and friends. The effort, however, had been enormous. On Barbara fell the heaviest burden: she had work and family, Ben admitted later. He took the right to put work first. Odd phrases reveal the weight of chores that devolved upon her: 'Half an hour late with tea', 'peeling spuds for 9'. Help was at a premium because it was wartime, so the daily chores in a house full of children fell upon her increasingly. She never looked down on domesticity, though there were times when there was far too much of it. Nor was she prepared to neglect the obligations of motherhood. It was just that doing everything made her preternaturally tense. Her resources were powerful but they weren't endless and being deprived of work drove her frantic.

* 1943.

She couldn't give the family the clear space they needed, but how were the triplets to know that her proverbial moods were nothing to do with them?

Simon, Rachel and Sarah's early years had largely been managed by a cook and a nanny. After that, their needs grew rapidly. At hardly any time more than the onset of adolescence is a child's sense of security, discovery and self-discovery more dependent upon the guidance and approval of its parents. Provided for, but by arrangements inevitably confounding to young intelligences, aware that because things happening at home were of such profound order their own provision elsewhere mattered a good deal, it was the triplets' fate to feel much more than they at first understood. Far from being rumbustious, they tended to react with uncertainty to the intensities in the midst of which they were growing up. Barbara had definite views on every aspect of rearing children, especially girls. Had time allowed, she could have written reams about the effects of social and sexual attitudes on girls' position in society. Yet how difficult it was, in a highly charged atmosphere, to make each child feel unequivocally and individually cherished.

The family seemed to catch every prevalent epidemic on top of pet complaints. After two years of bronchial troubles, Simon developed asthma, which Barbara feared was in his genes. Sarah's succumbing, towards the end of 1943, to an infection of the bone marrow was of a different order. Osteomyelitis could be serious before antibiotics were available. It could, and did in Sarah's case, require an operation to drain the pus forming in her leg, and always there was the danger of a recurrence. The infection necessitated a prolonged stay in Princess Elizabeth Orthopaedic Hospital in Exeter. In a family stretched to its financial and physical limits, the episode was undoubtedly a burden and Barbara fretted about her daughter in her absence. Whether the illness was entirely detrimental to the sufferer is unconfirmed. In a family where the pressure of important things being done by important people may, from time to time, have seemed daunting,

163

Sarah's invalidism earned her special attention. From all over the world, letters of condolence poured in. Osteomyelitis was the chief topic of conversation. Her visitors were many; Marcus Brumwell even supplied the hospital, throughout her convalescence, with postcard reproductions of modern art. Barbara admired Sarah's fortitude. It brought the two closer together. The other benefit was Barbara's friendship with Sarah's orthopaedic surgeon, Norman Capener, under whose skilful supervision Sarah made a complete recovery. When she emerged from hospital, on crutches and in a wheelchair, Barbara recouped Nanny Grey from the war machine, complaining bitterly that nothing was achieved without a struggle. It had taken eight months' agitation with the local MP to get help.

All sorts of relationships were opened up by the war. Barbara didn't feel she had known Joan since childhood, a situation repaired during 1944 when, partly as a rest cure and partly to help with Sarah, the middle Hepworth sister spent four months with the Hepworth-Nicholsons in Carbis Bay. One way of coping with school holidays was to swell out the household. Though scarcely decreasing the domestic load, cousins and half-brothers provided the triplets with company. Paul Skeaping and Jake and Andrew Nicholson, Ben's elder sons, were regular visitors. Joan's children, Anne and Martin Ellis, had been sent to boarding school when their father joined the Somerset Light Infantry, staying during holidays with one of their Ellis aunts. When the bombing in London got really bad, they joined their cousins.

Most of all, Anne remembered the sun pouring down on the cliff top and the sea. Every evening, Ben took for a walk along the cliff path two cats who made it plain they were going of their own accord. In a full household, all the children escaped to play on the beach, except Sarah, who lay on the sofa. Her invalidism was a major factor in the family. When Barbara's private life became public property in St Ives, everyone had views as to how she had managed the triplets. Anne found the family far less

doctrinaire than her own: Barbara reasoned with, rather than dictated to, the younger generation, which had several different effects. To be taken seriously by someone powerful – which both Ben and Barbara were – weighed upon the recipient. As Barbara lamented, there are situations in which it is impossible to win. Everything was difficult: her working, Ben working, the house and her children. The London years, in shining retrospect, had seemed much easier. Even to a fourteen-year-old, it was evident that Barbara's work mattered more to her than anything else. In a sense, nothing mattered except that. Perhaps this was emphasized because the children, treated otherwise more or less as adults, weren't allowed in her studio.

Ben and Barbara's friends descended upon St Ives, where, unless the place was full up with children, they were accommodated at Chy-an-Kerris. Having visitors meant that people saw Barbara's work, and kept her in touch with the world at large. Solly Zuckerman called in occasionally, both with and without his wife, Joan.★ With the outbreak of war he had become scientific adviser to the Combined Operations Military Headquarters, and at one point he and Desmond Bernal went to the Middle East on a war mission for the British Government. News and gossip was gathered and circulated. Barbara's letters are full of who was doing what among friends in the art network.

Bernal would hypnotize her by enlarging upon the mathematical and geometrical implications of her works. Marcus Brumwell, who knew them both well, remembered how they would clear a space on the floor and sketch excitedly. Barbara loved Bernal's visits. Science and social responsibility were the burning issues of his life. A dedicated Marxist, he had been for over a decade an active, card-holding member of the British Communist Party. Bernal believed absolutely in the planned Soviet society, and

★ He had married, the year Barbara fled London, Joan Isaacs, the daughter of an earl.

nearly argued her into joining the Party.* But after the war Barbara became disenchanted with Communism. Like Bernal, she could be naïve. For all their talk about the working classes, they were one highbrow speaking to another.

The winter that ushered in 1944 was a tough prelude to a tough year. Mondrian had died,† Chy-an-Kerris heard from the painter and New York art critic George Morris. Over 200 attended a service before burying him in a vast cemetery in Brooklyn, which he would have hated. Sarah was in hospital, her predicament weighing heavily upon Barbara, when a cold spell at the end of March brought a rush of bronchitis, flu and tonsillitis to add to the male indisposition – asthma. With Ben, Simon and Rachel all in bed, Barbara administered cough mixtures and lemonade, wondering loudly how she could be nurse, housewife and breadwinner. In the midst of everything, she could still rise to 'a day unique perhaps in a lifetime – everything was suspended, no sounds of planes or war, the Island a mirage between indistinguishable sea & sky. There was nothing on the beach no shell pebble or human being the tide low when I was there & complete silence.' The external world was acting and reacting upon her . . . 'there is such an unreasonable & compelling urgency in me at the moment to carve'.

Before Barbara left Hampstead, in one of the sculptures that seems to be stylistically ahead of its time she had carved a twelve-inch piece of teak into an oval, scooped out in the centre and punctured by a small hole. Lying sideways, womb-like, pond-like, *Conicoid* 1939 anticipated the process of transformation that was now inspiring her work. Since the move to Chy-an-Kerris, the aggressively weighted cubes and spheres of her Constructivist period were being replaced by ovals and ovoids,

* It is ironical that Bloomsbury, which she so despised, should have been alive to what was really happening behind the iron curtain.
† Shortly before he died, he destroyed a painting he had been working on for a year.

natural forms for conveying gentle, organic nuances. Her carvings were less compact, their interior space opened to such a degree that the inner surfaces, often dissected by cones of string, are revealed as distinctively as the outer defining surface.

Two Figures 1943 was a decisive move to new territory. The forms are slim redwood ovals, essentially vertical, just under two feet high, tapering towards the base to give a sensation of rising, and gouged into answering oval shapes. The 'male' has a phallic semblance, the stouter 'female' is pierced right through, with a cone of strings pulled across the 'womb'. The cavities spiral inwards, so that it is never quite clear where inside and outside end or begin. In these tall, dark effigies, edgy and restless, Hepworth has drawn on the transcendent merging of human beings and the landscape. Into successive ovals might be read the womb, the female, the head, the passive world of ideas; into the monolith, the male or a proclamation of physicality.

After *Two Figures*, she turned to a more overtly landscape theme.* *Oval Sculpture* 1943 was a recognizable development from the much squatter, cone-shaped *Sculpture with Colour* 1940 she had made when she first arrived in St Ives. Organic architecture might be a description for her wooden egg, carved out like the inside of a snail, with white-painted, labyrinthine cavities. Barbara made it during the worst of Sarah's illness, and it took on a votive tone. She referred to it as one of her most religious sculptures. But all her best work was 'quiet', she told Philip Hendy, though quietness certainly didn't preclude vitality. The serenity of its outer, pebble-like surface, and its immense delicacy make *Oval Sculpture* one of the most beautiful pieces she ever carved. The oval form is 'the closed form sometimes incorporating colour which holds nuances of landscape, the repose of a mother and child, or the embrace of living things'. Her sculpture encapsulates the maternal instinct and the white radiance of

* Far from being dully repetitive, she put down and picked up her themes at intervals.

Cornwall. *Wave* and *Tide*, in their various versions (there are two *Waves*, I and II, and two *Tides*) as well as *Pelagos*, developed from *Oval Sculpture*. The names of these pieces, following the purposefully neutral ones of the immediate past, confirm that, overall, landscape was replacing pure architecture as the guiding spirit. The wilderness of Carbis Bay under brilliant sunlight, and the glow from the surrounding sea, were enabling Barbara to break through the fusion of sky, land and water.

Wave 1944 could almost be a strip of material, bluntly narrowed at either end, pulled into a loose roll and kept in place by two sets of strings. It wasn't, of course, made like this. On the contrary, Hepworth's patient, passionate whittling away and hollowing out of a block of plane wood, to leave an infinitely subtle skeleton, could scarcely have been more different. To the shell-like delicacy, the perfect poise of *Oval Sculpture*, *Wave*, with its prominent sideways twist, engages powerful mobility. The exterior is sheer satin, the interior painted sky-blue. Into the form, she has trapped the surge and thrust, the rock and tumble of real waves before they are sucked back into the sea.

By mid year, news of Sarah was positive, but Ben was determined not to put up with another Cornish winter. It was possible, Barbara thought, that in future he would split the year between Hampstead and St Ives. In the autumn, he was again laid low. For weeks he kept to his bed while the rigmarole of epidemics repeated itself. They had no help whatever, Barbara fumed sullenly. It was a point at which the offer of scholarships to provide boarding-school education for the triplets seemed a godsend.

Barbara had met Dartington's founders, Leonard and Dorothy Elmhirst, on a visit with Gropius in the thirties. Even at that early date, a concern for social responsibility and zest for action had generated something between them. Dorothy was a wealthy American heiress, Leonard an idealistic Yorkshireman, and Dartington was their philanthropic dream-child. When the Elmhirsts discovered it, the 800 acres set round a beautiful medieval hall

were on the market. To rescue the estate from the crippling effects of the great Depression, they devised a large-scale experiment in rural reconstruction, an environmental and cultural scheme that incorporated a three-tier school. The idealism behind the concept in no way invalidated what time has proved to be an immensely successful venture. The estate lives on; a hallmark to quality in music, the arts, and life in Britain's countryside, while Dartington Hall school helped to pioneer much that is now accepted in education. The principle that every man is a special kind of artist was very social idealist, very Herbert Read, very Barbara Hepworth.

Margaret Gardiner had been to Bedales, from which Dartington's notable head, William Curry, had taken his cues. International and informal, the school managed with minimal rules, no corporal punishment, and a government composed of pupils. Most remarked upon, though not exceptional, it was co-educational. When Simon, Rachel and Sarah enrolled, Curry was in the middle of a twenty-six-year reign. Already his cult of child-orientated reasonableness and individual freedom had attracted the support of the left-wing intelligentsia. Margaret Gardiner and Desmond Bernal were sending their son; Bertrand Russell, Aldous Huxley and Jacob Epstein sent their children. Dartington's real distinctiveness lay in the emphasis placed upon the arts and crafts, its belief in self-expression, self-government, and using the estate as an essential part of the curriculum. Education *was* life, not just a preparation. In a decade that had lost vast numbers of youngsters on the threshold of adulthood, these values were poignantly apt.

In fact the carnage was about to end. On 7 May 1945, Col. General Alfred Jodl signed the terms of unconditional surrender. The war in Europe was officially over. Barbara stopped work to write a few letters, one to John Summerson, congratulating him on his appointment as Curator of the Soane Museum. The victory called for something impetuous, she felt. She was longing for a hair-do and a good dance. Two triplets were at Dartington;

if it hadn't been for Sarah, she'd have trekked up to London with Joan or Gabo. 'Think of me . . . putting up the damned black-out & sousing the bonfire before dark!' In the end she and Sarah spent the day alone, huddling round the radio, feeling depressed. Summerson, whose witty replies had been such a tonic during the dark years, celebrated privately around the end of the year, when Elizabeth became pregnant. Unlike her elder sister, she was aware almost from the start that she too was carrying triplets.* Three sons were born the following August.

A successful autumn show at Lefevre (October 1945) temporarily revived Ben's spirits, and Barbara, in sympathy, felt promise in the clear, warm, darkening days. For the first time in years, she was working, sleeping and eating to a 'normal' rhythm. There were still bouts of sick nursing, Sarah's 'downs' were exhausting and Barbara felt, on occasion, friendless. Work, however, was going with a tremendous rush. The following year, after a mutual spurt, Ben stopped making abstract reliefs to concentrate on still lifes and still life abstractions. The Cornish winter had its usual effect. He wasn't so sure about his work. On top of which, whooping cough and a run of bad luck were the climax to a minor breakdown. According to Barbara, it was a mixture of tiredness and neuroses. But the pattern was changing again, her work was sustaining; Ben's wasn't, and his annual threat, to leave the family, could have been touched with envy. This time, Barbara feared, he was serious. For her part, she knew she could never, for all its disadvantages, leave St Ives.

Work kept her going, day after day, in her small back garden. Meeting Barbara for the first time, Willi Barns-Graham's impression was of someone narrow-eyed, quick, neat and very alert. Barbara was the first woman Willi had come across who was entirely dedicated, and never did she, in forty years, discover anyone else who worked so hard. To visit Barbara's studio was stimulating and also a little depressing, because one felt diminished

* Joan had twins.

by the force of her power. So that afterwards, one had to adjust to one's own capabilities. Barbara and Ben were, Barns-Graham acknowledged, 'like gods' to her at the time. Sometimes one of Barbara's neighbours from Headland Road kept an eye on the triplets while they played on the beach,★ and like other children, the girls were invited to parties. But these were the elusive years. Beyond the fact that the Hepworth-Nicholsons were artists and hard up, residents of Carbis Bay didn't know much about them. Not even the other artists in St Ives were aware that within their midst was a couple gaining a foothold in the international art scene. The exception was Ethel Hodgkinson, daughter of a shipping magnate and an early purchaser of Ben's work, who used one of the grander houses as a summer retreat. Extroverted 'Hodgey', with her flood of golden hair, would occasionally be spied with Ben, disappearing along the beach.

Sooner or later, the traditionalists and the Modernists were bound to meet, and it was fitting that Borlase Smart, who had already done so much for the artist community, should be the one to contact Ben and Barbara.† Little did he realize what he had set in motion when he asked them to exhibit at the annual exhibition of the St Ives Society of Artists. First in Porthmeor Studio, then in a deconsecrated mariners' church beside the harbour, where, as something of a favour, the newcomers were allowed to put work in a corner near the font. Soon they were joined by Stokes, Mellis, Berlin, Lanyon and Wells.

In the autumn of 1946, an artist St Ives only tolerated on its own terms was packing endless sculptures for her first big post-war London exhibition at Lefevre. Now that the war was over and materials were once again at her disposal, Barbara had been in a real swing. That year she had completed nine sculptures and many drawings. Even time spent sending off work to exhibitions felt an intrusion. Stone and foreign hardwoods

★ Marion Lidgey.
† Through Willi Barns-Graham.

remained difficult to come by. More than half her carvings were in wood, and nearly all the wood was English.

The sculpture *Studio* chose for its cover is really a more evolved form of *Wave*. A sphere containing a double spiral, and generally reckoned to be one of her key pieces, *Pelagos* 1946 was inspired by the grand sweep of St Ives Bay as Barbara saw it from her study. Light catches and light plays in the whirligig of its arms, uniting stillness and serenity. It was as if she was both the creator and the form, she told an interviewer in 1960. Hoping to convey her own feeling, she deliberately set out to convey this ambiguity to the spectator. *Pelagos* distils observation, geometrical consistency and a multiplicity of associations into a form that represents her total experience up to the time it was conceived.

A sequel to the sculptures of this period is a work Barbara began making in holly some time before Lefevre. Today it is in the Tate Gallery, where it immediately intrigues because, unlike a typical Hepworth, *Tide I* 1946, a horizontal form, two feet long, with a pale, white-washed interior, is cracked and weathered-looking. Despite this it embodies, cracks and all, a strong sympathy with Cornish landscape. The wood split while Barbara was working on it. Presumably she slung it away, since it lay outside, summer and winter, in rain and snow, caterpillar-crawled, slug-slimed and green with algae for about four years, until David Lewis, helping Ben to clear Chy-an-Kerris, came across it in the hedge. Cleaned up, it was put in a box and there it stayed until Barbara died. When Ben unearthed it for a second time, he offered it to the Tate. 'And the Tate accepted it, and cleaned it, and put it in a glass case, and made a colour postcard of it.'

Affected by the country, but also keeping it in its place, Hepworth maintained her authority rather than letting it dissolve in sensations. This was quite an accomplishment considering its potency. Following Rilke's example, she was breaking down the normal distinctions between self and world, inside and outside. Seeking that illuminated space of the mind that Rilke craved, with a centre so translucent and so infinitely permeable that he

could fall right into it, she had taken the whole of existence inside herself.

Barbara was also reading Jung, she told Read. From something Read had written about Moore, she extracted what seemed to her a vital phrase, 'A life of forms', reflecting, 'These 4 words seem pregnant to me of everything that matters – the full reality of sculpture. Sculpture is "reality" for me . . . because sculpture has its own intrinsic power, it has natural laws, obeys them & yet rises above them – it has power over fields hills & men & the air above & around & it seems to me that there is no limitation on this power or vitality . . . I think *you* touch on the significance of forms in themselves just in the right way. It is a mysterious thing & you give the feeling of their past & future meaning which can only be apprehended as you say through the collective unconscious.' She was making the process of form, inner and outer, conscious or unconscious, a metaphor for inner and outer life.

Moore had a show at the Leicester Gallery which coincided with Barbara's at Lefevre. She preferred his stones to his wooden carvings apart from the *Northampton Madonna*, which, being realistic, she didn't like at all. Nor did she like those in lead, though she thought a series of war drawings were 'magnificent'. Under the direction of Kenneth Clark, Chairman of the War Artists' Advisory Committee, Moore had made a moving series of drawings in the underground shelters. 'Less grim and more abstract,' Maurice Collis wrote in the *Observer*, comparing two sculptors from Unit One recognizably in a class of their own. 'Barbara Hepworth is an extraordinary artist.' Patrick Heron pitted Moore's 'human life and trouble' against Hepworth's 'impersonal, sad' perfection. But it was quick-thinking, bird-like Helen Sutherland who gave, in private, the real measure of what Hepworth's sculpture meant to someone as receptive as her. 'Her great mastery, purity, tensions and intentions, the wonderful quality in the workmanship with the material, yet this technique is beautifully held in its rightful place – no more. The sculptures give me a new grasp of what *Form* is, the miracle of it and the

mysteriousness. These carvings seem as it were like a tiny mirroring of the whole vast Act of Creation – they are made in the same image – they give one a fascinated glimpse and hint into this strange Fact of Form and Order seen as mighty (and) spiritual . . .'

Barbara's exhibition at the Lefevre Gallery was a barometer to her future. Rectangularity had given way to flowing movement, carvings with impeccable surfaces had rounded masses often penetrated by interior space. Exterior enwrapped interior forms, making shapes within shapes.

Gabo finally left Britain at the end of the year, an event in which Ben and Barbara have been implicated ever since. He had remained in Cornwall throughout the war, making his transcendent geometries, broadcasting for the BBC, and writing articles. But he had always been out of place in St Ives, besides, he was selling very little work. Often he was depressed about it, and after more than seven years he had had enough. Four years after his first abrasions with E.A. Ramsden, he was still making accusations against her. Naturally, there had been competition between him, Barbara and Ben. All three were touchy about 'borrowings' from each other's work, and Gabo could work himself into a quick fury. Some took his side, some took the Hepworth-Nicholsons'. Peter Lanyon was to suggest that Barbara and Ben did some awful things to promote themselves at Gabo's expense. But Lanyon's relationship with Chy-an-Kerris was notorious, and St Ives grew thick with unproven stories. When Gabo first saw the Hepworth sculpture on the John Lewis building, he is said to have shouted, 'That's mine!' The fact that Bernard Leach and Adrian Stokes sympathized with him suggests that suspicious and emotional though he was, he had at least a valid stand. What he didn't do was leave St Ives because of a quarrel. The chief reason for going, Gabo told Norman Reid, was to sell his work. When Adrian Stokes and Margaret Mellis left separately, for new lives, there was further depletion of the advanced guard. The difficulty with so many competitive people jostling

for reputations in a closed community was in the tensions that grew, burst, and finally drove many artists to new shores.

Herbert Hepworth had won a CBE in a rush of post-war honours that must have sent a ripple of pleasure through the Hepworth family. To cheer up the dreaded Cornish winter, butter-conscious Ben had persuaded his American dealer, Curt Valentin, to send parcels of food. Rations simply didn't go round, he explained. The fat allowance was even smaller at the end of 1946 than it had been during the war. From Prince Overseas Relief in Fifth Avenue, New York, untold goodies had begun to flow. At each opening the Hepworth-Nicholsons blessed the name of Valentin. George Morris was also sending parcels from the US with nylons for Barbara.

CHAPTER THIRTEEN

A More Human Aspect

(1947–9)

The first chilly months of 1947 were dominated by the Waterloo Bridge competition. London County Council had invited Barbara to enter a limited contest for sculptures to grace the base of the plinths, and determined to win, she sat for hours beside the Thames, shivering on the stone balustrade, trying to relate the architectural and sculptural scale to the people passing in their thousands, under or over, trying to resolve the scene as a purposeful ebb and flow rather than the nerveless scurryings of modern life. 'Working for a site was, for a sculptor, almost reason personified,' she said. The only way to devise public works was to immerse herself in the setting and evolve a form which seemed to be appropriate.

Maquettes for four sculptures were duly produced. Scale being all-important, Barbara was to own later how ridiculous her tiny recumbent abstract figures had looked. It was impossible to transfer from one medium or size to another, she stressed. That was why she didn't use small-scale working models. Nevertheless, at the time, she thought she had a fair chance of success. George Morris, who'd seen photographs of the various entries in the press and had sounded out his New York friends, said the general consensus of opinion was that she would beat Henry Moore. When the competition was called off, Barbara was furious. All she had to show for her pains was a bad bout of bronchitis. Yet the exercise had probably been instructive. It all tied in with a burst of figure drawing.

Always, she'd been drawn to the ritualization of figures in movement. When Elizabeth and John Skeaping's sister were

training for the ballet, she had sometimes accompanied them, to sketch dancers practising. So again, towards the end of the year, she began using ballet dancers as models, inviting them to wander around her studio rather than take up rehearsed poses, drawing either in pencil, or on boards prepared with scumbled oil paints, in muted colours, often scraped and rubbed off as the drawing proceeded. In strong, free studies, using a pure quick line, with the merest scribble for shading and no correction, she would catch the gentle rhythm of a girl, or a woman kneeling over an armchair. The surety of line is remarkable. With little attempt to convey the three-dimensional quality of her early drawings, but with what Alan Bowness calls a search for rhythm, Barbara drew the outlines of the human body with the same total confidence with which Ben drew the landscape. Over the next three years she was to produce an enormous number of sketches, of which the simplest are often the most beautiful.

Looking back, it is easy to see how one thing led to another. Barbara's originality lay in her capacity to visit the outer reaches of her imagination, dredging, from the bottom of the unconscious, poems, archetypal images and Rilkean themes of subliminal metamorphosis. There was the Waterloo Bridge competition, Moore's figure drawings, above all those of miners, and her preoccupation with human form. All these threads, converging in such a way, at such a time, brought her to the brink of the next endeavour. Moore's figures weren't so much life drawings as Dantesque, personalized visions, more fragile and human than his carvings, and, unlike his drawings for sculpture, representational. For the first time he depicted drapery, and in a way that was clearly reminiscent of his old infatuation with Masaccio. Above all, his drawings illuminated a social issue. To Barbara, with her heightened social conscience, they were extraordinarily powerful. They, as much as anything, must have prompted her to ask her surgeon friend, Norman Capener, whether she might watch an operating theatre in action. The idea sprang partly out of her admiration for Capener, and during what Read was to

call, a new phase, Barbara's forms took on a 'more human aspect'. All her work was affected, every new experience somehow sucked in to her purpose.

Capener, at the crest of his career, was one of the well-rounded men one discovers in the higher ranks of medicine. Not only had he scaled the professional ladder, he painted and collected, discriminatingly, contemporary art. Sternly handsome, and thoroughly receptive to Barbara's theories on art and society, Capener was the husky man she didn't have in real life. Barbara, in her mid-forties, was not the stunningly severe and beautiful woman she once had been. But there was distinction in the care with which she dressed and the quaintly dated style in which she did her hair. She could, by her attentions, charm and flatter. In Capener, she sensed the high-minded dedication that suited the knight to her mission. The stage was set for an operation Capener was to perform at the Princess Elizabeth Orthopaedic Hospital, where Sarah had once been a patient. Barbara would be allowed to watch. Friendship was blossoming into a cerebral romance.

She was challenging unknown territory and this was one of her greatest strengths. Any reservations she had before watching the operation were quite dispelled by the time she emerged, amazed and uplifted, from a ten-hour session in the hospital theatre. In the dignity, sense of purpose and gestures of nurses and surgeons directed towards an altruistic cause, she found grace, rhythm, efficiency and economy that perfectly harmonized the physical and spiritual elements. Just before the end of the operation, happening to look into the great spotlight, she saw in its projecting hemisphere the entire scene, intensified and distorted so as to be barely recognizable. From the central cicatrix radiated heads, arms and hands, a spontaneous composition that turned the figures into a profoundly sculptural representation within the space of the theatre. A chance optical trick had brought about an experience similar to the slip of consciousness she had only, ever before, experienced in the countryside. Quite suddenly she was, as it were, a participant, inside each separate figure. So

strongly did she, personally, identify with the enclosed world about her, that she drew herself, masked and gowned, in one of her scenes.

Barbara returned many times to watch operations in various hospitals, sometimes in Exeter, sometimes in London,* standing on a box with a pen and a sterilized note-pad, to get a better view. Like Moore in his shelter project, she drew with the memory of what moved her fresh in her mind, imbuing human emotion with visionary intensity. High drama, co-ordination and immaculate precision are what she revealed. When an operation reached a particularly delicate stage, the bodies of the team inclined in suspense, their eyes grew wide, their hands took on more urgency. Tensely involved eyes peer, like Muslim women's, eerily over anonymous masks. In the hieratic pose of the surgeon, and the monumental, Masaccio-like stillness of bodies cloaked in aseptic masks and overalls, Barbara found a startling contrast with the dynamic movements of the hands. Of more than fifty medical studies, some depict a team in action, others close in upon hands at work on a complicated bone operation. Rilke invests the hand with metaphysical significance, using the image not only to embody artistic creativity, but also to give expression to his unproductive periods. Like the images in his poems, the hands in some of Barbara's drawings are detached, their auto-nomous function symbolizing a bridge between life and art. By contrasting the surgeon's manipulating hands with the exposed hand of a patient, she was symbolizing the creative inspiration and its underlying, unconscious control.

Masaccio had obviously been invoked. The drawings even have the quality of a fresco. Like Masaccio's figures, the white-swathed sisters and surgeons are static, imposing, and beautifully modelled. In Masaccio, but not much before him, hardly even in Giotto, you get feet standing firmly on the ground. But even Barbara's drapery is reminiscent of the Greek tunics Masaccio

* The National Orthopaedic Hospital and the London Clinic.

painted★ in Florence's Brancacci chapel, where she'd felt his powerfulness many years before. From Masaccio she had learned about the arrangement of figures in horizontal lines or a circular pattern, because to the classical Quattrocento, the circle symbolized perfection. Moore was hardly less evident. Both his miner and his shelter drawings had been absorbed. Miners hacked away at rock, their tunnels corresponding to sculptural cavities in the same way that the surgeon incised and cut up flesh, while the sleepers' hands, in some of the tunnel drawings, answer the rhythmic curves in the drapery in the way that Barbara's figures transmit a flowing horizontal movement through hands, fitting and smoothing on surgical gloves.

More than once, Capener stayed at Chy-an-Kerris. In an involvement the precise nature of which kept Barbara's assistants on tenterhooks, each was an inspiration to the other. Barbara modelled his right hand – a custom among surgeons – not smoothly, but applying clay in lathes with a wooden spatula, producing a copy that combines great strength and great delicacy. In a token of friendship she was to extend to two other professional men, she encouraged Capener to take up sculpture. By inviting him into her studio and lending him tools, she was sharing the most sacred part of herself. Capener exhibited in St Ives for over twenty years, often using the name Noël Carne, and he reached the finals of the 'Unknown Political Prisoner' competition in 1953. In a vote of thanks for all that Barbara had been and done, he wrote the foreword to her exhibition at Lefevre. It had taken a rare artist, one equipped with stamina and vision, to realize the mystery of one of the great dramas in medicine.† Still figuratively wearing his mask of secrecy, he signed his contribution 'A Surgeon'.

The *Wakefield Express* called the theatre drawings 'unusual',

★ In *The Tribute Money*.
† Capener thought Barbara's work had a striking relationship to Bach's more abstract music.

the *Tatler* reckoned they were 'something of a sensation'. The *Scotsman*, which had levelled some pretty uncomplimentary shots at Hepworth in the past, discovered, ambiguously, a sense of 'bigness and achievement . . . that is absent from the sculpture and drawings for sculpture'. Infinitely more important to Barbara was Read's devoting a page of the *Listener* to what she felt was just the right note of empathy. Twenty drawings were to be exhibited in what was to be her first single show in the US.*

Lefevre's next show was of fourteen sculptures and thirty-nine drawings, bringing attention to the fact that although Barbara sometimes disapproved of others' realism, she was working simultaneously in realist and abstract styles. Read thought the 'monumentality' of the surgical series told of an artist who understood abstract form. The early Italian artists, who had also shown this quality, were highly aware of the abstract principles in architecture. Quizzed by him about this, Barbara declared that she wasn't aware of any difference in her intentions or mood which might determine the outcome. Sometimes she didn't even know, when she picked up a pencil, which style would assert itself.

Once engaged, however, the processes did raise different sentiments. Drawing in the abstract was an adventure, because there was no guide except her mood. Mood absorbed the texture and colour of the surface, at which point the first line or curve, with its characteristic bite, opened a world of possibilities. Drawing from life was almost the opposite. Every known factor was filtered and selected: which makes it sound rather like the difference between writing fiction and non-fiction. 'It all feels the same – the same happiness & pain, the same joy in a line, a form, a colour – the same feeling of being lost in pursuit of something. The same feeling at the end . . .' 'Working realistically replenishes one's love for life, humanity & the earth. Working abstractly seems to release one's personality & sharpen the perceptions.' A highly abstracted sculptural shape might develop in her

* October 1949, Durlacher Gallery.

imagination, human parts and purpose, a surgeon might become a monolith, or looking at landscape, quite unconsciously, she would transform what was in front of her into an abstract carving. Barbara's imagination circles a subject lovingly and melts into it. Rilke told her that without human presence there *can be* no conception of landscape. Transition and metamorphosis become constant characteristics.

Sometimes the place-names of Hepworth's sculptures are simply symbolic. *Pendour* 1947, however, was directly inspired by a cove of the same name that lies to the west of Zennor Head. At this spot, the sea has eaten away the rocks, forming a maze of smooth-sided tunnels and caves. In concept, *Pendour* developed from *Oval Sculpture* 1943; in character, it looked forward to a looser, more organic interpretation of the surroundings. Where *Oval Sculpture* resembled the inside of a snail shell, *Pendour's* excavations – accentuated with white and pale blue paint – are the cool inner surfaces of caves. Its wooden lacunae echo with the sea's sighing. The human presence is not depicted as much as contained.

Two Figures 1947–8 was another new rendering of an old theme, one, moreover, that clarified just how relaxed and flowing Hepworth had become since her previous work of the same title five years before. The piece represents, as two forms always did, the relationship between two living beings. All round Barbara were the prehistoric standing stones of the Penwith peninsula; watchful pillars and circles taught with ancient magic, lichen-encrusted relics of burial mounds, cinerary urns that had opened to the sky on gorse-covered moors for thousands of years or more. These images and the concentration on the human figure dominating her drawings were taking her sculptures, from about this time, into a more humanistic phase.

Two seminal pieces from the late forties, *Biolith* 1949 and *The Cosdon Head* 1949, centre specifically on the relationship between man and woman. *Biolith* follows naturally from its predecessor,★

★ *Eocene* 1949.

in which a cowled, nun-like face inhabits, mesmeric as Rodin or Medardo Rosso, three feet of Portland stone. But *Biolith*, being more abstracted, more intellectual, has a unique character of its own. Into an almost oval sweep of blue limestone, Hepworth carved a curvilinear basin, of which the inner edge makes the profile of a face. One side (the female), secretive, withdrawn, is part of the basin; the other (male) side is the surface of the stone (a conception clearly taken from Ben's *St-Rémy, Provence*). Professor Hodin read into *Biolith* the liberationist message that men and women have equal contributions to make to life. What Barbara said at this point, on the subject of emancipation, is that art is beyond sex.

The Cosdon Head also bears a common profile between two planes, to make male and female faces. Squatter, denser, heavier, more intrinsically pebble than *Biolith* (which is pierced right through), *The Cosdon Head* is, by its grandeur and simplicity, even more striking: a being less part of life than of mythology, a hero, prompting the reflection that Rilke's heroes don't require praise, their fame lives on among men. A teasing sophistication underlies perceived bluntness. The profile is highly accentuated, while the face fuses indefinitely into the pebble. The perfect circle of the male eye is slightly forbidding, beholding without actually seeing, while the female eye, engraved in the surface of the stone, accepts and complements. Like some of Barbara's earlier sculptures, *The Cosdon Head* is engraved with a human hand as well as an eye. Hewn from a singularly intractable metamorphic rock, it was an elegy to a rare and precious friendship with Norman Capener. 'The very nature of my tussle . . . gave the whole carving a quality of some giant pebble worn by centuries of waves beating on it.' Male and female speak through the medium of stone.

Shortly after *The Cosdon Head*, Barbara carved a birdlike monolith engraved with two human profiles★ that has the same

★ *Dyad* 1949.

magisterial quality as Brancusi's *Maiastro* 1910–12. But the theatre drawings had led her back to the study of anatomy, to the human figure and integrated groups of figures. This was the spirit in which she carved the statuesque image of *Bicentric Form* 1949–50, which harks back to her thirties attraction to sculpture from ancient Egypt. In fact, the conception was taken from a life study of two standing girls, side by side, with trunk and limbs fused, seen so as to overlap each other in a single outline. In more than five feet of blue limestone, the figures blend as they seem to in dance, into a single rhythmic form. Fused, they become rock.

For an artist of Barbara's reputation, her working facilities had remained extremely modest. At Chy-an-Kerris she could carve outside, and there was a perfect view. She spurned, anyway, mechanical labour-saving devices or automatic tools. But she hadn't got basic amenities. Neighbours objected to the noise of hammering, and always the wind blew, so that out in the yard, beneath the little glass shelter, it seemed colder than anywhere else. Work was at strife with the domestic scene. It was not fair to the children or to herself. At fifteen, the triplets were virtually adult in size, numbers swelled, moreover, during school holidays. Once again, Barbara began to complain that the architecture of the house was wrong. Ben had acquired a studio in St Ives, overlooking Porthmeor Beach. The time had come for her to have one too. It was Marcus Brumwell, the communications man, who alerted her to the sale of Trewyn Studio, stone-built and stone-walled.★ The minute Barbara had seen it, her whole life and work seemed to hang upon its acquisition.

The studio stood on a steep incline a few hundred yards from the harbour, in the part of St Ives that divides the old town from the new. Behind its walls sprang mature trees and rose-beds in a pretty subtropical garden overlooked by the yellow granite parish church. Lots of people were after Trewyn, and Barbara, who loved it intemperately, didn't think she would get it. Before the

★ It had once been a part of Trewyn House.

auction, she worked herself into a frenzy. Persuaded, nevertheless, to go along, she entrusted Brumwell with the bidding. She would motion to him when the price had risen beyond what she could afford. This never happened, because as soon as the first price was called, already beyond her means, Barbara added to the drama of the occasion by fainting. But the first price was never reached, and the studio became hers. To offset a worrying financial burden, she had proper space for carving and preparation, space for display, and a glorious light coming off the sea. Still living in Carbis Bay, she began to travel daily to and from Trewyn by taxi. So perfect was the atmosphere that she started a new carving her first morning there.

One change had followed upon another. Apart from the odd bit of roughing out Jack Hepworth did for Barbara when he was apprenticed to Moore, she had managed single-handed until the spring of 1949. Shortage of room, money, reluctance to jeopardize control, and uncertainty about what her relationship with an employee would be, might all have been contributing factors. But the chief reason was that she wanted every touch to be her own. She was afraid that employing assistants devalued the work. Something must have made her change her mind, since one day's trial found her employing Denis Mitchell at first three days a week, then every weekday.

Mitchell was thirty-seven when he started working for her on the recommendation of Bernard Leach. A smallish, genial Welshman who had renovated cottages and run a smallholding with his brother since arriving from Swansea some twenty years earlier, the war put him in a tin mine, hewing rock and handling tools. This experience, a long-term interest in painting, a wife to keep, few qualifications and very little money, had drawn him to the job.

Barbara wasn't placid enough to be a good employer. The sixteen assistants she had, in all, held her greatly in awe, from which there was rather a narrow gap to being frightened of her. She 'was and she wasn't' tyrannical, Denis Mitchell explained

ingenuously, meaning that she had her own way of dealing with them. In effect, she worked her assistants as she worked herself – like slaves. She didn't find it easy to delegate and her dogmatism made her difficult. Reactions varied. All those who worked for her admired her professionalism. In some, this admiration spilled over into a personal devotion. Not all, however, enjoyed the experience. It was Rilke's thesis that we must try to achieve the greatest possible consciousness of our existence, giving ourselves to all that is beyond self. Barbara took this fairly literally; her fastidious intellect would accept no compromise. Nothing should be allowed to interfere with the control over her emotions that was a prerequisite for working. She didn't like upsets, and three out of her sixteen assistants were fired for sticking up for their views.

One result of employing assistants was increased integration with the expanding Modernist section of St Ives artists, among whom Barbara and Ben were gradually taking a lead. Their activity belied their numbers. Bryan Wynter and Terry Frost were both newcomers. Wynter was holding solo exhibitions at the Redfern Gallery in London, showing small gouaches of rural subjects with occasional melodramatic undertones, and Terry Frost was doubling up as a waiter while he worked on his famous series of rocking boats. Both were among the seventeen to exhibit alongside Barbara Hepworth in the spring of 1947, once again, in the crypt of the New Gallery. Relations between traditionalists and Modernists were inevitably suspicious. From the former came rumblings of dissent that were going to result, a year later, in full-scale rebellion. The death of Borlase Smart brought temporary quiescence. But Alfred Munnings replaced Smart as President of the St Ives Society. It was his attack on the works of Matisse at the Tate Gallery that incited St Ives's 'advanced' group to action. Clearly they needed their own platform.

Barbara and Ben were among the nineteen founding members of the new group, called the Penwith Society to indicate a wider

catchment. Unlike the old group, the 'Penwith', as it came to be called, included craftsmen and lay members; quickly, it defined itself by inviting Herbert Read to be President. From the start, Barbara took an active part. It was her suggestion that the hanging committee – which was where the power lay – should be made up of craftsmen, sculptors, modern and traditional artists, in equal numbers. Members could choose to which section they belonged, mark their work and vote accordingly. Six months later, in an effort to raise the standing of the Modernist section, Barbara and Ben wanted the categories reduced to three, one representational, one abstract and one for craftsmen, 'A', 'B' and 'C'. The reaction was immediate. Amid strong objections to being sheep and goats, local papers wrote of 'vindictiveness' and 'intrigue'. Old patterns were being repeated in the art community.

The Penwith was built on dangerous foundations. Thrown together for mutual benefit, its members were wary of each other's self-interest. Several were going so far as to avoid each other socially. Leach had withdrawn from Ben and Barbara since the Gabo episode. Sven Berlin had his own reasons for being dissatisfied and, later, he wrote a book about them.* Peter Lanyon, once Ben's acolyte, returned from the air force† with an intense reaction to what felt like being bossed. No longer did he take kindly to interference of any sort. Quite suddenly, the poet Sydney Graham's 'uneasy, lovable man' needed to free himself. Besides, he had played an active role in setting up the Penwith, a contribution promptly undermined by Barbara and Ben. In an atmosphere of intense internal politicking, there were too many suspicions, too much gossip and too many taking sides.

A different set of complications was to dog the efforts of London County Council to run a series of outdoor sculpture exhibitions in their magnificent parks. 'Sculpture was public,'

* It was withdrawn after four successful libel actions.
† He subsequently played down his debt to Nicholon, and played up his debt to Gabo.

Barbara had argued towards the end of the war, 'it must be exposed to viewers.' In her estimation, sculpture belonged, *a priori*, to landscape and this was a very positive gesture from the LCC. In all five exhibitions between 1948 and 1960 she was represented. By 1949 she had joined an advisory panel to select exhibits. The shows got off to a dynamic start but by the sixties, the diplomatics of combining the views of Royal Academy, Royal Society of British Sculptors, Arts Council and British Council had proved beyond the means of the organizing committee.

It was Barbara's fate to have a clear mind and the courage to follow her convictions, even if she had to pay an emotional price. Always she seemed to have problems, and always she needed sympathy. When Cyril Reddihough brought his young wife, Oona, to meet old friends in St Ives, Oona went for a drive with Ben while Red had secret talks with Barbara. Barbara wanted to discuss things with Red alone. Ben was another problem. The death of his architect brother, Kit, in October 1948, in an international gliding championship, was a blow he had to contain. But rather generally, Ben had got fed up with Barbara's craving for reassurance. No longer could he be relied on for sympathy. This, by great good luck, was the point at which Frank Halliday, his wife, Nancibel, and their flaxen-haired son, Sebastian, moved to St Ives and into Barbara's life. Befriending Barbara was a taxing thing to ask of all but the sturdiest, but the Hallidays looked like sturdy people. Above all, they were a 'proper' family. She had found two immensely sustaining people to support the last third of her life.

Frank Halliday came from Bradford.★ Upstanding, hard-working and intensely disciplined, he was described by his son as quite likely to have gone to his grave without knowing who the Beatles were. Both his parents were 'innocent', Sebastian reckoned, a word that was used more than once in describing Barbara. Halliday had been a schoolmaster at Cheltenham until a

★ His father had been a cotton warp dresser outside Wakefield.

couple of successful books on Shakespeare prompted early retirement. In St Ives he planned to paint during his spare time, and write some more books. Nancie wore her hair in long plaits, wound, Quaker-fashion, round her head. She would do what she had always done, look after Sebastian and Frank. In marriage the Hallidays' roles were clearly defined. The woman paid deference to a reticent, self-critical, high-minded male. It was what Barbara respected, complete with conventions, seeing in it a paradigm of her parents' marriage. Nancie being a Christian Scientist rather completed the picture.

The brilliant Christmas Day★ that the Hallidays walked along the beach to Chy-an-Kerris was described by Frank as his first real meeting with the Hepworth-Nicholsons. In the orchard he had left three bullfinches, on the shore he passed three seals, and at tea he was confronted with triplets. Sebastian, too, remembered that Christmas, and several after, at his home, where the same group congregated for conundrums and other party games. At Chy-an-Kerris, he played ping-pong with Ben,† while Barbara sat in her first floor studio. Sebastian got to know Simon, who virtually shared his home during the next few years. Barbara's relationship with the Hallidays assumed an increasingly important role because the human being who mattered most to her was slipping away. Change was all about her, beneath the surface.

★ 1948.
† During school holidays.

Love and Magic

(1950–52)

Would Barbara Hepworth have reached the summit of whatever she had chosen to do, given her drive, her capabilities, and her father's conditioning? 'It does not matter what you choose,' it is said in Olive Schreiner's *Story of an African Farm*, 'be it a farmer, businessman, artist, what you will – but know your aim, and live for that one thing. We have only one life. The secret of success is concentration; wherever there has been a great life, or a great work, that has gone before. Taste everything a little, look at everything a little; but live for one thing. Anything is possible to a man who knows this . . . and moves straight for it.'

Barbara reckoned she had been born to sculpt, precociously equipped with conceptional and tactile powers. This clarified her direction though it by no means eased the way. Some wait a jolly long time for their deserts, she was to reflect. At last they were arriving. After the next three years, with exposure like the Venice Biennale and the Festival of Britain, with work in the Tate Gallery and Read's glamorous monograph, life would never be quite the same again.

That a time of winning should also be a time of losing wasn't irony so much as logic. Personal relations had sustained a lot of tension. Ben had shared twenty-two struggling years. He had his own worries besides coping with what made Barbara, as someone in St Ives remarked, like a quivering violin string stretched out to the point of highest tension. She had built up a champion persona who was difficult to live with, and it hadn't been working for Ben. As far as he was concerned, marriage was a limited contract. When tensions threatened beyond a certain point, it was time to move on. Over Christmas 1949 they agreed to part.

Friends and acquaintances invariably had their own angle on the separation. Denis Mitchell, who was with Barbara throughout this period, thought Trewyn was responsible. At first she went daily by taxi and returned at night, then she began sleeping at Trewyn. Soon she spent weekends there as well. Yet Trewyn was only a synonym for work. An *idée fixe* can be a limitation. Seeing art as the great sacred thing itself, however far-flung her natural horizons, Barbara couldn't escape a form of tunnel vision. She worshipped and needed Ben, but she shut her eyes to signs she afterwards felt she should have heeded, would have heeded, had she been less bent upon her own ends.

Much of the bickering in the last years at Chy-an-Kerris centred on trying to combine domestic and working quarters. Barbara felt that being cramped was preventing her work from developing, and Ben objected strongly to what felt like encroachment. Reddihough thought he had a case, but heard largely one side of the argument. Ben could be mischievous and rather a womanizer, at the same time as being proprietorial. He couldn't accept any form of romance on Barbara's part. Then money became a pretext for everything else. Money governed time, energy, security and, by inference, success. A lifetime's scraping, moreover, had left Barbara insecure. Would anything tangible have held them together? Weren't money and space symbols of the competitiveness that was building up between two intensely ambitious artists? Ben's reputation, as he was the elder, had always been that much more advanced, but Barbara, he could scarcely have been unaware, was catching up. He was frustrated if he thought she was working away at full capacity and he wasn't working well. If people didn't appreciate her work, Ben wrote to them and complained, yet he resented her being sent to the Venice Biennale instead of him. There were even commissions he seemed not to want her to get. By no means was it coincidental that the two parted company as Barbara achieved public recognition. What people in St Ives didn't realize (their relations were the talk of the town) was that difficulties had been building up

for years. Winifred had spent too much time with her children; Barbara spent too much with her work.

It was a depressing time. Ben accused Barbara of taking things from him, Barbara thought Ben managed the finances to her detriment, so Chy-an-Kerris had to be dismantled by two people who weren't on speaking terms. Barbara moved permanently to Trewyn, the seventeen-year-old triplets took quarters in a cottage almost opposite, and Ben found a house a few minutes' walk away, overlooking the harbour, on Salubrious Place. Barbara often saw him. Finances mattered, the children mattered, she still loved him, and didn't want to be alone. Not long after the break, she tried moving back. It didn't work. To create the freedom which nourished his work, Ben was better off alone. Photographs of Barbara at the Wakefield retrospective show a face full of misery.

Various readjustments took place in both their lives. Ben spent many an evening with Willi Barns-Graham and David Lewis. By day he played ping-pong or tennis, in a white singlet and baggy trousers, with Frank Halliday. If Ben's score was down he replaced the net with a plank. Barbara was leaning increasingly on Nancie, who loved and looked after her as uncritically as she loved and cared for Frank. Such cultural assets as Nancie Halliday had were really acquired from her husband, and this was different from Barbara's other friends. Barbara admired Nancie's goodness and her marriage. She could rely on her, trust her, respect her, and feel comfortable, knowing that she wasn't being judged. Barbara used Nancie; Nancie knew this and didn't mind. Three or four times a week she padded into St Ives on foot because it was difficult to park. It was easy for her to drop in at Trewyn. The need was mutual. Sebastian, an only child, had effectively left home, leaving a gap, and Barbara badly needed support. Her marriage was dissolved in the first months of 1951.

With Frank, Barbara had a separate, intellectual relationship. Frank's influence was the only consistent male background the triplets were experiencing, and this was suddenly supremely

important, because Ben wasn't going to look after them and Barbara was pretty uneasy about the sort of care she was providing. The Hallidays shared a sense of family. Simon spent a lot of time with them and Sebastian became, for a couple of summer holidays, Barbara's unofficial apprentice. Like Anne Ellis, Sebastian recalled being treated as an adult by Barbara, whom he enjoyed being with. John Wells and Terry Frost had joined Mitchell to work on two stylized figures for the Festival of Britain, a male and female, rapt in a moment of perfect consciousness, their masses seen as if in a dream. While they were chipping away at the dominating *Contrapuntal Forms* 1950, Sebastian chopped up bits of stone.

Leach, who was fast becoming the greatest name in twentieth-century pottery, had intermittent marital problems and liked an audience. Sometimes he turned up at Trewyn after 5.00 p.m. to find David Lewis or Barbara's musical friend, Priaulx Rainier, a composer of music so spiky that William Walton wondered whether she wore barbed-wire underwear. Priaulx, who adored Barbara, was, like her, essentially a career woman. Born in South Africa, she divided her life between lodgings in St Ives, and Notting Hill. In London she extended hospitality to a trail of political refugees. Michael Tippett, who loved her regardless of her impracticalities, felt that she was inclined to make things difficult for herself. Some found her a little alarming, but young Halliday saw her as an enthusiastic woman who laughed a lot.

In bizarre complement to their private lives, Barbara and Ben stood united at the Penwith while all around them were in disarray. These were the 'topsy-turvy' years. Nominally, the chief cause of resignations, backbiting, scandals and floods of indignant letters to the press was the divisive ABC grouping they had been instrumental in establishing. The real issue was Ben and Barbara's threatening to take control. Peter Lanyon saw their ruling as preoccupation with ideas at the expense of people. Ironically, Lanyon's plea for tolerance between traditional and modern artists wasn't evident in his stand as a Cornishman

towards outsiders. In what became a permanent rift between Ben, Barbara and himself, for some reason, Barbara took the brunt of his anger. Lanyon had a total commitment to painting and to radical causes, boundless energy and a wonderful rapport with the landscape. It was as if sharing so much emphasized the contrarieties symbolized by their art. Lanyon (the romantic) expressed as vividly as possible feelings aroused by fragments of his experience. Barbara (primarily a classical artist) was trying to relate her experience to a more enduring order. The quarrel was agitated by Lanyon's horror of being patronized. It was very painful for Barbara because Sarah and Rachel had been flower-girls at his wedding, and she had loved him as a son. Battles that mattered inordinately at the time were, one sees in hindsight, like Ben and Barbara's private ones, about freedom and competition, high stakes, jealousy and strong personalities.

In St Ives's maze of narrow streets, everyone ran into everyone else. Pleasures were shared; sores rubbed that time and distance might more gently have healed. Sense of neighbourhood co-existed with lack of privacy, artists smouldering from real or imagined slights met in queues for bread. Temperatures ran high, rivalries simmered, yet the Penwith gathered strength. Ben and Barbara didn't play skittles in the Sloop Inn, but metaphorically as well as physically they had established central positions. There are artists working today in the neighbourhood who remember the frenetic excitement of a new exhibition at the Penwith Gallery during its early reign, the anticipations and expectations when art that was being produced fought for recognition among international contenders.

David Lewis was the second South African refugee to be caught up and bowled along by the thrill of St Ives. Lewis had moved to Zennor with his ideals, his books of poems and his as yet undefined cultural yearnings. Discovering Barbara through Lanyon in 1948, and being as penniless as most of the artists, he had found himself, a few years later, employed by her for several months, cataloguing and photographing sculptures for Read's

monograph. Increasingly conversant with Barbara's work, he wrote the catalogue notes for the Venice Biennale and a number of articles about her in prestigious magazines. Lewis was being cultivated, the grapevine rumoured, as Hepworth's future biographer. Through his friendships and his marriage to Willi Barns-Graham, he had become part of the artist community, the perfect choice, when the Arts Council came up with a grant in the spring of 1951 to fund a full-time curator of the Penwith. For three years, Lewis became 'the knot that tied everybody together'.

More and more people were going to the Penwith shows. Things were 'really vital down there', Barbara wrote to Lilian Somerville, Director of Fine Arts at the British Council (FAAS), as part of her unremitting efforts to entice anyone useful to the art community. In a tiny colony at the extreme south-westerly tip of England, something unique in the history of the twentieth century was happening, a phenomenon to which Barbara Hepworth contributed, over the next twenty-five years, tremendous leadership. International politics had catapulted figures like Gabo and Mondrian to London. Within months Gabo had joined Barbara and Ben in St Ives. The Europeans passed on, but Hepworth and Nicholson stayed, becoming the centre of a group of modern artists. Bernard Leach had arrived first. Leach combined Western tradition with the consciousness of the East to wring an altogether new poetry from clay. In the end, he and Barbara would outstay most of the artists. Are there, as Patrick Heron has suggested, such things as magically significant spots of the earth's surface? Heron had worked in Leach's pottery. Better known at the time as a critic than a painter, he was accused of making extravagant claims on behalf of the art colony he had joined.*

* To Heron there was no sounder proof of St Ives's importance than the fact that New York dealers were visiting the Penwith shows, and artists associated with the town had dominated post-war exhibitions in the US.

The precise significance of the St Ives artists is something time is still evaluating.

Decorating the gallery and hanging awnings in the street were the Penwith Society's contributions to the Festival of Britain celebrations. Barbara Hepworth won a joint prize for a whitish carving in Portland stone that stands about two feet high. Neither pebble nor monolith, but somewhere in between, broad at the base, narrow at the top, *Rock Form (Penwith)* 1951 has the silhouette of an Arab in national dress. Inside its curved, excavated centre, 'lifted' by the flow of space passing through a hole directly beneath it, was a large incised profile cut half an inch deep. The first *Penwith Broadsheet* showed a photograph of Barbara with her new sculpture on the front cover. Read didn't like the work, in so far as he could tell from the illustration, his criticism rounding on the uneasy mixture of naturalism and abstraction. In its context, the profile looked 'decorative'. Adverse comment called for an immediate defence. The profile had been prompted by an urge to record Barbara's integration with the rocky hilltops of her surroundings. It was a secret sign to release the life of the form at its focal point.

One sculpture she hadn't expected to be making at the turn of the decade was a memorial for Duncan MacDonald's grave. Through twenty years of relative obscurity, MacDonald and the Lefevre Gallery had supported Barbara Hepworth. He had died quite suddenly, shortly after a stunning exhibition of her work.* Barbara cried, Denis Mitchell remembered. Despite coinciding with an election, Lefevre had had plenty of reviews. Every day the gallery had been full of people. Sales of the catalogue had broken all records. At least MacDonald would have died knowing that his faith had been well-founded. Within weeks, the Tate bought their first Hepworth, *Bicentric Form*. The garden at Trewyn was a mass of strange flowers. In the warmth of spring, Barbara was feeling 'more integrated than ever before'. People

* February 1950.

thought making sculpture was pretentious, she told Read: her guiding spirits were 'love and magic'.

Interrupted by a stray reporter, she was attacking two four-ton blocks of blue Galway limestone with what looks, in the accompanying photograph, a comically small hammer and bouchard. Five months later, flooded by spotlight, ten-foot figures commissioned by the Institute of Contemporary Arts for the Festival of Britain★ stood beneath a twenty-one-foot steel tripod, with canvas awnings that drew round, tent-like, on rainy days. 'Miss Hepworth is slender, small, dark-haired, and looks fragile for the strenuous work she puts into her 9-hour day.' Barbara was pleased with *Contrapuntal Forms*, she informed Read. What reporters often failed to note were the three stalwart assistants lurking in the background.

Barbara can hardly have been unaware that her gender set her apart. Since she left school, it had been so. Women had attended London art schools for sixty years, there was nothing exceptional in this, but being a carver was entering a male preserve. She knew that if she were to make a case she had to be best. The fifties brought with them a new sort of attention. In the rising current of women's liberation, she began to be noticed specifically for her feminist role. Paul Hodin, a Czech art historian and critic, observed how seldom one found, among women, outstanding composers or sculptors. Hodin had known Barbara since Chy-an-Kerris days. Having married a Cornish girl, he repaired, from time to time, to a house at Newlyn. Read had alerted Barbara to someone who might be useful and, sharp to opportunity, she had arrived on Hodin's doorstep the following day, Sarah in one hand, Read's letter in the other. Friendship blossoming between two equally earnest people was to produce the second Hepworth monograph, a marvellous sculptural record with a somewhat adulatory text. *Picture Post* ran a showy illustrated feature on 'two talented women', coupling Barbara

★ Hepworth was one of the four sculptors with such a commission.

Hepworth with the actress Claire Bloom, while a regional paper billed her the first woman of any nationality to achieve a 'front-rank international reputation'.

The moving spirit behind the next leap in her career was, as it happened, female. Lilian Somerville, who was very nearly Barbara's age, had studied at the Slade, married, given birth to a daughter and continued to paint under a male pseudonym. With personal understanding of the difficulties encountered by women artists, she joined the British Council's FAAS in the early forties. A few years later, she gave up painting. Before the end of the decade, she was directing her department, an appointment that contributed to a run of international success for British artists. There is no doubt at all that Somerville pressed the decision to show Hepworth alongside John Constable and Matthew Smith in the twenty-fifth Venice Biennale. Nicholson had had work in the Tate Gallery for ten years and an international reputation beside which Barbara's didn't compare. Some thought he was the obvious choice. Moore's acclaim at Venice two years before made it unlikely that a British sculptor would again take a major prize. But Lilian Somerville wanted a woman, and women of Barbara Hepworth's stature were few. The decision brought trouble from the first. Wanting to make a splash, Barbara chose more than fifty pieces. The Committee cut this down to less than half, and she was aghast. Burying her disillusion, when the time arrived she left for Venice.

Almost thirty years had passed since she had been in Italy. Yet, in her mind, it was but yesterday she had ascended, removing her astrakhan furs, to an atmosphere so light and clear it felt like entering the great blue sky. In 1924, John Skeaping had been the voice of her heart, then came Ben. Two she had loved and lost. Once more, she was alone. Life had scarcely modified her memories of the radiant beginnings of love. For the shuttle of time going back and forth wove the decades into a wholeness. And even now, she yearned for Ben's mind and his coolness. As time passed, his absence had become a physical

discomfort, insupportable and irreparable. Thanks to Lilian Somerville's sympathetic arrangements, Venice shone through the clouds of a profound weariness, so that the present, entering her, transformed itself in her, being shaped and shaping, as the present always can.

Venice in June spun earth colours into a bleached, midday heat. Watching late-afternoon shadows playing hide and seek, Barbara noted the play of horizontals and verticals complemented by myriad echoes of water and scattering peals of bells. There were vast skies, flat seas, and canals, supporting and reflecting borders of stucco and gilt. Outside St Mark's Cathedral, she felt inside her the concentrations of mass and space, the interplay between the two so finely adjusted that she could anticipate the great building from the square. Venice seemed to generate happiness. It was implicit in people's gestures, as if, sensing unconsciously the dignity of their surroundings, they were caught up in a great formal dance. Rather as Rilke, by disrupting logic, merged tangible things with conditions, Barbara was trying to destroy boundaries between internal and external, consciousness and object, man and nature, finite and infinite. By mediating between the human and the transcendent realm, sculpture linked human scale, human sensibility and the greater dimensions of architecture.

Nothing in the approved literature suggests the first Biennale was anything less than part of the ascendancy to fame. Nowhere is one told that Barbara returned to an empty house. Denis Mitchell was unwell.* No sign of Ben. Six months later, presentiments of unhappiness she had anticipated even while she was in Venice, aggravated by shingles and the long hours she was putting into the Festival sculptures, resulted in what she described as a narrowly averted breakdown. Bit by bit the news had percolated through. The Biennale attracted half the attendance

* And, Lilian Somerville thought, underpaid.

and half the press of Moore's. Such reviews as appeared were generally about Constable. Where Barbara's name occurred, she was described as Moore's pupil. Winning the Hoffman Wood Trust Gold Medal for *Biolith* had been offset by a factor more consequential than all Lilian Somerville's exertions on her behalf – Moore's reputation. 'Privately, Somerville put Moore's success down to his personality. Barbara's reserve made her a dead loss.' Doubly insidious, the episode was bound to affect future relations with the British Council.

Having too briefly won the Council's support, Barbara was soon querying their apparent lack of interest. Hacking away, affirming her faith in the human race, she could, nevertheless, be irritatingly high-handed about details. Not all the staff felt B.H. should rough-ride their arrangements. A letter informing them she had overridden the Committee's decision to exclude drawings in an exhibition, by writing to George Morris, carries a pencilled note from Miss D.M. Nash: 'She really is the limit. I don't think we will answer this.' Morris, who was acting for the British Council in New York, naturally did. So Barbara Hepworth got her way. Miss Nash relieved her annoyance by replying to their tricky customer's quest for a cure to shingles: 'It just seems to be one of those things that needs rest, rest and more rest. One of the most elusive commodities in this modern world.'

Communications with the Arts Council had their precarious side. Barbara eventually fell out with Philip James, but this was after the Festival of Britain exhibition. For the moment all was enthusiasm. 'Look, we've recovered!' the Festival of Britain seemed to say, six years after the war. 'We're going to live joyfully, and art and culture will play an integral part.' *Contrapuntal Forms* stood prominently, between the Skylon and the great curved Dome of Discovery. The other Hepworth, *Turning Forms* 1950, was in a small courtyard in front of the Riverside Festival Restaurant, inside which hung a painting by Ben Nicholson. *Turning Forms*, with its gentle spiralling motion,

was an antidote to the hectic bustle around it.* Close to Gabo and the Constructivists, now a swan or a gull, now a dancer, its curving white reinforced concrete surface gleamed in reflected sun.

Barbara was increasingly in the news. With a political/social conscience as alive as ever, there was no excuse, she felt, to remain inactive. Besides, the discipline sculpture demanded required some degree of social integration. Not only did she support a major exhibition run by Artists for Peace, she lent illustrations of her work for the accompanying broadsheet, *Abstract Art*.† The Unknown Political Prisoner competition, run by the ICA at the end of 1952, was a much bigger event. In the illustrious company of Lynn Chadwick, Naum Gabo and his brother, Antoine Pevsner, Hepworth won a second prize.‡ Entries came in from all over the Western world, more than 500 from Britain alone. Reg Butler achieved a major position when he beat nearly every well-known sculptor in the world. Barbara was quick to appreciate the brilliant nervous energy of the winning entry, a work that caught the lingering anguish of the war years and the liberal aspirations of the time. In 1953 she became a pacifist, the following year she joined the Labour Party.

Like most people she reneged on her opinions from time to time, and since two extreme positions seem to be further apart than two liberal ones, her changes of mind were more pronounced. At the beginning of 1950 she was expressing, with characteristic vehemence, disdain for sculptural materials other than wood and stone. Before the year was out she had employed not only concrete, but metal as well.

The first liberty she took was in the form of two steel rods, bent round into harmonizing profiles. Neither quite tree nor quite face, the resulting hieroglyph was a fruitful rhythmic

* And the stylistically confusing mixture of traditional and progressive architecture.
† May and June 1951.
‡ She received £750 against Reg Butler's winning £4,500.

presence, magic and shrine-like. The sculpture was part of a stage
set for Sophocles' *Electra* at the Old Vic.★ Knowing her work,
Michel St Denis had asked her to help him design the sets and
costumes. Digression into theatre was, in itself, a challenge. Of all
the Greek plays, moreover, *Electra* is the one that compounds the
ultimate problems of human life. Barbara's reaction was to steep
herself in the drama, then try and tease out the heroine's terrible
purpose. Spareness, boldness and symbolism were the hallmarks
of her pure white sets enlivened by costumes in primary colours.
She clashed with the stage management over a relatively small,
but to her, a vital issue. Reasoning told her that continuous space
between stage and backstage harmonized with her set; a definite
exit would destroy the naturalness she had striven hard to achieve.
The Old Vic insisted upon having a door. Presumably there were
sound theatrical reasons, and Barbara, ungracefully, lost the case.
On her own, in her studio, eliminating the clatter of things
needing doing, she felt intervals of great equilibrium. But she
was totally unequipped for teamwork. The divided reception her
sets received she attributed to the old-fashioned attitudes of
theatre-goers in the fifties.

Barbara was spreading her wings, discovering new worlds and
drawing in old ones. On 19 May 1951, crowds of visitors were
self-consciously fingering her carvings in the gardens of Wakefield
Art Gallery. Across the road was her old High School; further
down, the clock still boomed the hours through Herbert Hep-
worth's old stronghold, marking the time which had, and yet
hadn't, changed them all so much. 'Time is stretchable, diminish-
able. You don't look back along time but look through it, like
water. Sometimes this comes to the surface, sometimes that,
sometimes nothing. Nothing goes away.' Wakefield's contribution
to the Festival of Britain was a retrospective for its home-
town celebrity, the opening address to be given by a Yorkshireman.
All culture was the province of Sir Herbert Read, who,

★ *Apollo* 1951.

offered a knighthood in the new year, hadn't felt important enough to refuse. Great honours had been paid to Barbara Hepworth in greater cities than Wakefield, he declared ingenuously. If the local officials rubbing shoulders with various Hepworth relations were fairly flummoxed by what they were viewing, they had at least the benefit of being cajoled by the *Yorkshire Post*. In W.T. Oliver, Barbara had a lasting ally.

Ten years earlier, Barbara had written, 'I think I'm less known in Wakefield than anywhere!' Wakefield's ignorance, or perhaps what later seemed to her a shared negligence, was a sadness that left a complicated reaction to her birthplace spelt out in at least three letters to different people, two in Wakefield, another in Leeds, each claiming that her correspondent was the *only* one she knew in her old home. Somewhere Barbara felt an enduring loyalty, and her conscience wasn't clear. Maybe she had used Yorkshire. Yet she was to raise the same charge about artists who left St Ives, proving only, perhaps, that artists do what they have to do. From land where even the skies on a hot day hold threats of storm and clouds, and by their shadows, give form to what lies below, from dankness, mist canopies, mildew and sousing rain, Barbara Hepworth had been drawn, moth-like, towards the light. First to foreign countries, then to a small flag of headland studded with ancient reminders, a land of cairns and bracken and cultivated green-land. The most distant history is close to the surface. Rather as Cornwall's ancient structures inform the present, so Hepworth's sculptures are both innovations and reinterpretations of the past. There was something in the bareness of Penwith that stripped her vision of inessentials, something in its contrasts that made the rocks jutting through treeless soil akin to spiritual roots.

Towards the end of 1952, she was showing once again at Lefevre, thirty drawings and paintings and fifteen sculptures, all of which had been carved in the preceding eighteen months. Male and female figures, standing, lying, seated, and the portraits of 'Lisa' with her dark brown mane of hair, had all been done in the evening, after a full day's work. The human presence she was

sensing in the landscape wasn't discernible in all her sculptures. In a mammoth lump of limestone trapped by great iron hoops, for instance, one finds simply an expression of form under tension. Yet almost every shade of human metamorphosis was represented. Some of the sculptures have human features, some just profiles, in others the human element is still more elusive. It is there, all the same, in gaunt monoliths disposed with hollows and strings. Multiple, very reduced, limbless figures, nine or ten inches high, reflect Barbara's preoccupation with groups of people and their interaction. *Evocation* 1952 and *People Waiting* 1952 were conceived from her lone meditations on Waterloo Bridge and in St Mark's Square, *Concourse* 1951 from her forays into the medical world. To be precise, it was based on the oil painting in which she consummated and personalized her operating theatre experience by including herself. A figure★ yearns aggressively at the sad dark human fate, a young girl† slides like an arboreal princess, mysteriously from five feet of West African mahogany, crystallizing the springing grace of her seventeen-year-old daughters.

From half-way up a punctured slip of elm, two long triangular hollows fan outwards, one up, one down. Light caressing these hollows is broken by cones of strings. *Solitary Figure* 1952‡ combines a totem-like, human presence with ethereal beauty in a rare, timeless invocation, catching the quality of land that both broods and clarifies, defining and enlarging form and structure, giving everything new meaning. Without obvious landscape reference, *Solitary Figure* speaks hauntingly of bleached, shimmering grasses, half-seen rocks, mist, rain, storm and sun on the moors. Without obvious human reference, the hard-edged, cerebral cavity above and the womb one below suggest a woman. Infinitely solitary, withdrawn, musical, it could be a personal statement. Rilke said:

★ *Churinga* 1952.
† *Young Girl* 1951–2.
‡ *Wood and String (Solitary Figure)* 1952.

Is it not time that, in loving,
we freed ourselves from the loved one, and, quivering,
endured.

Being resolute about his personal life had given Ben's work a
new authority and it made him jaunty. Barbara hadn't exactly
lost him. From time to time he turned up at Trewyn, cap peaked
to one side, to spy out the land. Ben had a key, her assistants
noticed. He'd come to the back door, never knock at the front,
when they were working and she was drinking tea. Occasionally
he would oblige with what was to Barbara the most precious
thing he could offer, an opinion, but her solemnness made her an
easy target. When Ben had seen what she was doing, he would
ask quizzically, 'Do you think *that's* right? Are you really doing
it right, Barbara?' The air would splinter, the lines in her face
would furrow even deeper and, jaunty as ever, Ben would turn
on his heel and leave. If others argued with Barbara, she would
say, 'But Ben said so and so,' and they knew they had no sway.
After Ben, who approved the Festival pieces and extolled some
of her Biennale work, Barbara cared most about Read's views.
After that, she trusted herself. This doesn't mean she didn't need
appreciation, it just means that she stood by her own judgement.
 Wider acceptance by no means deterred her critics. Every
shade of censure was received, from what Barbara called 'fair
scrap' to the backhanded depreciation of those who offered sugar
pills, then cut her down to something they could manage.
Something like their own size. Heron was among those whose
compliments were accompanied by accusation, in his case, of
superficiality. Lauding the femininity of Barbara's line and im-
agery, he noted how light-reflecting curves of pure geometry
had given way to planes that met and went round corners,
leaving ridges and creating edges. Her surfaces were not often
continuous, and to him, this suggested forms worn from the
outside, grooved, fluted or hollowed-out, shell-like or pebble-
like, rather than growing and fructifying (as Moore's did) from

within. Twice in the introduction to her Wakefield catalogue Heron compared her work unfavourably with Moore's fully-fleshed, more obviously humanist creations. In Hepworth, he found the strong 'bare bones', which Moore (though Heron didn't say so) sometimes lost sight of beneath the flesh.

Barbara complained about determined denigration from the younger generation of male critics. The *Spectator* found her human associations forced and the marble groups like the products of a pastry cutter, so many inert shapes of uniform thickness, 'for all the world like marble coffins and cello cases stood on end'. Her awkward integrity, her single-mindedness, worked best, in their critic's★ view, when her work was less directed. After all, the slow, austere rhythms, the disciplined counterpoint of convex and concave surfaces, were ends in themselves. The *Guardian* writer felt, chauvinistically, rebuked by such austere art. Amid the calmness for which Hepworth strove, desire for romantic excitement, interest in 'fragile, contradictory, silly ephemeral humanity' seemed 'mere frivolity'. Her critics might well, but often didn't, mention her humanity, purity and her timelessness. Instead, they reproved, as if being a woman and totally uncompromising, reaching, perhaps, in her externalized expression, the essence of her own personality, made *them* uncomfortable. Why does one, reading these reviews, trying to remain unbiased, so often sense that Hepworth's sex made her fair game?

Despite Heron's somewhat undermining verdict, he paid Hepworth the compliment of realizing, as Stokes had done, that being a woman was a strength, using six times the key words 'woman', 'feminine', 'masculine', 'male'. Only by a woman could the thrall of womanhood truly be told. The exhilaration of motherhood enabled her to freeze, indelibly, in the limb of a child or the breast of a dove, a shape more lasting than the transient reality where all things flower and elude us. This is what Barbara herself consistently maintained. A woman's creative

★ M.H. Middleton.

ability was in no sense inferior, nor was it like a man's. Her contribution was complementary.

Neither remoteness nor severity seems to have troubled Herbert Read, who hadn't stressed or diminished the relevance of Barbara's sex. But in the new climate, some special reference to her gender seemed to be called for. In Jungian terms, he explained, all carry an image of the other sex as well as their own. The power of a projected image rose from the tension between the two. Barbara was deeply grateful for his objectivity. A weight was removed from her mind. Read's monograph on Moore had been produced in linen hardback in 1944 and sold well. His Hepworth was under way, and for Barbara's special perusal he had sent a copy of the text. Everyone involved was Yorkshire, including Lund Humphries's publisher, Peter Gregory.* Productions more splendid than the schools of Paris had accorded Braque, Picasso or Matisse were to find their way to museums and libraries throughout the Western world.

When the Festival of Britain was dismantled, *Contrapuntal Forms* was set up gazing loftily over Harlow New Town. This was an honour, even if Barbara would have preferred a London site. Knowing how precious she held *The Story of an African Farm*, one listens again to an author whose words seem to have become ingrained. 'If she waits patiently, if she is never cast down, never despairs, never forgets her end, moves straight towards it, bending men and things most unlikely to her purpose – she must succeed at last.' It was a time of fortune and a time of sadness. Barbara Hepworth had waited fifty years for the success she was receiving, only to find that it was relative because it was blocked by Henry Moore. At the same time, she had a tragic longing to be Ben's wife. All her life Barbara kept repeating in one way or another, as if she were aware that she belonged to him, her wish for Ben. One day, she was sure, he would return.

* Until Peter Gregory realized a market for quality monographs on modern artists, Lund Humphries had specialized in railway timetables.

Living Bravely

(1953–5)

Herbert Read's contemplative disposition was one of the 'firm rocks' of Barbara's life. There was no one with whom she would prefer to share her thoughts. Being with him in London to judge a sculpture competition for the Institute of Contemporary Arts (ICA) so cheered her up that returning to Trewyn, she arranged, on impulse, a mirror to reflect the morning sun.

From her bed, she watched enrapt. 'For half an hour, with incredible splendour this moving & focussed source of light travels slowly over the nine sculptures in its path – Hollow & piercings, forms within forms, strings & features, volume & space are animated to a new vibration of life[,] & every form & contour, known so intimately by my hands, reveals its proper significance. Just as a composer can never know whether he has really achieved his conception unless he can get a proper perform-ance produced according to his will – so I feel, a sculptor can never be sure that his particular magic has been released without the sun.' In a thousand beautiful lights, she had seen these works, yet the reappraisal gave her strength. Transfigurations never repeat themselves; there would always be something new.

Hitherto, she'd been smarting over an uncomplimentary review of Hodin's new monograph. Not that it was particularly scurrilous. But suffering from accumulated assault, Barbara had an irresistible need to confide in someone. Perhaps fluorescently-lit art galleries deprived critics of the ability to make genuine responses. Could Read imagine a critic climbing a hill or walking through a forest to reach a clearing the sun would pierce at a certain hour, in order to see a particular work? After centuries of

amnesia, receptivity to sculpture was abysmally low. People should be alive to myths, images, the fetish, the strength of a suckling child. Society swallowed quack medicine instead of living bravely. For her, the secret of art lay in Michelangelo's drawings and the British Museum.

Warming to suppressed irritation, Barbara chastised her correspondent. Why should he suggest that sculpture didn't have its own aesthetic? What, indeed, was he looking for? To Read, on the threshold of delivering the Mellon lectures, her vehemence was unsettling. Two days later, Barbara soothed. Of course she hadn't meant to include him in her diatribe. Herbert was a creator in all he did.

The next time Barbara picked up a pen to write to Read, a month or so after her fiftieth birthday, something terrible beyond comprehension had severed the warp of her life. News travelled quickly; he may already have heard that Paul Skeaping had lost his life flying over Thailand. Ben had walked away, and she yearned for him. The death of her twenty-six-year-old son had to be borne alone.

Paul died on Friday, 13 February 1953. Barbara had been at a Penwith committee meeting when she heard, and the suddenness of the news slid her into profound shock. Priaulx came down from London to look after her, but Barbara was inconsolable. Paul was with her continually at first, the walls between the living and the dead being very thin, so that those who die young exist in our minds, more intensely than when they were alive. And there had been gaps in her relationship with her son it was difficult to explain. Later on, an ungovernable sorrow welled up in her. Sorrow was close to anger, which, having no outlet, dried into a dull weight. This is what death does to those who are left behind.

When Paul was a child, Barbara had seemed to be a sort of goddess. If she reproved him, it was almost frightening, which hadn't been a secure feeling. Perhaps it had mattered that even his drawings of horses wouldn't look right. Since he was seven, Paul had of his own volition spent most of his time with his father,

reacting violently against the world of art. But holidays at Carbis Bay had been successful; Barbara had sensed in him the warmth and sensitivity of an adolescent who needed confidence. Leaving school when he was eighteen, not at all sure what to do, Paul had lived with John and Morwenna Skeaping at their Devonshire home. The pace had seemed to be right; after several months fly fishing, he settled and matured enough to arrange a job in an aircraft factory. By studying in the evenings, he worked his way to joining the RAF. Still, there were disruptions. Paul had had his father's impetuousness, his aversion to authoritarianism, but not his insouciance. At a trainee flying school in South Africa, he fell out with his seniors. A peccadillo was sorted out with the help of one or two of his father's distinguished friends and he became a fledgeling pilot. At last Paul had found something he was good at. Enormously encouraged, the spring before he died, he became engaged, and started rediscovering Barbara. She had misinterpreted his shy overtures. Paul had felt much more strongly for her than she knew until after his death. The twenty months that passed before she next wrote to Herbert Read was a measure of her reaction to the accident.

John Skeaping was answering questions at the end of a lecture in the Ashmolean Museum when his telegram arrived. Going immediately home, walking in the woods that Paul had known so well, he erected a rough wooden crucifix from crude lengths of timber. Both he and Barbara felt an urge to create something. Barbara painted a six-foot oil of two abstract figures symbolizing Paul and his pilot. Later on, she carved a relief in the round, the Gill-like *Madonna and Child* 1954 that stands near the altar of the Lady Chapel in St Ives parish church. Time would not be allowed to obscure Paul's character, his achievements or his promise. It was dedicated into the church by the Bishop of Truro.

Throughout her years in St Ives, Barbara had been in touch with Margaret Gardiner, frequently corresponding, occasionally staying in Hampstead or receiving Margaret in Cornwall. Considering Margaret her oldest and closest female friend, Barbara had

shared nearly all her trials with her. Margaret had known Paul since he was little. Realizing the effect of his death on her friend, she stepped in with the offer of a Hellenic cruise. It was a wonderful idea, and far too good to miss. Since early schooldays, Barbara had been familiar with Greek sculpture. For thirty years she had felt inside her Greece's ancient culture and mythology. Nothing could have given her, in her stressed condition, more help.

Athens, Mycenae, Delphi, Delos, Crete, Rhodes, Santorini; for two weeks Barbara submitted herself to places which no enumeration of their physical characteristics can completely describe. In and out of museums and ancient sites, visiting springs, being subjected to earthquakes and volcanic fumes: all these things she recorded in words and drawings. Up to a point, a traveller discovers what he seeks. Beyond the schoolgirlish exuberance, one senses someone seeking to submerge her grief. Climbing Mount Kynthes at Delos, a ferocious wind tore at her hair and clothes, hurling her to the ground. Scrambling up, she persevered. Sketchbook in hand, she ran up hills like a hare, to receive the full impact of solitude. First to the top, she mused upon the 199 trundling behind. Her recollections have an ambiguous undercurrent. It was hard for Barbara Hepworth to forget her leading position in the arts. In a sense, only Moore was left on Mount Olympus. And a state of illuminated innocence that went with the realization of her powers transcended her, filling her with awe and wonder. Once again, fleetingly, the distinctions between subject and object were merged, the barriers of selfhood broken down. In a world of pure existence, there was no past or future, no end, no limit, no separation or parting, no death as it is usually conceived. It was when she turned landscape into sculpture that the strange cerebral alchemy of what she saw and felt made her unique.

Rarity was what a young photographer called Dudley Shaw Ashton recognized in Barbara Hepworth and her work. Before meeting her, he had made films about what he described as rather

dull topics, hoping, always, to move into the arts. No one had taken on the challenge of explaining works which a lot of people, still, in the early fifties, felt they didn't like or understand. Here was his chance. Gathering round him a team that included Jacquetta Hawkes, Cecil Day Lewis, Priaulx Rainier and James Blades, Shaw Ashton set out to portray Barbara's sculpture as natural, wholesome and belonging. Back and forth over hundreds of miles, he scoured the Penwith peninsula for locations that seemed to clarify the subtle harmonies between form and landscape, choosing for the opening shots a private cove near Land's End approached by miles of private driveway. To Nanjizal, two of Barbara's assistants carried a heavy alabaster sculpture in a fishnet. They were escorted by Barbara, Shaw Ashton with his camera, and Ben Nicholson, who couldn't bear being left out of any fun. Barbara had been delighted that he wanted to join them. She hoped they would be together throughout the session. But opportunity played to Ben in the shape of a rather luscious, bikini-clad girl down on the beach, with a male escort. Allowing his eye to be entirely distracted, Ben disconcerted both the escort and Barbara.

By placing the sculptures in the natural landscape (risking Barbara's concern about a surreal element), Shaw Ashton threw up the symbolic significance of certain shapes. At flood tide, water rushes through a natural, elongated hole in a great granite rock on one side of Nanjizal Bay. In a powerful introductory sequence, the camera moved from this fountain of water to Hepworth's sculpture, standing on the beach, then to her hands, moving down, holding the sculpture. By the time the artist appears, hammer and chisel in hand, her carvings seem necessary and inevitable, married to the landscape and to the surrounding light. Ancient stones, holy crosses, pillars and rings stand strong and primitive in a confluence of greens and blues. Shivering reflections come and go at the whim of the sun. Distances shift. Echoes evaporate. Shadows metamorphose beneath torn skies and curdled waters. Interpretations aren't forced, comparisons are

implied rather than laboured, and few claims are made. In the strange atmosphere caused by intense light, the relative values of all the objects in the landscape are altered and resolved, correspondences are being established, not only between the sculpture and other man-made objects but between one sculpture and another. Hard surfaces interplay with the caressing movement of water. Artefact signals to artefact across the intervening waste of nature. Archetype is reinforced by archetype. Detached, timeless and far more provocative than ever it appeared in art galleries, the sculpture speaks for itself, like pyramids in desert sands.

Another name behind the first flush of Hepworth's recognition is that of Bryan Robertson, twenty-nine-year-old director of Whitechapel Art Gallery, where he'd been for two years. Exhibitions were free. The public were even allowed to smoke among the exhibits. His contract was to bring good art to the East End. Sensing Hepworth's ability, sensing her power, Robertson took a gamble and confronted his audience with her unlikely figures. This is art! he reassured. Here's something you will enjoy! Come and see for yourself! Sixteen thousand visited what was 'unquestionably the most provocative show in London'.

Weeks before the exhibition, the principal piece was being finished. *Empyrean* 1953, according to the catalogue, was a 'monument to those who seek their freedom in the upper air, even though it involves fire and falling earthwards'. This would be a bewildering description without the wisdom of Barbara's debt to Rilke: 'And we who have always thought/ of happiness climbing, he who presumes to surpass all the birds in flying . . .' must grow capable of falling, patiently resting in heaviness. Nearly human, solitary, herculean, *Empyrean* is penetrated in head and stomach positions by pitted holes surrounded by spiralling, convex, light-reflecting curves. The indeterminate flux of the interiors contrasts with the emphatic solidity of the silhouette. Ideally, Barbara said, it should stand on a summit, suggesting man's mind springing from its deep unconscious will to the freedom of light and movement.

The two-and-a-half-ton carving in blue corrib limestone – nearly nine feet of it – spent the journey from St Ives to London on a low-loader car. Outside the Whitechapel Gallery the sculpture had to be jacked up above the level of the steps, and once inside, the ghostly grey monolith, standing today in the gardens of Kenwood House, took twenty-four hours to mount on its base. Barbara was extraordinarily fussy and exacting about the way in which her sculpture was handled. Before it was moved, she worked herself into a state of extreme tension. Assistants were duly inspected, buttons noted, and garments with metal ones, as well as watches, had to be removed. Even the soles of her assistants' shoes would be examined for a good purchase, against the possibility of slipping. 'Everything was more or less wrapped in cotton-wool. Because they were her babies you see and they were so precious. She'd spent hours and hours and hours grinding and polishing and getting them perfect, because she was a martyr to herself for the perfection of surface. Only she really understood.' On more than one occasion she sent a plaster to her London foundry by taxi.

Two of her assistants, Denis Mitchell and Roger Leigh,* had been sent in advance to the Whitechapel Gallery. It was the end of March, and the first of April arriving less than a week before the opening proved an irresistible temptation. Rooting about the gallery, they had lighted upon Whitechapel's old museum stock. Turning the discovery to the occasion, they augmented the exhibition with stuffed animals. Peering from behind *Empyrean*, when Barbara entered the gallery with Bryan Robertson, was a bear. In one of the cavities lay a number of seagull's eggs. Elsewhere among her sculptures lurked a king penguin. They were taking a risk, the nervous perpetrators were aware. Somewhat to their relief, Robertson, seeing the exhibition first, put on his spectacles and laughed. Then he and Barbara

* Frost and Wells were replaced by Roger Leigh, John Milne and Brian Wall.

laughed. *Punch* quipped of the artist:

> The stars have not dealt me the worst they could do:
> My pleasures are plenty, my troubles are two.
> I'll never be cultured, or decently fed
> With holes in my stomach and string in my head.

What the public saw in the lofty gallery with head light on both sides was an avenue of wood and stone leading to the large painting *Ten Figures in a Landscape*, a further avenue that tapered into infinity. The walls were hung with drawings and paintings, most of them realistic, just as most of the sculpture was abstract. Of five smaller works carved in the preceding year, four were similar to *Empyrean*, upright and sharply faceted. The other one, a pristine horizontal piece in shiny tombstone marble,★ had a face incised horizontally inside its basin. The basin is transformed by the mind into a clean green valley.

In terms of publicity, the Whitechapel Art Gallery and Barbara Hepworth had made a quantum leap. So popular was the exhibition, that its closing date was extended, a snub for the unforthcoming *Times*, *Listener*, and *New Statesman* – whose John Berger simply wasn't on Hepworth's wavelength. Even the *Cleckheaton Guardian* had picked up the story, explaining Barbara Hepworth to its readers as the granddaughter of the late County Alderman B.G. Hepworth, the Dewsbury blanket manufacturer. One spin-off was a smallish one-man show arranged by Barbara's New York gallery, the Martha Jackson, to travel for two years through various museums of North America.

Carving from 8.00 a.m. until 6.00 p.m. left little opportunity for anything else, Barbara occasionally complained. Only when an enterprise was part of the whole grand thrust would she spare it her time. During preparations for the St Ives Festival of 1953 she had got to know Michael Tippett. Coming from Cornish stock made him susceptible to Celtic sensibilities, and more than

★ *Pastorale* 1953.

once he stayed in her cottage, setting up in the summerhouse for days on end, discovering in its elemental surroundings the right atmosphere for composing. It was during one of these visits that they discussed his first opera. Six years of sweat had gone into *The Midsummer Marriage*. Tippett had never expected to see his strange mixture of natural and supernatural at Covent Garden. The story was obscure, the score unconventional, and no one seemed in the least anxious to work on a production. It was only after Graham Sutherland and Ben Nicholson had been approached by the administration at Covent Garden, six months before the opera was due to open, that the composer was allowed to choose Barbara Hepworth as his designer.

Day and night, for weeks on end, travelling by tube from the Grand Hotel in Paddington to Covent Garden Opera House, Barbara was sucked into the exhausting well of rehearsals. Adapting to the conflicting demands of 400 people was devilishly exacting, she told Read. So much depended upon the producer's authority and interpretation. The main set she conceived in great Mondrian-like blocks of colour, with a temple on a wooded hill, suggested by nets and grills. For the chorus, she tried to create a bold massed pattern to complement Tippett's using them as a single voice. He loved her coloured gauze trees, lit from inside. But in a production beset with problems, the length of time needed to stage three acts had been hopelessly underestimated. Virtually no time was allowed for the last one.

Barbara gave both her assistants seats on the opening night.* All was hushed, when who should make a spectacular entry but Ben Nicholson in a gold suit with a silver tie. One critic called the production 'outstanding'. Unfortunately, he was an exception, and even the well-disposed were bemused as to what the opera was all about. Opera always gave Barbara ideas. The disadvantage was the feeling of deprivation that grew in her when she was away from her studio. More than ever, she was wooed by the

* January 1955.

36. St Ives with the sea on both sides; Porthmeor Beach on the Atlantic and the harbour in St Ives Bay. Trewyn Studio with its garden and workshop, and the Palais, lie within the white rectangle

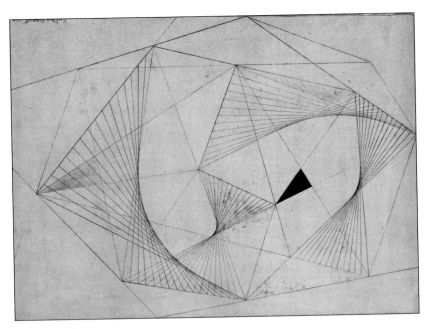

38. *Red in Tension* 1941, pencil and gouache

37. *Oval Sculpture* 1943, in plane wood

39. *(Top)* Gabo in his studio in Carbis Bay
40. *(Above left)* Marcus Brumwell,
ace businessman and supporter of the arts
41. *(Below left)* Rene Brumwell
42. *(Above)* John Summerson, Barbara's
brother-in-law

43. *(Above left)* Dudley Shaw Ashton at Trewyn with Barbara, working on his film
44. *(Above right)* Norman Capener, orthopaedic surgeon at hospitals in London and Exeter
45. *(Below) Three Groups – hand on shoulder* 1949, blue and yellow ground oil and pencil

46. *(Above) The Cosdon Head*
1949, blue marble

47. *(Below)* Trewyn Studio,
January 1958

48. Barbara working on *Contrapuntal Forms* 1950, her sculpture for the Festival of Britain, blue limestone

49. *(Above)* Three of Barbara's one-time assistants: Denis Mitchell, Terry Frost and Sven Berlin

50. *(Below left)* Osbert Lancaster's 1950s cartoon

51. *(Below right) Wood and Strings (Solitary Figure)* 1952, elm

52. Hepworth, *Self-portrait* 1950

seductive knowledge that a pile of logs with four-foot girths lay waiting for her in the yard.

Returning from Greece, she had been greeted by an unexpected gift. Seventeen tons of 1,500-year-old Nigerian hardwood known as scented guarea had arrived at Tilbury Docks. Would she arrange to collect it? With a whirl of command that rather counteracted her efficiency, Barbara moved into action, telephoning, writing letters and agonizing over what became virtually an epic drama. In the end, each log, weighing up to two tons, had to be individually handled through the cobbled streets of St Ives. For a whole year, as if confirming the Greek experience, she was turning some of the most beautiful timber she had ever seen into sculptures with names like *Corinthos*, *Delphi*, *Delos* and *Phira*. 'When I have finished I shall be able to get inside.' It was almost as if she were exploring with her bare hands and her body the sensuous wells and spirals of the fine dark wood with its massive contours.

Using a little gouge, she sometimes roughened the inner surface to a texture like the feathers of an owl, increasing the contrast between inner and outer forms. Some she punctured clear through to a cool, white, meditative pool of space, reflecting not so much Cornwall's spectral light as the blinding sun and heat, the chiaroscuro, and the fullness of Greece. The Nigerian wood sculptures don't seem ponderous because the light and rhythm in their shapely, painted, and often textured interiors is finely drawn, the home not only of light they contain, but of light that, as one looks at them, sheds forth. Some are similar to forms she had carved before, yet their consoling roundness, their resonance, and their immensity make them new and different. She also made drawings which complement the Nigerian wood sculptures, voluptuous convolutes, aided here and there by rhythmic areas of mud and sand-coloured gouache, spiralling into cool water-blue backgrounds. Perpetually flowing lines seem to conjure, rather than actually delineate, forms from the surrounding space.*

* See *Stone Form* 1961.

These sculptures, as much as any, prompt the realization that Hepworth is a sculptor of interior landscape; probably the most compulsive tunneller in the history of sculpture, and most of the complexities and refinements of her art occur inside the object. Sometimes she is content to make deep concavities, boring them with a small, trim, circular hole as a sort of climax, but her most exciting work is characterized by an extreme opening-up of the interior. Much of the tunnelling is small at the point of entrance, and large at the exit. Sometimes she attacks from all sides, and the tunnels converge in a large interior chamber. Perusing such mysterious rooms, one's sense of scale collapses and one finds oneself on the verge of a landscape of the mind infinitely larger than the form which encloses it.

She wasn't tackling her giant timbers single-handed. Roger Leigh, Brian Wall and John Milne were all, as it happened, students in sculpture. Brian Wall was waved down from London because he was painting abstract art. St Ives, it was reckoned, was his natural school. While earning his keep at the Pandora Café, he was introduced to Barbara by Denis Mitchell. Leigh was fresh from university, where he had taken degrees in architecture and town planning. Enthralled by the open-air sculpture exhibition at Battersea Park,* he found a block of cherry wood and began to carve. Of stone and marble he had no experience, and a novice he had certainly felt the evening he arrived in St Ives. Barbara cooked up a big fry. What she couldn't do, because she was shy, was to put him at ease. The effect was to impose upon him a sense of his own nervousness.

'A most sociable creature' might be how Barbara described herself, but it wasn't how others saw her. Friday nights she went ballroom dancing with Nancie Halliday, and she saw quite a bit of Priaulx, yet what impressed itself upon those around her was that her relentless drive precluded the usual sort of ease and

* 1948.

pleasure people receive from each other's company. The hair-dresser went to Trewyn, she didn't go out except to the Arts Club and Penwith meetings. Even when she met people she knew, there was something commensurate in her heavy presence with the weight in her mind, where reason was from necessity exact. People were uneasy when she spoke to them, few could intrude upon her because there was no place for intrusion. Inevitably, it affected her relations with her assistants. Even with her children, she seemed to her assistants to be nervous and remote. Her encounters with them often brought her dissatisfaction. It was like trying to talk under water, so she turned back to her work.

She was very moody, which made her a tricky employer. She wasn't entirely without humour. One time, at a Newlyn Arts ball, when two young artists were scuffling on the floor, she squeezed a large tube of toothpaste (one of the prizes) all the way down the leg of one of the contenders, replaced the cap and walked away. But some days she was grumpy, others she'd be reasonably accessible. Only if Ben was going to tea would she be positively jolly. Independent of mood, she was disposed to treat her assistants unequally, to be more demanding with one than with the other, withhold or bestow token favours – tools at Christmas, a chocolate biscuit with morning coffee. Inconsistency, it seemed, was a side effect of tension. She was tense because, as one of them said, 'She just worked so bloody hard.' In practice, her bullying increased their camaraderie.

That Barbara didn't approve of having them was something of a joke. If anyone important was expected, her assistants were shut in the greenhouse with tea, biscuits and instructions to stay where they were. When American women visitors said, 'Why Barbara, how do you manage this big heavy work?' she would reply, 'Well, there are things like muscles and I have power tools.' Even in interviews she seemed to impart the suggestion that she alone was responsible for the actual carving, which simply wasn't true. Throughout the ages, well-known sculptors have produced work

without necessarily touching the final products. Barbara was suspicious that it devalued the sculpture in the eyes of her public, who couldn't be expected to discriminate about her precise role. Never, of course, did an assistant conceive or modify one of her works. Denis Mitchell was quite clear about this. He was 'her hands'. She once told an interviewer that she could spot a millimetre imperfection a mile away.

All her assistants admired her professionalism. When they were roughing up, which was long and very tedious, every single stroke should, nevertheless, define the form. Barbara knew whether they were concentrating. Like a predatory spider, she was alert to the slightest suggestion of slackening. Hearing the wrong sounds, she would emerge rapidly, run her hand over the area her assistants had been working and spot the minutest aberration. With a sense that, by its empathy, continued to amaze them, however large the piece, she could turn it and read it from top to bottom, and from side to side. The closer the sculpture was to completion, the more vital the exercise. Sometimes, returning from lunch, the assistants found a big claw marking a discrepancy. What she didn't understand was that her work was not *their* life. They weren't allowed to whistle – though Barbara did, occasionally, when she was happy. They couldn't sing. And if the triplets pottered into the workshop to see what was going on, she'd shoo them away. Occasionally, to get a commission finished on time, they would work into the night, with heat from a brazier and lights flooding the sculpture. If it was very cold, Barbara fried bread with Marmite, which they ate beneath the huge church tower, and a common purpose prevailed.

The St Ives artist community was beset by comings and goings, new aspirations, new friends, new failures and continual gossip. Bryan Pearce, who was to become such a part of the scene, began painting, as Guido Morris's press went into liquidation. Denis Mitchell hadn't been working for Barbara long when his painting eye and craftsman's skill lured him to the art of

sculpture. He became chairman of the Penwith as Victor Pasmore resigned. Sven Berlin, the first assistant to fall out with Barbara, left St Ives to seek new territory with his piebald horse and caravan. No longer was the colourful figure with a huge frame, bearded face and old seaman's hat to be seen hewing away at lumps of alabaster in his yard. Roger Leigh left, though it wasn't for good, and Ben Nicholson caught level with Barbara by winning an award at the Venice Biennale. Barbara yearned for Paul and for Ben. Seeing Ben going from person to person, unable to endure the knowledge that she was forgotten, realizing that a growing tension was in her, she lay awake at night. Her heart longed for him, and dressing, she would go outside, so that she might recover herself. Then, her eyes becoming accustomed to the obscurity, she perceived the mystery of familiar shapes relieved against the darkness. Ben was an amputation that she couldn't renounce. If only he would return to settle her thoughts. One of Rilke's fundamental convictions was that life is real in proportion to its difficulty. Art was helpful only in as much as it allowed her to bear her distress more passionately.

Those who die young can reconcile us to our transitoriness. Heroes, according to Rilke again, were the key to the ultimate identity, of life and death.★ Barbara used the word as the title for the drawing she dedicated to Paul and his pilot. Her other dedication being the Madonna. Read might not like it? A question mark to her statement suggests she wanted a reply. After the fuss she had made about Moore's Madonna being realistic, hers, which is certainly representational, comes as a surprise. 'How on earth,' she had asked, ten years before, could she carve a Virgin and child if she didn't believe? It looks as though she had lost the precious sense of communication with God without losing the need for it. Paul's death had prompted a change of heart. From this time, inwardly, she made her life a tribute, full of echoes, to memories of Paul and Ben.

★ 'The hero continues, for his fame lives on among men.'

These Large Figures

(1956–9)

'Why shouldn't I carve these large figures? It makes it so pleasant to carve the little tiny ones.' John Summerson's increasing eminence in Georgian architecture didn't make him a connoisseur of modern sculpture, but criticism brought out the battle instincts in his sister-in-law. *Empyrean* had been nearly nine feet. She was going up and up. The impulse was strong, and using metal made it practicable. 'I've always wanted to go to my arm's length and walk round things, or climb up them. I kept on thinking of large works in a landscape: this has always been a dream in my mind.'

That Hepworth was really a carver is almost a cliché. In pursuit of money and power, the accusation continues, she extended her range and lost her touch. A grain of truth distorts a much larger issue. A CBE, the Grand Prix at the São Paulo Biennale, and transatlantic exhibitions rapidly increased her stature – the result being that she was called upon to produce bigger works and more of them. In the circumstances, it was easier to use techniques that could be reproduced. But long ago, before the war, Barbara had felt the urge to create large sculptures. *Monumental Stela* 1936 and *Monument to the Spanish War* 1938–9 must not be forgotten. Both were around six feet. Nor was it out of character for her to espouse methods or materials for which she had hitherto assumed a strong antipathy. Because she secluded herself behind a twenty-foot wall, there's no reason to assume Barbara was isolated from the art world. On the contrary, few were more aware than she how sculptural horizons had been altered by the international début of a younger generation at the Venice Biennale of 1952, an occasion on which she had been

desolated to find herself excluded. Sculptors who had grown up with iron – Adams, Armitage, Butler, Chadwick, Clarke, Meadows, Paolozzi and Caro – were introducing new values. There were two streams in contemporary sculpture, she reflected, equally relevant: carving, and a 'more fluid approach [in metal] which is perhaps nearer to the realm of painting'.

Two years later, Read's *Art of Sculpture*,★ and an exhibition of young British sculptors touring the US had set her thinking seriously about her position in art. Her reputation was assured. If she had spent the rest of her life carving she would have honour and fame. This wasn't enough. In one sense she belonged to the Nicholson, Moore, Gabo generation, but she was younger, and younger sculptors were using metal and assemblage. Restlessness and lack of tactility worried her most about contemporary sculpture, but the spirit of contemporaneity was an imperative consideration. Her work *must* be socially relevant. If she stuck to carving, the slowest and most arduous form of sculpture, she was going to be left behind.

She admired enormously Reg Butler and the lesser-known John Hoskin, both of whom worked in iron. That Butler's Unknown Political Prisoner entry had been placed before hers in an open competition was definitely a consideration. So was the fact that her wooden works were beginning to split in hot climates. Metal was durable, reproducible, and lent itself to the bigger public commissions she was now being asked to fulfil. Most of all, she wanted to compete with Moore on outdoor sites. Nothing, however, would have prevailed upon her unless she had realized its aesthetic potential. In metal she sought 'the quality of "evocation"', and the 'poignancy of the fire'. 'The problem [was] how to extend the forms beyond the capacity of stone & wood. How to swing up & outwards when feeling cannot be contained by the block.'

Released from pebble-like or monolithic compositions, she

★ Mellon Lectures, 1954, dedicated to Gabo, Moore and Hepworth.

conceived some incredibly flowing, architectural outlines, best explained as evocations of sound.★ The various versions of *Forms in Movement* are continuous loops capturing uneven rings of space. One in metallized plaster can be seen at Wakefield Art Gallery and a larger one in concrete belongs to the Hepworth Museum.

There were endless variations on the traditional technique of making bronzes, by casting models of clay or plaster.† The advantage being that a limited number of editions could be cast from the same mould. The important thing, as far as Hepworth was concerned, was to avoid modelling, a process for which she still maintained a personal distaste. This she accomplished by building armatures of chicken wire with a fine-grained dental plaster she had used for maquettes when she first arrived in St Ives.‡ Creating an armature was like building a boat; applying the plaster like covering the bones with skin and muscle. The plaster could then be carved before it was cast in the normal way. With the assistance of Brian Wall she cut and welded copper sheets. After a number of metal works, she would return with renewed pleasure to her old materials. During 1956, for instance, of some twenty figures, four or five were wood, two stone, and one concrete, the rest were metal. As the years passed, the proportion of wooden ones decreased slightly.

Whatever her material, dominant themes and images had long been established, bird or angel-like symbols, growth, landscape, the human figure and interactions between them. Art 'affirms', a word Barbara was to use a lot from about this time.§ More than ever, the great stringed bird/aeroplanes, *Curlew* 1956 and *Orpheus* 1956, embody the upward, often armlike strivings of undefined

★ Barbara once said that the rhythms of sound seemed nearer to sculpture than the rhythms of words.
† Butler invented and patented a new technique which didn't work.
‡ It was a method used by architectural plasterers.
§ Rilke believed the artist reaches out to a transcendent realm of unified consciousness, in his attempts to escape life's tragedies.

Rilkean aspirations that had for so long been points of contact for her inner world. Made from brass sheets, bent to a continuous surface and held in tension by deep-sea cat-gut, they are 'As pure as the bird/when the surging season uplifts him'. Always a little alien, they seem to combine the wing of a lark, the poise of an arrow, and the craft of a harp. Like birds, which fly into the sky before they return to earth, breaking barriers, to move into infinite, cosmic space. Often they had been thought out in her drawings of ruled cords inside continuous perimeters.

A series of robust bronze torsos, generally pictured against the horizon of the sea, are human, rather than birdlike, although still transcendent. So are *Cantate Domino* 1958, a simple design of two ribbed wings flung upwards in a spontaneous and ecstatic appeal of a human gesture, and a beautifully curved and counter-rhythmed piece in elm-wood called *Nyanga* 1959–60.

However you look at Hepworth's sculpture, the Cornish landscape lies behind its arcs, curves, tensions and balance. One of the fifties bronzes was based on the view from a hill called Travalgan that rises between St Ives and Zennor. Having scaled the gorse-flickered slopes, Barbara was standing among the boulders on the summit, gazing seaward to a point where the cliffs divide as they touch the sea. In this position, 'facing the setting sun across the Atlantic, where sky and sea blend with hills and rocks, the forms seem to enfold the watcher and lift him towards the sky'. There are probably plenty of hills from which *Trevalgan* 1956★ could equally well have been conceived; nevertheless, it is nice to know there is a real place you can run up and see, just as Barbara did, where her sculpture was born. An illustration used as a coverplate to yet another monograph shows her from the waist up, poised inside the deceptively simple, vertical, horseshoe-shaped *Trevalgan*. Her elbows span the base of the sculpture, her hands clasp above them, her head is poised on her fingers as if she were

★ *Curved Form (Trevalgan)* 1956, the first bronze Hepworth made specifically for casting.

caught in the magnitudes between earth and sky. The coverplate was another bid to emphasize Barbara's integration with the work and with her surroundings.

Sea Form (Porthmeor) 1958 was a response to the silver-sanded bay of the same name, lying on the west of the Island, where wind-surfers on the dole now spend seven days a week in wetsuits, oblivious to the delights of the new Tate Gallery. The sculpture looks as if it might have been made from beaten sheet metal, although it was cast in bronze. Like *Oval Sculpture*, made more than a decade earlier, it contains three prominent cavities, but instead of being gouged from a solid, they are punctured in a relatively thin, irregular, lipped, bronze saucer. If *Oval Sculpture* conveyed the fragile delicacy of a bird's egg, *Porthmeor*, with its white-encrusted, unevenly finished surface, has the deceptive transfiguration of something that has long lain beneath the sea. Barbara had become bewitched by the Atlantic beach, *Porthmeor* was its ebb and flow. The year between making it and making *Trevalgan*, she produced what was by now a traditional wooden 'Hepworth'. *Icon* 1957 was eighteen inches of light-enchanted mahogany, mysteriously tunnelled and finished like spun silk.

Constantly, in her letters, Barbara dwelt upon the artist's relationship with society. The contemporary movement had fought for and won acceptance. If the majority still found modern art difficult, they were at least tuned to its presence. But there could be no rest. Ground gained had diligently to be maintained, the international market encouraged, promotion reappraised, retrospectives staggered with smaller exhibitions of current work. With her sculpture changing and developing, it was all the more imperative to impress her image. Since the Venice Biennale, she had not had much support from the British Council, who reported, in turn, little call for her work.

Until the mid fifties, Barbara had handled her public relations, gathering round her, despite her shyness, people impressed by her seriousness. Ben's support had been invaluable. Both liked things to be done so very precisely that invariably it was easier to

manage them themselves. But without Ben there were signs it was getting too much. Ben was being represented by Gimpel Fils, and on his recommendation they took on Barbara's London shows. She liked Charles, Kay and Peter very much indeed; the time had come to formalize the relationship. Both stood to gain. A gallery can be, for an artist, grand impresario to his entire career. But for someone who had fought so hard and counted her pennies for so long, releasing control was agony. The eleven-page letter Barbara sent Gimpel Fils about a draft contract was fair warning that their new client wouldn't be easy. No doubt Gimpel had already guessed. Over the years, she sent them hundreds of letters, affectionate, accusing, apologetic, and nearly always extraordinarily demanding. Barbara's American gallery, the Martha Jackson, broke off their contract after a single unsuccessful show, because she was so difficult.* Alone and vulnerable, fragile, overworked and frequently unwell, Barbara had needs and insecurities that were interfering with her relationships. Something unforeseen, moreover, was to aggravate her situation. By chance, Gimpel played a part in the personal drama of their two most outstanding and most difficult clients.

Felicitas Vogler was a young German photographer working for *Time and Life*. Having arranged to go to St Ives, she contacted the gallery, who naturally gave her an introduction to Barbara Hepworth. Felicitas travelled down. The two women met and, perceiving a useful contact for Ben, Barbara sent her on. When Ben met Felicitas, something took place for which the common laws of contingency are not accountable. Since Ben had left Barbara, he had been living with a girl he met at the golf club. With Felicitas it was different. Janet Leach described her as a rather tough-looking Prussian with a black dress and pearls who 'had something with the fellows'. Felicitas was an accomplished pianist with a good academic mind and immediate sympathy

* 19 December 1956–26 January 1957, after touring major museums in Canada and the US.

with Ben's work. It has been suggested that she would be a means of embracing the international community where Ben felt he belonged, or that he might have wanted, after all these years, to be looked after. But Ben had already paved his way in Europe and New York, he didn't need ambassadors. Nor was he misled as to Felicitas's nature. 'She's a "gentle", "sweet" little thing – so many people think – but how misleading that impression is!' Felicitas Vogler was fiercely protective of her own career. Far from wanting a change, Ben was attracted by the strength and single-mindedness he had married twice before. Without losing much time, the couple became engaged.* In July 1957, less than a month later, they married in Hampstead Registry Office, where once, in passion, Ben had given himself to Barbara Hepworth. Within days Barbara had signed her first long-term contract. Gimpel Fils would be sole agents for her work. She wanted to 'blossom out' and 'expand'.

It wasn't until the sixties that Barbara rather suddenly began to build up the wealth that was to leave her worth three million pounds. Beyond work and studio, she had no resources to meet the cost of casting big works in bronze, for which several thousand pounds at a time had to be found. Meanwhile, Gimpel would advance at immediate notice as much as she required. When she needed cash, they bought up her work for stock. On at least one occasion they paid outright for a sale that wasn't honoured. For Barbara, who rigorously repaid every pound within her family, it was a difficult situation. She didn't like borrowing. Unless she had money in hand, she was very uneasy, and over small expenditures her meanness could still be ludicrous. To justify her behaviour, she laid unnecessary weight upon her obligations. Whether or not Ben's marriage altered her financial position, she *felt* and said it did. What the marriage did reinforce was her consciousness of her responsibilities, including her career, and facts became adjusted in her mind. From time to time

* 1 July 1957.

Gimpel suggested diplomatically that she had funds available if she cared to use them. In reality Barbara knew that 'debts worry me quite unduly. Long years of trying to manage and rear a family meant long years of responsibility & gambling worries me.' The picture was further confused by something she could not admit, though everyone round her knew. No price she received for her work was high enough, while Henry Moore was getting so much more. The reason, Barbara felt, could only be that she received a woman's price. It was a recipe for discontent.

An inordinate number of notes flowed between St Ives and Gimpel Fils in South Molton Street. 'Could you wrap something round *Torco* (*Torcello*) when they collect it.' 'Please wash white marble carvings, not [underlined three times] with soap, hot water & an infinitesimal [underlined] amount of fine vim.' Details were often repeated by telephone. The testimony to Hepworth pragmatism is the set of files, always referred to by Gimpel as 'The Bible', that list the complete provenance of every drawing, sculpture and cast. But Barbara fussed so much, Kay Gimpel conceded, that personal relationships could be exceedingly unnerving and results counterproductive. Because she didn't delegate easily, she confused the lines of command. Barbara didn't exactly mistrust Gimpel, it was just that her requirements were so exacting she couldn't accept that anyone could perform them as she herself would have done.

At the end of 1957 she was suddenly bored and miserable. Ben had gone into purdah with his new wife, Barbara told Summerson, abandoning interest in her and the family, and flirtation (Summerson's suggestion) didn't appeal. The moment could scarcely have been more appropriate for the New Year honour. For someone who was impressed by prestige, revered royalty and revelled in ceremony, the promise of making a curtsy at Buckingham Palace to receive her CBE cast a glow of anticipatory warmth over the New Year. Barbara didn't like cocktail parties because people rested their glasses on the bases of her sculptures, so Gimpel put on a small, preliminary dinner. Margaret Gardiner

proffered material for a suitable garment, and Barbara had it made up professionally. For 'once in her life', she would like to lean 'ever so faintly' upon someone else. As the Summersons planned to escort her to 'BP', it had to be John.

Herbert Hepworth CBE died on 8 January 1958, too soon for the ceremony, but not too soon to know that the family bent for public service was being upheld. Ben, who was playing for bigger stakes, turned down a CBE, and Barbara's friends were bristling with public honours. But she was a woman, competition in the fine arts was intense, and far fewer women achieved recognition. In dance and theatre at least the sexes divided naturally, but painting and sculpture were dominated by men. Barbara Hepworth CBE had distinction. Gimpel would use it on every possible occasion, Kay flattered.

Despite the comparative ease of life in a small town, its local press conditioned by generations of art colonies, not all St Ives inhabitants were enthusiastic about their artists. There were four Methodist chapels, of which the primitive one in Fore Street hadn't been preached in by an Anglican right into the 1970s. Relations between them, in the view of one of the parish vicars, were a glorious example of how Christians shouldn't behave. To outsiders, they were inclined to be still worse. One Sunday morning, a congregation, spilling down the hill outside Trewyn Studio, and hearing Barbara hammering, threw stones through the glass of her windows. There were occasions when the minutes of the Penwith regretted lack of co-operation from the Town Council. None of this influenced Barbara's public statements about the town, which were always the height of diplomacy. Like her father and his old father, she was determined to do her bit for the community.

Anything that affected the town's appearance was close to her heart. The St Ives Trust was set up to control the development of new buildings in the town, and not only was Barbara instrumental in starting the group, she drew in her assistant, Roger Leigh, as chairman. Michael Canney, curator of the Newlyn Art Gallery,

worked with her on several arts-related activities, for each of which, he remembered, she used a school exercise book, so that information was compact and to hand. Her professionalism struck him as a stark contrast to the general dilettantism of British art at the time. With it went a certain ruthlessness. But what did people mean when they called Barbara 'ruthless'? Not that she hadn't pity or compassion: rather that she swept away other considerations in the interests of what seemed most important. She was disinclined to make concessions for others or for herself.

The death of her father set Barbara musing over familial debts and duties. When she was little, he had picked her from the floor and tucked her in bed at night, she told Janet Leach. When she moved to Carbis Bay, he was still sending money every week to help feed the children. A sum, incidentally, she felt it incumbent upon herself to repay her mother. Gerda Hepworth lived another fourteen years, a responsibility that troubled her children a good deal. Joan wasn't in good health and neither Barbara nor the Summersons were rich when they were first keeping her in an old people's home. Barbara hadn't enjoyed an easy relationship with her mother, notwithstanding she was a generous and dutiful daughter. Love and duty were what she hoped would guide her children in the fullness of time. What puzzled her was how unlike herself the triplets were. While she had fought for independence, her children, reaching twenty-one, clung like limpets.

Cats and palm-trees received the zealous ministrations she bestowed upon her sculpture. Palms were wrapped in newspaper to protect them from frosts. A little Siamese used to rush up and down them while holding one's image intently in its blue eyes. A lost cat meant Barbara's assistants dropped tools until it was found, and if a kitten got into the wood stack, this might take hours. Barbara could manage cats which were undemanding and independent. From a distance it is easy to see that confidence is the key to independence in children, a quality neither her nervy tensions nor Ben's idiosyncratic paternal contributions had instilled. In a piece of self-deception so ludicrous that it betrays

Barbara's need for justification, she had written, before leaving for Greece, that it was the first time she had left her family in twenty years. Just once, she felt, would be expedient. Self-justification was necessary because she couldn't be sure she had done what was right. Her anxiety didn't help her children. On the contrary, it implied that something was wrong with them.

Circumstances had conspired to give the Hepworth-Nicholson juniors a curious childhood. From the day they were born, SRS had been consigned to nurse, cook and nanny, shared, dispatched, recalled and redistributed. Simon's second homes were with the Shaw Ashtons and the Hallidays, both girls had stayed with the Reddihoughs, Rachel often stayed with the Brumwells and with Nicholson cousins. Sometimes there had been notices pinned to the door that read 'Working – Don't disturb', and people around them commented upon the paucity of happy-go-lucky childhood pastimes available. Visitors who came to their house weren't there for tea-parties with their mother or cigar-smoking evenings with Ben. They came because their art was going to regenerate the world. That was the atmosphere in the house. Home wasn't a stable environment and, coming from school, they had a term of comparison for the screwed-up intensity of the scene. It is easy to be hypocritical; disadvantages were balanced by a special status conferred upon the triplets out of respect for their parents' world, and Barbara and Ben respected their individuality. Barbara might not have been a very good mother, which is hardly uncommon. If, on occasion, her children were a burden she could have done without, it doesn't mean she didn't love them. Two irreconcilable states co-existed in her, her devotion to her children and a refusal to modify her schedules. The deprivation she experienced when she couldn't work overlay her instinct. Almost inevitably, the triplets became used in their parents' tug of war, and when, after the separation, they were set up in the cottage, Ben and Barbara joined them in the evening for dinner.

Barbara was reasonably ambitious for her children, among whom there was brain and talent. Sarah, who was very wrapped

up in flute-playing, had a keen direction. This is always easier for parents, and one senses Barbara's approval. After leaving Darting-ton, as a pupil, she returned to the music school there. Rachel had a mind of her own and a practicality that Ben, especially, admired. She took a course in catering, worked very hard for very little recompense at one or two jobs, and went to France to learn French. Since childhood, Simon had spent much of his time drawing. To Edna Shaw Ashton, with whom he had frequently stayed, he appeared to be happy enough, jumping goat-like on the cliffs, constructing clever montages and devising Ben-like games. He could have done lots of things. But after Dartington, much like Ben as a young man, Simon found it difficult to decide which way to turn.

Completing a year in the sculpture department of the Royal College under John Skeaping, combining, as Barbara had done before him, a two-year course in one, Simon then changed tack and made an illustrated survey of prehistoric sites in the Scilly Islands. His dilemma by no means sorted out, he went up to Trinity to read Anthropology and Archaeology, while part of him still hankered for the world of visual art. When he left Cambridge at the age of twenty-four, to make a final bid for art, he was trained in something different, faced for the first time in his life with earning a living, and petrified of not being able to live up to what was expected. This was when Simon's real difficulties began. Not that he didn't have friends, but they couldn't help him resolve what was a crisis of confidence dressed up to seem like alternate arrogance and immaturity. Alarmed by the way he looked and behaved, they said Simon was inaccessible.

With Barbara, he seldom communicated. Thanks to various friends in London, she and Ben were kept informed of his moves. Ben's immediate reaction was to alleviate the pressure on him by offering a year's financial support. At the end of the year, the situation hadn't significantly improved. Various intermediaries were called in for advice. Herbert Read thought Simon should

take a part-time job which had nothing to do with art, to bring in some money. Marcus Brumwell concurred. For his own self-respect, he should become independent as soon as possible. But Brum's usefulness was limited, he felt, by Simon's being so remote. Ben reckoned a real painter would paint, come what may. Simon obviously had talent, so he supported his son another year.

Sarah, meanwhile, had met a clean young Englishman. Alan Bowness had taken two years off from the Courtauld Institute, as a regional arts officer for the Arts Council. The general impression he gave was one of alertness and a pleasant readiness to take responsibility. Barbara admired his intelligence. When he married Sarah, in 1957, it was plain to those around that his mother-in-law found him an eminently suitable match. Marriage lightened her burden. 'I can not any more support my sweet family who weigh on me (the minute they catch sight of me!) like a ton of intractable stone out of my workshop. Bless them – I expect its my fault for being such an odd sort of Mama.' It was a Barbara-ism. Alan Bowness points out that she hadn't been supporting the girls for years.

Several people mentioned that Barbara occasionally showed off. She could be a bit patronizing, and sometimes they had had enough. What they couldn't deny was the concentrated effort she exercised in the interests of the artist community. If important visitors were arriving, she called out the best pictures, the standard went up, dealers saw the work of young, needy or otherwise neglected artists, and everyone benefited. Thanks largely to her, the mighty were drawn to St Ives. Many testify to her personal interventions on their behalf. Frost, MacKenzie and Wall were just a few of those whose work she brought to the attention of her friends. When Ben resigned from the Penwith, in February 1957, Barbara worked harder than ever, conscientiously attending meetings when general apathy prevailed. There was a dilemma. Members of the forty-five-odd Penwith Society were happy for her to do what needed doing, but they objected to oligarchy.

From time to time, someone resigned in protest at what he or she felt, with Bernard and Janet Leach and Barbara Hepworth on the committee, was an establishment-weighted organization and rather a closed shop. By enrolling her assistants, Barbara effectively increased her control. Often the Penwith's chairman, sometimes both chairman and secretary, were chosen from her ranks.*

Trewyn's most recent recruit, Keith Leonard, had been so affected by the Whitechapel exhibition that he gave up teaching in the Midlands to join Barbara. For more than four years, Brian Wall had been the youngest and favourite employee. Though democratically elected, it was difficult for her assistants to be entirely objective during meetings, when they confronted her as slaves the next day. Brian Wall didn't survive contradicting her at a committee meeting. The morning after the incident, he appeared for work as usual, only to be dismissed. Impenitent, Wall moved to the US and made his name.

Peter Lanyon had once been another blue-eyed boy. Although his work was again being exhibited with the Penwith Society, it was far from being an act of homage to Barbara Hepworth. Of all the artist rivalries, none was more firmly entrenched than the Lanyon/Hepworth-Nicholson divide. Visiting the three artists they represented, the Gimpels had to be careful not to spend more time with any one of them. Even friendship with one party rather precluded a relationship with the other: circles, in every sense, were tightly drawn. Each year Barbara dressed up for the Penwith Arts Ball – her assistants thought it was sporting of her. But the one retained in the minds of those who were present was when Peter Lanyon, for no obvious reason, expressed in public his rage against her. Highly talented people often attract envy, jealousy and resentment in the less able. Here were two able ones setting each other on edge. There was a different Barbara, it

* Leigh was chairman of the Penwith 1959–61, Wall was secretary in 1959.

seems, for everyone, suggesting that she behaved differently according to whom she was with.

At intervals, she held parties, mixing artists with friends from the past, visiting art world luminaries and anyone else who might be persuaded to buy art. Brumwells, Hallidays, Holmans, Leaches, Herons and MacKenzies would meet her assistants; impoverished artists encountered Lilian Somerville from the British Council, Philip James from the Arts Council, Michael Tippett or Lord Snowdon. Bill Holman was chairman of one of the biggest mining and engineering firms in the country, a Cornishman who travelled to London by private aeroplane in half an hour. His wife, Linden, ex film-star Lin Travers, found Barbara a bit intimidating, although she liked her and wasn't the least put out by her innate preference for Bill. In married couples, this was invariably the case. Rene Brumwell, too, was fond of Barbara. She and Marcus had built and moved into a beautiful modern house overlooking the mouth of the River Fal, which they filled with the cream of abstract art.

'See that you're clean; don't say anything to anyone', Barbara clandestinely forewarned Roger Leigh in a series of nervous telephone calls that preceded one of Snowdon's visits. When the evening came, she was so shy that her assistants were left making conversation to fill a stilted silence. You had only to be in a room with her for fifteen minutes to realize how shy she was. She recognized that her seriousness drew others and dominated them; it was the way they might feel with royalty, that slight sense of being on edge, and not quite sure they were saying the right thing. She liked people of achievement, but she couldn't accept Snowdon without deference to his associations. People who didn't like Barbara thought she lived in a rarefied atmosphere where everything was too precious to touch. There were only great people, the rich and famous. They were excluded; and she was queen.

Queens have an entourage or a court. For more than a quarter of a century Barbara's mainstay had been Ben. Even when she

signed the divorce papers, she had retained a hold on him. Sexual separation she accepted; what she wanted was artistic sympathy. When Ben went off with Felicitas, she felt monstrously alone. At every street corner she would see his shadow, and in the evenings, sometimes, he seemed to return to her for sleep and safety. Listening to faint sounds from the street, murmurs from the garden, she would hear an unevolved rustle that spoke of the growth of noise that would be Ben coming to her. But he always went out again. At times she would get up and walk about beneath the church tower to make the interminable night pass more quickly, to bring Ben back by the very strength of her longing. Walking, suddenly, she would sit down and despair. She would think, you have got to come back with me or I can't go on. Ben was king, never a prince consort, and that was part of the problem. He needed his own kingdom. It shook Barbara, it shook St Ives, when he went away with Felicitas and, holidaying the following spring among Switzerland's snow-capped mountains, they decided to settle in Ben's old haunt, Ticino. Much as he liked St Ives, it had become too small for him to indulge in private life, Ben wrote to his old friend Staite Murray. He needed privacy to work. With Ben gone, how dark the months were, Barbara told Nancie.

From time to time she was immobilized by the concentrated effects of overwork. Flapping about her finances was always a bad sign, and two major international exhibitions in a single year was a prescription for intemperance. But it was six years since the British Council had taken Moore to São Paulo, two years since they had shown Ben. Barbara's turn had come at last, and this time all were determined to prepare the way. In March 1959, she sent off the first consignment of work to the São Paulo Biennale. In contrast to her Venice Biennale exhibition of 1950 where the early carvings received a lukewarm reception, virtually everything that went was post-war. Barbara admitted she was very tired. There were pre-exhibition traumas as well as post-exhibition traumas, her doctor reckoned. In April, thoroughly 'browned

off', she had begun to worry about New York. All would be well, she decided, if the show was postponed. Gimpel thought her fears were groundless, that preparations, anyway, had reached a stage from which it was difficult to retreat. After a spell in hospital and two weeks' convalescence, Barbara was back in action. New York still alarmed her. Uncertain about her new work and pressurized by schedules, she was feeling, by mid-year, a 'commodity'. Slowly pulling through, working ten hours a day, seven days a week, all through the summer heat, she complained that prolonged pressure removed all the fun out of achievement. By the time the results emerged from Brazil, she had released her tensions in a vitriolic missive to Gimpel Fils. The news, however, completely regenerated her. Apologizing to her gallery, she admitted she had felt desperate. Profound nervous exhaustion was the cause. It was nearly five years since she had 'been allowed' (a Barbara-ism meaning 'allowed herself') a pause or a holiday. The year had been too hard.

When Barbara received the telegram she wandered about the garden, unable to believe in her success. 'She was high as a kite,' Janet Leach said. 'To have beaten Henry in particular.' Moore had been awarded a prize for the best foreign sculpture; Ben Nicholson for the best foreign painter. Barbara's major international prize (worth £16,000) had beaten them both.* Lilian Somerville's decision to show the bronze *Cantate Domino* instead of the soaring yew-wood *Figure (Nanjizal)* 1958 that Barbara would have preferred was vindicated when the museum selected it for purchase. After insisting for six months that she couldn't afford the trip, rallying to her success and the prize, Barbara flew out by Comet to the opening of her exhibition at New York's Galerie Chalette. Unknown to her, Marcus Brumwell arranged a programme of star treatment. The result was all she could have

* The selection committee had included four of her inveterate supporters, Philip Hendy, now of the National Gallery, Read, Lilian Somerville and Bryan Robertson.

wished: the visual experience of the flight, the gallery, New York, and the enthusiasm of her reception surpassed all expectations. 'Is one ever the same again?' Barbara asked Read. At a select dinner party, Brum had arranged for her to meet two people she held in greatest admiration, Djuna Barnes the writer, and Secretary-General of the United Nations Dag Hammarskjöld. Djuna Barnes was extremely amusing; Hammarskjöld bought a drawing and turned up at Barbara's farewell party. She was highly flattered.

No sooner was she home than she was off to Paris to finish Susse Frères' cast of *Meridian* 1960. It wasn't her first bronze to be commissioned. Mullard Electronics had put in a bid soon after she began working in metal. The spiky, Gaboesque piece at their new headquarters (Mullard House) was displayed at intervals in the pages of *The Times*. But *Meridian* was the largest one to date, and she was paid £10,000 for it. The commission came from Wohl, the industrialist who sponsored State House, and the sculpture stood for thirty-five years outside the building in High Holborn.

The whole affair was conducted in a highly professional way. If the vernal leap for joy of Barbara's maquette was never quite realized in the final, fifteen-foot version, it merely proves her earlier assertions about the impossibility of changing scale. Barbara was shown the site when only one storey was standing amid a mass of jibs and cranes, and her idea sprang clearly out of that first visit. Immediately, she made a five-foot working model. The mechanics of blowing up such a complex shape to three times its size were highly involved. Having steamed seventeen-foot timbers so that they could be freely curved, she had them clamped in pairs. Short, horizontal lathes then bound the paired timbers into a strong two-dimensional frame. By winding the forms with hessian soaked in plaster of Paris, she had surfaces that she could build up with more plaster using a large spatula. Before the year was out, there was wind of an enormous office block in Holborn prepared to commission a twenty-foot flowing abstract

frieze. By the end of the decade it was apparent that whether one is speaking about Hepworth's status, the height of her sculptures or the prices she got for them, a significant expansion had taken place.

Barbara usually dreaded, and invariably enjoyed, her foreign tours. In Paris, euphoric, after twenty-one years, accompanied by Janet Leach and Kay Gimpel, she celebrated by buying on impulse a chic Parisian hat. Kay, who was acting as interpreter, was amused at the slightly raised French eyebrows earned by Barbara and Janet Leach. It was cold, so both wore slacks. Were they a couple? 'So I kept saying Madame had three children.' When the foundry session was over, Barbara met various artists: Joray, Seuphor, Arp and Soulages. But unable to indulge for long in what many would call the good things in life, she was anticipating a long spell of carving the moment she got back.

Within the space of six months, her father had died and Ben had left the country. At her lowest ebb, Barbara owned to Nancie Halliday that her personal life seemed a reprimand. When she was working, she could see her way through: if over-extended, she was happy. It was when she stopped the bogies crept in. Human beings are finite, transitory and perpetually distracted. Looked at in one way, these are limitations. Viewed another way, they are conditions for the fulfilment of a specifi-cally human task. If negation is overcome by affirmation, transitoriness becomes acceptable. She had, at a relatively advanced stage of stylistic development, not only gone on produc-ing a steady body of work, but infused new tension. It is worth remembering that the bronze and brass sculptures that represent Hepworth all over the world were made in her last twenty years. With her mature need to leave behind her works of lasting truth, Barbara discovered freedom in complete dedication and submission to her human task. Her transcendent figures are about the jubilation that wells up behind pain, hardship and endurance.

'I went up to a high hill on Midsummer night to watch the sun set over the Atlantic,' she wrote with reigned-in excitement.

'No sound but the birds and distant sea. Even the birds have extended their song for weeks beyond their time . . . Perhaps it is really necessary & salutary to accept the suffering in order to keep intact the terrible & vital perceptions of adolescence . . . If Jung is right about the shadow fight (I think he is) we can only live and create in equilibrium by facing darkness from time to time.'

Public Sympathy

(1960–62)

For years Barbara's work had been misrepresented and maligned. She had learned to accommodate to this, but only because, though ignored in larger circles, she had been acclaimed by the few who mattered most. Meanwhile, the damage to her nervous system was slow but thorough. There had been too many illnesses, too many human losses, too much rage wasted on those who couldn't appreciate her scale of priorities, and the reserves she was throwing into the work had worn her down. Refusing to fritter her light-filled passion, waste herself, or cheat the heart of things, she stood up and went on being original.

Everything snowballed in the sixties. The Queen and Prince Philip purchased a gouache.* The public bought works, galleries bought works, sales brought in money and Hepworth prices rose several times in succession. One by one, space, time and money ceased to inhibit. In a decade, she was to produce almost as many works as she had in the whole of her previous career. The literal opening-up promised in *Meridian*, to looser, more agitated forms, was not pursued. Her initial statements, particularly those in stone, were largely variations on the simply-fashioned, bulky forms of earlier years, subtly rounded as though the forces of nature had refined upon the mass of a boulder by scraping and polishing. Curvatures were gentle, explorations, those of erosion, the old monumentality being reinforced by slightly smaller openings in relatively greater masses. The range and scale of her metal sculptures continued to broaden, specifically to flattish shield

* *Arthrodesis of the Hip* 1949.

shapes, and constructions of hard-edged slabs – the first time since the thirties she had used squares and rectangles – so that her sculpture seemed to take on a painting aesthetic.

Bronze was a lot less reliable than wood and stone. Two casts of the same sculpture were never alike, which, for someone whose hallmark was precision, was mortifyingly unpredictable. Perhaps she shouldn't be doing bronzes at all, Barbara wrote, underlined and twice queried, in a letter to her gallery. Nevertheless, when Read questioned the basis of texturing surfaces, she was quick to retaliate. By comparison with the 'accidental' finishes of much sixties sculpture, her work had remained directed. But casting from plaster gave her the power to use a range of distinctive finishes. Her bronzes might glitter to a golden sheen,★ or bear the mark of tools, or deliberate rucks, crimps and crevices left in the surface. Effects varied from the heavily embossed, leathery-looking *Archaean* 1959 to the whitish *Anima* 1959, worked to a semblance of something eroded and salt-encrusted by tide and wind. The sacred issue being jeopardized was 'Truth to materials'.

Why was using plaster less true than using clay, Barbara rejoined? Arp's new bronzes, cut from sheet-metal, seemed valid enough, and Chadwick resorted to bronze because his iron sculpture rusted. Was that being true to material? The British Council wanted bronzes, the Biennales clamoured for them, and bronzes were easier to transport. Museum and critic were much to blame; society allowed no peacefulness in which to carve. Should she starve herself? An argument begun on aesthetic grounds had degenerated to pragmatism and finally become hypothetical. Barbara was revealing her insecurity, though the matter was soon dropped because Read overcame his disapproval of texture. Problems of casting, however, were endemic.

Much as Barbara appreciated the skills of the French foundry Susse Frères, she found it stressful travelling to the Continent, and

★ They travelled in plastic bags with impregnated dusters.

Morris Singer, whose exclusive services she was to employ from the summer of 1959 until the end of her life, didn't always rise to her exacting standards. The best way of protecting the quality of her work was to elicit the personal ministrations of Singer's assistant manager. In fact it was Eric Gibbard who approached her first. Telephoning Trewyn when he was on holiday near St Ives, he encountered Barbara in her summerhouse. Amid butterflies, sculpture and sultry growth, something gelled between the two.

The aim of casting is to make a bronze which is as close a copy as possible of the model. Basically, a wax copy of the plaster was compressed with wet sand, then molten metal was injected into the wax, melting it, to leave a metal shell. Four craftsmen were involved, two to make the sand mould, a chaser who corrected any faults – marks made, for instance, where the metal entered the mould – and a patinater, who coloured the surface of the bronze with acids. So sensitive is the last process to humidity that the slightest variation alters the resulting shade. Gibbard had no pretensions to being an artist: he had been schooled by casting Epstein's *St Michael and the Devil*. Humouring Barbara, arguing when he felt inclined, he soon made himself indispensable. In return, Barbara made him feel important, which he was. She sometimes confided in him, paid his hotel bills and remembered every Christmas and birthday. Three or four times a year, Gibbard visited St Ives to familiarize himself with large plasters in the process of being made and their idiosyncrasies. Thenceforth, he coordinated the casting.

With working men, Barbara's relations were unambiguous and generally good. Denis Mitchell, who left her employment in 1959 to become an artist in his own right, said he'd been apprenticed far too long. Barbara hadn't been good to *him* and, not surprisingly, he resented it. A superb craftsman, who occasionally managed to free himself from her influence, a man who found it difficult to say 'no' to people, he became, with his shock of hair and unfailing good humour, a central figure in the art

world of St Ives. Of three new assistants Barbara engaged in the first years of the sixties,* Norman Stocker was a mechanic, Dicon Nance a craftsman, and Tommy Rowe, who had been to Corsham Art School, stopped making sculptures after a promising early start. Rowe returned to work with Barbara later. Nance stayed twelve years and Stocker remained with her to the end. Barbara didn't want any more students.

Though her outlay was high, and money had attendant demands, she was on the brink of what Gimpel called a less struggling period. Arranging to reverse all telephone charges made to the gallery in the evenings was a symptom of accelerated business. Long-term, Gimpel knew, foreign markets were the important ones, a policy amply rewarded by autumn 1960, when £20,000 worth of goods were sold at New York's Galerie Chalette. A new contract was due, but if Gimpel hoped for relaxation to reflect financial stability, they were sorely disheartened. Barbara put all her assets into her work, giving her an excuse to apply constant pressure to receive funds. Every letter from them concerning her work she wanted to see, every move was questioned, every figure checked.† She was still dealing with handling and transit charges and the surprisingly difficult task of keeping track of the casts of all her bronzes. The super-efficient secretarial assistance of Margaret Moire wasn't as reliable as had been hoped because Miss Moire was frequently unwell.

Moire had been a theatre nurse in the Exeter hospital where Barbara made her drawings. Attracted by the mixture of idealism and pragmatism that Barbara personified, she joined Trewyn when she retired, as a house manager cum personal assistant. Visitors might be taken aback by the jealousy with which she guarded her employer, or by the force of the skirmishes, often conducted publicly, between the two. Bossing and being bossed, swearing and cursing in her sharp Scottish voice, Moire served

* After Broido, Breon O'Casey and Tom Pierce, all 1959–61 or 62.
† Sometimes she found small inaccuracies.

Barbara loyally, keeping meticulous records of her work. Barbara admired strength, and people who weren't cowed by her made her feel more relaxed. Mostly they were men, Marcus Brumwell, Brian Wall, Terry Frost, Eric Gibbard.

Barbara was driven not only by work, and adverse response to it, but by the fact that she, too, was constantly unwell. If time itself was running out, absolutely nothing should be allowed to hinder production. She loved her agents dearly, acknowledging that they had coloured an otherwise austere life. But six months of protracted meetings, proposals and counter-proposals bred, on their part, a mood of suspicion and self-defence. Whether she liked it or not, Barbara Hepworth was becoming an institution. Before negotiations were complete she had accumulated a business adviser, a solicitor and an accountant.* The service of all three was about to be summoned. In the ten years since she had taken Trewyn, the studio that had once seemed roomy had become inadequate.

The front door of Trewyn opened into a cellar where Barbara had a kitchen-dining room. Wooden stairs at the far end led to her studio bedroom. Every inch was functional. 'What order here!' thought Michael Canney, artist and proprietor of Newlyn Art Gallery, reminded of Peter Grimes's hut in the Britten opera. Some were amazed at the simplicity retained by an international artist. The thirties dresser with wrinkly glass doors stacked with countrified blue and white striped china, the black couch covered in plastic to protect it from scratching cats. Entering the basement and mounting the studio stairs was like being inside one of her sculptures. To this day, visitors to the Hepworth museum can feel the dark interior with luminescent cavities, the almost virginal whiteness of interior space, as they climb up to the garden and showroom landing with its liquid flood of light. The other remarkable experience is the sudden view as you step into a sea of exotic evergreens, sculptures and mature deciduous trees.

* Mr Thomas Stallabrass.

Before the outside workshop was built, Barbara used some old greenhouses, refurbished by Denis Mitchell, for rough carving. In 1957, the present utilitarian workshop was slotted neatly beside the house: stone floor, seven metres by five, white walls straddled by a rough wooden gantry that lifts eight hundredweight at the touch of the finger. Something of Barbara is bound to be retained in her tools. Assorted tables bear hard-worn carborundums, a clutter of wooden mallets, steel rasps, chisels and hardboard circles of various diameters that she used as templates. One or two stone blocks are placed in position for carving, plastic goggles lie around, and dusty, paint-spattered overalls hang on the door. In the yard, once piled with wood and stone, a huge turntable tells of the days when she began to accumulate more and more of them, to relate her own changing movements to the sun. And the garden, in which her sculpture so entirely fitted, became somewhere that sun and moon hinged upon earth and heaven; the still point at the centre of cosmic movement where growth was unleashed, where flowers bloomed and faded in the turning year.

The plot came to her with a framework of mature trees, pear, copper beech, ailanthus, holly, palms, and a beautiful monster oak. There were heart-shaped rose-beds set in a sloping lawn, and a cemented pond. It was relatively wild until Priaulx Rainier replanned it to create a magical enclosure of terraces and flowers with a series of discreet intimate places for Barbara's work. The assistants pruned the roses and clipped the hedge. Barbara loved roses, but they had to go, because they got in the way when the sculpture was wheeled around. In the seventies, she bought an extra bit of land from John Milne at Trewyn House, extending the garden a little, adding another greenhouse to the line of buildings, and Denis rebuilt part of an old flint wall. Over the ensuing years, the garden has been filled in with pittosporum, ginkgo, pampas, magnolias, yuccas, chocolate and blue-green phormiums, and bushy evergreens such as mahonia, arriving gradually at the present oasis of flowers, shrubs and terraced

walkways. Cold winters have killed off the palms and bamboos, which have had to be replanted. April bulbs are succeeded by sprays of white *Chrysanthemum foeniculaceum* outside the higher garden door. In May and June the cherries bloom, and as the year unfolds, the eccentric *Echium fastuosum* shoots up in six-foot spikes. Mexican sage twitches red by the glasshouse, to be superseded, in late summer, by Japanese anemones and blue hibiscus.

Above all, she needed more gallery in which dealers and private buyers could view her work. Space was ever a cause of conflict. Objection was made at the Penwith about quarters in Fore Street that Barbara seems to have rented after urging them to quit. Precisely what happened isn't clear. Any accusation was false, though as a prominent committee member, Barbara was in a good position to jump on what was available. Half-way through 1960, another premises under discussion was the Victorian Palais de Danse that stood opposite Trewyn. At £9,000 it was too expensive for the Penwith. But six months later, Peter Gimpel was writing to Barbara that buying the Palais was clearly a chance in a lifetime. A loan of £15,000 (the cost seems to have inflated) was a relatively simple matter to arrange. What he failed to understand, since this was the first he had heard of the plan, was why business adviser, lawyer and accountant couldn't advise. The indispensable triumvirate had indeed been consulted. Gimpel were last to know this because Barbara had conducted the affair in secret. The Palais's 100-foot hall and workshop, underneath storage, and yard for unloading made it as perfect as Trewyn had been before. No longer would the road be closed for several hours when large sculptures had to be moved. No more drumbeats would puncture the nights. With the Palais on one side of the road and Trewyn on the other, her stronghold was complete. A promise of greater production was made to placate Gimpel for having concealed her plans. Barbara could work away to her heart's content.

Growth was figuratively being released by Philip Hendy,

director of the National Gallery, one March morning in High Holborn,* when he snipped the golden cord that unveiled *Meridian*.† A chill wind blew strains of amplified Chopin round the ankles of a score of invited guests, and Barbara prickled, 'You always find a certain type of people who are hostile . . . I expect there will be controversy over this.' In fact the twisting openness of the forms made a good contrast with the solidity of building, and the public seemed perfectly happy. More flattering was Birmingham University's conferring upon her an honorary degree, and quite a different cause for relaxing the pitiless time-table was a small, family party in her London *pied-à-terre*, Priaulx's house in Ladbroke Grove,‡ to celebrate Rachel's marriage to a long-legged academic. Everyone had noticed how much happier Rachel looked since she had fallen in love with Michael Kidd. The occasion was slightly strained. The in-laws hadn't a lot in common with one another. Ben, who didn't like public occasions, was represented by two of his children from his first marriage, Andrew Nicholson with his wife and young family, and Andrew's sister, Kate. Sebastian Halliday brought his pretty wife, Margaret Gardiner and Desmond Bernal's son, Martin, brought his, and Bernard went with Janet Leach. Both Sarah and Rachel looked attractive and happy, Brum faithfully reported to Ben, without mentioning the groom.

For the triplets, the marrying time had come. Simon had already taken Silvie Georgiadis to meet his mother, and wasn't going to be left out. Smallish and dark, Silvie had an openness and warmth that totally beguiled him, and a daughter, who seemed to bring him resolution. By the time Silvie met Simon, he had developed Barbara's forehead, Ben's soft mouth, and, like Ben, quite early, he had begun to lose his hair. Dressing unaffect-edly and living frugally, Simon struck Silvie as strangely

* 1960.
† The form encapsulates essence of sprouting germs.
‡ Shared with the writer Elizabeth Sprigge.

unworldly, full of boyish charm. With Barbara, his relationship appeared to be stable. Trying to be supportive, she had reintroduced him to Herbert Read. They had got on well and she was delighted. Ben he admired, but Ben was in Switzerland, so Simon didn't see much of him. After four years of Cambridge, Simon was trying to make a go of things as a creative artist.

A couple of months after Rachel's wedding, Barbara flew to Zurich with Margaret Gardiner for an exhibition in Charles Lienhard's gallery. To count against ten lost days in the studio, the show was a resounding success. She had been working with John Read, Herbert's eldest son, on a television film for the BBC.★ Then she bought the Palais. Three days later, in high good spirits, she put on a Greek wedding feast for Simon and Silvie. Frank was witness, Nancie made the cake, informal and very gay celebrations continued from late lunch into the night. The general consensus of opinion was that Silvie would be the salvation of Simon. Barbara thought her twenty-six-year-old son was a changed person. She was delighted that he had found somebody like Silvie, someone he truly loved.

In St Ives, the couple decided, they might rent somewhere cheap, while Simon tried his luck as a freelance artist. He was doing some very good work and Barbara wanted to help. What worried her were his prospects of earning a living, let alone supporting Silvie and her baby. Barbara would have liked to trust Simon's judgement, but his moving in on her territory made her feel responsible in a way she definitely didn't want to be. Her mother was sufficient financial burden without all her children simultaneously needing their first dwellings. Why couldn't Ben lay out something for his children, she complained to Summerson, in what amounted to gross misrepresentation. She can hardly have

★ The filming was finished the following spring, when holiday-makers watched several tons of Hepworth sculpture arrayed for the camera on St Ives's beaches and harbour walls. The film was to receive an award at the Venice Festival the following year.

been unaware that Ben had been keeping Simon for two years. Alternately she wanted to give and grew frightened by the responsibility.

In retrospect, moving to St Ives was a thoroughly bad idea. Simon's need for security was more intense than anyone except perhaps Margaret Gardiner realized. His bid to raise money by selling Barbara's twenty-first birthday present was a sign there was going to be trouble. Instead of seeing the practical side, Barbara took his act as a personal insult. Rather than allow *Discs in Echelon* on the market, she bought it back. But she grudged the outlay, and harboured the grudge. Nor was it, as she had surmised, easy for Simon to launch on his own. He found a huge studio in a converted sail loft near where Ben Nicholson and, later, Patrick Heron worked. After four months searching for somewhere to live, he and Silvie ended up in a bungalow opposite the Leach pottery. Here, Silvie gave birth to a boy who died within two days. Courageous, Simon and Silvie became, notwithstanding, less resilient.

Dismayed by their predicament, genuinely wanting to make a gesture of sympathy, Barbara offered one of the beautiful, scented guarea wooden sculptures, *Pierced Form (Epidauros)* 1960. The trouble was that she wanted to give, but she made conditions. It was the same for all the triplets, whom she was careful to give the same money, the same gifts. Nothing was properly discussed, and the giver controls. Another thing Simon couldn't accept was the mechanisms Barbara used to safeguard her rigorous schedules. Her work was so time-consuming and all-important that she couldn't spare the morning or the afternoon. It irritated him to hear her speaking of herself as an 'artist' as if she belonged to some sacred and superior order. To him, her unavailability was playing a part. Something rang a false note. Everything she said had to be profound. Trapped in the search for uplifting experience, she was unable to make gentle, undemanding relationships. Maybe, where the sanctity of art is pitted against the holiness of the human heart, the head must learn from the heart,

not the other way round. Simon had a quick tongue and enormous pride. Needing approval, he was refractory. It is possible that the friendship he had felt for Barbara was more generous than the 'much love' she so freely bequeathed, for she had not answered his needs, but wound about him the trammels of her emotions, even if she hadn't known she was. Simon scarcely had the stability to look after himself, let alone withstand emotional pressures.

It worried Barbara that he and the family were living so simply while she had acquired yet another property. Barnaloft was part of a modern complex overlooking Porthmeor Beach designed by a local architect, Henry Gilbert, for a block of small studio livings. Having acquired one as an extra studio for drawing, as well as accommodating friends and the extending family in St Ives, she now offered to let Simon and Silvie stay there. For them it was hard to get away from the feeling of being favoured, and they declined.

Many of Barbara's sixties drawings were made from the modern comfort of Barnaloft, poised above the changing calligraphy of tide and water movement, of sand, wind, and the pattern of people's feet. Drawings were like practising scales, recording, endlessly, her observations. The process was much easier than sculpting. Shells, patterns of waves and the movement of tides glimmer through tight, precise pencil lines she was making on painted backgrounds. Sometimes her sculptures seemed directly inspired by paintings, sometimes her inspiration worked the other way round. There is a drawing called *Thea*, for example, made in 1960, in which the shape and markings are just like *Serene Head (Thea)* 1959, a sculpture made the previous year.

To 'open up in every way' was her confident aim. She wanted to be true to her materials, but she didn't want to feel trapped by what had gone before. Whether a silhouette was spherical, spiral or vertical, she made what Bryan Robertson was to call 'journeys of discovery', which leave one conscious of being invited below the predestined surface, searching for depths, finding light. Strings, employed occasionally, taut, direct and unequivocal,

gave the impression that here was an artist for whom sculpture was always to some extent intellectual.

Two stunningly simple polished bronzes featured prominently in exhibition catalogues, each barely more than a foot high. One* was a stylized torso with provocative contrapuntal curves, the other, *Serene Head*, a simple D-shape engraved with a long diagonal line, in front of which, in the top half of the 'D', lies a wide, reflective valley. Each sculpture was a stepping stone. *Serene Head* paved the way for the much flatter bronzes that followed, though one might go right back to *Two Forms* 1937 for a precursor to the enormous, slow-curved, monolithic standing wings or shields, ingenious pieces of engineering, strong and rhythmically beautiful, that stand in larger and smaller editions outside the United Nations skyscraper in New York, and beneath the willows in Battersea Park.†

Since Barbara was a child, she had been set upon a course to better the world. Work and public service were part of the same grand propitiation, a thrust that assembled instinct, toughness and intelligence to opportunity and made her effective on committees. The trouble with her role at the Penwith is that she had held the reins for too long, holding so tightly, that it rather took them from anyone else. Success invariably causes resentment: far from endearing her to her fellow artists in St Ives, her leadership was accompanied by increasing pique. Aware of criticism, she had remained on the committee, she argued a little patronizingly, for fear the society would disintegrate. In truth, she enjoyed pulling her weight, and it came as a real shock when a public call was made for her resignation. With a sense of outrage the Penwith proceedings were apt to incite, she insisted on withdrawing entirely. She would act on her terms or not at all. The move

* *Figure* (*Chun*) 1960. Like *Single Figure* (*Chun Quoit*) 1961, the sculpture takes its name from the prehistoric remains on Chun Downs, about four miles inland from Penzance. The precise reason isn't obvious.

† In general, the shape resembles *Single Figure* (*Chun Quoit*).

played into her interests. Four months later, she was recalled to represent the Penwith on the Civic Trust. Her pride appeased, Barbara agreed. Before the year was out, she had been elected to the hanging committee, and three years later she was again on the general one. The Penwith needed the Hepworth drive, vision and tenacity.

The night after United Nations Secretary-General Dag Hammarskjöld was killed in an air crash,* several of Barbara's friends kept vigil in Trafalgar Square. It was two years since she had first met this private, quiet-spoken, dedicated man, and many things had drawn them together. Two equally exacting personalities communicated sharply at a spiritual level, yet were strangely unable to soften the edges of human relationships, something that locked them between alignment and loneliness. Both had family traditions for public service, and loved Rilke. Hammarskjöld wrote of one of her sculptures, 'Shall my soul meet so severe a curve, journeying on its way to form?' Not only did he possess two Hepworths in his private collection, he had been considering one of her sculptures to set off the United Nations building in New York. Barely two weeks before his death, Barbara had seen him in London. It was as if a light had gone out, she told Bernard Leach. She was overwhelmed by a sense of personal loss. First Tim Bennett, a very young architect friend, had been killed in an aeroplane in the early years of the war, then Paul Skeaping, and now Hammarskjöld. Death for which there has been no preparation is the hardest to bear.

Friendship, sanctified by Hammarskjöld's death, was honoured in a sculpture similar to the sublime piece of walnut, *Single Form (September)* 1961,† that Dag had so much praised. The only mark on *September* was a circle inscribed on the lower shoulder. Barbara moved this focal point so that it lay beneath the high shoulder of the new piece, punched the hole right through, and blew up the

* Sunday, 18 September 1961.
† The wood grain partly dictated its form.

size to ten feet. The exercise was opportune. U Thant, Hammarsk-jöld's successor, had discussed Hepworth's sculpture during his last walk with the former Secretary-General. U Thant wanted a piece to dedicate to the memory of his friend. An oil company in Baltimore* agreed to bear the cost; only the size remained to be decided. Barbara's next journey to New York was to accompany a seventeen-foot wooden version of her sculpture. Should this be the final size? Seeing it in position, she knew that the completion of the Memorial Library in the background had altered the scale. Her sculpture would have to be twenty-one feet, the largest that she had ever made. The proportions, moreover, had to be slightly changed. The swell at the top needed to be half as thick again, the eye enlarged and spiralled. Inside *Single Form* (*Memorial*) 1961–2 she wrote a private message: 'To the glory of God, and the memory of Dag.'

Nineteen sixty-two brought violent spring winds and bitter temperatures: snow invading the Palais made it too cold to work. At the risk of being knocked out by flying slates, Barbara's assistants saved the twenty-foot *Winged Figure* 1962, an aluminium sculpture now pinned cumbersomely above streaming traffic, on the elevation of John Lewis's Oxford Street store.† The other sculptures were face down, flat on the grass. After two nights without sleep, Barbara was still in her clothes. Collecting another Hon. D. Litt. from the University of Leeds awakened fearful nostalgia, though bitter winds drove her home. John Summerson was chairing an influential committee to assess education in the arts. Staying *en route* with her sister, she tried to engage his help in raising the status of Falmouth School of Art.

Momentous events had taken place during the eight years since Barbara Hepworth's first Whitechapel exhibition: São Paulo, a

* Blausten.

† It has been suggested that *Forms in Echelon* 1961, which was turned down by John Lewis, would have looked better than the very pedestrian chosen piece.

CBE, Hodin's monograph, as beautiful as Read's and more comprehensive, published in German, French and English, and now, the Hammarskjöld memorial. Full academic and artistic honours were spelled out in a sumptuously illustrated catalogue to 'One of the most important exhibitions of sculpture ever held in this country'. No praise, it seemed, was too extravagant for Robertson's six-page panegyric; the public should have a clear recognition of an artist's size. There had been a time, he conceded, before the 1954 Retrospective, when people mistook Hepworth's calm poise for coldness. But the years of doubt were over. An entire revolution in taste and vision had taken place. Now that the public accepted its error, Hepworth could be embraced. Not only was she *not* cold, her sculpture was 'warm, eloquent and extremely sensuous'. There's a special tension in really tight statements. By using words like 'erotic' and 'sensual', in likening her stillness to that of Piero or Brancusi, Robertson made a case, and surely there is one, for sensuality that is only possible when something is compressed or held back. As for the work in the current exhibition, in his opinion, the climate of 'public sympathy' in which it was wrought had in itself contributed. It was the best work of her life. Most of the public is unconvinced about artists' value until their work sells well, but an artist's personality can help or hurt the attention the public gives to his works. Aware of this, Robertson enlarged upon Hepworth's altruism, and the vulnerability of her sex.

Things were happening all at once, and Barbara didn't want to miss out on them. Her style of life didn't change; behind the high walls, she did what she had always done. This doesn't mean that she didn't enjoy public sympathy. On the contrary, being starved of sympathy, as she told Read, it was like balm. The chief difference made by money and fame was that more of her needs were accommodated. She wasn't above playing the grand lady. Returning from America, bored by what she felt were pretentious surroundings, she asked the pilot if she could look at the sunrise

from his cockpit. As Paul had once done, she watched the forces of nature become supernatural.

Nothing could eradicate the hard, unloved years. They had made her tough. In fact, an idiosyncratic mixture of toughness and insecurity had governed her personal relations since childhood. From now on, there was an increasing dichotomy between the face Barbara showed her friends and the one she revealed to the public. Meeting her for the first time, Edouard Roditi, an American conducting a series of artist interviews, sensed unusual poise and efficiency. She was, he felt, 'exactly as she would like to be'. Nancie Halliday, who sewed her nighties and wrote daily, comforting notes, saw someone very different. Strong as she felt herself to be in her studio, Barbara knew herself weak and vulnerable in relationships with her own species. She knew that her feeling of rejection was outside the range of anything rational; she could only observe it. Sometimes she felt like a wounded gull, being pecked to death by the healthy ones. She was vulnerable because she had a profound sense of loss.

There is a time for fastening on ambition and battling through, that is when experience is rich on the ground, but if the fight goes on too long, you wither from high tension, learn what it is to lose in love, or what happens when your child is no longer speaking to you. You are considered important by some and put down by others, and every time you meet a new man, the battle is on. It is inevitable that falls will come to the strong-willed who remain embattled because their reputations are locked in the trains of public fashion; thus, encounters with every man and woman around become charged and overcharged. Reading that a painter called Elizabeth Barbara Hepworth had dropped the 'Elizabeth', Barbara bundled off the article to Gimpel, suggesting that they might like to intervene. 'It was becoming more than a joke.' Charles Gimpel took the incident in the vein it deserved. E.B.H. looked an attractive lady, and she, too, might find it aggravating that the former Mrs Nicholson chose to call herself Barbara Hepworth.

The strain of living in the same town as Simon was telling. Barbara had shown every sign of a breakdown, she confessed to Summerson – a claim she made at various times but never succumbed to. Working live, and over-alert, she'd tire into what felt like death, afraid all the way because she had achieved the worst of vicious circles in herself, and become too tired. She was more tired than she had ever been. By evening a riot of bad nerves would be upon her; there was only a worn-out part of her to keep protesting. The cause, she said, was entirely personal, but this was another 'twist'. She couldn't admit that the great panacea, the one thing that offered peace and happiness, also contributed to her problems. What she put first was rewarding *because* she made it rewarding for the ten best hours of the day. What she squeezed into the remainder suffered because she was worn out.

In a Man's World

(1963–5)

For centuries, England had failed to produce a sculptor to compare with its writers or painters. Out of this wasteland sprang, quite suddenly, two outstanding generations. That women were prominent was especially surprising, as sculpture was essentially a male preserve. Barbara Hepworth's being created a Dame of the British Empire was the first public recognition that a woman could excel. She was well aware of her contribution: 'I think I can say I was the first in my field to bring the work to a truly professional level! It seems natural now to have several women sculptors round the world . . . for me it has been a long & uphill fight . . . & jolly difficult at times.' Every facet of her character had rejected marginalization. Recognition was not for herself but for her work. The only aggravation was that Henry Moore and Ben Nicholson got OMs. If Barbara had been male, would she not have one too? The damehood was a woman's niche. You never got out of it.

Germaine Richier and Elisabeth Frink were the other women sculptors in her class, and Richier was almost Barbara's age, which makes her story comparable. Though her work was related to that of post-war British artists, almost any other link one made between the two would be disparate. Richier, who was a Provençal, and powerfully affected by the horrors of Nazism, chose to capture the sinisterness of a threatening world in half decayed, half metamorphosed creatures. When she died, aged only fifty-four, she had a large popular, rather than an international, following. Frink was a generation younger and made her London début when she was twenty-two. By the time

Hepworth received her DBE, Frink's preying birds, helmeted warriors and powerful male nudes had marked her as being exceptional. Like Hepworth, she went on to win a DBE. Being a generation younger didn't make it any easier to express her talent, it just meant that to some extent the path had been opened.

For senior and established artists, the sixties were, in their own way, difficult. Noise, effervescence and innovation encouraged the irreverent questioning of everybody and everything, especially reputations. Boundaries between painting and sculpture were smudged, nature became less important than artifice, country less important than town, and with it all emerged a new abstract visual language. John Hoskin had been among the pioneers of welded metal sculptures in the late fifties. By the first year of the new decade, he had been joined by Anthony Caro,★ hot from the US. Releasing art from the realm of rarefied aesthetic discourse was part of the current ethos; to which end, they scavenged materials from scrapyards, abolished pedestals and employed techniques used in modern building construction. The impact of purposeful impersonality was deeply felt among the New Generation, as the younger sculptors came to be called after an exhibition at the Whitechapel Gallery. William Turnbull, William Tucker, Phillip King, Robert Adams and Hubert Dalwood were a young and aggressively modern band against whom the establishment had to maintain credibility. Minimalism, constructionism, pop art, improvisation and spectator involvement all played a part in the ensuing novelty. Weightlessness and swiftness of execution captured immediate ideas. Plastics, fibreglass and aluminium replaced the adamant character of stone and bronze. Dalwood's brooding elemental personalities appealed to everything that's irrational. Little could be further from his jerky work, suffused with bogies of the nursery, than the smooth, three-dimensional flow of a Barbara Hepworth.

★ Caro had worked for a short time with Moore.

Adaptations to the new climate were made by Hepworth's contemporaries. After representing Britain in a fifties Venice Biennale, Lynn Chadwick introduced playfully grotesque bird figures with wing-like arms and spiky legs. Armitage, too, was spiky. Only irreverence linked that other post-war reputation – Edouardo Paolozzi – to the racehorse-elegant Caro or the Cubist Robert Adams. After introducing overtones of pop, Paolozzi reverted to his persecuted half-human forms, distorted by the pressures of industrial civilization into veritable monsters. Reg Butler's wax-modelled sexy girls were, again, a protest against preciousness, deliberately impure, spontaneously fleshly, and totally unlike the sculpture with which he had won the Unknown Political Prisoner competition. Moore's powerful brooding was rather grand for the sixties. His humanism remained his strength and influence. Grouped round his *Standing Figure* in the Battersea Park exhibition of 1963 were works by a number of more or less figurative sculptors, Kenneth Armitage's arboreal trunk-like conceits, Ralph Brown's maimed torsos, McWilliam's seductive surrealism, Reg Butler, Bernard Meadows and Elisabeth Frink.

Barbara's work didn't consist of aesthetic games or the expression of personal ego, unlike that of many contemporaries. As she told Herbert Read, sculpture was 'something so primitive & deep in ones unconscious it simply must, by its mass, hit you in the stomach so that your spine straightens & your feet move; or it must envelope you in love & sensuous tenderness of archaic touch; – so that one is, as ephemeral flesh & blood, caught up in the pulse of life. Or both. But it is a deep world. Intellect is needed to carry out & bear the passion.'

In practice, she was with Brancusi's deliberation turning Gabo's cerebral impulse into something timeless and classical. Repose is largely relative. In her monolithic single forms, her totemic pillars and the large, penetrated boles, one becomes aware that gleaming marbles, alabasters, slate, wood and bronze are in themselves reflecting and refracting. Her single pieces carry their

own presence into a setting, demanding and acquiring space, while the composite twos and threes – of which there were an increasing number – perform to the circumnavigation of the spectator, a grave choreography. Like Caro, Hepworth was extracting from architecture, like Richier, she was obsessed by the process of transformation, like Moore, she was anthropoid and pantheistic. But her faith in her materials was a far cry from Caro's vibrantly painted metal. Her impulse was monastic (only her life was theatrical), her Rilkean transformation produced fierce, biblical purity, singing with an absolutism beside which Moore can look clumsy. It wasn't just craftsman's lore that made her so defined about what she had to do. The air of calculation, of reticence or self-containment was achieved as a seagull wheels on currents of air. Balance, poise, streamlining, the whole relation of the solid to its surroundings, had to be precise. Man's destiny, justice, equality, human dignity and the brotherhood of man were seminal to her great driving force. From the Greeks onward, sculpture had been thrusting and disturbing. It is easy to under-value her subtlety.

On Barbara's own account, the sixties were a fulfilment of her youthful thirties vision. Returning to squares and rectangles, she built a sculpture called *Square Forms with Circles* 1963, from seven rough-cast panels, square or rectangular, rising, superimposed, defying gravity, to a height of eight and a half feet, engraving the slightly predatory monolith with a perfectly circular 'eye'. Unlike the traditional Hepworth, that reads convincingly from every angle, some of the new ones suggest the ambiguity of paint and canvas. Sculpture was getting close to painting, very 'Ben Nicholson'.*

One of her most beautiful sculptures of the mid sixties must surely be *River Form* 1965, of which a bronze edition lies in the courtyard of Kensington Town Hall. A good deal has been lost

* Compare the drawing *Square and Circle* 1963 or *Square Forms 2* (*Green and Ochre*) 1963 with the sculpture *Square Forms with Circles* 1963.

in transferring from one medium to another. In the original American walnut, one senses the deep-grained swell of a river bed punctured by its three sources, as sacred as the crib of a child. Several small bronze originals include two very open sculptures, one of them reminiscent of a sheep's skull,* and another looking like a squashed armillary sphere. Helen Sutherland saw the latter, *Trezion*,† at Gimpel Fils and thought it the most moving Hepworth she had ever seen, possessing its own particular power and majesty, 'inspired *right through* – like a growing tree. Its great rhythms, the earth's rhythms.' Because she was an early supporter, Barbara was allowed to sell it to her without the 30 per cent commission.

Another piece looks like two sculptures placed one inside the other;‡ a cherished nesting bird, curiously snug and right in its interior world, sun-splashed and shadowed according to the direction of the prevailing light. These three sculptures could exist in no other material, which is more than can be said for some of the new thirties derivatives being re-cast in polished bronze. A plethora of slim slate forms, largely in twos or threes, coming from Trewyn were carved largely by Barbara's assistant, Dicon Nance. The Olympian authority, the impeccable formal organization, could only be Hepworth's, but the flawlessly worked surfaces seem to be less personal than the early work.

Until the big unveiling, Hammarskjöld's *Memorial* preoccupied its maker beyond all else. A photograph in *A Pictorial Autobiography* shows the great flat shape being built up in a similar way to *Meridian*, only the cross spits were made of metal and the frame was covered with metal sheets. At twenty-one feet, it was the largest single work that the Morris Singer Foundry had ever reproduced, a job that took nine months to transform from plaster to bronze. It was cast in seven pieces, cut just beside the

* *Pierced Form (Patmos)* 1963.
† *Oval Form (Trezion)* 1961–3.
‡ *Sphere with Inner Form* 1963.

visible sections in order to keep the engraved lines pure. When *Memorial* was being lifted in a big warehouse in Clerkenwell, the mobile rope on the crane snapped, tumbling the work to the ground. The foundry had just four weeks in which to repair the damage.

The sculpture that stands in Battersea Park is a half-size copy of the one that flags the way to the UN building on New York's East River. The perfect symbol of the fierce idealism that brought Hepworth and Hammarskjöld together is a brilliant piece of engineering and a beautiful work of art. Conflict wasn't inevitable, Barbara had been announcing since her confrontation with man's devastation of the Yorkshire landscape. Using the language of harmony at a time of social disequilibrium, using the tension created between classic and organic impulse, she was appeasing the human conscience. 'If it succeeds,' she said in her speech at the ceremony, 'it is our success. If it fails, it is our failure.' She had tried to perfect a symbol that would reflect the nobility of Hammarskjöld's life and challenge the future.

The sixties were bringing to Britain the most dramatic social levelling of the century. Even anarchy seemed respectable and, true intellectual that Barbara was, she maintained a state of constant political and social awareness. Rejecting capital punishment, supporting pacifism, the United Nations, nuclear disarmament and the Treason Trial Fund of South Africa, deploring the bloody guerrilla warfare by the Viet Cong in South Vietnam, she capitalized on her opportunity to expose her views to an increasingly powerful media. An interviewer from the *Daily Express* was left in no doubt as to the strength of her opinions. The world was going to be brought together through the universal language of art.

To a feminism more militant than Barbara had expressed in public before, 'We must protest' was a constant refrain. Male brainwashing, she declared, made 'hypnotized hens' of her sex. Women's nature was to preserve life. They should pull together and declare their interests, write to politicians, telephone the

BBC, totally reject apathy. 'Women ... must realize that they can no longer keep quiet and submit in order to keep the peace in a man's world. They must understand that they are there to complement men, not to compete with them. We don't want a matriarchy, God forbid, just a balance. And women are our only hope now – the only people who can help because they are intrinsically opposed to destroying life.' One day, she was in her studio, working on a lithograph with Stanley Jones, when there was a crash so loud that shock waves trembled the air for several minutes. Discovering that Concorde was the culprit, Barbara picked up the telephone receiver and dialled the Home Office. 'This is Dame Barbara Hepworth speaking ...' For a long time she seemed to hang on before she was passed through to the Home Secretary.

For someone who loved the limelight and tended to speak in global terms, it was appropriate that she should be holding exhibitions in Copenhagen and in Holland. Belatedly, in her opinion, the British Council had decided to tour a retrospective to three Scandinavian and four German cities. Gimpel Fils weren't in favour either. After mismanaging a vital exhibition in Kassel some years earlier, by sending three diminutive works, 'entirely inadequate and absolutely damning', she'd been excluded entirely from the next one. Moore and Nicholson had had fine showings, she added. She was the only one left out. A set-back she couldn't possibly afford at her age and reputation. Her presentation in historical shows was a 'must'. Barbara went to Scandinavia and Holland, extending the first trip to visit the Swedish countryside home Hammarskjöld had intended for his retirement.* The New York installation of her memorial was enjoyable because Dag Hammarskjöld was acknowledged to be a great man and Barbara drew in his reflected glory. Bringing the past into the present, she rounded up acquaintances as far back as John Wolfenden from Alverthorpe to attend the celebrations.

* It had been turned into a museum.

But New York's August heat, the strain of duties and the jet flights brought on ferocious bronchial asthma. The underside of her power-drive showed sudden insecurities. She was a little too controlled, too anxious about being away from the studio. Returning home from the unveiling ceremony, she was tired out, and when she was tired she fretted for Simon and Ben. A prominent article about Ben's new house in Ticino was illustrated by Felicitas's photographs. Ben described himself as a non-stop worker and his skull-like image hardly made him look as if he was enjoying life. At sixty-nine, he looked an old man.

Nineteen sixty-one had been the year of the grandchild. Simon adopted Minka, Silvie was pregnant again, and Sarah bore for her mother another 'Paul'. Three years later, the birth of Rachel's second child gave Barbara six grandchildren, evenly distributed among the triplets. The newcomer watched television until midnight and 'weighed a ton'. The Kidds' domestic arrangements were a little too disorganized for Barbara's taste, though she approved of the way in which the Bownesses organized their lives, and found their children a delight.* Simon had completely withdrawn his family. The quarrel had exploded shortly after Barbara's sixtieth birthday.

In a flash of concern about her son's financial dependence upon her, feeling that he ought to be more assertive, more responsible for himself, she suggested he take on some part-time work and make arrangements to hold an exhibition. She had given him a car and ten pounds a week towards the kitty, which was not ungenerous, but all sorts of little things about Barbara were making Simon shy away. Her unavailability, her judgements, her nervous straining, as if the world lay upon her shoulders. All these things arose from panic that other strains in life would interfere with the serious professional one, which had to be absolute master or she wouldn't achieve what she had to achieve.

* If Sarah's music, after she married, had assumed second place to her family, that was right for Sarah.

Her arrow-like driving force to do what she wanted to do would take any form it needed in order to accomplish what it must. Art was a gilded casket and she wasn't receptive to the accents of ordinary existence. Twisting, even in love, so that Simon didn't trust what she professed to bestow, Barbara seemed always to take control.

Three sculptures she had given to him and Silvie were stored in the Palais until such time as they should have suitable (in Barbara's eyes) accommodation. Simon was hypersensitive, maybe he was egged on by his own frustrations to put their relations to the test, but a tug of war grew up round these gifts because they were symbols of love and Barbara's terms for giving love. After he'd been impolite, telephone conversations were abruptly terminated. One after the other, communications failed. Throughout a bitter early spring, with sub-zero temperatures and Barbara nearly four weeks in bed,★ mother and son corresponded through Barbara's solicitor because each used the other's words to make their own meaning, and words became accusations. Everything about Barbara angered Simon. Instead of confronting issues and discussing difficulties with him and Silvie, she gathered her friends around her until they were ostracized. It is possible that Simon imagined this, but not altogether, as one simple case attests. Communicating with one of her clergymen friends, Barbara dramatized the quarrel by claiming sympathy for eight years' loss of contact with Simon, eighteen months after he had resumed friendly correspondence. The size of the hurt might have been eight years long, nevertheless she was manipulating opinion by distorting the facts. Silvie became shocked by the way in which her generous protestations of love could be let down by her actions. How could Simon trust her? For eight years mother and son didn't physically address one another. For nineteen months, and this was hardest for Barbara to bear, Simon and his family were living in St Ives.

★ Conditions in which Cornwall was far more bleak than Yorkshire, Barbara said.

If Simon had misgivings about his ability to make a career in art, they should have been dispelled by his first one-man exhibition at the McRoberts & Tunnard Gallery. 'Perhaps the most assured and delicate of the year's debuts,' John Russell commented in *Art News*. With the 'grave handicap' of being Ben Nicholson's son and William Nicholson's grandson, Simon had imparted to the meanest scraps of material, such as shells and rubber bands, a classical beauty. Simon had Ben's exactitude, but he didn't derive predictably from his father. Simon in his prolonged crisis needed confidence above all. This was increasingly difficult to attain.

It is axiomatic that the faults you see in others are often your own, so the critical are the self-despising. Simon was, like Barbara, innocent, gifted, defensive and dangerously rigid. Offers of help seemed like patronization, advice felt like criticism, and the whole regalia of her success was an affront. Desperately trying to maintain the codes of right and wrong he'd been brought up to recognize, despising his own weakness, he was unable to deal with anger that seemed to involve his very survival. When Simon met Barbara, his eyes slid past her, unfocused. Six months, nine months, a whole year turned, by which time Barbara could no longer bear to brave the shock of meeting again. So she remained inside, in a realm of her own, bounded by symbol and torment. Photographs of the physical havoc wreaked upon the once beautiful face bear witness to her pain; the wrinkling of her broad forehead into desperate valleys, accentuating the tiny pointed nose, cracked, parchment skin and little eyes with stones in them. What hurt as much as anything was Simon's disloyalty, the disintegration of family ideals. Barbara called in friends to sympathize with her displaced maternal instinct. Frank and Nancie were baffled. Angela Connor, who was one of her assistants during nine months of the unfortunate year, saw what was happening and felt powerless to help. Inevitably, she was used as a go-between. Friends told Ben of a terrible isolation increased by illness.

Simon refused to accept Barbara's financial support. He was doing all he could to hurt her. But for Silvie, she wouldn't

have seen his second daughter when he sailed for California. When he had gone, at least Barbara was free to go out again. The girls and their families rallied round, and, come what may, the Halliday lunch took place on Sunday. Nancie had a strong steadying influence on Barbara, and this bit of her life, apart from strains of work, was fixed and soothing as a warm bath. Barbara was aware of some lost land within herself, as if something yet more monstrously unfulfilled than anything she had suffered before had thrown a shadow over her. What could be worse, she asked Herbert Read, than losing the life of one son and the love of another? Looking for explanations, she decided it was a great mistake to have one's children address one by Christian name, because roles got muddled. Nor should she have tried to be both mother and father. Her very capabilities worked against her, Summerson humoured. She should try playing a bit more helpless. 'How on earth can I plead helplessness when I must be so efficient. What a bore it all is being a female & alone. I want to be coddled but I intimidate because I'm efficient & creative. I want to be maternal but provoke violent reaction.' The month after Simon's departure, Peter Lanyon died, unreconciled, in a gliding accident.★ Barbara's past was full of recriminations. Reflections were disquieting, sometimes savage.

Shortly before the end of the year, Bernard Leach returned from the US. Barbara welcomed him with the intelligence that St Ives was inundated with visiting VIPs. It was a suitable prelude to what was, for sculpture, a year of tremendous realization. Two Institute of Contemporary Arts sculpture exhibitions were held in London, one at the Tate and one at the Whitechapel Gallery: together, they claimed a range and intensity hitherto unmatched anywhere. In the mature (Tate) group,† Hepworth was given a prominent position.‡

★ 31 August 1964.
† Sixty Years of British Sculpture.
‡ Plans to interest Dartington trustees in a sculpture park on the estate

Sympathy with foreign conceptions of abstraction was one of the themes of the exhibitions, and Barbara was bound for Holland where a retrospective at the Kröller–Müller celebrated the opening of a new Pavilion. It was a triumph for her as well as for Professor Hammacher, who had dreamed up the first permanent sculpture park amid windswept sand dunes punctuated by pines and silver birch. No trouble was too great, no effort spared in lauding Barbara. Her devoted escorts were art historians Paul Hodin and Renilda Hammacher, A.M. Hammacher, whose biography of her was nearing completion, and R.W.D. Oxenaar, his successor as director of the sculpture park. The exhibition was superb, Barbara told Read, who had left for the US. It was as if birds, freed from their cages, had spread their wings and turned into mighty statues.*

Holland 1965 was Barbara's last trip abroad. Shows afoot in Basle, Brussels, Turin, four in Germany and one in New York's Marlborough Gallery would have to go unseen because medical opinion precluded her from flying again. On top of chronic asthma, continual gastric flu and various other complaints whipped up by years of relentless pressure, her doctor had diagnosed a weak heart. He promised to keep her alive three or four months, she added histrionically, since all sorts of exciting things were afoot. Though Barbara lived another ten years, she was dogged by continual fatigue and frequent pain. Attempts to conserve energy were only marginally effective, yet she did what she had to do. Doctor's advice was chiefly reserved for avoiding social engagements. The schedules and goals she set herself remained as tough as ever.

were not realized. The first permanent British site was the Yorkshire Sculpture Park in West Bretton.

* Another British exhibition in which she was involved was the Marlborough Gallery's Art in Britain: 1930–40, based on an exhibition of the same name held a couple of years earlier at the National Museum of Wales.

Education for the underprivileged went straight back to Benjamin George Hepworth. Falmouth Art School was campaigning to get its status upgraded. Barbara was a governor of the school and her brother-in-law was now leading a national committee on further education. Naturally she solicited his support. This wasn't easily obtained. On the contrary, Summerson seemed particularly resistant to her case. For six months she bombarded him with letters, lists and telephone calls. At one point, relations were very strained. Mobilizing her considerable powers of persuasion, Barbara had to put up a real fight before he would see the wisdom of her case.

Before the year had begun, machinations Barbara knew nothing about had been in operation. Lilian Somerville had written to Sir Philip Hendy, director of the National Portrait Gallery, putting her name forward very strongly as a candidate for a DBE. Six months later, Barbara was wondering whether to make a tiara from wire and fish line for a second visit to Buckingham Palace. From all over the world, congratulations arrived. She adored the paraphernalia. She had a very acute sense of power, so that people tended to run round her. Now everyone was allotted his or her part in the proceedings. John Summerson could advise on headed writing paper. Should she use her new title for business and/or friends? What should she write in the International 'Who Who Who'? Family must stick together.* The Summersons put on a party for her, Gimpel put on another. Racing time made her feel important. There was only an hour between sculptural duties in Leeds and the foundry at Lambeth in which to buy a dress, she boasted to Nancie. In the event, she nearly passed out at the ceremony. One photograph in the press showed Barbara flanked by her thirty-one-year-old daughters, Rachel with pursed lips, Sarah in a feather boa, smiling broadly. Snowdon's *Sunday Times* supplement contribution was unquestionably more exotic. In skinny black elasticated leggings, clutching

* Joan's death in March 1963 left only two Hepworth sisters.

a very furry coat around her characteristic red scarf, Barbara reclines on St Ives foreshore with granite rocks lumped around her like shaggy sheep.

The Tate constitution requires, by law, four artist Trustees, and Dame Barbara Hepworth was a natural choice. She was sixty-two,* the first woman to be so honoured, and certainly regarded it as a serious undertaking. The only disadvantage being, as time progressed, that she wasn't necessarily at her best at afternoon board meetings. Artists on committees can be, in Norman Reid's experience, either very good or extraordinarily bad. The bad ones can't really look at the work of others because their own bias is too strong, the good ones lean over backwards to see and sympathize with art which is not their field at all. Barbara adored her governorship and took it seriously. He didn't actually say whether she was good or bad.

Important committees were offset by news from Auckland, New Zealand, where a city councillor referred to one of Hepworth's abstract bronzes as the buttock of a dead cow washed up on the beach. Councillors were never particularly receptive. In Oldham (part of Manchester), a six-and-a-half-foot, flat-topped standing form punctured by long ovals, *Sea Form (Atlantic)* 1964, was said by another civic representative to resemble a Yogi Bear. It took so little effort to be destructive, Barbara chafed, when *Rosewall*† was tarred, feathered and capped with a Beatle wig after a month outside a new GPO building in Chesterfield. On an altogether more serious count, thousands of Churchill cigarettes had taken their toll. Herbert Read had had cancer of the tongue since 1964. Shortly after becoming a dame, Barbara's first enemy was diagnosed as being the same complaint.

* When artists are at their most active they want to get on with their work.
† *Curved Reclining Form (Rosewall)* 1960–62.

My Silly Room in the Great Western

(1966–9)

Being a dame made Barbara rather too big a fish to be restricted to Cornish waters. For a long time she had hankered after a London base. As a Trustee of the Tate Gallery she was involved in almost monthly meetings in the city and this gave her a pretext to rent a hotel room. The time had come for a little self-indulgence. What she referred to variously as her 'astonishing lair' and her 'silly room at the Great Western' was surprisingly luxurious. Close to her gallery, to London hospitals and her Harley Street surgeon, it was envisaged as an alternative centre of communications.

While St Ives remained the hub of the Hepworth industry, the Great Western Hotel was the venue for constant social-cum-strategic gatherings of friends, old and new, largely in the field of art and art promotion. Herbert Read, until he died in the summer of 1968, the Brumwells, the Reids, the Lousadas, Margaret Gardiner, Ronald Lande (Barbara's GP), Bryan Robertson, the Summersons, Kay and Peter Gimpel, Gilbert Lloyd, Michael Tippett, Eric Gibbard, the critic Edward Mullins, even a film director, Billy Wilder, featured in the engagement book monitored by Brian Smith, Barbara's new personal secretary.

Conspiratorial as ever, Barbara was marking and underlining a fair proportion of her letters 'confidential'. Secrecy concerned primarily art, its promotion and, in as much as it affected them, her state of health. For months after an operation for cancer she was very low. The operation left her unable to eat without nausea, the result being, by March, acute malnutrition. If the cancer itself seemed dormant, it worried her, understandably, and

bronchitis was soon followed by pleurisy. Putting on a brave face, she buckled down to work. Big fish have to maintain their currents. Nothing could be left to chance; even with Brian Smith's support, the business side of being an institution was taking more and more time. To the first copy of the catalogue for her 1966 exhibition at Gimpel Fils, Barbara objected that her accomplishments had been skimped. There was plenty of space for a full list of awards, exhibitions and monographs. You could say her self-publicization was fed by concern for the advancement of art, competitiveness, toughened by early neglect into diehard resolution, or by lust for power. Excelling, of course, was not so much choice as necessity, and whatever her motives, they were liable to be aggravated by ill-health. Altogether, it was an appalling year. Despite which, Read thought she was working as well as ever, noting particularly some little slate multiples. From intrinsically brittle material, she seemed to extract the dark warmth of ebony.

By the mid sixties, the art boom was in full swing. While Hepworths were being acquired by galleries in New Zealand, Japan and the US, art was rivalling gold as a medium of exchange. In London, art houses were aggressively competitive, big names solicited and tenaciously held. When Read alerted Barbara to the interest of Harry Fischer of Marlborough Fine Art (MFA), she knew that any move she made would be seen as a threat by Gimpel Fils. This didn't stop her investigating. Fischer was powerful, authoritarian, deaf, and Barbara liked him. Pinching artists unashamedly from other galleries, Fischer and Frank Lloyd had built MFA into the biggest and wealthiest outfit in London. Painters like Auerbach, Bacon and Sutherland were on their books, and sculptors like Kenneth Armitage and Lynn Chadwick. Barbara's relations with MFA had gone smoothly over the 1930–40 exhibition, she approved of their efficiency and further dealings were undoubtedly discussed when Fisher and his wife spent five days in St Ives in October 1964. The result, two years later, was a show at New York's

Marlborough–Gerson gallery almost coinciding with Barbara's London one at Gimpel Fils.★ Read wrote the foreword to the catalogue. Among a large favourable press, Barbara was called, by Hilton Kramer of the *New York Times*, a sculptor who mattered. Naturally Gimpel resented, after years of cosseting one of their prize clients, the intervention of as tough a rival as MFA. From this time, correspondence between them and Barbara gives the impression of more courting and less trust.

In fact, Kramer's review was restrained. Weighing Hepworth against Brancusi and Moore, he emphasized weakness instead of exploring strengths, made comparisons, qualifications and concessions where a brave new vision might have been praised. Reservations long since planted in her critical record were taken out and dusted. Admittedly, Barbara's work was uneven. She was producing, annually, an average of just over twenty-three works. As Ben didn't hesitate to remark, too much was leaving her studio. All the same, Kramer might have dwelt less on the 'prosperous looking bronzes', more on the carvings, and if he found her struggle for pure statement 'more a matter of culture and craft than of interior drama', he could have been missing something.

Both Hepworth and Moore were hollowing out their materials. Comparing them brought British critics closer to the essence of each sculptor. Where the cavities in a Moore represented a removal of what is felt to be irrelevant, in a Hepworth, Edwin Mullins noted, these cavities are focal to each piece. Read said much the same, that Moore's holes were accidental in evolution, arising from his distortion of the human body and perhaps from erosion of rocks, while Barbara's were evolved formally. Norbert Lynton took these views a step further. 'At her best . . . she is a more perfect sculptor than Moore, more capable of bringing a work to an absolute conclusion and endowing it with that total harmony of image and substance that is one of art's rarest gifts to mankind. Yet to bracket [them] can be dangerous, especially if it

★ From 1965, MFA listed her as one of their artists.

leads to diminishing either. They could in many respects scarcely be more different. Moore is a maker of compelling public images, epic in scale and sometimes tragic in mood. Hepworth's world is much more personal and intimate, and essentially lyrical in character.'

Right into 1967, Barbara was terribly drawn and thin, eating less, drinking more alcohol and seeming to run on will-power. A few days in bed, and she'd be up directing her 'boys', as she called her middle-aged assistants. Her drinking was not a secret; first thing in the morning alcohol was on her breath. Brum guessed a bottle of whisky a day, a trend he was trying to counteract by tempting her with cases of champagne. Read, who was in and out of hospital for radiotherapy, reckoned he would find lethal the quantity of whisky she consumed. When Barbara was forced to make an exit in the middle of a Tate Trustee meeting because of stomach pains, he attributed the cause to slops and alcohol. Whisky was undermining her efficiency. By midday she was waffly and indistinct. The first cause, cancer, was undoubtedly exacerbated by the loneliness that fell upon her the minute she wasn't routinely employed. It was a singular situation transpiring partly because Barbara's needs had increased. She had lots of friends. Far from neglecting them, she kept her friendships in good repair. It was time for another house party on the beautiful island of Tresco.

Being nearer the Gulf Stream than the west of Cornwall, Tresco's flora is even more exotic; being an island, it assumes an air of privacy. Within the sanctuary of its sea-pounded shoreline, each man, theoretically at least, could unroll. The first working holiday Barbara had organized, six years before, passed, according to Janet Leach, in hilarious discord. Within minutes of her arrival, Barbara heard the sound of an electric lawn-mower from the grounds of their grand new hotel and promptly had grass-cutting banned for the week. Bernard Leach sat at a desk in the beautiful hotel lounge planning an expedition to Japan, which Janet, being excluded from, was indignant about.

Priaulx ran round listening to birds, Frank Halliday tramped every pathway in the island within two days and didn't know how to occupy himself the rest of the time. Nancie maintained uneasy peace.

Notwithstanding, the promise of gathering round her again those whose company she most enjoyed was keeping Barbara working through the cold wet spring of 1967. Ludo and the ailing Herbert Read, Hammachers, Brumwells and Jenkins were to swell the party. Frank and Nancie had cut short a visit to the US, to be on time for what transpired was a wet and stormy week. Attentive as ever,* Nancie accommodated Barbara with a pair of gym shoes because she had swollen ankles. Despite the shoes, the accident happened. It was the last day. Walking to the air terminal, Nancie was holding Barbara's arm. Leaving momentarily, to check the luggage, she returned to find Barbara had tripped and fallen. The following day and many days after that, there wasn't a cloud in the sky.

A fractured hip was set by Norman Capener. During several weeks in hospital, Barbara discovered that the X-ray of the head of her femur looked like Exeter Cathedral. At home again, she announced her return to circulation by hosting a small cocktail party from a wheelchair. Months of convalescence saw her, eventually, on her feet, working with special tools mounted on bamboo canes, but she was never properly well or free of pain. Besides, a sculptor on crutches, she mocked, is a bit of an enigma. An all-clear from cancer in the autumn was followed by a kidney stone, despite which the enforced rest and proper diet had done her good. She had even put on some weight, and around the end of the year, her health made a definite turn for the better. Between themselves, friends muttered, the fall and her Tate exhibition had saved her life.

To any artist, a Tate retrospective is a milestone. In the mind

* A mutual friend, Donald Harris, called the Hallidays Lord and Lady in Waiting, because they treated Barbara like a princess.

of the Director, Norman Reid, Barbara Hepworth's was long overdue. One of the quirks of fame is to distort an artist's reception. Amid remarkable press and television coverage, work once scorned as non-art could have been so blandly received that there was hardly any response to individual works, only to Hepworth's name. This didn't happen. On the contrary, the message that came over was that here was an artist to be taken seriously. What made the Tate retrospective a real turning point was the critics' almost unanimous decision to write about Barbara Hepworth in her own right, without patronizing her or mentioning Moore. No longer could Robertson be singled out, as a lone singer of praise. On the contrary, some of his phrases from the Whitechapel catalogues were now the critics' stock-in-trade. Confronted with so much bold evidence, they too felt the passion burning away behind a vision initially calm and poised. One of the 'two or three sculptors of our time' was being applauded in her own right. There was no other artist able to express femininity as directly and unsentimentally.

From the Continent and America, exhibits arrived for the largest collection of Hepworths ever assembled. Forty drawings and paintings, with 186 sculptures ranging over forty years in time. Bronzes stood monumentally on the steps of the great gallery, looking like hollowed tree-trunks. Inside, works ranging from three inches to the dominating, highly architectural fourteen-foot bronze, *Four Square* (*Walk Through*) 1966* were displayed on piles of blocks interspersed with pots of plants. What was the thread that linked *Walk Through*, ostensibly so different, with the earliest piece on show, the marble sleeping doves of 1927, beaks tucked back, bodies nestling together? To Lynton's conspicuously fresh eye, the answer lay in a unique quality of friendly forms, obvious enough in the doves, more subtle in *Walk Through*, where its source could be discovered in

* *Walk Through* evolved from the much smaller, curved, open form *Trezion* 1961–3.

'the bright glow of the polished openings in the great patinated slabs, and in the barely noticeable swelling of their sides'.

Virtually everyone admired the smaller works, particularly from the thirties and forties, and the great African wood sculptures of the mid fifties, massive, solid, panther-like in their physicality. At the other extreme was a welded sculpture Barbara had envisaged when she was in hospital with cancer. *Construction* (*Crucifixion*) 1966 was a totally new experiment derived from drawings. In the churchyard below Trewyn, its raw metal struts and painted circles had looked all right. Seeing it afresh at the Tate Gallery, Barbara made one of the few admissions she ever did make about her work. She disliked it.

Wheeling round the unspeaking, stroke-atrophied Des Bernal in a chair, Marcus Brumwell was told by assistants that the Tate was so packed on Sundays you could hardly get in. Good things were happening altogether. When news came through that Ben Nicholson had received an OM, Barbara, her friends relayed, was touchingly pleased. Ben needed to be appeased. The illustrations in Hammacher's slightly pedestrian book, *Barbara Hepworth*, had evoked strong reactions in him. For the last year or two, the overlap between Barbara's drawings and his reliefs had been worrying him to the point of obsession. To their largely noncommittal mutual friends, one after another, he had complained. Now it was the sculpture. *Walk Through*, he thought, was too much like his work. Accusations of plagiarism surprised Margaret Gardiner, who saw that a certain exchange of ideas was part of the progress of art. (Personally, she wasn't too keen on much of Barbara's recent work.) Herbert Read did his best to pacify. Ben had to try and be objective. Most influence between artists in any period was unconscious. If Barbara imitated his technique, he had a legitimate complaint. Her conceptions did sometimes resemble his, *Walk Through* was a case in point, but she herself would be outraged by Ben's accusations.

Since Simon had decamped, four years before, Barbara had been kept informed of his moves by friends in, and visitors to,

the US. A year at Moore College of Art in Philadelphia led to an appointment in the design department of the University of California at Berkeley, where he organized courses in practical and experimental art. In San Francisco he was visited, among many, by Christopher Cornford, Dean of the Royal College of Art, who was out there in the role of visiting professor. They had first met in Cambridge when Simon was an undergraduate. Both enjoyed golf, and when they played together on the Gogs, Simon had taken the course barefoot. In San Francisco, Cornford found Simon's studio full of beautifully made three-dimensional abstract and minimalist objects. Anything to hand, ping-pong balls, ice-cream spoons or plant labels, he assembled into elegant structure harmonies. Painting, carving and modelling were taboo, for these belonged to the territory of fine art. To Cornford, Simon's comportment seemed to be one of a very upstanding, invincible sort of person. At the same time, he noticed, there wasn't a two-way communication because somehow he always felt he was being addressed. This he saw as the arrogance of someone who had made a tremendous struggle to achieve independence. Children's needs and everybody's innate creativity, their insights and natural curiosity, were to become Simon's appropriate preoccupations. Society suppresses these instincts, he thought, while promoting artists as a gifted élite. Art colleges should be far more interdisciplinary, based on social thinking rather than simply on how to become a success in the designer world. One can see the rapport with the equally rebellious Cornford for a young man with something struggling to burst out.

As Barbara was gaining a son, she was losing someone who had been part of her life for forty years. Herbert Read had proved John Skeaping right: his talent for spotting winners had been uncanny. Moore, Nicholson, Gabo and Hepworth had all received their Tate retrospectives. Like some of his protégés, Read had become part of the establishment, wielding considerable power in the world of committees, boards and selection panels. Since the poet in him subscribed to a sphere where power is

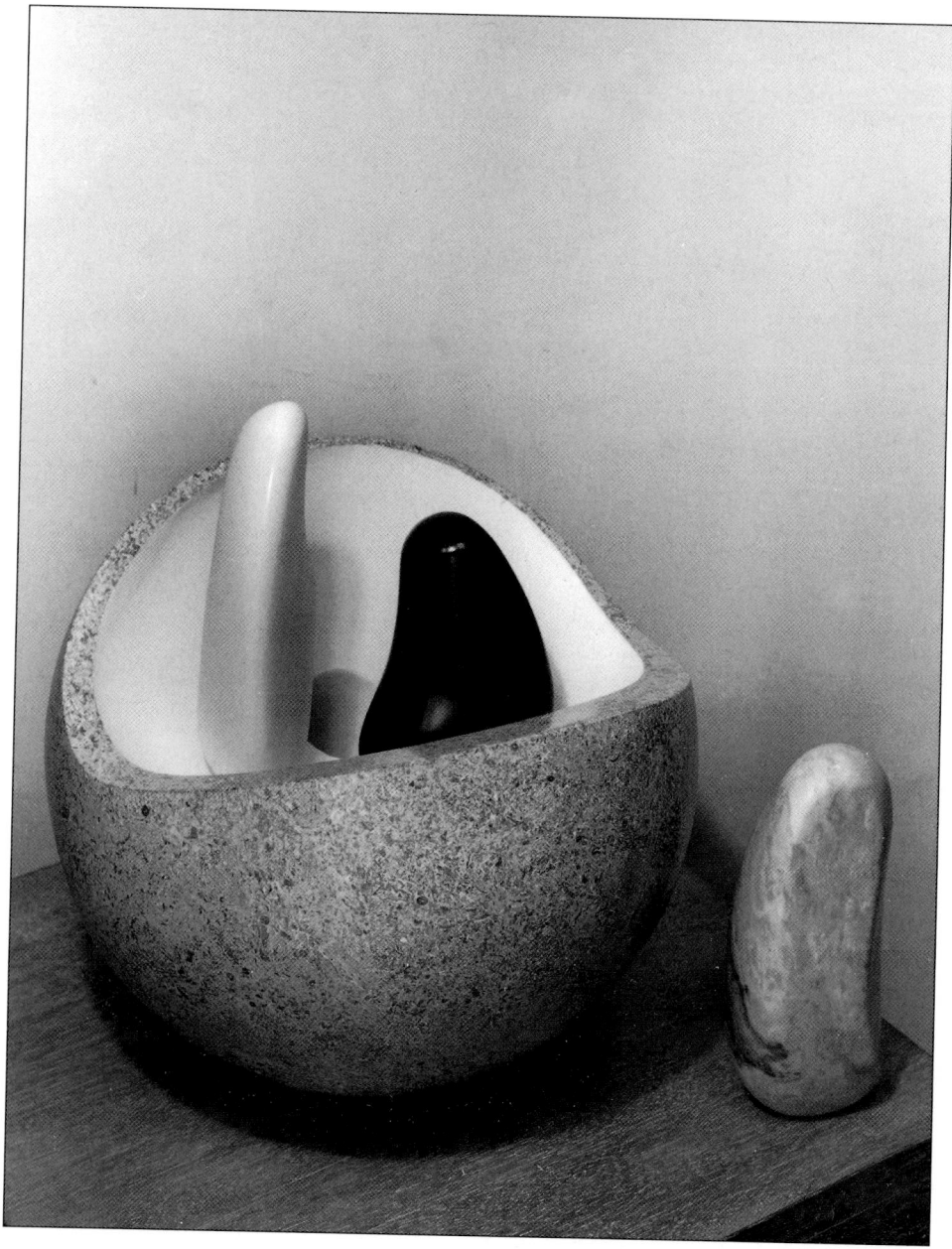

53. *Pierced Hemisphere with a Cluster of Stones* 1969, Hopton Wood stone with marble and slate

54. Working at night, *Cantate Domino* 1958

55. *(Left)* Paul Skeaping, son of Barbara and John Skeaping, *c.*1954
56. *(Right)* Priaulx Rainier, composer

57. *(Left)* Sarah and Alan Bowness, 1962, five years after they married
58. *(Right)* Rachel Kidd in 1982 at the opening of one of her exhibitions at the
Montpelier Studio. Professionally she uses the name Nicholson

59. Simon and
Silvie Nicholson,
1977. The first and
last time Silvie saw
her husband in a
suit

60. *Single Form (Memorial)* 1961–2, Battersea Park

61. *(Left)* Barbara carving in the 1960s

62. Dinner with Margaret Gardiner *(right)*, Bernard Leach and his wife Janet Leach

63. Barbara in her bedroom/studio, late 1960s

64. *(Above)* St Ives painters in 1984,
showing *(back, left to right)* Janet
Leach, Terry Frost, Tony O'Malley,
Jack Pender, Alice Moore, Robin
Nance, William Marshall, Kate
Nicholson, John Wells, Alexander
MacKenzie, Bryan Pearce; *(in front)*
Paul Feiler, Denis Mitchell and
W. Barns-Graham

65. *(Left)* Dame Barbara Hepworth,
1971

66. *(Right) Two Forms (Divided Circle)* 1969, as precarious as a stork on one leg

67. *(Below left)* Frank Halliday

68. *(Below right)* Nancie Halliday

69. *Ultimate Form*, one of the *Family of Man* 1970

questioned and romance flowers, inevitably, there was a conflict between his different selves. For two years he and Barbara had shared hospital, surgeon and complaint. Bombarded by radiotherapy, weary and often depressed, Read poked fun at his spectral, bearded (to hide the sutures) visage. It was like one of Francis Bacon's nightmares. A trip to Cuba revived his spirits. So alive had he seemed on his return that no one guessed he was near to death. To the last, Barbara corresponded. In his memory, she gave Ludo and the family a painting of three interlocking rectangular forms, two pierced, the central one inscribed with a circle. It was signed, 'In praise of Sir Herbert Read, his poetry & eloquence, his creative silences.' When her show was over, Barbara packed in the spaces between visits to the Tate as a Trustee and visits to Westminster Hospital with reams of correspondence. Working late into the night, she crossed letters off her list. Read's death encouraged her to put her own life in readiness for an end that it seemed, in the last months of 1968, could not be far away.

What she set out to achieve, she had, by and large, achieved. From the honours that flowed in from town and gown, she got a great deal of pleasure. Exeter, Oxford and St Ives were sources of crested invitations, to be received by august bodies, with public orators and complicated orders of proceedings. Photographs in *A Pictorial Autobiography* show Barbara Hepworth, wizened and doll-bodied, attending various venerable ceremonials. She had a special relationship with Exeter. It was Norman Capener's home, and there, at the Princess Elizabeth Hospital, she had made the theatre drawings. Oxford gave the poshest address (in Latin), all very colourful and exciting despite proverbial English summer rain. St Ives probably meant most of all, since she loved the little town that had succoured her and her talent. You couldn't have called Barbara popular in her home. Searching for explanations, one finds they are the old ones. She wasn't easy, wasn't relaxed, didn't suffer fools and didn't try. Barbara had the guts to do what she felt was right whatever the cost. Physically she was at her lowest ebb when she took action against the Town

Council to stop them skinning the grass from half the island to make a tarmac car-park. Hers was the courage of a woman who believed she was born for a purpose. Mindful of her power, ability and judgement, people felt inferior and backed away.

St Ives's barding ceremony was a good opportunity to forget recriminations. Barbara was thrilled by the ancient ritual. Monk-ish robes and Arab-looking headgear took the place of University caps and gowns. Singing voices, horn, pipe, harp and a vagrant wind made up the accompaniment. The formal bequeathal of her official name, 'Gravyor', meaning a sculptor, was one of thirty-six items on the programme of events, each conducted with due pomp before she and eighty-year-old Bernard Leach were be-queathed the freedom of the town.* It was nearly thirty years since she had arrived that inclement August afternoon. Now she was virtually part of the place. At last, the correspondent of the *Guardian* deliberated, the borough was recognizing the fact that artists belonged in the little fishing community. A joint exhibition of Hepworth and Leach was held in the town hall, and Barbara bequeathed another bronze. Kay Gimpel referred to the proceed-ings as 'quiet', 'dignified', 'moving' and 'simple', which was just what Barbara would have liked to hear.

All around her, the projects she had supported were prospering. The St Ives Trust became the Friends of St Ives, while her longtime protagonist, Marcus Brumwell, took the chair of the Penwith Society. When he attended meetings, Rene Brumwell kept Barbara company. Was it chiefly for Ben, for creativity, old times' sake, or for Barbara herself that the Brumwells looked after her so solicitously?

Among their considerable circle of friends were Herbert Simon and his book-designing brother, Oliver. When Herbert became managing director of Curwen Press, Brum masterminded a new project. Robert Erskine of St George's Gallery was one of the

* Two days before the ceremony, on 5 January 1968, Barbara gave a dinner for eighty people to celebrate Leach's eightieth birthday.

pioneers of print-making in post-war Britain. He had seen what was happening in Paris and, anxious to promote the same facilities in England, he scouted around for artists whose work might be adaptable. It was Erskine's suggestion that Curwen sent Stanley Jones, who had worked in Paris, on a pilot scheme to try and involve artists in St Ives. All this took place in 1958, when Barbara, among others, had made two images, one of which went into a first edition.* In the meantime, the consumer boom transformed the market, and galleries hitherto uninterested were clamouring for prints. Unlike mechanical copying, lithographic images are hand-drawn, and this is crucial to the perpetrators. Barbara appreciated the craftsmanship of Stanley Jones, while he found her approach to the subject both particular and imaginative. Anxious to understand the technology and keen to experiment, she made an ideal pupil for the Curwen philosophy that the artist should begin lithographs simply, with a few colours, and develop as possibilities open up. Good will generated by the previous encounter was turned to further account when Barbara was commissioned to make a series of prints. As before, Jones went down to assist, this time with his family. Barbara's designs were similar to her current abstract drawings, austere circles, stringed arcs and vehemently interacting forms on marbled background washes. Some relate to her sculpture, others to the sun and moon rising over high seas. In the summer of 1969, Curwen released a portfolio of twelve, selling in a limited edition† to an immediately enthusiastic market. Brum reckoned they were a success because Barbara had enjoyed doing them.

Both Gimpel and MFA were approached by Curwen Press as outlets for the lithographs. Gimpel bought and sold a number of sets, but MFA saw a better deal in a lavish portfolio package. Since the object of the exercise had been to offer people of modest means an 'original', Curwen wouldn't agree to this. Not

* Published by Felix Man.
† Sixty in Britain, thirty in the US.

to be outdone, MFA sent Chris Prater to work with Barbara on silk-screen prints. Being a photographic technique, silk-screening was virtually reproduction, the purists sniped. Prater, however, was said to have metamorphosed screen-printing into a fine art. At any rate, the prints sold, and Curwen, encouraged by the first success, produced, two years later, a freer Aegean Suite.

It was difficult to steer a way through furiously competing middle-men. When Barbara wanted to reassess the terms of her contract, there was alarm at Gimpel Fils. More freedom was her pretext for bargaining a forthcoming exhibition with MFA in London for Gimpel's services abroad. A subtle change of power was taking place. While *The Times* was sporting a half-page illustration of her at the Tate Gallery, grim and grand on her walking sticks, like Alice in a wonder-landscape of gigantic stones, woods and bronzes, Gimpel could do no less than accept her terms. Undoubtedly, they put pressure on the relationship. Gimpel was suspicious that Barbara's contractual arrangements with their rival went further still.

Expecting to live a year at the most, she was tidying up different areas of her life. Religion was in her bones, she had once told Read, even when she didn't believe. She had lost the precious sense of communication with God, while renewing the need for it. To Bishop Morgan of Truro, she spoke of her need to be readmitted into the church, lost, she firmly believed, through her years of living, unmarried, with Ben. It was as if the conventions she had been brought up with were reasserting themselves in later life. Once again, the concept of wholeness drew her towards the sacramental church. The Vicar in St Ives was extremely helpful; her funeral service was arranged, and she wanted a London niche in case she got caught up in Westminster Hospital. The day she travelled to Oxford to receive her honorary degree, she alerted Father Donald Harris, Vicar of St Paul's in Knightsbridge, to whom she was introduced by the Hallidays. Barbara's letters to Father Harris are relaxed and pertinent. She had read Adler's comments on how artists resolve their sins, she

was reading de Chardin, Kierkegaard and Trahern; still she worried that the peacefulness she experienced in the workshop gave way to anguish when she ventured out. After five minutes she was harassed and burdened again. She wanted the clear conscience of someone who had attended confessional, though she had nothing to confess beyond the usual sloth, indulgence and selfishness, unless her persistent love for Ben was a sin. Was this a touch of theatre? A bid to be loved? She could be slightly affected, as if the indulgence she sternly withheld from her work had overflowed in her private life. To Norman Reid, she once made the remark, 'I am dying, you know,' as if she looked at herself detached and felt she was unique.

Male sympathy, flattery, admirers, and if possible, a male escort kept Barbara vitalized. The wives of the men she knew noted how she tolerated them provided they didn't try to steal the limelight, and turned, on all serious issues, to their husbands. Reid, Lousada, Brumwell, Jenkins, Capener, Gibbard, Lande, Harris, Herbert Read and the ailing Frank Halliday each had a tiny niche in the place she reserved for Ben. Ben's opinions, like those of her father, and of Moore, had meant almost everything. Her father had wanted her to be happy, to be a success, and she had been the pride of his life. Up to a point, Barbara's relationship with these men was built upon professional interaction, but being what she was, she wanted exchanges of a very personal – what she was apt to think of as 'spiritual' – dimension. She wanted to be vulnerable, so that they would be indulgent. Several times, she sought closer male friendships by teaching men to sculpt. Two medical practitioners, Norman Capener and Roger Slack, gained a great deal of pleasure from skills she generated in them. An academic, prompted by her tuition, went so far as to take up the challenge of her profession.

Moelwyn Merchant was Professor of English at the University of Exeter, a poet, and Dean of Salisbury Cathedral when Barbara met him through her honorary degree. Merchant had other friends in the visual arts, notably John Piper and Josef Herman,

suggesting a receptive predisposition. Besides, he was disenchanted with academic life. It was a moment at which Trewyn's enchanted garden with its blocks of marble and ready assistants seemed vibrant with purpose. The day Barbara trundled her wheelchair across the floor and handed him a set of sculpting tools set events in motion that led to his resigning his university chair. The exchange was two-way. Barbara wanted to know people who understood what they meant by 'God', and passionate souls don't necessarily find friendship easy.

Merchant was interested in the religious content of her work. While she was constructing the *Crucifixion* for the Close at Salisbury Cathedral, he was invited to prepare a religious TV programme for the BBC. This, he decided, would be the subject of his investigation. Despite Barbara's apprehensions, all went well. In a live interview, she spoke without stumbling. The larger problem with *Construction (Crucifixion)* 1966 was that other people were unable to appreciate, by looking at the sculpture, the profound reverence that had certainly been its intention. Such were the objections to its installation in the Close that Wiltshire County Council was obliged to intervene. With Merchant arguing forcibly on Hepworth's behalf, the Council backed down. But the issue wasn't resolved. A year later, a live incendiary bomb found under the statue was defused and handed to the police. The sculpture continued to be the subject of controversy among local people, and Barbara minded.

When Roger Leigh, her former assistant, held a sculpture exhibition in his Wiltshire garden, he didn't invite her to contribute, and once again, she minded. Henry Moore was being included. Reading about the exhibition in *The Times*, Barbara wrote to Leigh 'at a loss' to explain her exclusion. The real reason was simple. Moore was so easy to make arrangements with, Barbara so difficult.

Since he had left England, Simon had made a tentative gesture to his mother by enclosing a drawing for her in a letter to Brum. At the end of 1969, he made contact with her directly. Unfortu-

nately, by this time, his relations with the department at Berkeley had deteriorated. This was an additional worry. Stanley Jones remembered how, suffering from acute insomnia, Barbara would draw in the middle of the night, and walk in her garden at dawn. More and more time spent on the telephone didn't prevent her being lonely. Without work she was prey to a voracious emptiness that dominated her life. Devoured by anxieties, mapping out the precise contours of her loneliness, she drank to deaden the outer rim of her fear. A time of increasing fame had been a time of escalating needs, to which end Christianity was becoming her rock. Calling herself an Anglican Catholic, Barbara told her friends that, through prayer, she hoped to reach spiritual strength. Just before Easter, she had hobbled to St Paul's during a lunch-hour break from the Tate Gallery, to find it full of music. Soon after, she arranged to leave £1,000 to be used as Father Harris thought fit. With the help of friends, she managed to get to the Christmas Mass that heralded the new decade.

The Family of Man

(1970–72)

By 1969, war in Vietnam had dragged on for thirteen years. Some 500,000 American troops were backing the nominally democratic south against the Communist government in what everyone knew was a struggle between the great powers at Vietnam's expense. No one was winning, thousands of grisly deaths had been incurred, thousands more young lives mutilated. At a private level, Simon had been abroad five years without making direct contact, a personal war in which hardly a day passed without Barbara sorrowing. The climactic Tate show was over; she didn't expect to see her seventieth birthday. Ill, crippled, drinking heavily, she confessed publicly, she had been deeply depressed about the world. There was still work. Something radical seemed to be called for. Herbert Read had once written that Barbara Hepworth 'allowed her roots to strike deep into the past as well as to spread widely in the present'. On a smaller time-scale than he was referring to, this was how she conceived the images of nine figures that had first appeared to her after the war,* rising out of the sea. To the old vision, she brought a slight, if recognizable, shift of emphasis.

'I'm not exactly the sculpture in the landscape any more. I think of the works as objects which rise out of the land of the sea, mysteriously. You can't make a sculpture without it being a thing – a creature, a figure, a fetish . . . any stone standing in the hills here is a figure, but you have to go further than that. What figure? And which countenance? . . . I like to dream of things

* In 1947.

rising from the ground – it would be marvellous to walk in the woods and suddenly come across such things . . .' That such a romantic view was tenable is a measure of the change that had taken place.

One criticism of contemporary sculpture was that it lacked the inner force of superstitions or religious belief. This force was an essential ingredient of *The Family of Man* 1970. They are autobiographical, and they are totems, inscrutable, to be approached with curiosity and respect. They are about man's ascendancy. They are piled stones, each pile weighing more than a ton and a half. Barbara's standing forms of 1934 and 1935 were totemic figures, and she'd been stacking or piling stones at least as far back as 1935.* Two years later she stacked geometrical, wooden forms, and throughout the sixties she had returned to the theme.

The *Family* are not like humans except in their stance, yet each expresses a human form with which the viewer inevitably identifies. Even the hole through the headpiece of the commanding spirit, *Ultimate Form*, is a sort of invisible countenance rather than an abstract indication of space. Parents, ancestors, youth, young girl, bridegroom, bride and presiding deity represent the great race that inhabits the earth. The ancestors are each about nine feet tall, combining, typically, echoes of Barbara's childhood and family experience with a more general response to man's primitive longing for forefathers. One of them, *Ancestor II*, recalls anthropomorphic African figures. Significantly, the father figure is only a few inches shorter. Each is built of geometrically-based forms, thirty in all, cubes, rectangles and oval shapes, with a certain approximation to human head, torso and legs. None is exactly repeated, but there are echoes from one figure to another which link the group. Some of the forms are smooth, in others, the bronze is stroked and teased into dappled textures. The hollows are coloured a soft blue-green.

* *Cup and Ball* 1935, first called *Sphere in Hemisphere*.

Barbara's mind had been turning back the years to her youth and adolescence; to her great-great-grandmother (Frances Chadwick, wife of Benjamin Hepworth), before whom she, a tiny child, was presented as if to Queen Victoria. Through a sense of family, she maintained, one learns to establish balance, hope and a sense of identity, to learn what we owe to our forebears and our children, where debts lie and what our future holds. What could be more open, yearning and graceful than *Young Girl*, more virile than *Bridegroom*, more substantial than *Parent I*, more comforting than *Parent II*. By any standards the figures are arresting. The forms are thin; at the same time they take up a lot of space with their presence.

Something to be acknowledged about the *Family* is that at every critical echelon they have received pronounced diversity of opinion, deprecated by some artists and leading critics, praised highly by others, equally august. Some think that the intervention of the foundry diluted the purity and integrity of Hepworth's vision. Sweepingly dismissing all the bronzes, they suggest that a change took place in Barbara during her life which they symbolize. More specifically, objectors find the figures too stark for integration, the surfaces unduly fussed, or that they occupy an uneasy niche between figurative and abstract without being wholly convincing as either. To look for the compulsive tunneller, the revealer of worlds within worlds, is to be disappointed. The *Family* has to be approached on different terms. Perhaps it is significant that the woman who once claimed her best work was quiet now approved of fierceness and arrogance.

Quite what the men who stole five pieces thought of them is a riddle. Found the following day, on 27 July 1984, in a scrap-metal yard, they were returned, scratched and dented, to the Yorkshire Sculpture Park.

The reflection that contributed to *The Family of Man* had a literary outlet in Barbara's *Pictorial Autobiography*, brought out to coincide with her sixty-eighth birthday. Enclosing a copy, she wrote to Simon in San Francisco. Six generations of Hepworths,

photographically documented, would amuse his daughters, especially when they had children of their own. Simon, she suspected, wouldn't like it much. She was probably right. The autobiography chronicles a relentlessly single-minded endeavour, in which the plethora of photographed certificates, laudatory reviews and name-dropping challenged everything Simon represented. To those of Barbara's friends who disapproved of its self-advertisement, one could only comment that she had always craved recognition, it is strange they hadn't noticed before. Perhaps they were expecting too much from her. There may have been a time when she would have found the address, delivered at her Hon. D. Litt. from London, too sentimental. If so, the time had passed. To make things worse, she wanted the talk reproduced for Gimpel's New York exhibition catalogue, a desire reluctantly conceded. The austere artist Gimpel Fils represented was not averse to sentiment when she was the subject.

After seven years in the US, what began as a break for freedom for Simon and Silvie was beginning to feel like exile. For some time he had wanted to sell *Epidauros* to raise money for a trip home, but if good relations were at last to be established, Simon knew he must consult Barbara first. She wouldn't send a telegram, she explained, for Simon's last birthday in San Francisco, since a telegram cost about the same as a fur coat. That she was trying to inculcate standards of economy she felt were necessary to his circumstances was probably clear to him and, by implication, a slight reproof. Simon, however, was determined not to be provoked when he and his family landed in England in the summer of 1971. Paying their respects to St Ives on the way, they headed for Oxford, where he'd been offered an exciting job in the Technology Faculty of the Open University. It is difficult to know how Barbara, being older and less resilient, felt about her son's sudden arrival. A very grand presentation* of

* 14 October 1971.

Figure 1964, at the Kennedy Center in Washington, could have seemed the more real event of the two, but twelve weeks of shingles towards the end of the year might have blunted her response to both.

Passing into national collections was all part of the process of ensuring her reputation, an objective in which Norman Reid played a significant role. One of the hardest jobs he was called upon to carry out, as a newly appointed Director, was collecting from the Brumwells a work Barbara had persuaded them, against all their natural inclinations, to give to the Tate. They had bought the sculpture they referred to as three ostrich eggs on a slab★ when it was first made and loved it dearly.

Reid had a great many personal friends among artists. Valuing his astuteness, warming to his dry humour and lack of pomposity, they had responded, since he became Director, to his good sense. Adrian Stokes, like Barbara a Trustee, alerted him to the fact that she was considering donating a group of works, and Reid clinched the deal. Several artists inspired each other: Gabo donated a group of works, Ben, Barbara, Giacometti and Rothko all followed suit.

A few months into the new decade, Barbara had attended a joint exhibition of four rather special gifts from Nicholson, Gabo, Moore and herself in memory of Herbert Read. Gabo's enormous white object hovering in space and three honey-coloured offerings were a touching memorial to friendship in the eyes of Read's widow. Gabo, Henry and Barbara were present at the Tate, with the Norman Reids and lots of Reads. Only Ben – and Herbert – were missing. With a stick, handbag, and gold leaves embroidered on her dress, Barbara looked like an ageing lady mayoress.

Five years the elder, Moore, beside her, looked a paradigm of youth and health. His Tate retrospective, the same year as Barbara's, had marked the beginning of an omnipotent decade. At British Week in Tokyo the following year, he had been the

★ *Three Forms* 1935.

first British artist to hold a major one-man exhibition in Japan. In the new Museum of Modern Art, it was seen by an average of 3,000 visitors a day. When Barbara was showing *The Family of Man* at the Marlborough Gallery,★ Henry was in the Forte de Belvedere, a massive fortress on the outskirts of Florence. He was making a million pounds a year and the inauguration of his big bronzes in the US had become commonplace. Even when his work was sloppy, Moore continued to receive the better notices.

Despite Dag Hammarskjöld's magnificent overture, the extroverted US continued to show resistance to the more exacting beauty of Hepworth's sculpture, a pattern that has been maintained for a further twenty-five years. The Hirshhorn Museum in Washington, DC possesses thirteen of her works, New York's Museum of Modern Art has three, but her public exposure doesn't compare with Moore's. Canada offers a more British reception.† In Japan and Australia, moreover, both, as it happens, male-dominated societies, her work is most highly acclaimed of all.

A British Council exhibition at the Hakone Open-air Museum near Tokyo the year after Moore's was an amazing affair. Unable to be there, wanting somebody she could rely upon to represent her and supervise the opening, Barbara sent her accountant, Anthony Lousada, and his wife. It was a very large show, Lousada remembered; he was driven out from the Embassy to a country setting with idyllic views of Mount Fuji, to be greeted by an army of assistants, all in white gloves, awaiting his opinion of their arrangement. With a cue from the British Council to 'feel' his way, Lousada moved in gently and ended up re-shuffling the entire exhibition. He even arranged the lighting. The experience was exhilarating, he said, like conducting an orchestra.

When Harold Wilson failed to win the general election in June 1970, Barbara lost her bet with Peter Gimpel and had to part

★ MFA, May 1972.
† The Art Gallery of Ontario owns fifteen carvings and bronzes, and eight prints.

with a pound. Her relationship with her gallery was very much on her mind. Financial vigilance isn't automatically associated with artists, still less women artists. To Barbara Hepworth, it was nothing less than part of the job. More than one person remarked later that she seemed to them like another woman of toughness, ability and definite convictions. Margaret Thatcher was brought up conventionally, thrived in a man's world, and she, too, had a cause. Both were products of middle England, middle-class society, monarchist and nationalist: their attraction to authoritarian models of leadership, and to idealized views of family, flowed from this. Driven and sustained by underlying beliefs in the greatness of Britain, or of art, what was in their interests could be condoned because it was right for the country, or right for art. Barbara seems never to have considered – because that would have made her a different person – that art fulfils, to some extent, a selfish function. Friendship that was unable to sustain the hard edge of dedication was, by its nature, false, she once told Read, for true loyalty understood the pre-eminence of art. Her sentiment was understood in a note to Nicolete Gray, when Helen Sutherland died. 'The idea between us all is everlasting.'

It was a rule she stuck to when she finally quit Gimpel Fils, early in 1972, knowing what it would mean to a triumvirate with whom she had been in almost daily contact for sixteen years. The effort that goes into promoting a major artist can hardly be over-estimated, even an artist with as natural an urge towards her advancement as Barbara Hepworth. Gimpel took her on a rising current. They had, nevertheless, played a considerable part in consolidating her reputation. In 1956 she had been struggling desperately to keep solvent; by the seventies she was a wealthy woman. Naturally Gimpel had received their share of the profits, but Barbara was no longer sure that what was best for Gimpel was best for her. It rankled to think she might be better off elsewhere, and she hated feeling constrained. Besides, allegiance to two galleries engendered lack of trust. This had become an additional source of strain.

That Ben Nicholson was being represented by MFA was a good guide to their service. Important, too, to Barbara was the gallery's new and superior premises in Albemarle Street. Critics of a previous exhibition had complained that her large sculptures seemed to need more headroom. To someone as concerned as she with an advantageous setting for her work, this was a potent issue. MFA was the only gallery in London sufficient in size to show her *Family*. Besides the US, MFA would represent her in Germany, where, she was convinced, opportunities had been missed. But the essence of her dissatisfaction had always been her impression that Gimpel had 'one set of rules for Henry and another for me'. That Harry Fischer had left the firm in a flurry of aggressive politics to set up Fischer Fine Art made no difference. Tough as nails and sharp-bargaining, MFA insisted upon exclusive arrangements, leaving Barbara with the unenviable task of informing Gimpel Fils that she had no further need for their services. Exchanging unsold stock between galleries at home and abroad was only a part of the disruption involved. Unable to face the communications her decision entailed, Barbara organized her solicitor and accountant to act as buffers.

Being a celebrity had a lot of advantages. Exhibitions, ever more exalted, took place under the auspices of the British Council and MFA in Tokyo, Plymouth, New York, London, and two in the Tate within the first three years of the seventies. The attention Barbara had coveted for forty years was hers. Everyone knew what a Hepworth looked like; ideas that she and Henry Moore had once fought to establish had almost become clichés, hurried past in search of something less familiar. The temptation should be resisted, wrote Richard Cork of MFA's London show in February 1970. New sculptures, lithographs and drawings were pouring out. Barbara's vitality stunned the critics, and the odd dismissal was amply compensated by the general consensus of opinion that she was one of the important sculptors of the century. Only in private did Barbara sometimes admit what it cost. Drawing was no longer easy because her concentration was

intruded upon by pain. This was the other side of the lined and hobbling prima donna, bickered over and made much of, maintaining her leading role in a flattering world.

For lavishness, Marlborough's catalogues to the *Family of Man* exhibition outdid all previous presentations. Photographed in her Cornish garden, the gauntness of the sculpture was intensified by tropical luxuriance in colour and gloss. Nowhere was Gimpel Fils mentioned in the list of former exhibitions. To benefit from their long association with Barbara Hepworth, her old gallery exhibited their most recent stocks of her work. Gilbert Lloyd was said to be incensed that they should be referred to as 'new'. Her capture was regarded in the art world as a considerable coup and the galleries were not on speaking terms.

When Marlborough's youngest member, Geoffrey Parton, arrived at St Ives, he was greeted by an enormous whisky. This he was careful to drain. Had he failed to complete the task, Barbara, he felt, might not have approved. Like many of the artists he dealt with, she was demanding, but not as formidable as she had once been. She would listen to sound argument.

Honours, like exhibitions, were increasingly illustrious, Manchester's honorary degree being outdone by London, who invited the Queen Mother. Perhaps Barbara's willingness to receive the Grand Prix as Woman Artist of the Year from the Prefect of the Alpes-Maritimes★ says more about her relaxed codes of behaviour. Hitherto, she had taken pains to avoid the women-only network.

When Stanley Jones made a third visit to St Ives to collect lithographs for the Aegean Suite, Barbara had lost a lot of her former zest. Since the beginning of the decade she had lived in an extraordinary and, to her friends, depressing, condition of jumble and loneliness. Something deeply, at a personal level, unfulfilled was evident to many who engaged in more than cursory contact. With her at Trewyn one weekend, Jones was struck by the total

★ She was the first English woman to receive the honour.

silence in which she chain-smoked cigarettes. Lonely, as ever, for Ben, seeking comfort in the conventional wisdom of Christian ritual, she seemed an object of compassion.

The Revd Douglas Freeman officiated at the church which stood at the base of her garden. Shortly after his arrival in the parish, the Freemans and their children were invited to tea. Father Freeman was confided in about Barbara's unbaptized grandchildren (their parents, she lamented, were humanists) and garden cuttings were exchanged with Mrs F. To set off her Madonna in the Lady Chapel and celebrate the new rector, Barbara designed a pair of stainless steel candlesticks for the parish church. Right at the end of her life, she donated money to move the choir stalls, transforming the main part of the church. Plans to provide funds for a new vestry were interrupted by her death.

The time for giving had arrived. Though Anthony Lousada had bought quite an important piece of Barbara's sculpture and told her that any present was totally unnecessary, she gave him two more. One of them was in gold.* Lousada didn't feel entirely comfortable, but he could hardly refuse, since giving was Barbara's way of showing her gratitude and appreciation. With Norman Reid, she did much the same. First she quizzed him about what he liked, soliciting his admiration and approval, then she proffered something much larger, slightly more grandiose, and therefore less to his taste than the object he had selected. It was as if size and price of the material were a measure of love.

The day before Barbara's Marlborough exhibition opened, her mother nearly died. Having pulled through, she survived another two years. Gertrude Allison Hepworth finally faded away in April 1972, at the age of ninety-four. Barbara had been carrying two-thirds of the financial load, but Elizabeth had made the increasingly depressing personal contribution of twice-weekly

* A measure she was persuaded to take by a number of people connected with Morris Singer.

visits to a nursing home in New Barnet. With no one between her and mortality, Barbara braved on, consoled by her four cats.

While critics were dividing into camps over the *Family*, there was a new reaction to Hepworth and Moore in the voices of *The Times* and the *Financial Times*. Paul Overy disapproved of the big bronzes. Their work had, he thought, become 'overblown and insensitive'. Guy Brett was equally dismissive, writing of Hepworth's sculptures in the Marlborough Gallery, 'Their presence is to me extraordinarily hard and curt, and comes close to the cartoonist's traditional mocking image of the "sculpture with the hole".' The exhibition included some large, brittle-looking pieces in which severe angling and ridging resulted in a less smooth surface, because it was always being interrupted, a tendency that made the outer layer of *Hollow Form with Inner Form* 1968 look as if it might peel away like a banana skin. Yet there was in the same show an exquisite speckled nest in Hopton Wood stone,* a bowl with a curling, elliptical rim that seemed to shelter two upright, polished stones that stood inside. A third pebble stood outside, so that the grouping appeared more or less random. One thinks of stone as the most immutable material. Here it was honed to the delicacy of an eggshell. Another memorable piece was the black marble *Touchstone* 1969, which now belongs to the Tate Gallery. Basically a cuboid column, two feet high, with two opposite corners sliced away, supremely alive, still, watchful, essentially inhabited, utterly clear, pure, fearless and uncompromising. Its entirely new personality could only be Barbara Hepworth. At her best, she had remained rare, precious and inspired.

In the summer, John Hulton, Director of Fine Arts at the British Council, opening a small travelling exhibition in Darwin, drew attention to the similarity between some of her upright figures and the Aborigines' Pukamuni poles. In September, her geometrical bronze mural, eleven feet high, made of overlapping semi-circular discs, was unveiled above a building society in

* *Pierced Hemisphere with a Cluster of Stones* 1969.

Cheltenham.* The seventieth birthday she had not expected to be alive for was drawing near. A special exhibition in its honour, opening at the Tate three weeks before the calendar event, wooed her into 1973.

* Her mural at Cheltenham, *Theme and Variations* 1970, bears a resemblance to Robert Adams's collage in which segments of circles tumble across rectangular sheets, *Moving Forms* 1954, rather as Hepworth's *Curved Form (Wave II)* 1959, in the Tate Gallery collection, bears a resemblance to Moore's *Stringed Figure* 1937–9. According to Kay Gimpel, they were 'in the air'. The previous year, Barbara had played with half-circles in two of the lithographs in her Aegean Suite.

The Very Essence of Life

(1973–May 1975)

To a remote knuckle of Cornwall, dolmen-guarded, chilly and storm-lashed, greetings arrived from far reaches for Barbara's seventieth birthday. St Ives had been the main anchor to her life for over thirty years. Living and working there, she had repeatedly sung its praises, always identifying with its working community. Of the legendary honours and distinctions accorded to her, the Freedom of the Borough was one she especially prized, the St Ives *Times & Echo* reported proprietorially.

The seventh Hepworth bronze in the borough had recently made an appearance where it stands today, on a semi-circular dais that marks the most easterly point of the town. High above the harbour, gazing seawards through a single, all-seeing eye, *Epidauros* II of 1961, fastens its energy into orbits, life-cycles and tides. Like many an exchange between the local corporation and their celebrated resident, the gift had caused some variance. Until publicly reprimanded by Bernard Leach, the finance committee grumbled at disbursing £65 for a plinth. Suggestions that the sculpture be stuck on an old granite gate post were insulting, Leach argued on behalf of his friend.

On the tenth day of the new year, no sign of dissonance was allowed to tremble a spirit of determined good will. Representatives of the local administration joined family and friends, 150 in all, some of them art-world celebrities, for a lavish birthday reception at the Tregenna Castle Hotel. British Rail put extra coaches on the train from London to St Ives, for what it transpired was an unforgettable evening. Champagne ran, John Williams gave a superb guitar recital, Greek songs were sung and

two Greek bands from London struck up tunes for general danc-ing. Old friends met new ones while seven grandchildren ran hither and thither. Barbara radiated happiness. Sometimes she was in good spirits, despite her ravaged body. Long after the hotel had quietened, the lights were on in Trewyn studio. After all, Frank Halliday declared in a brief toast, they were celebrating the first great woman sculptor.

That there were undercurrents of less than total concord, goes almost without saying. Asked to contribute to the laudatory essays apt to accompany significant birthdays of famous people, John Summerson couldn't rise to the occasion. He didn't get to the party either. 'It made you think,' Elizabeth reflected to Ben, to whom correspondents were given to sharing their misgivings about Barbara. She was Queen Bee, they all said, disapproving of her appetite for the limelight, with the complaint that she drew round herself, in old age, largely people who weren't artists. Too many of her friends were people who had furthered her career. It was an old charge and an ambiguous one. Barbara's set had placed no barriers between art and science. Her friendships had always included people of varying talents provided they were alive to the arts. She was also drawn, rather obviously, to people who liked her work, and was particularly loyal to those who had backed her early in her career. Artists such as the Leaches, Alexander MacKenzie and Patrick Heron were among her friends. If she was wary of those who were judgemental, it was fair enough. She'd had a good share of judgement in her life. Distinguished people flattered and interested her. She had a side that was quite the reverse of the stereotype bohemian artist. Anthony Lousada remembered an occasion when the Queen went to the Tate to meet the King of Saudi Arabia before escorting him to the Palace. Being the one to receive her at the bottom of the steps, Lousada walked up with her, introduced her to Norman Reid, and then to the Trustees. Barbara, curtsying, in her white ermine coat, quite overcome by the occasion, was patently a loyal and appreciative subject.

Some friendships had become professional by virtue of pooled interests. Six months after her party,★ she was rolled into the US Embassy in a wheelchair to receive honorary membership of the American Academy of Arts and Letters at the same time as Michael Tippett. Where acquaintances had become fêted, this too, pulled them together. The opening of her retrospective exhibition in Plymouth was attended by John Wolfenden CBE. Not long after, the boy who had lived close to her in Wakefield was created a baron. Like Barbara, he was one who had stood apart from Alverthorpe's village games.

Towards the end of her seventieth year, Paul Jolles, a Swiss civil servant and collector, spent two hours with Barbara, talking and looking at her sculpture. As the day wore on, her secretary and assistants disappeared, leaving her alone in her studio with two enormous, silent cats, one wrinkled hand by holding the inevitable cigarette, the other, the inevitable glass. Liquid food stood by in a thermos flask. Jolles was struck, more than by any of the larger works, by a small white marble on a black slate slab, not one for sale, called *Solitary Eye* 1972. The piece felt an integral part of the surroundings and an expression of its creator's present rather secluded and solitary life. Three weeks later there arrived in Berne the most sensitive and serenely beautiful little work its new owner had ever seen.

There aren't many themes running through Hepworth's work. As she had done in the sixties, she was returning to early ideas, bringing forward the constructural simplicity of the middle thirties. The seventies output tends to be distinguished by its more obvious cosmic associations. Barbara set the sculptures on turntables because they symbolized the turning earth, incorporating in their impulse the birth and death, the grandeur and simplicity, of human life. During the two years, four months and ten days between her seventieth birthday and her death, she managed to make, besides smaller pieces, three larger, composite sculptures.

★ 4 June 1973.

Like *Fallen Images, Sea Forms* 1974–5 was a group of spheres, cubes and egg-shapes, carved in white marble, scattered randomly as shore-line objects which might have appeared on a wave and lain in the wet sand. The other 'major' piece, *Conversation with Magic Stones* 1973, occupies the highest corner of the garden at Trewyn. Three upright, notched, and three procumbent forms, of which the tall ones seem to be protective, the low ones brooding. One minute they are trees and sheep, the next, they are pure geometry, mystery lying at the foundations of nature, as if it were the first of the tools of life. Sit among them and they are magic stones, harbouring ancient secrets, their solidness accentuated by an elegant little steel-wire form the other side of the garden path. A painter friend of Barbara's who admired much of her work cannot imagine how she could have made the sculpture. Others find something profoundly satisfying in six boldly faceted, geometrical shapes. At all events, the six forms are deep in talk among the tamarisks and the church towers, looked down upon by the church clock, large-looming to generations of assistants, who have watched the hands slip round to end their working day. On the east, the town rises in flights of grey Victorian gables towards Carbis Bay.

Since she was a girl in the Yorkshire countryside, when Barbara first felt the leap of hills and valleys travelling in her father's car, the landscape had never been a series of painterly scenes, but something that flowed through her body, enabling her to express, either through dance or through mallet and chisel, concepts of poise and counterpoise, thrust, rhythm and balance. 'The consciousness and understanding of volume and mass,' she wrote in *Circle*, 'laws of gravity, contour of the earth under our feet, thrusts and stresses of internal structure, space displacement and space volume, the relation of man to a mountain and man's eye to the horizon, and all laws of movement and equilibrium – these are surely the very essence of life, the principles and laws which are the vitalization of our experience, and sculpture a vehicle for projecting our sensibility to the whole of existence.'

She was brought up at a time when, despite the wars, poverty and unemployment, there remained a widely held confidence among thinking men that the great creative self would triumph over the destructive self; that we can reach in our lifetime a state of equilibrium with our fellow men and our environment. Spurning the distractedness or dividedness that prevents the greater proportion of mankind from performing their proper task on earth, she worked until work became, she admitted, 'the only thing that calms'. Covered with dust and chippings, she was elated and in control. 'Sculpture is to me an affirmative statement of our will to live.'

Barbara revelled in the ebb and flow of natural forces, as if she was the still point of the turning earth. And when she was alone, at one with her stone, the spirit of creation insinuated itself until she was the hills and *was* her material. It was as if her consciousness merged with that of the perceptible world until the world perceived *was* her total consciousness. There was no distinction between knowledge and object; both seemed to be a part of herself. In a Rilkean passage about harnessing body and intellect, she described how her right hand, the motor hand, the hammer-holder, was the doer, while the left one, listening for flaws in the material, transferred thought into action. In practice, this power to direct an idea into immediate action was one of the faculties that made her so effective. It extended to any area in which she was involved. Protesting to the Secretary of State for the Environment about turning a pig farm into holiday accommodation was merely one new instance of the battles she maintained on behalf of the principles by which she stood, for art, education, political rights, world affairs and visual beauty.

Often, it is said that she 'put St Ives on the map' through her mediations on the Penwith Committee and her relations with the art world. Time has shown how true this was. Besides being Director of the Tate, Norman Reid was, for a time, chairman of the Penwith, and, consequently, a trustee of such properties as they had acquired. This included the studios on Porthmeor Beach

304

to which Barbara was very keen on enticing visiting artists. Artists must have studios, she saw, and if they were going to sell their work, the town must attract a discerning public. Many a time, Trewyn became the headquarters for discussing precisely these issues. She realized the wisdom of sponsoring a permanent art collection in the town. There was, indeed, an early attempt to do so. Janet Leach had promised a collection of Leach pots, and Barbara, among various artists, lent work to the Penwith's new gallery. Financial troubles ensued, little interest was shown by the town, one by one the studios had to be sold, and hopes of a permanent collection disappeared. But the spirit behind the present Tate Gallery in the west had been born. One-eyed *Epidauros* contemplates distantly from the 'Malakoff'; outside the Guildhall, the life-size components of another Hepworth, *Dual Form* 1965, play dos-y-do. In the town museum the little piece that Herbert Read wasn't sure he liked, *Rock Form (Penwith)* half-hides a slender profile in Portland stone. In the church, the Madonna dominates the Lady Chapel, and at the entrance to Longstone Cemetery stands a sprightly bronze, *Ascending Form*.

Barbara's *Times* obituary concluded with a snide comment about the gravestone she had created for herself. The problem was that it stood three feet above the permitted height. The story surrounding *Cantate Domino* could scarcely be more Hepworthian. The municipal cemetery, where Barbara bought a plot, permitted headstones up to two feet six inches, a limit designed to encourage maintenance. Barbara's sculpture, being six feet, was unacceptable, the Borough Council decreed. During the ensuing row, the sculpture remained at Trewyn where it was spotted and claimed for the Tate Gallery. It was in the Tate when she died, and white flowers were placed at its base. The tale doesn't end there, because, having clarified the fact that the sculpture was intended to stand near by, as a memorial, rather than on the grave, the superintendent of the graveyard had second thoughts, and felt he had been deprived. People were always trying to strip Barbara down to size. She had broken the

rules over the ways a woman should behave, and this made her a threat. The simplest way to deal with this was to be nasty, to diminish her. To be fair, there were those, neither envying nor feeling excluded, who couldn't accept her single-mindedness. In the end, she was a strong and difficult woman, with a circle of close, lifelong friends, who didn't bother to endear herself to everyone.

In St Ives, her death made the final dramatic sequel to the by then legendary stories. Barbara was the sort of person about whom stories were told and repeated even by people who didn't know her. Most, less than generous, stress her problems and shortcomings, rather than her guts, her breadth of outlook, her fine, educated response to the arts in general or her compassion for neighbours who were sick and bereaved. Behind the cutting edge there was envy, resentment at being made to feel less able, and, in the background, the old resistance to an outsider, especially one so capable, that had once turned Peter Lanyon to impotent fury.

Quite unrealistically, she had gone on expecting to see Ben. Though he had returned to England four years before she died, he hadn't been to see her. Angela Verren-Taunt, who often accompanied him at this stage, once suggested driving down to St Ives. Ben didn't want to go. He would meet too many people who'd want to talk to him. But he was shaken by Barbara's death and the way she died. It left a terrible silence. Professor Hammacher wrote to Ben, in poignant broken English, that he couldn't help returning in his mind to what was impossible to know. The funeral was held in the parish church where Moelwyn Merchant officiated.* Barbara would have revelled in it, Brum told Ben. The sun was shining, bells ringing in church and out, and crowds gathered in the street. For a big congregation, the

* In 1973 his son, Paul, produced a book of six poems illustrated with a couple of Barbara's lithographs: Paul Merchant, *Stones*, The Rougemont Press, Exeter, 1973.

stage management was superb. Sarah's son, Paul, and John Summerson read the lessons. Simon, at a conference on child education in the US, was represented by Silvie and the girls. All the grandchildren were there. Alan Bowness was the chief executor, supported by Anthony Lousada and Norman Reid. The duties would entail years of work.

Barbara didn't live to see her son-in-law Director of the Tate Gallery. All her executors collected knighthoods and Sarah became Lady Bowness in 1988, which says a lot about her entrenchment in the establishment. For each triplet, change was in store. The year after her mother's death, Rachel began showing very small still-lifes in a consciously naïve style, slightly William Scott and rather more Ben Nicholson. Since then, adding landscapes and interiors to her repertoire, she has built up a reputation, exhibiting in London's Montpelier Studio and in Tokyo. Rachel's positiveness was thrown into relief by Simon's decline. After his return from America, he thought everything was all right between him and Barbara. He enjoyed her party at the Tregenna Castle, enjoyed his work with the Open University, hoped for the renewal of his contract, and, still courting his mother's approval, sent her his introduction to the summer school. For Barbara's favourite child, the future seemed its most auspicious.

It is a measure of Simon's faith in his new relations with his mother that he was soon asking whether she would help him with a mortgage for a house. Barbara wouldn't,* informing him, quite illogically, that she and Elizabeth had managed to help their old mother for many years. None of her own children looked like being able to do the same for her. In reality, when Barbara was the same age (forty), her father was sending her weekly cheques, and Elizabeth was always dependent upon her husband. If Barbara gave Simon sculptures, she persisted, revealingly, he tried to sell them. Twice she had been forced to buy pieces back,

* Ben did.

causing her debts that she wouldn't, during her lifetime, resolve. Ben might be able to help, but she didn't want her name imputed. Simon shouldn't be assuming responsibilities for housing. Work was what mattered.

Simon had tried desperately hard to launch himself as an artist, although he never really found that work gave him any solace. He had will and talent, but he lacked stability. At the Open University he drove himself once again. The highly unconventional course he conceived and presided over, TAD 292, Art and Environment, became, despite internal opposition, a cult among its students. The whole thrust was to empower the participant as a creative agent and a decision-maker. Simon got on much better with his students than with the authorities. Far from being rebuffed by Barbara's decision, he sent gifts, photographs of the girls, and occasionally took the family to St Ives, where Barbara would send Mr Eva to meet them at the station. Simon's understanding that good relations with Barbara had been restored was one of the reasons why he was shattered to discover that although she left money to his children, he, personally, had been excluded from her will. Of an estate valued at £2,838,424, ten thousand went to Westminster Hospital, two thousand for the maintenance of St Ives parish church, and the bulk to her daughters. Barbara's 'wealth' was in her work. £2.4 million was the value placed on her sculptures and drawings, a further £234,000 was the estimate for her Nicholson paintings and drawings which were shared equally among her children. It remains difficult to know whether treating Simon differently from the girls shows her in a spirit of Christian charity. Perhaps his greatest crime was to have caused her so much self-doubt.

Whether his subsequent behaviour was affected by the will can never be known. Simon's fate could have been locked inside him for many years. Ostensibly he blotted out the episode with hurt and shock, but by the time TAD 292 expired, ten years later, he was drinking heavily. Still trying to design new courses for the OU, he accepted invitations to set up workshops in various parts

of the world, a crusade that became as intense and exclusive, as puzzling to outsiders, and lonely to himself, as the code by which Barbara had stood. Anti-nuclear, assertively ecological, he jogged obsessively to keep fit. When Margaret Gardiner's somewhat idealized memoir of Barbara appeared, he felt like one of the pawns in a great game that had taken place around him, cheated into insignificance. Why hadn't Margaret told the *whole* truth? That someone who had needed his own opportunity to shape a better world should have died of alcohol poisoning★ in his fifty-sixth year can only be seen as a failure and a waste. Four days before his death, Simon created from a plate of salad the smiling face he no longer wore. How like Ben, who once returned a dinner plate to a waiter, dotted with mustard except for a thumb-shaped space. Beneath that space, the mustard coated the underside of the plate.

Whether art can really deflect human society from a course dictated by tyranny, selfishness and vested interests must be doubtful. Whether an artist has the right to authority or expertise outside the aesthetic sphere is doubtful too. Like any strong sympathy, art transmits feelings that draw people together, but art addresses the final purposes of life rather than assisting life itself. Expecting as much of others as she did from herself, Barbara rocked life around her. It was a bit like the fairy tale called 'The Monkey's Paw'; to one's prizes, there are conditions. Barbara might have lost peace of mind in her fight for art, but it was Simon's life, not hers, that was the tragedy. If hers was sad, it was full of light, love and drama. One has only to look at some of her carvings to feel the self-fulfilment.

The personal imbroglios left in her wake made a keen contrast with the professional order.† The Hepworth Museum was supported by the family estate until the Tate Gallery gift in 1980,

★ 17 January 1990.
† Her death had caused the cancellation of a major MFA exhibition in August.

and after cataloguing her sixties work Alan Bowness was lined up to write the definitive biography. Where untidiness impinged upon order, loose ends might be tucked away until time had modified opinion. Part of the Hepworth legend was the unchanging nature of Barbara's way of life. What messages her senses were happy to pick up from the world around her and what they automatically blocked out. She had chosen to work in a small place, miles away from anywhere. She could have raised her sculpture on the cliffside, she could have bought strips of Cornwall, her garden was minute compared with Moore's. She preferred to concentrate herself at Trewyn, which is very Japanese in the way that the forms open up when one gets inside. Even the big pieces don't dominate the space or crowd each other out, and they work extremely well with the plants. Often Barbara spoke about scale. At one of her last big shows in New York, sculptures ranged from three inches to more than eight feet high. Huge or hand-sized, her work tends to address the viewer at *his* scale.

After Barbara died, her studio was offered to the nation by her family and trustees. Wearing his directorial cap, Reid, who was in the invidious position of being both trustee and potential recipient, approached three different ministers in succession to help with finances. All responded with enthusiasm, but no funds. Time passed, and Reid was getting near retirement. Bowness had been appointed successor and couldn't very well, being Barbara's son-in-law, complete the deal. So Reid pressed it through. Trewyn complemented what the Tate already owned, conditions being that work could be exchanged between the two. 'Hodgey', the colourful figure who had lived near the Hepworth-Nicholsons in Carbis Bay, left a houseful of early pieces to the Tate. Which, with the new Tate Gallery in St Ives, brings Barbara's ideas to perfect eventuality.

The sea battles on, unrelenting, its haunting music never far away. Wind and sea carve the rocks, whittling their images. Between the two coasts, sprout gaunt skeleton frames of defunct

mine-heads, Celtic crosses, Bronze Age menhirs, or standing-stones. What difference would it have made if Barbara had had more personal contact with a wider group of artists? Probably very little; exclusion was a tool that complemented her intense vision. She could hold images and memories in her mind and transpose them into her work. The gorse flickers with flowers, gulls' cries die on the wind. It is elemental land.

West Cornwall, with its moor-scattered quoits and cromlechs, its bright light staring through rocks and holes, was Barbara Hepworth's greatest source of inspiration. Her ability to animate stillness simply by engaging light is by no means confined to the pierced sculptures. To see her work at Trewyn is to witness, in pagan lightfulness, the transformation of their massiveness and their austerity into something timeless. She was aiming for 'a valid thing which will last no matter where the Concorde flies or doesn't fly'.

References

FOREWORD

p. xv 'On May Bank Holiday . . .' W.S. Graham, *The Thermal Stair*.

p. xvi 'Among critics . . .' *Guardian*, 4 June 1966.

p. xvi 'Herbert Read took . . .' Herbert Read, *Barbara Hepworth: Carvings and Drawings*, Lund Humphries, 1952.

p. xvi 'Hodin and Hammacher . . .' J.P. Hodin, *Barbara Hepworth*, Lund Humphries, 1961; A.M. Hammacher, *Barbara Hepworth*, Thames & Hudson, 1968 and 1987.

p. xvi 'Sir Alan Bowness . . .' Alan Bowness, *Drawings from a Sculptor's Landscape*, Corey, Adams & Mackay, 1970.

p. xvi 'In the *Pictorial* . . .' Barbara Hepworth, *A Pictorial Autobiography*, Moonraker Press, 1970 and 1978.

p. xvii 'Margaret Gardiner's memoir . . .' Margaret Gardiner, *Barbara Hepworth: A Memoir*, Salamander Press, 1982.

PROLOGUE: A SORT OF MAGIC

p. 3 'Early on, she had decided . . .' Gardiner, *Barbara Hepworth: A Memoir*.

p. 4 '"You must have a passion . . .' *Daily Express*, 21 May 1975.

p. 4 '"The first woman . . .' *Daily Telegraph*, 22 May 1975.

p. 4 '"the greatest woman . . .' *Observer*, 25 May 1975.

p. 4 '"a perfect relationship . . .' Herbert Read (ed.), *Unit One*, Cassell, 1934.

p. 5 '"We are so placed . . .' Hepworth, *Pictorial Autobiography*.

p. 5 'an "enormous optimist" . . .' *The Times* Diary, 9 January 1973.

pp. 8–9 'She was at a party . . .' Gardiner, *Barbara Hepworth: A Memoir*.

p. 9 'When she was seven . . .' Bowness, *Drawings from a Sculptor's Landscape*.

p. 9 '"You don't look . . .' Margaret Atwood, *Cat's Eye*,
Bloomsbury, 1989.

Chapter 1: Grim and Wonderful Contrasts

pp. 11–12 'At Dewsbury's New Wakefield . . .' *Kelly's Directory*.
p. 16 '*Dewsbury Reporter* obituary . . .' 4 August 1928.
p. 17 '"grim and wonderful . . .' Catalogue to Retrospective
Exhibition, Whitechapel Gallery, London, 1954.
p. 17 'inside the Mills mankind . . .' Ted Hughes, 'Hill-Stone Was
Content', *Remains of Elmet*, Faber, 1979.

Chapter 2: Finding What One Wants to Say

p. 18 '"Perhaps what one wants . . .' Catalogue to Retrospective
Exhibition, Whitechapel Gallery, London, 1954.
p. 22 'but novelist Leo Walmsley . . .' Leo Walmsley, *So Many
Loves*, Reprint Society, 1945.
p. 24 'Herbert Hepworth had . . .' Hepworth, *A Pictorial
Autobiography*.
p. 25 'At dawn, she crept . . .' ibid.

Chapter 3: A Special Kind of Compulsion

p. 28 '"Habits formed during . . .' *Wakefield Girls' High School
Review*, 1909.
p. 33 '"The hills were sculptures . . .' Hepworth, *A Pictorial
Autobiography*.
p. 33 '"Every hill and valley . . .' Read, *Barbara Hepworth: Carvings
and Drawings*.

Chapter 4: No Aim Beyond Getting On

p. 36 '"Life is marvellously free . . .' *Wakefield Girls' High School
Review*, 1924.
pp. 36–7 'At twenty-one . . .' ibid.
p. 37 'As a fellow student complained . . .' Raymond Coxon,
quoted in *Barbara Hepworth: Early Life*, Wakefield Art Gallery,
1985.
p. 38 'Professor Hammacher's suggestion . . .' *A. M. Hammacher,
Barbara Hepworth*.

p. 39 'her forehead "bulging . . .' Roger Berthoud, *The Life of Henry Moore*, Dutton, 1987.

p. 43 'The Permanent Secretary . . .' Christopher Frayling, *The Royal College of Art*, Barrie & Jenkins, 1987.

p. 44 'Twice, Barbara mentions . . .' Read, *Barbara Hepworth: Carvings and Drawings*; Hammacher, *Barbara Hepworth*.

p. 44 '"All the time . . .' Tate Gallery Archive, TAV2AB.

Chapter 5: The Fulfilment of a Dream

p. 51 'What Italy itself . . .' Read, *Barbara Hepworth: Carvings and Drawings*.

p. 55 'It was inevitable . . .' *John Skeaping, Drawn from Life*, Collins, 1977.

p. 57 '"If one has no ideas . . .' British School at Rome, J. Skeaping to Evelyn Shaw, 18 February 1925.

p. 58 'On the tenth of March. . .' British School at Rome, Evelyn Shaw to John Skeaping, 10 March 1925.

p. 64 '"my most formative year . . .' Read, *Barbara Hepworth: Carvings and Drawings*.

Chapter 6: Two Brilliant Young Sculptors

p. 65 'It was "not a lucrative . . .' Stanley Casson, *Some Modern Sculptors*, Oxford, 1928.

p. 65 '"Be kind to him . . .' British School, B. Ashmole to E. Shaw, 4 October 1926.

p. 67 'An article Bedford wrote . . .' *Old Furniture*, 4:223–4.

p. 68 '"Art enters into . . .' Laurence Binyon, Arthur Kemp Memorial Lecture, Bristol University, 1929; Binyon, *The Flight of the Dragon*, London, 1911.

p. 70 'Classical purity and firmness . . .' *The Times*, 13 June 1928.

pp. 70–71 'When George Hill . . .' George Hill in *The Medal* (No. 12), Spring 1988, British Museum Publications.

pp. 71–2 '"Every piece of wood . . .' Warren Forma, *Five British Sculptors*, Grossman, New York, 1964.

p. 73 'Henry admitted . . .' Penelope Curtis, Alan Wilkinson, *Barbara Hepworth: A Retrospective*.

p. 77 'Massiveness and simplification . . .' *Scotsman*, 3 June 1930.

p. 78 'Another boost came . . .' *Studio*, 99: 27–31.

p. 78 'When they exhibited . . .' *Morning Post* and *Connoisseur*.

p. 78 'To compensate . . .' *Scotsman*, 31 May 1930.

p. 80 'To be called brilliant . . .' *Sunday Times*, 26 October 1930; P.G. Konody, *Observer*, 1930 (showcase in Hepworth Museum).

p. 81 'The Skeapings' "necessary" compromise . . .' *The Times*, 16 October 1930.

p. 81 'To counter hints of disapproval . . .' *Apollo*, November 1930.

p. 81 'Husband and wife . . .' *The Times*, 16 October 1930.

Chapter 7: Work Shapes Up More and More Strongly

p. 83 '"It often happens that one . . .' Read, *Barbara Hepworth: Carvings and Drawings*.

p. 85 'Hugh Casson confessed . . .' *The Nicholsons: A Story of Four People and their Designs*, York City Art Gallery, 1988, Introduction.

p. 86 'Frank Halliday, a retired . . .' Frank Halliday, *Indifferent Honest*, Duckworth, 1960.

p. 87 'The press had lately . . .' *Kentish Independent*, 27 February 1931.

p. 89 'Shortly before its conception . . .' *Apollo*, November 1930.

p. 90 '"began to burrow into . . .' Edouard Roditi, *Dialogues on Art*, Secker & Warburg, 1960.

p. 90 '*Pierced Form* was by far . . .' Hepworth, Whitechapel Retrospective Exhibition catalogue, 1954.

p. 91 '"Pale triangular face . . .' *News Chronicle*, 19 February 1932.

p. 92 'Yet why, Read asked . . .' *The Meaning of Art*, Faber, 1931.

p. 93 '"For what is aesthetic experience . . .' ibid.

p. 94 '"Deep similitude . . .' Paul Nash, *Week-end Review*, 19 November 1932.

p. 95 'Between trying to placate . . .' Hepworth, *A Pictorial Autobiography*.

p. 95 'Kineton Parkes, for instance . . .' *Apollo*, 16: 308.

p. 95 'After puffing up Read . . .' *Yorkshire Post*, 23 November 1932.

p. 95 'Though the *Yorkshire Post*'s . . .' ibid., 14 November 1932.

p. 96 'If the *Scotsman* . . .' *Scotsman*, 18 May 1930.

p. 96 '*Studio* linked her . . .' *Studio*, 104: 332.

p. 96 '"Mrs Skeaping – better known . . .' *Yorkshire Evening News*, 15 October 1930.

p. 96 'Mrs John Skeaping . . .' *Daily Mail*, early October 1930.

p. 96 'Barbara wasn't mentioned . . .' R. Wilenski, *The Meaning of Modern Sculpture*, 1932.

p. 96 'Ben and Winifred . . .' *Western Morning News*, 19 February 1932.

p. 97 ‘"a decent long stay" . . . Winifred Nicholson, *Unknown Colour*, comp. Andrew Nicholson, Faber, 1987.

p. 97 ‘"I can't tell you . . .’ Ben to Winifred Nicholson, 26 November 1932. Quotation from Ben Nicholson © The Trustees of the Tate Gallery.

Chapter 8: Imminent Discovery

p. 98 ‘The days seemed . . .’ Herbert Read, *Unit One*, 1934.

p. 98 ‘Travelling to Avignon . . .’ Hepworth, *A Pictorial Autobiography*.

p. 99 ‘Later, Barbara recalled . . .’ ibid.

p. 101 ‘Obstinately, Winifred . . .’ Nancy Nicholson to Alan Bowness, 1967. Quotation from Ben Nicholson © The Trustees of the Tate Gallery.

p. 102 ‘while *Room and Book* . . .’ Paul Nash, *Room and Book*, London, Soncino Press, 1932.

p. 103 ‘Everything was coming . . .’ Letter to *The Times*, 2 June 1933.

p. 103 ‘"Extraordinary Interest . . .’ *Yorkshire Weekly Post*, 1 July 1933.

p. 103 ‘Le Corbusier's challenging . . .’ *Vers une architecture*, Editions Cres, Paris, 1923, tr. Frederick Etchells, Architectural Press, 1985.

p. 104 ‘questioned for the *Studio* . . .’ December 1932.

p. 105 ‘Frank Rutter, art critic . . .’ *Art in My Time*, London, 1933.

p. 105 ‘equally "freakish" . . .’ TGA, MB to Ben Nicholson, 26 October 1959.

p. 105 ‘A decade later . . .’ TGA, MB to Ben Nicholson, 27 October 1944.

p. 109 ‘Jim Ede, the art collector . . .’ Jim Ede, *A Way of Life: Kettle's Yard*, CUP, 1984.

p. 109 ‘"If I send you £8.10 . . .’ TGA, BN to BH, March 1933. Quotation from Ben Nicholson © The Trustees of the Tate Gallery.

Chapter 9: Absolute and Permanent Values

p. 111 ‘Ben had been interested . . .’ TGA, BN to BH, 12 December 1933.

p. 112 ‘No English sculptor . . .’ Geoffrey Grigson, *The Bookman*, November 1933.

p. 112 'A column in the *Spectator* . . .' 3 November 1933.

p. 112 'To Barbara, abstract art . . .' Herbert Read, *Unit One*, Cassell, 1934.

p. 113 'She was taking . . .' Charles Harrison, *English Art and Modernism 1900–1939*, Allen Lane/Indiana, 1981.

p. 113 'Like "the growth . . .' Herbert Read, *Unit One*, Cassell, 1934.

p. 114 'In the *Daily Express* . . .' *Daily Express*, 11 April 1934.

p. 114 '*The Times* recommended . . .' *The Times*, 12 April 1934.

p. 114 'Referring to himself . . .' *The Times*, 8 October 1933.

p. 115 'shortly after the Unit One . . .' TGA, 876, 16 May 1934.

p. 116 'A basement flat . . ' Hepworth, *A Pictorial Autobiography*.

p. 118 'Contemporary art . . .' Herbert Read, *Art Now*, Faber, 1933.

p. 118 'Artists were returning . . .' ibid.

p. 118 'At their own cost . . .' Geoffrey Grigson, *The Bookman*, November 1933.

p. 120 'Mondrian's painting . . .' Handwritten script by BH in Hepworth Museum.

p. 120 '"It seemed to me . . .' Read, *Barbara Hepworth: Carvings and Drawings*.

pp. 120–21 '"mutability of flesh . . .' Jim Ede, *A Way of Life: Kettle's Yard*, CUP, 1984.

p. 121 'But it was their . . .' Myfanwy Evans (ed.), *Axis*, No. 3, July 1935.

p. 122 'a "paradox of disunion" . . .' Geoffrey Grigson, *Bookman*, May 1934.

p. 122 '"BH." and "BN." would be . . .' T G A, 876, Ben Nicholson to Fred Murray, 29 November 1934.

p. 123 'This didn't prevent . . .' TGA, BH to BN, April 1935.

p. 124 'made a concerted attack . . .' *Listener*, 2 October 1935.

p. 124 '"nice clean healthy nature" . . .' TGA, Read to BN, 7 November 1941.

p. 124 '"à la Brancusi" . . .' Anthony Blunt, *Spectator*, 11 October 1935.

p. 124 'a "Soviet-like flavour . . .' *Scotsman*, 28 October 1933.

p. 124 'a "partiality for Absolutes" . . .' Brian Howard, 'Absolutism and Unit One', *New Statesman*, 21 April 1934.

Chapter 10: A Not So Gentle Nest

p. 126 '"Suddenly England seemed . . .' Hepworth, *A Pictorial Autobiography*.

p. 126 ‘"Left, right, black, red . . ." Myfanwy Evans, *The Painter's Object*, G. Howe, 1937.

p. 128 ‘"the new abstractionist . . ." Introduction to Catalogue, The Helen Sutherland Collection: a pioneer collection of the 1930s, Arts Council, 1970, Hayward Gallery.

p. 129 ‘"his forms are the true forms . . ." Hepworth to Herbert Read, HR/BH-313.

p. 134 ‘"the first plastic expression . . ." Ben to Winifred Nicholson, 16 April 1936. Quotation from Ben Nicholson © The Trustees of the Tate Gallery.

p. 135 ‘"Fragile, slender" . . ." *Daily Press*, 29 September 1937.

p. 135 ‘"abstraction, pure but . . ." *Yorkshire Post*, 29 September 1937.

p. 135 ‘"Miss Hepworth never . . ." *Architecture and Building News*, 1 October 1937.

p. 135 ‘"A high degree . . ." *The Times*, 2 October 1937.

p. 135 ‘Respect was by no means . . ." *New Statesman & Nation*, 2 October 1937.

p. 135 ‘"Nothing could be . . ." Patrick Heron, *The Changing Forms of Art*, Routledge, 1955.

pp. 135–6 ‘Rather a different line . . ." Charles Harrison, *English Art and Modernism 1900–1939*, Allen Lane/Indiana, 1981.

p. 136 ‘"reddened strings" . . ." Adrian Stokes, *Colour and Form*, Faber, 1950.

p. 136 ‘He could have done hundreds . . ." Roger Berthoud, *The Life of Henry Moore*, Dutton, 1987.

p. 136 ‘Barbara thought . . ." Read Letters, HR/BH-88.

p. 137 ‘"The war between nations . . ." Winifred Nicholson, *Unknown Colour*, Faber, 1987.

Chapter 11: A Good Place to Live in

p. 139 ‘In the midst . . ." Hepworth, *A Pictorial Autobiography*.

p. 141 ‘"It's truly grand country . . ." BH to John Summerson, 3 January 1940.

p. 142 ‘The town wasn't . . ." Virginia Woolf, *Moments of Being*, ed. Jeanne Schulkind, Hogarth Press, 1985.

p. 143 ‘James Whistler was . . ." Tom Cross, *Painting the Warmth of the Sun: St Ives Artists 1939–1975*, Lutterworth, 1984.

p. 144 ‘"We have ample chances . . ." BH to John Summerson, 3 January 1940.

p. 145 ‘Art, Read said . . ." *Horizon*, March 1942.

p. 148 ‘"I must do some work" . . .’ TGA, 8722, BH to Alistair
Morton, August 1939.

p. 150 ‘The experience of cooking . . .’ Read, *Barbara Hepworth: Carvings and Drawings*.

p. 151 ‘Read, busy writing . . .’ *Education Through Art*, Faber, 1943.

p. 153 ‘"He maybe sensed . . .’ TGA, TAV275.

p. 153 ‘What irked Barbara . . .’ *Listener*, XXVII: 404.

p. 154 ‘"It is now the time . . .’ Read Letters, HR/BH-44.

p. 154 ‘Even Read agreed . . .’ TGA, Brumwell to Ben, 2 August 1944.

p. 154 ‘In the ensuing . . .’ TGA, BH to Gabo, n.d.

p. 155 ‘The years in Cornwall . . .’ Read Letters HR/BH-37.

Chapter 12: I Was the Figure in the Landscape

p. 158 ‘according to Read . . .’ Herbert Read, *Art Now*, Faber, 1933.

pp. 158–8 ‘"I was the figure . . .’ Read, *Barbara Hepworth: Carvings and Drawings*.

p. 159 ‘Over the next few years . . .’ Hepworth, *A Pictorial Autobiography*.

p. 159 ‘on the cover of *Studio* . . .’ October 1946.

p. 160 ‘"I've finished two new carvings . . .’ TGA, BH to Paul Nash, 70.50/1005.

p. 160 ‘Two days after her birthday . . .’ Read Letters, HR/BH-61.

p. 161 ‘Appearances don't . . .’ Hepworth, *A Pictorial Autobiography*.

p. 162 ‘even Barbara allowed . . .’ Leeds Art Gallery, BH to Philip Hendy, 1943.

p. 162 ‘"Half an hour late . . .’ Read Letters, HR/BH-80.

p. 163 ‘Barbara had definite views . . .’ Read Letters, HR/BH-70.

p. 166 ‘"a day unique . . .’ Read Letters, HR/BH-71–2.

p. 167 ‘But all her best work . . .’ Leeds Art Gallery, BH to Philip Hendy, 21.5.43.

p. 167 ‘The oval form is . . .’ Hepworth, *A Pictorial Autobiography*.

p. 169 ‘Barbara stopped work . . .’ BH to John Summerson, 7 May 1945.

p. 171 ‘"like gods" to her . . .’ TGA, TAV250.

p. 172 ‘"And the Tate accepted . . .’ TGA, David Lewis to Denis Mitchell, 12 November 1983.

p. 173 ‘Barbara was also reading . . .’ Read Letters, HR/BH-77–8.

p. 173 ‘She preferred his stones . . .’ Read Letters, HR/BH-90.

p. 173 ‘"Less grim . . .’ *Observer*, 6 September 1946.

p. 173 'Patrick Heron pitted . . .' Patrick Heron, *Changing Forms of Art*, Routledge, 1955.

p. 173 '"Her great mastery . . .' Catalogue to Helen Sutherland Collection in Hayward Gallery, Arts Council, p. 22.

p. 175 'To cheer up the dreaded . . .' TGA, 8213, Ben Nicholson to Curt Valentin, 27 September 1946.

Chapter 13: A More Human Aspect

p. 176 '"Working for a site" . . .' Arts Council, BH to Philip James, 13 June 1949.

p. 178 'During what Read . . .' *Listener*, XXXIX: 592.

p. 180 '"unusual" . . .' *Wakefield Express*, 17 April 1948.

p. 181 '"bigness and achievement . . .' *Scotsman*, 28 April 1948.

p. 181 '"It all feels the same . . .' Read Letters, HR/BH-99–102.

p. 183 'Professor Hodin read . . .' Hodin, *Barbara Hepworth*.

p. 183 'What Barbara said . . .' Read, *Barbara Hepworth, Carvings and Drawings*.

p. 183 'prompting the reflection that . . .' Rilke, *First Duino Elegy*, 1. 40.

p. 183 '"The very nature . . .' Read, *Barbara Hepworth, Carvings and Drawings*.

p. 184 'For an artist . . .' TGA, Denis Mitchell, TAV249.

p. 186 'Barbara and Ben . . .' St Ives 1939–65 exhibition catalogue, David Brown's 'Chronology', Tate Gallery, 1985.

p. 187 'Sven Berlin had . . .' Sven Berlin, *The Dark Monarch: A Portrait from Within*, Gallery Press, 1962.

p. 187 '"Sculpture was public" . . .' Read Letters HR/BH-75, 14 May 1944.

Chapter 14: Love and Magic

p. 190 '"It does not matter . . .' Olive Schreiner, *The Story of an African Farm*, London, 1927.

p. 190 'Barbara reckoned . . .' TGA, *Christian Scientist Monitor*, Press file, n.d.

p. 193 'Michael Tippett, who . . .' Michael Tippett, *Moving into Aquarius*, Routledge, 1959.

p. 193 'These were the "topsy- . . .' St Ives 1939–65 exhibition catalogue, 'A personal memoir', David Lewis, Tate Gallery, 1985.

p. 195 '"the knot that tied . . .' TGA, W. Barns-Graham, TAV250.

p. 195 '"really vital down there" . . .' British Council Archives, BH. to LS, 26 April 1952.

p. 195 'To Heron there was no . . .' TGA, 247 AB.

p. 196 'Read didn't like . . .' Read Letters, HR/BH-127.

p. 197 'Barbara was feeling . . .' Read Letters, HR/BH-112–13.

p. 197 '"Miss Hepworth is slender . . .' TGA, Press File, Vol.XI, p.12, no source, 18 September 1950.

p. 197 'Paul Hodin . . .' *Art News and Review*, 11 February 1950.

pp. 197–8 '"two talented women" . . .' *Picture Post*, 1 March 1950.

p. 198 'The first woman . . .' *Liverpool Daily Post*, 2 October 1952.

p. 198 'The committee cut this down . . .' Kew Public Record Office, BH to Lilian Somerville, 17 March 1950.

p. 199 'Nowhere is one told . . .' British Council Archives, BH/LS, 10 December 1950.

p. 200 '"Privately, Somerville . . .' Penelope Curtis, Alan Wilkinson, *Barbara Hepworth: A Retrospective*.

p. 200 '"She really is the limit . . .' British Council Archives, BH to D.M Nash, 25 November 1950.

p. 200 '"It just seems . . .' British Council Archives, D M Nash to B H, 7 December 1950.

p. 201 'At the beginning . . .' *Art News and Review*, 11 February 1950.

p. 202 '"Time is stretchable . . .' Margaret Atwood, *Cat's Eye*, Bloomsbury, 1989.

p. 203 'Ten years earlier . . .' Leeds Art Gallery, BH to Phillip Musgrave, 7 December 1942.

p. 205 'After Ben, who . . .' TGA, 876, BN to Fred Murray, n.d.

p. 205 '"fair scrap" . . .' Read Letters, HR/BH-31.

p. 205 'Heron was among those . . .' Patrick Heron, *The Changing Forms of Art*, Routledge, 1955.

p. 206 'The *Spectator* found . . .' *Spectator*, 10 October 1952.

p. 206 'The *Guardian* writer . . .' *Guardian*, 3 October 1952.

p. 207 'Neither remoteness . . .' Read Letters, HR/BH-135.

Chapter 15: Living Bravely

p. 208 'Herbert Read's contemplative . . .' Read Letters, HR/BH-151, 177.

p. 208 '"For half an hour . . .' Read Letters, HR/BH-141–2.

p. 208 'Hitherto, she'd been smarting . . .' Joseph Ryrwert, *Time & Tide*, 17 January 1953.

p. 208 'Could Read imagine . . .' Read Letters, HR/BH-146.

p. 209 'For her, the secret . . .' Read Letters, HR/BH-143.

p. 209 'The next time Barbara . . .' Read Letters, HR/BH-150.

p. 213 '"unquestionably the most . . .' *Hackney Gazette*, 25 April 1954.

p. 213 '*Empyrean* (1953) . . .' Barbara Hepworth Retrospective exhibition catalogue, Whitechapel Art Gallery, April–June 1954.

p. 213 '"And we who have always . . .' R.M. Rilke, *Duino Elegies*, trans. J.B. Leishman and Stephen Spender, Hogarth Press, 1942, 10:110–11.

p. 214 'Assistants were duly . . .' Roger Leigh tape, 1992.

p. 215 '"The stars have not . . .' B.A.Y. *Punch*, n.d.

p. 215 'Even the *Cleckheaton* . . .' *Cleckheaton Guardian*, 25 April 1954.

p. 215 'Carving from 8.00 a.m. . . .' Read Letters, HR/BH-162.

p. 216 'Adapting to the conflicting . . .' Read Letters, HR/BH-156.

p. 216 'One critic called . . .' *Art News & Review*, from A.M. Hammacher, *Barbara Hepworth*, Thames & Hudson, 1968.

p. 216 'Opera always gave . . .' Read Letters, HR/BH-181.

p. 217 '"When I have finished . . .' Hammacher, *Barbara Hepworth*.

p. 221 'Heroes, according to . . .' R.M. Rilke, *Duino Elegies*, trans. J.B. Leishman and Stephen Spender, 1:140.

p. 221 '"How on earth" . . .' BH to John Summerson, 21 June 1944.

Chapter 16: These Large Figures

p. 222 '"Why shouldn't I carve . . .' BH to John Summerson, December 1957.

p. 222 '"I've always wanted . . .' Alan Bowness, *The Complete Sculpture of Barbara Hepworth 1960–1969*.

p. 223 'There were two streams . . .' British Council Archives, BH to Lilian Somerville, 26 April 1952.

p. 223 'In one sense . . .' Read Letters, HR/BH-169.

p. 223 'In metal she sought . . .' Read Letters, HR/BH-214, –240.

p. 225 '"As pure as the bird . . .' R.M. Rilke, *Duino Elegies*, trans. J.B. Leishman and Stephen Spender, 7:2.

p. 225 '"facing the setting sun . . .' BH, Tate Gallery Guide, The Tate Gallery, 1982.

p. 225 'yet another monograph . . .' William Gibson, *Barbara Hepworth*, London, 1946.

p. 228 '"She's a 'gentle' . . .' BN to Kay Gimpel, 19 September 1957. Quotation from Ben Nicholson © The Trustees of the Tate Gallery.

p. 228 'She wanted to . . .' BH to Gimpel Fils, 2 August 1957.

p. 229 '"debts worry me . . .' BH to Peter Gimpel, 19 September 1959.

p. 229 'An inordinate number . . .' BH to Peter Gimpel, September 1958; BH to Gimpel Fils, August–September 1957.

p. 230 'For "once in her life" . . .' BH to John Summerson, 6 January 1958.

p. 230 'Gimpel would use it . . .' Kay Gimpel to BH, 9 January 1958.

p. 230 'There were occasions . . .' TGA, Penwith Minutes, 18 December 1953.

p. 234 '"I can not any more support . . .' BH to John Summerson, December 1957.

p. 236 '"See that you're clean . . .' Roger Leigh, 1992.

p. 237 'Much as he liked St Ives . . .' TGA, 876, Ben Nicholson to Fred Murray.

pp. 237–8 'thoroughly "browned off" . . .' BH to Peter Gimpel, 27 April 1959.

p. 238 'Uncertain about . . .' BH to Kay Gimpel, 22 June 1959.

p. 238 'Slowly pulling through . . .' BH to Kay Gimpel, 4 August 1959.

p. 238 'Apologizing to her gallery . . .' BH to Peter Gimpel, 19 September 1959.

p. 238 'It was nearly five years . . .' BH to Gimpel Fils, 21 September 1959; BH to Peter Gimpel, 17 September 1959.

p. 239 '"Is one ever the same . . .' Read Letters, HR/BH-223.

p. 241 '"I went up to a high hill . . .' Read Letters, HR/BH-221, 98.

Chapter 17: Public Sympathy

p. 243 'Perhaps she shouldn't be . . .' BH to Kay Gimpel, 10 April 1960.

p. 243 'Nevertheless, when Read . . .' Read Letters, HR/BH-239–242.

p. 245 'Though her outlay . . .' BH to Peter Gimpel, 16 February 1960.

p. 247 'In 1957 . . .' BH to John Summerson, December 1957.

p. 249 'A chill wind . . .' Daily Express, 18 March 1960.

p. 252 'To "open up . . .' BH to Gimpel Fils, 17 February 1960.

p. 252 '"journeys of discovery" . . .' Barbara Hepworth exhibition catalogue, Whitechapel Art Gallery, 1962.

p. 253 'Aware of criticism . . .' BH to Roger Leigh, 10 February 1960.

p. 254 'Both had family . . .' Dag Hammarskjöld, *Times* obituary, 19 September 1961.

p. 256 '"One of the most important . . .' Barbara Hepworth exhibition catalogue, Whitechapel Art Gallery, 1962.

p. 256 '"warm, eloquent . . .' ibid.

p. 256 'On the contrary . . .' Read Letters, HR/BH-243.

p. 257 'Meeting her for the first time . . .' Edouard Roditi, *Dialogues on Art*, Secker & Warburg, 1960.

p. 257 'Barbara bundled off . . .' BH to Peter Gimpel, 29 August 1960.

Chapter 18: In a Man's World

p. 259 '"I think I can say . . .' BH to John Summerson, Autumn–Winter 1962.

p. 261 '"something so primitive . . .' Read Letters, HR/BH-312.

p. 263 'Helen Sutherland saw the latter . . .' TGA, Helen Sutherland to BH, n.d.

p. 264 'To a feminism . . .' *Daily Express*, 3 October 1961.

p. 265 'After mismanaging . . .' BH to Peter Gimpel, 27 July 1959, 9 July 1964 and 11 August 1964.

p. 267 'Communicating with one . . .' BH to Donald Harrison, 27 June 1969.

p. 268 '"Perhaps the most assured . . .' *Art News*, January 1964.

p. 269 '"How on earth . . .' BH to John Summerson, 9 August 1964.

p. 269 'Barbara welcomed him . . .' Menstrie Museum, BH to Bernard Leach, 30 November 1964.

p. 270 'The exhibition was superb . . .' Read Letters, HR/BH-301.

p. 271 'Lilian Somerville had written . . .' British Council, Lilian Somerville to Philip Hendy, 2 November 1964.

p. 271 'What should she write . . .' BH to John Summerson, 11 July 1965.

p. 271 'Snowdon's *Sunday Times* . . .' *Sunday Times* magazine, 26 September 1965.

p. 272 'Important committees . . .' *Daily Telegraph*, 12 July 1963.

p. 272 'In Oldham . . .' TGA, *Daily Telegraph*, card, 1966.

Chapter 19: My Silly Room in the Great Western

p. 273 '"astonishing lair". . .' Read Letters, HR/BH-291.

p. 273 '"silly room at the Great Western". . .' BH to John Summerson, 26 April 1968.

p. 275 'In fact, Kramer's review . . .' Hilton Kramer, *New York Times*, 13 March 1966.

p. 275 'Where the cavities . . .' Edwin Mullins, review of Marlborough-Gerson, 29 May 1966.

p. 275 'Read said much the same . . .' TGA, Herbert Read to Ben Nicholson, 10 September 1966.

p. 275 'Norbert Lynton took . . .' Norbert Lynton, *Guardian*, 4 June 1966.

p. 277 'Besides, a sculptor . . .' BH to Simon and Silvie Nicholson, 21 June 1967.

p. 278 'One of the "two or three . . .' ibid., 3 April 1968.

p. 278 'To Lynton's conspicuously . . .' ibid.

p. 279 'The illustrations . . .' A.M. Hammacher, *Barbara Hepworth*, Thames & Hudson, 1968.

p. 279 'Herbert Read did his best . . .' TGA, Read to Ben Nicholson, 30 December 1966.

p. 282 'Kay Gimpel referred . . .' Kay Gimpel to BH, 25 September 1968.

p. 286 'Barbara wrote to Leigh . . .' BH to Roger Leigh, 5 August 1969.

Chapter 20: The Family of Man

p. 288 'Herbert Read had once written . . .' Read, *Barbara Hepworth*.

p. 288 '"I'm not exactly . . .' Alan Bowness (ed.), *The Complete Sculpture of Barbara Hepworth: 1960–1969*, Lund Humphries, 1971.

p. 290 'Perhaps it is significant . . .' TGA, BH to Ben Nicholson, quoted in Penelope Curtis, Alan Wilkinson, *Barbara Hepworth: A Retrospective*.

p. 291 'Barbara's *Pictorial Autobiography* . . .' Moonraker Press, 1970 and 1978.

p. 291 'Enclosing a copy . . .' BH to Simon Nicholson, 8 June 1970.

p. 292 'A few months . . .' TGA, Margaret Read to Ben, 2 March 1970.

p. 294 'Her sentiment was . . .' TGA, BH to Nicolete Binyon/Gray, 3 May 1966.

p. 295 'But the essence . . .' BH to Peter Gimpel, 9 July 1964.

p. 295 'The temptation should . . .' Richard Cork, *Evening Standard*, 17 February 1970.

p. 296 'Barbara's vitality stunned . . .' *Daily Telegraph*, 16 February 1970.

p. 296 'Only in private . . .' BH to Peter Gimpel, 14 January 1971.

p. 298 'Their work had, he thought . . .' Paul Overy, *Financial Times*, 21 August 1970.

p. 298 '"Their presence is to me . . .' Guy Brett, *The Times*, 24 February 1970.

Chapter 21: The Very Essence of Life

p. 302 'Towards the end of her seventieth . . .' TGA, Paul Jolles to Ben Nicholson, 25 November 1973; 16 December 1973.

p. 303 '"The consciousness and understanding . . .' J.L. Martin, Ben Nicholson and N. Gabo (eds.), *Circle*, 1936.

p. 304 '"the only thing that calms" . . .' BH to John Summerson, 17 September 1961.

p. 304 'In a Rilkean passage . . .' BH, *A Pictorial Autobiography*, Moonraker Press, 1970.

p. 305 'Barbara's *Times* obituary . . .' *Times* obituary, 22 May 1975.

p. 305 'The story surrounding *Cantate Domino* . . .' *Observer*, 25 May 1975.

p. 307 'Barbara wouldn't . . .' BH to Simon Nicholson, 5 February 1973.

p. 309 'Whether art can . . .' Roger C. Tallis, *The Freezing Coachman: Some Reflections on Art and Morality*, BBC Radio 3 script, November 1992.

p. 311 'She was aiming for . . .' *Guardian*, 17 January 1973.

Select Bibliography

MONOGRAPHS

Barbara Hepworth: Early Life, Wakefield Art Gallery, 1985.

Alan Bowness, *The Complete Sculpture of Barbara Hepworth 1960–1969*, Lund Humphries, 1971.

Alan Bowness, *Drawings from a Sculptor's Landscape*, Corey, Adams & Mackay, 1970.

Penelope Curtis, Alan Wilkinson, *Barbara Hepworth: A Retrospective*, Tate Gallery Publications, 1994.

Margaret Gardiner, *Barbara Hepworth: a Memoir*, Salamander Press, Edinburgh, 1982.

William Gibson, *Barbara Hepworth*, Faber, 1946.

A.M. Hammacher, *Barbara Hepworth*, Thames & Hudson, 1968 and 1987.

Barbara Hepworth, *A Pictorial Autobiography*, Moonraker Press, 1970, 1978.

J.P. Hodin, *Barbara Hepworth, Life and Work*, Lund Humphries, 1961.

Herbert Read (ed.), *Barbara Hepworth: Carvings and Drawings*, Lund Humphries, 1952.

Michael Shepherd, *Barbara Hepworth*, Methuen, 1963.

THESES

Penelope Curtis, *Barbara Hepworth: Early Works and Context*, M.A. Report, Courtauld Institute, University of London, 1985.

Sarah K. Davenport, *Statements from a Sculptor's Landscape: An Analysis of the critical accounts centred on the life and work of Barbara Hepworth*, B.A. Dissertation, Leeds University, 1990.

Nicholas C.J. Hely-Hutchinson, *The Reluctant Modernist: John R. Skeaping, R.A., 1901–1980*, M.A. Dissertation, University of St Andrews, 1982.

GENERAL BOOKS

Roger Berthoud, *The Life of Henry Moore*, Dutton, 1987.

R.L. Binyon, *The Flight of the Dragon*, John Murray, 1935.

Stanley Casson, *Some Modern Sculptors*, Oxford, 1928.

Stanley Casson, *Twentieth-century Sculptors*, London, 1930.

Tom Cross, *Painting the Warmth of the Sun: St Ives Artists 1939–1975*, Lutterworth, 1984.

Jim Ede, *A Way of Life: Kettle's Yard*, C.U.P., 1984.

Myfanwy Evans, *The Painter's Object*, G. Howe, 1937.

Myfanwy Evans (ed.), *Axis: A Quarterly (1935–37)*, Arno, N.Y., 1968.

Christopher Frayling, *The Royal College of Art*, Barrie & Jenkins, 1987.

Maurice Goldsmith, *Sage: A Life of J.D. Bernal*, Hutchinson, 1980.

John Goodchild, *Wakefield and District Directory*, Barretts Publications, 1966.

Lynda Grier, *Achievement in Education: The Work of Michael Ernest Sadler*, Constable, 1952.

Frank Halliday, *Indifferent Honest*, Duckworth, 1960.

Charles Harrison, *English Art and Modernism*, Allen Lane/Indiana, 1981.

Patrick Heron, *The Changing Forms of Art*, Routledge, 1955.

Peter Khoroshe, *Ivon Hitchens*, André Deutsch, 1990.

James King, *Interior Landscapes: A Life of Paul Nash*, Weidenfeld & Nicolson, 1987.

James King, *The Last Modern: A Life of Herbert Read*, Weidenfeld & Nicolson, 1990.

Jeremy Lewison, *Ben Nicholson*, Tate Gallery Publications, 1993.

J.L. Martin, Ben Nicholson and N. Gabo (eds.), *Circle*, Praeger, N.Y., 1971.

Lynda Morris and Robert Radford, *The Story of the Artists International Association 1933–53*, The Museum of Modern Art, Oxford, 1983.

Sandy Nairne and Nicholas Serota (eds.), *British Sculpture in the Twentieth Century*, Whitechapel Art Gallery, 1981.

Steven A. Nash and Jorn Merkert, *Naum Gabo: Sixty Years of Constructivism*, Prestel–Verlag, 1985.

Christopher Neve, *Leon Underwood*, Thames & Hudson, 1974.

Winifred Nicholson, *Unknown Colour*, Faber, 1987.

The Nicholsons: A Story of Four People and Their Designs, York City Art Gallery, 1988.

Herbert Read, *The Meaning of Art*, Faber, 1931.

Herbert Read, *Art Now*, Faber, 1933.

Herbert Read, *Art and Society*, Heinemann, 1937.

Herbert Read, *Education Through Art*, Faber, 1943.

Herbert Read, 'A Nest of Gentle Artists', *Apollo*, 67, No. 7 (September 1962).

SELECT BIBLIOGRAPHY

Herbert Read, *A Concise History of Modern Sculpture*, Thames & Hudson, 1964.

Herbert Read, *Henry Moore*, Thames & Hudson, 1965.

Herbert Read, *Arp*, Thames & Hudson, 1969.

Rainer Maria Rilke, *Duino Elegies*, ed. J.B. Leishman and Stephen Spender, Hogarth, 1942.

E. Roditi, *More Dialogues on Art*, Ross-Erikson, California, 1984.

Frank Rutter, *Art in My Time*, London, 1933.

Christopher Scargill and Richard Lee, *Dewsbury As It Was*, Hendon Pub. Co., 1983.

St Ives 1939–64, Tate Gallery Catalogue, Tate Gallery Publications, 1985.

Evelyn Silber, Terry Friedman et al., *Jacob Epstein: Sculpture and Drawings*, Leeds City and Whitechapel Art Galleries, 1987.

John Skeaping, *Drawn from Life: an Autobiography*, Collins, 1977.

John Skeaping 1901–80, A Retrospective, Ackermann catalogue, 1991.

Frances Spalding, *British Art since 1900*, Thames & Hudson, reprinted 1992.

Adrian Stokes, *Colour and Form*, Faber, 1950.

Michael Tippett, *Moving into Aquarius*, Routledge, 1959.

Leo Walmsley, *So Many Loves*, Reprint Society, 1945.

R.H. Wilenski, *The Meaning of Modern Sculpture*, Faber, 1932.

John Wolfenden, *Turning Points: The Memoirs of Lord Wolfenden*, Bodley Head, 1976.

Virginia Woolf, *Moments of Being*, Hogarth Press, 1985.

PUBLIC COLLECTIONS

The largest source of correspondence was the Archive Department of the Tate Gallery.

Barbara Hepworth's letters to Herbert Read were lent to me by courtesy of Special Collections, P.O. Box 1800, University of Victoria, B.C., Canada.

Letters to the British Council are at 10 Spring Gardens, SW1A 2BN and Kew Public Record Office; to the Arts Council, at the Festival Hall archive; to Philip Hendy, at the Henry Moore Centre for the Study of Sculpture, 74 The Headrow, Leeds LS1 3AA; to Dag Hammarskjöld, at the United Nations archive in New York.

Information about John Skeaping's years at the British School at Rome is at the Oliver Building, Regents College, Regent's Park, London NW1.

A few letters to, and information about, Bernard Leach came from the Holburne Museum and Crafts Study Centre, Great Pulteney Street, Bath BA2 4DB.

Index